the HOW and WHY of
CHINESE PAINTING

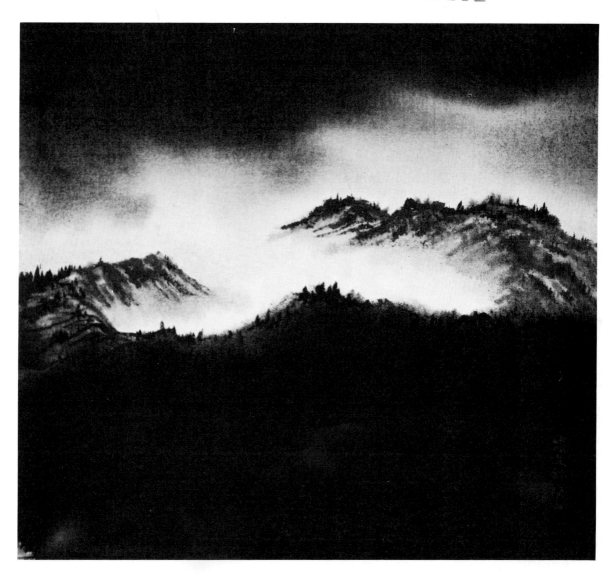

Art-in-Practice Series

Project Editor and Designer: Barbara Klinger

the HOW and WHY of
CHINESE PAINTING
DIANA KAN

Photographs by Sing-Si Schwartz

Text by Diana Kan with Miriam Mermey

VNR **VAN NOSTRAND REINHOLD COMPANY**
New York Cincinnati Toronto London Melbourne

For Paul

I would like to thank my teacher Professor Chang Dai-chien and
my friend Mr. John M. Crawford, Jr.

Van Nostrand Reinhold Company Regional Offices:
New York Cincinnati Chicago Millbrae Dallas
Van Nostrand Reinhold Company International Offices:
London Toronto Melbourne

Copyright© 1974 by Litton Educational Publishing, Inc.
Library of Congress Catalog Card Number 73-16711
ISBN 0-442-24243-3

Designed by Barbara Klinger

Published by Van Nostrand Reinhold Company
A Division of Litton Educational Publishing, Inc.
450 West 33rd Street, New York, N.Y. 10001
1 3 5 7 9 11 13 15 16 14 12 10 8 6 4 2

Library of Congress Cataloging in Publication Data

Kan, Diana, 1926-
 The how and why of Chinese painting.

 (Art-in-practice series)
 1. Painting—Technique. 2. Painting, Chinese.
ND1505.K36 751.4'25 73-16711
ISBN 0-442-24243-3

Contents

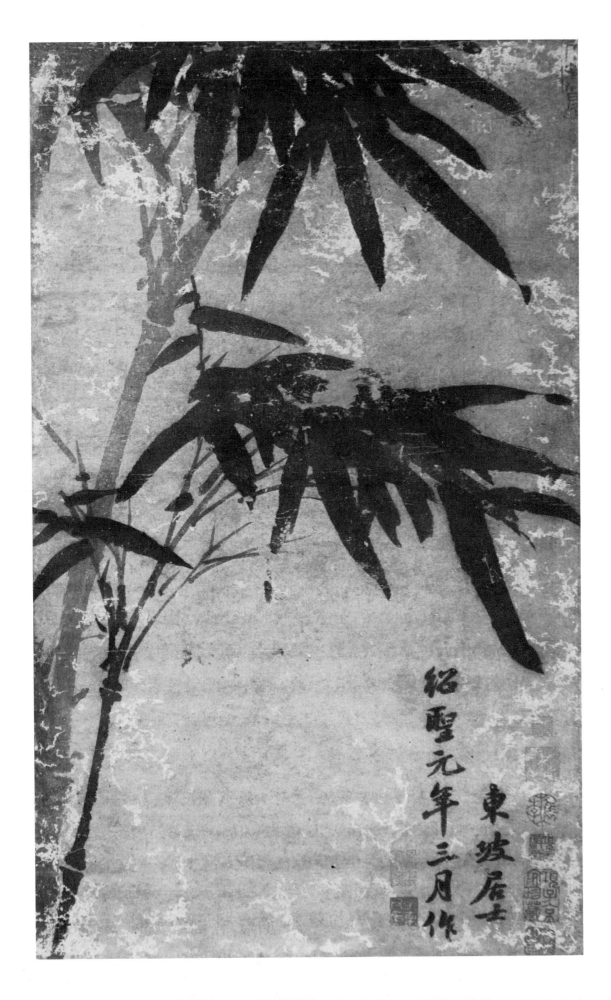

紹聖元年三月作 東坡居士

6

Introduction

This introduction may be likened, perhaps, to the overture or prologue of an opera one has come to hear. Many of the themes established here will be restated and re-encountered as the book unfolds, and it is hoped that they will provide an anticipatory pleasure and suggest a mood for the work to come.

Chinese painting is much more than meets the eye. Of course, the pictorial content of the composition can easily be read, but unless its inner and symbolic meanings are recognized, the whole painting will have been only partially seen and partially enjoyed. Underlying the apparent simplicity and harmony of composition, and the aura of serenity, there is first of all a philosophy, one that sees a unifying pattern of life in all natural forms. This unity is based on the belief that the forces of nature oppose and equalize each other so that, despite fluctuation and change, there is always an overall balance and continuity. In winter, for instance, the feminine or *yin* aspects of the universe — moisture, darkness, coolness — are predominant, while in summer the masculine or *yang* aspects of light, heat, and dryness take command. Thus winter yields to spring and spring to summer, but each is certain to return the following year. Although the seasons are constantly shifting, their cyclical pattern remains unchanged.

The consequences of these philosophical thoughts are many. The artist must express both the pervasive spirit of vitality and renewal and the eternal harmony and order implicit in nature. Therefore, the painter finds in every natural form, no matter how insignificant, a sense of loftiness and purpose; he celebrates the simplest things on earth as representing continuing life. This attitude is evidenced in all aspects of painting — choice of subject matter, simplicity of composition, and manner of execution — and it is part of the continuum of Chinese painting.

Art in China has evolved from centuries-old beliefs and traditions. It does not exist for art's sake alone but is an outgrowth of living. The early gentleman-painters, from whom we have inherited our standards, were in fact distinguished scholars, government officials, and literati, who turned to art as an adjunct to their other careers. They had the cultural background for mature, philosophical thought, and their artistic sensibilities had been heightened by long nurturing of an appreciation for beauty and harmony. In their art, both painting and poetry, they strove to express their understanding of nature.

These early poet-painters were intoxicated with the immensity and harmony of the universe. It was a universe in which every natural form was kin and each individual form had the power to communicate not only its own essence *(li)* but that of life itself *(Ch'i)*. To transmit this quality of life, the brush itself must be infused with spirit. This is the first principle in the Six Canons formulated and codified as rules and instructions by the renowned painter Hsieh Ho, in about 500 A. D., and passed down to us through succeeding generations. Without the quality of *Ch'i*, without a sense of vitality in handling the brush, the painting will be lifeless, regardless of correct technique. The intangibles of insight and feeling are still fundamental to the artist; perfection in brushwork cannot be achieved without them.

An ancient painting of bamboo signed by and attributed to Su Shih, also known as Su Tung-p'o (1036–1101), a famous poet-painter of the Sung Dynasty; from the collection of John M. Crawford, Jr. (Painted in ink on paper, 13 by 21¼ inches.)

All of the Six Canons are important, of course, but we might take special note of the sixth as well as the first. The Western world has always prized originality and nonconformity. The Chinese artist, however, believes in the expediency of copying not only as a learning device but also as a means of perpetuating ancient rules and techniques which might otherwise be lost. The paintings of the old masters are highly respected and copying is considered a good method of recording and preserving these works for posterity. Such copies, if they are of high quality, are accepted as works of art "in the style of" or "after" the original artist.

In addition, no matter how many persons copy a painting, each copy will be imbued with the unique personality of the individual artist. The student, therefore, is encouraged to learn by copying the established techniques of the teacher until the knowledge and skill essential to success have been acquired. Combined with the student's own creative consciousness, this method will eventually result in the creation of works of art. The Chinese liken this procedure to the feeding of the silkworm on mulberry leaves; after absorbing and assimilating the necessary nourishment, the silkworm transforms the material into pure silk.

Closely allied to the philosophical concepts of the early artists, whose traditions we still follow, were the Neo-Confucian ideals of good behavior. Accordingly, the natural forms we paint as symbols of life have also come to symbolize standards of virtue. The Four Gentlemen, for example — the bamboo, the plum tree, the orchid, and the chrysanthemum — are each considered paragons of admired attributes: judicious flexibility and perseverance; rejuvenation and hardihood; modesty and purity; fortitude and patience. The mountains, the rocks, the trees — all of these embody ethical qualities and often take on other human characteristics as well. Thus the flowers can respond to the wind and rain; the petals can sing and the leaves dance; the rocks have faces; a mountain can raise its head and spread its arms.

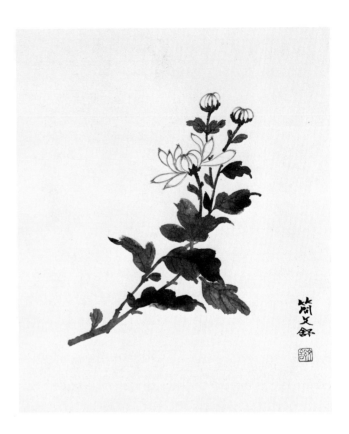

The chrysanthemum above has petals in double contour style; the light gray outlines are reiterated by the thin, dark ones of a constant weight or thickness. The leaves and stems are in *mo ku* or boneless style. In *mo ku* style, the brush is guided with varying pressure to shape each stroke according to the subject matter. The Chinese orchid below is also in *mo ku* style; each petal and leaf is accomplished separately, with a single stroke of varied thickness.

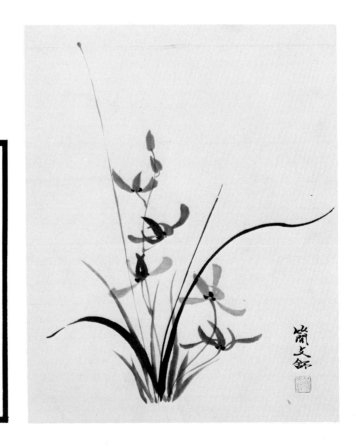

THE SIX CANONS

1. Ch'i-yun sheng-tung: Spiritual quality generates rhythmic vitality.

2. Ku-fa yung-pi: Use the brush to create structure (bone manner).

3. Ying-wu hsiang-hsing: To establish the form, write its likeness.

4. Sui-lei fu-ts'ai: Apply color in accordance with nature.

5. Ching-ying wei-chi: Plan the design with each element in its proper place.

6. Ch'uan-i mo-hsieh: Study by copying the old masters.

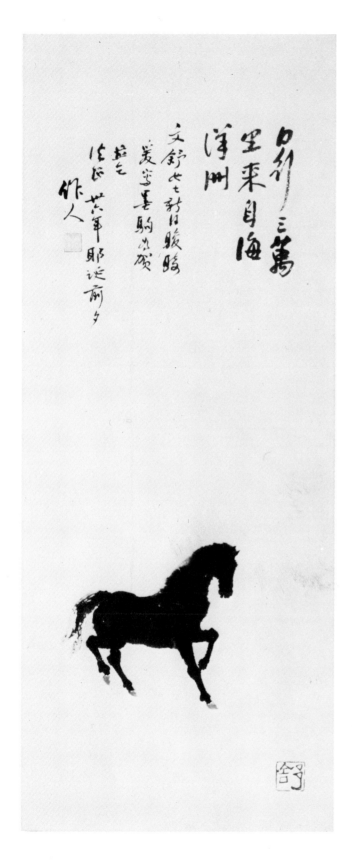

This horse by Wu Tso-jen was painted on Christmas Eve, 1947. The calligraphy describes how Professor Wu saw the young lady Man Shu (Miss Kan's Chinese name) riding a horse in Hong Kong in the early morning of a previous day; he painted the colt as a gift and as a symbol that she will travel far in her career. (Ink on paper; 10¾ by 27 inches.)

In order to transmit these qualities, the artist himself must be virtuous. For, if the artist considers simplicity and humility in life-style more desirable than self-seeking, then these virtues will be transferred from the artist's consciousness to the subject he paints. The development of the artist as a being is considered as important as his development of technique. Mastery of technique arises from the fusion of philosophical and ethical concepts with the action of the brush, and it is this fusion that results in quality of brushwork. Quality of brushwork is the paramount goal in Chinese painting, whether the work is in the precise, essentially linear style known as *kou le*, or in the freer, more painterly style known as *mo ku*.

In *kou le*, or contour style, carefully drawn ink outlines are used to establish the basic structures of the composition. The outlined forms are generally drawn in light ink first and are then reiterated with thinner, darker lines drawn over the lighter ones to strengthen the forms. In floral or tree paintings, this technique is known as *shuan kou* (double outline). Sometimes, the outline is drawn in one ink tone only — such as light gray for plum blossom petals, or medium to dark gray for bamboo trees. Any of these plain ink drawings may be left uncolored, or colored only with a flat wash of ink, in which case it is known as *pai miao* (white sketch) drawing. But the contours, done in light ink or in light ink reinforced with darker ink, may also be used to provide the bones, or structural foundation, for a color composition in which dimension and detail are added by meticulously building up the colors, in either opaque pigments or transparent washes, with fine brushwork *(kung pi)*.

In *mo ku*, or boneless style, no outlines are used at all; the brushstrokes themselves form the individual structures of the composition. These strokes are not only less restrained, they are primarily indistinguishable as lines, for they are inextricably wedded to the forms they describe. The strokes are used in ink tones for a monochrome composition and in various colors for a color composition. This approach is necessarily more spontaneous and emotional, less formalized and more dramatic. While contour style painting strives for realistic likenesses through the use of finely drawn outlines and detailed modeling, the *mo ku* style stresses the overall impression of the natural forms.

In both of these techniques, and in the technique of landscape, which we will come to in a later chapter, the brush is of course the primary instrument, and you will soon see how it affords the artist enormous variety in strokes and in nuances of tone. A brushstroke can result in a line as fine as the vein of a leaf, a form as full and round as a plum petal, or any of a trillion other forms. It can be as dry as the wood of an ancient pine tree or as moist as a panda's paw. But whatever the form or tone, the stroke has spiritual as well as physical dimension and content. A brushstroke is the artist's touch, the artist's will, exercised on paper, and according to his skill and concept, the stroke will be intoxicating and life-enhancing or dull and flat.

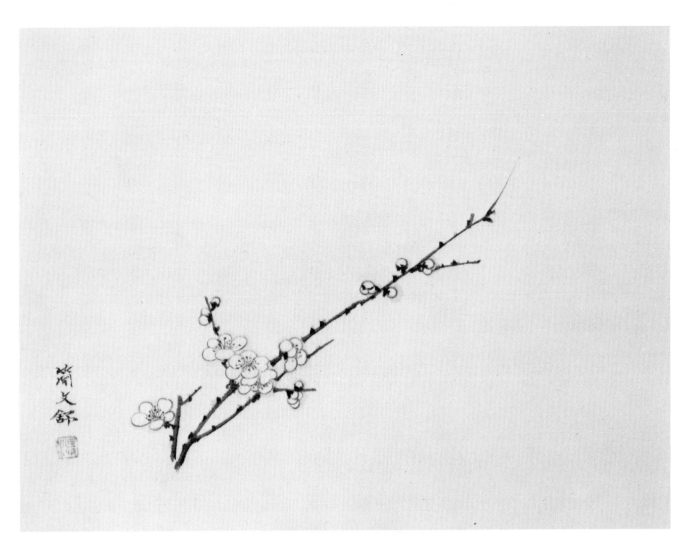

Above: Plum blossoms with petals in contour style. The petals were outlined in light gray ink and a pale blue wash was added around the contours. The branches were done directly in color, in *mo ku* style.

Right and far right: Giant pandas by Wu Tso-jen; *mo ku* style. Each animal limb is shaped with one large, moist stroke; the body contour is formed by a continuous but varied line.

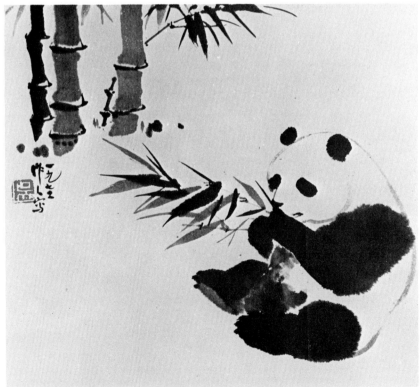

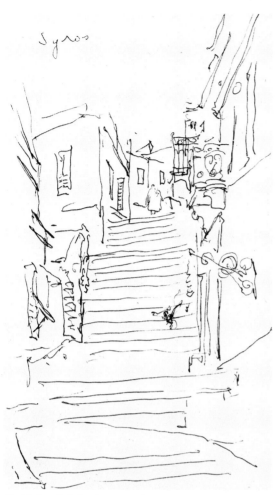

Sketch done in ball-point pen by Chen Chi, from a collection called *Two or Three Lines,* published by the artist in 1969. (Paper, 5 by 8 inches.)

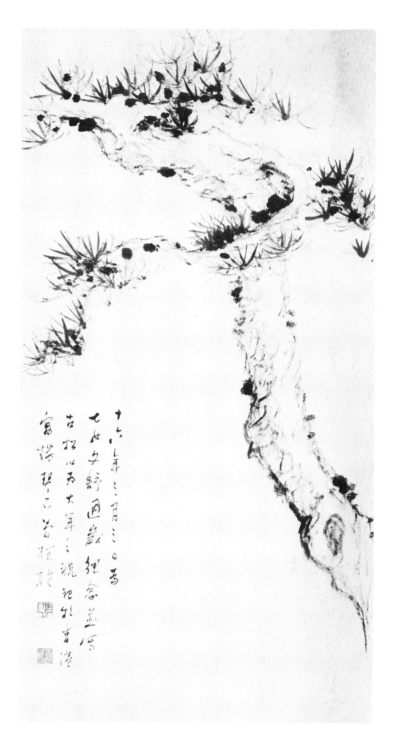

Pine tree painted in dry-brush outlining and modeling strokes by Kan Kam Shek, Miss Kan's father, in honor of her first birthday. The accompanying calligraphy is a poem which also celebrates the occasion. (Ink on paper, 13 by 25¼ inches.)

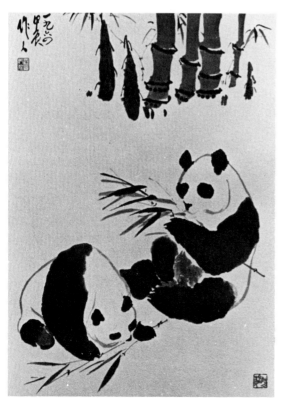

There are of course other instruments of the artist's touch. The accomplished artist can transmit his intentions with a ball point or felt-tipped pen, or his fingertips if he desires; he can engrave, carve, or etch his strokes. But there is probably no instrument as pliant and versatile as the Chinese brush. So to begin, the artist must become acquainted with this tool and with the ink, colors, ink-stone, and paper he will use as well.

Two paintings by Prince Pu Chüan, uncle of the last Emperor of China (Pu Yi) and known as the master of the North. A fingerprint was used to shape the body of each animal. (Ink on paper, 12 by 5¾ inches each.)

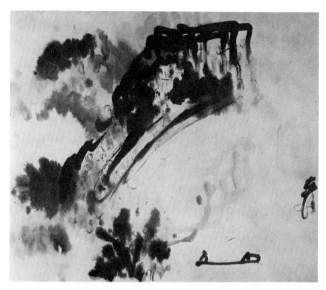

In this painting exercise, Professor Chang Dai-chien used his fingertips to spread the ink. (Ink on paper, 14¼ by 17¼ inches.)

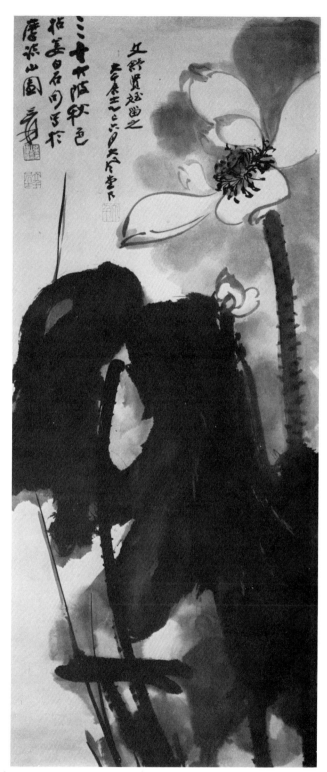

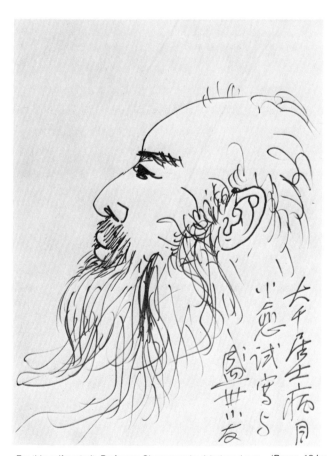

For this self-portrait, Professor Chang used a felt-tipped pen. (Paper, 12 by 18 inches.)

Lotus by Professor Chang, a renowned artist known as the master of the South, with whom Miss Kan has studied for many years. (Ink on paper, 36¾ by 15½ inches.)

1. The Four Treasures

New inventions and materials have not greatly affected traditional Chinese painting, which is governed by procedures that have been used for many generations. The reliance on ink, inkstone, brush, and rice paper — the Four Treasures of the Abode of Culture — has its origins in the initial connection between calligraphy and painting, and in the historic perpetuation of that link by the poet-painters who used the same materials and tools for their artistic pursuits as for their literary and scholarly ones.

In addition, the use of ink monochrome is in accord with the goal of expressing the inner essence of form. Instead of being mislead by the outward appearance of surface colors or hues, the artist stresses the more basic, inner quality of "color," the personality of the form, through the subtle and varied tonal dimensions of ink alone. For when properly diluted with water and combined with skillful manipulation of the brush, Chinese ink is capable of producing gradations in tone ranging from velvety black to palest gray. This is what is meant by the ancient saying, "When you have ink, you have color." When colored pigments are used, they are either added after the forms have been expressed in ink outlines (contour style) or they are used in the manner of ink to execute the form-giving stroke *(mo ku)*.

All of the materials and tools you will need can be obtained from large art supply stores or from importers and retailers of Oriental goods. For local suppliers consult your classified telephone book; to order catalogs and materials from special suppliers refer to page 176.

INK

The ink itself comes in the form of a solid stick, usually of rectangular shape; it is produced with great care and handled with respect. To make the ink, pine wood is burned in a kiln or allowed to smolder in a small room in which strips of silk have been hung from the ceiling. The soot from the rising smoke clings to the kiln walls or to the strips of silk, and it is then scraped off, heated, and strained. The fine pine soot is mixed with glue and poured into molds, which are placed in a sandalwood room so that, as the ink solidifies and matures, it absorbs the fragrance of the sandalwood mingled with the pine scent. Some inks are also made by burning vegetable oils to obtain lampblack, but the soot of the pine produces a more brilliant, glossier ink and is preferred to that of lampblack. The blackest ink comes from burning the inner part of fine pine wood. Inferior wood yields ink of brownish or grayish tones.

The making of pine soot ink *(sung yen mo)* began in about 205 B. C., when it replaced the graphite or stone ink *(shuh mo)* that had previously been in use, and ink making then became a highly specialized art. During the T'ang and later dynasties, many personal recipes were developed and different ingredients such as ground jade, pearl powder, and perfume were added to enhance the quality of the ink. Throughout China's history, ink of high quality and good reputation has been sought after for its inherent value as well as for use in painting and writing, and the ink from one dynasty or one particular maker became more highly prized than that of another.

The esteem with which fine ink is regarded in the Eastern culture spans countries as well as generations, and the gift of a prized ink stick is considered more valuable than money. I received such a gift from a Japanese nobleman for whom I had undertaken the very difficult task of translating an ancient Chinese scroll. Because he was pleased by my work, he said he wished to repay me with a favor of equal honorability. When the ink stick passed from his hand to mine, the barriers of our separate nationalities ceased to exist and, for the moment, we shared a single culture.

I was so happy with this gift that, upon leaving his home, I hugged the handbag in which I had placed it, and hurried to the restaurant where I was to meet my husband for dinner. There I discovered that, in my happiness, I had hugged my handbag too vigorously and the ink stick had broken into small pieces. As soon as the personnel became aware of this disaster, they closed the doors of the restaurant and called a halt to the busy dinner hour in order to help me put the pieces back together again. Such is the feeling of Chinese people for our cultural heritage.

THE INKSTONE

Like the ink stick, the inkstone — on which the stick is rotated and slowly ground with water — is a highly prized item, and fine examples of rare or unusually decorative inkstones are passed on from one generation of artists to another and are collected by connoisseurs. Stones have been carved from precious jade and have been fashioned from ceramic ware but most inkstones are of non-porous slate. The surface must be smooth, never gritty or uneven. The grinding area may be circular or rectangular, and in the latter case, there is a shallow well at one end of a flat, sloping surface to serve as a reservoir for the liquified ink.

To prepare fresh ink for painting, drop two teaspoons of clear water into the stone's shallow well. Holding the ink

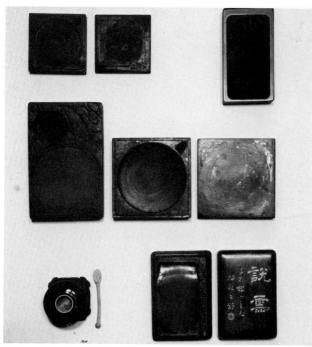

Inkstones in various sizes and shapes. The small container and spoon at the left is for adding water to the stone.

As soon as you have finished using the ink stick, immediately dry it with a tissue to prevent its cracking. The ink stick is like a human being; it will "catch cold" if exposed to extremes of temperature, or if left in a draft, and will become brittle. Also do not leave it unattended on the inkstone while it is moist, because the glue in the composition will cause it to stick to the stone. Wash the inkstone with lukewarm water immediately after each use and dry it with a soft cloth or paper towel. The stone is fragile and should not be carelessly handled or dropped.

BRUSHES

As significant as the ink and inkstone is the brush, the artist's true friend and a major contributor to the magic of Chinese painting. A uniquely versatile instrument, the Chinese brush is made from animal hairs or bristles, tufts of which are bound together and glued into a hollow handle of bamboo. It is said to have been originated by Méng T'ien in about 250 B. C. and many different hairs, including mouse whiskers, were used. Before the T'ang Dynasty, the brush tip was short and the handle was made of ivory, glass, or lacquered wood. Since that time, long-bristled brushes (introduced by the calligrapher Liu Kung-Chuan) and bamboo handles have been used.

Some brushes are made of rabbit's hair or the processed wool from sheep; these are soft and flexible and retain water exceptionally well. Other brushes are made with goat, deer, wolf, weasel, horse, or sable hairs and can vary in flexibility. All of these brushes come in many sizes and shapes, but most artists tend to rely on one or two favorites. For my students, I recommend four brushes in particular. Though it is difficult to obtain Chinese brushes, the Japanese equivalents (made of similar materials) are readily available, and Western-style sable brushes may even be used instead.

stick upright, dip one end into this water to moisten it; then slide the stick up the stone's sloping surface in a straight path to the flat area in the center. Begin to rub the moistened end of the ink stick on this flat surface with a clockwise motion. This task has been likened to that of a weary man dragging a team of unwilling horses round and round in a field.

The grinding should be done in a quiet mood, slowly and with firm pressure on the stick. You will need to make about 400 rotations for every two teaspoons of water, and the stick should be moistened between rotations by dipping it in the well of water whenever the circular motion feels sticky instead of fluid. As the ink is ground, it will run down the inclined surface along the path you have made with the stick and will collect in the well, mingling with the water. Eventually this fluid will take on the consistency of ink and you must then stop grinding or add more water to the well. (The precise number of rotations depends on the quality of the ink stick; the better the stick, the fewer the rotations.) To test the consistency, dip a brush into the fluid and note whether the bristles become a rich black. A light, watery gray color means the ink is not thick enough and more grinding is necessary.

Be sure you have a sufficient amount of ink ground for the painting you plan to do; you will not want to disrupt the mood and action of your painting to grind more. The layer of freshly ground ink on the flat surface of the stone will be thicker and darker than the ink that has run into the well, but ink on a flat surface tends to evaporate quickly. In order to assure a plentiful supply of very dark ink, you might fill a small bottle with specially ground, thick ink and keep it covered nearby, adding it to the flat surface of the stone as it is needed. Use the ink in the well for mixing gray tones.

Moisten one end of the ink stick and rotate it on the flat surface of the stone.

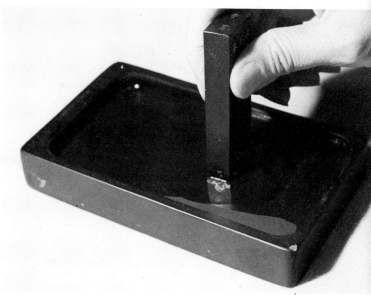

The first is a medium-sized, moderately flexible brush of white goat's hair *(yang hao)*. This all-purpose brush, capable of yielding a soft, broad stroke as well as a strong, thread-like line, is designated the number one brush because of its utility. The Japanese version is a white-haired calligraphy brush measuring about 1⅛ inches in length and ¼-inch in width. The Western equivalent of this brush would be a medium-sized (#8), round watercolor brush of red sable.

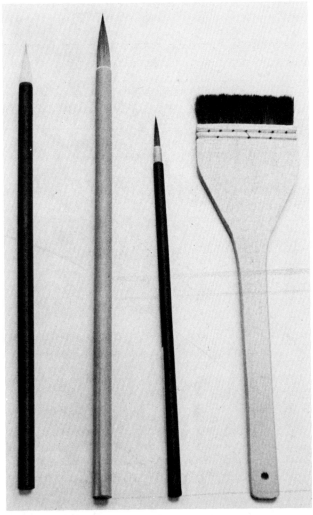

Above, the four brushes from left to right: (1) all-purpose; (2) soft-haired; (3) fine line; (4) broad wash. *Below,* a brush as it progresses from new to used.

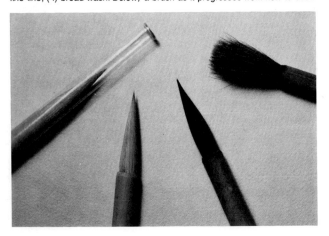

A larger, softer brush, one made of rabbit's hair *(tao mao)*, is designated as the number two brush. Although still capable of providing a fine, definitive line, this brush can cover a greater area in one stroke. The Japanese version is a sheep's hair coloring brush, and should measure approximately 1⅜ inches in length and ⁵⁄₁₆ of an inch in width. Its Western equivalent in size and purpose, although not quite as resilient, would be a #12 red sable watercolor brush.

The Chinese brush designated as number three is smaller than the all-purpose number one brush and is slightly less flexible, making it most suited for delicate outlining. This is made of wolf's hair *(long hao)* or weasel. If you cannot obtain the Oriental fine line brush, measuring ⅛ of an inch in width and from ¾ to 1 inch in length, substitute a #2 red sable watercolor brush.

Finally, the number four brush, of mountain pony *(shan ma)* or sheep's wool, provides the best coverage for broad areas of washes. A similar, flat and short-bristled Japanese brush with a wooden handle is sold in art supply stores and comes in various widths. The Japanese brush is called *hake*.

Brushes have also always been greatly respected and must be properly cared for. Treat each of your brushes as a friend. In China, a brush may be used for many years, passing from one generation to another, and when it is finally too old to be used it is wrapped in white silk and placed in a sandalwood box, which is then carefully buried.

A new Chinese or Japanese brush has a plastic or bamboo cover protecting the bristles. To "open up" the brush, remove the cover and never put it on again; for the bristles require air and a dry atmosphere. To store your brushes, roll them up in a straw placemat. The bristles of a new brush will have been treated with glue or starch to retain the finely pointed shape. Dipping the brush in a bowl of cool or lukewarm water will remove the stiffness.

Always clean the brush after you have used it, by rinsing the bristles in a bowl of clear water (cool or lukewarm, never hot). Gently remove excess moisture by pressing the bristles first between your thumb and forefinger and then with a soft cloth. Place the brush flat on a table to dry. Do not stand it upright on its handle, since any moisture remaining may seep back into the handle and disintegrate the glue. When dry, the bristles of an often used brush will appear disarranged; however, when next you use the brush, as soon as you dip the bristles in water, they will re-form their original fine point.

After some use, the bristles will also be discolored by the ink. Therefore, for a more thorough cleansing, occasionally wash the bristles in a mixture of warm water and mucilage (10 parts of water to 1 part of glue), using your fingers to distribute the liquid throughout. Do not use soap, detergent or hot water. Press out the excess glue mixture with your fingers and arrange the bristles to their original shape. Allow the brush to dry in a flat position for one day. The bristles will soften as soon as they are dipped in water for use.

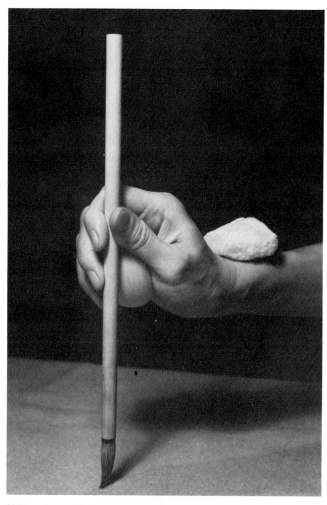

A great deal of the power of adaptability ascribed to the Chinese brush resides in the way it is held and used. As the brush is an extension of the artist's will, there must be a passageway between the brush and the artist's heart and mind. The entire arm therefore must be allowed free movement so that it may respond to and transmit the artist's intent, and energy may flow through it unimpeded to the brush. Accordingly, the brush is not held as a pencil, with fingers tightly squeezing the handle near the bristles, nor is it guided by the fingers or the wrist. Instead, it is held rather high on the handle, with a touch so gentle that the hand could hold an egg in its palm at the same time without crushing the shell, and with the wrist so steady that it could balance a small rock. The handle of the brush is perpendicular to the paper, and the tip of the brush may move in any direction.

In holding the brush upright, the placement of the fingers is comparable to their positioning for holding chopsticks. The handle rests against the inner part of the index finger and the outer part of the fourth finger and it is firmly held in place by the tips of the thumb, index finger and middle finger; none of the fingers touch the palm. It is the movement of the entire arm responding to the artist's intuitions and thoughts that guides the brush.

When the brush is held upright in this manner, it is susceptible to the slightest variance in pressure, which governs the breadth and shape of a stroke. With only the tip of the brush in contact with the paper, the stroke may be regulated to the width of a thin pencil line, regardless of the thickness of the brush. The upright position is thus always used for painting contours and other fine lines, such as veining. But it is also used for an infinite variety of *mo ku* strokes and for dotting as well. You will soon see how pressure is used to bring more bristles into contact

Holding the upright brush is comparable to holding chopsticks. No finger should touch the palm. Finely drawn contours require a steady wrist; twisting *mo ku* strokes require a flexible wrist.

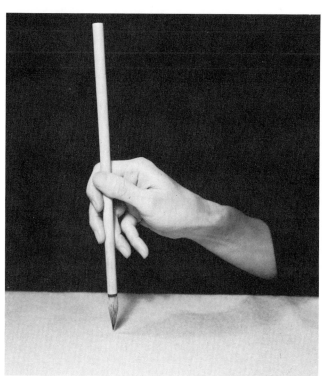

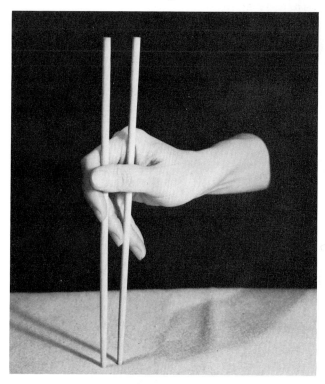

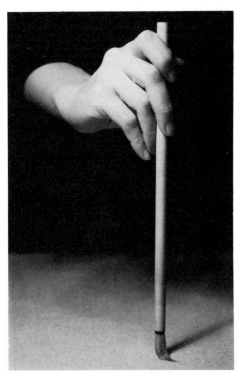
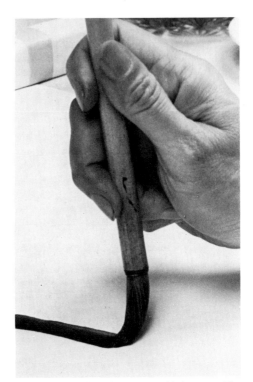

Above: The upright stroke is broadened by increasing pressure and bringing more bristles into contact with the paper. The stroke may move in any direction.

Below: In the oblique position, the brush is at an angle, rather than perpendicular, to the paper's surface; in the photo at the right, the handle is parallel to the vertical side of the paper, so the stroke must move in a horizontal direction.

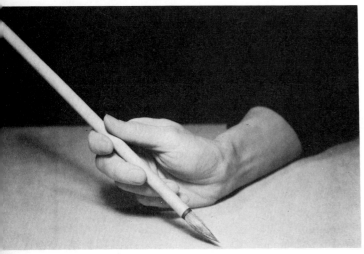

with the paper and broaden or shape the stroke. For most strokes the brush is held midway up the handle, but for small details it may be held further down toward the bristles, and for large strokes it may be held higher up.

For some forms, such as the thick, rugged branch of a plum tree or the broad expanse of a lotus leaf, the stroke can best be accomplished by holding the brush in an oblique position; that is, with the handle slanted at an angle to the paper rather than upright to it. The placement of the fingers remains the same, but the slant of the brush increases the area of bristles in contact with the paper without any increase in pressure. It also gives the brush handle a position on the paper which the upright brush does not have; that is, the handle may lie in a horizontal direction (parallel to the top and bottom of the paper), in a

vertical direction (parallel to the sides of the paper), or in a diagonal direction. Whichever direction the handle is in, the oblique stroke must move in a line that is perpendicular to it; if the line of the brush handle is horizontal, for instance, the direction of the stroke must be vertical.

The movement of the obliquely held brush shifts the tip of the brush (which is generally darkest in tone) from the center of the stroke to the edge of the stroke and mutes the definitiveness, so you cannot use this position for sharp contours. Instead, it is used for forming large areas of less distinct shape and for applying broad washes. Both the fully oblique and the fully perpendicular positions may be modified in order to obtain specific effects. It is in studying the different brushstrokes that the true versatility of the brush will become clear.

18

PAPER AND SILK

Paper is a Chinese invention dating back to 105 A.D., when a court official of the Han Dynasty, Ts'ai Lun, matted vegetable fibers together to produce a flexible material, using a procedure similar to making felt cloth from animal fibers. Ts'ai Lun used tree bark, old rags, hemp, and fish nets. Since that time, as the art of papermaking was introduced to different parts of the world and paper replaced the papyrus leaves, animal-skin parchment, and clay or wooden tablets of other peoples, many different plant materials have been used in China and elsewhere.

When papermaking spread to other areas of Asia during the seventh and eighth centuries, for example, the Japanese favored the use of mulberry bark, while the Arabs in Samarkand favored flax and hemp fibers. When papermaking reached Europe in the twelfth century, and America somewhat later, the most commonly used materials there were reprocessed rags and cloth. Since the introduction of new processes in the mid-1800's, most Western paper has been machine-made from various kinds of wood pulp.

Papermaking in the East, however, continues to rely primarily upon traditional hand operations and indigenous plant materials, such as bamboo, mulberry bark (kozo), mitsumata bark, hemp, linen, rice straw, and the sliced pith of a plant called the rice-paper tree. The use of the last two materials probably gave rise to the term ''rice paper'' to describe all Oriental papers in the West. Not all so-called rice papers are made of these materials, however, and not all of them are suitable for painting, as some are extremely decorative with heavy, undigested fibers or even colored leaves embedded in them.

In choosing an appropriate paper, you must first discard those papers whose textured designs would interfere with painting. Even the plain Oriental papers, however, come in a great variety of formats, weights, and degrees of absorbency. You should therefore consider whether you are more comfortable with a thin paper or a heavier one, with a long, uncut roll of paper or with flat tablets of pre-cut sheets, with a relatively absorbent sheet or with a heavily sized sheet. Sized paper has been made less absorbent by the addition of starch, glue, or gelatin during the manufacturing process and it offers more control in painting the fine lines of the contour style. Absorbent paper is better able to receive the broad strokes of the *mo ku* style. Paper that is slightly sized can be used for both *mo ku* and contour painting. Whether sized or absorbent, most often the paper has a smooth side and a rough side; always paint on the smooth side. The sampling of papers on page 176 describes some different characteristics.

Since paper of good quality enhances the artist's work, the advanced student should be a bit particular in buying paper and should experiment with the many varieties available. For the beginner, however, it would probably be best to practice on the less expensive tablets or rolls of such papers as Hosho and Shoji, or sheets of Sunome, Hanshi, Mulberry, or Okawara, and to reserve the use of more expensive sheets, as Suzuki, for finished paintings. Fine paper can be rolled up and wrapped in cloth or kept in a cardboard tube for use at some future time. Such papers mellow with age and some have been kept for over 100 years. In general, Oriental papers present a delicate painting surface; too much pressure of the brush or too moist a brush may wreak havoc, so have patience in developing your brushwork through practice.

Before the invention of paper, the Chinese used woven silk as a ground for their paintings, and this practice has continued along with the use of paper. Many different kinds of silk have been used in the past, but today we use a very finely woven, semi-transparent material that has been sized. This is expensive and difficult to obtain, although some large importers carry this silk already mounted in scroll form. As a substitute, you can use fine stencil silk, which art stores carry for silk screening. This comes in different gauges (10 XX is adequate) and is diffent widths (40, 50 and 60 inches), and it may be purchased by the yard. If the silk is not mounted, use paperweights to keep it flat while painting. The painting — whether on silk or on paper — may be framed later, or it may be matted and mounted as a scroll according to Chinese tradition (see Chapter 9), by backing the painting with silk or paper and by affixing strips of silk brocade to this as a border, in place of a stiff paper mat and a cardboard backing.

Chinese painting is not an easel art. The paper like the silk must be placed flat on your work table, with a paperweight at the top edge to hold it in position and prevent its pulling away under pressure of the brush. In the kold day's in China, the master's pupil stood at one end of the table and held the paper in place for the master as he stood painting at the opposite end of the table. The artist stands while painting in order to have an overall view of the entire paper, so he may take command of the work. The standing position also allows unhampered movement of the arm and encourages spontaneity of brushwork. The pupil stands in order to obtain the same scope or view of the work as the master and as a sign of respect.

Both the master (Professor Chang) and the student (Miss Kan) stand in order to view the work in its entirety while painting.

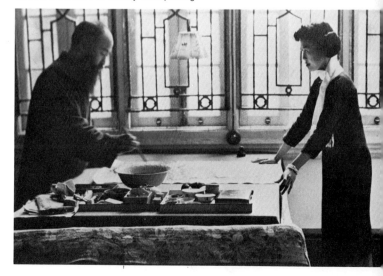

The standing position allows for free movement of the entire arm and encourages vitality of brushwork. Unless it is large enough to overhang the table, the paper or silk should be weighted down to prevent movement.

2. Brushwork

In addition to its maneuverability and its sensitivity to pressure, the brush has another inimitable feature: it has the capacity to bear water and ink in a regulated way. When pressure, position, and movement of the brush are combined with the proper amounts of water and ink in the brush, great diversity of tone is possible, not only among several strokes but within a single given one as well. Proper brushwork thus requires a knowledge of how to charge the brush, first with water and then with ink.

There are two important reasons for controlling the amount of water in the brush. First, the amount of water in the brush controls the wetness of the stroke. Most often you will want a stroke that is fluid but still controllable. If there is a great deal of water in the brush, the water will disperse over a larger area of the paper as it is absorbed, diffusing the shape of the stroke, and control is lost. If there is very little water in the brush, the white of the paper becomes part of the stroke and fluidity is lost. Second, the water in the brush adds an extra tone, so that when the brush is inked it is capable of producing two and even three tones instead of just one.

Although it is much more common, and easier, to use one or two tones, the mechanics of inking the brush with three tones is important in showing how to combine ink with the water in the brush to obtain the extra tone. To see how this is done, set up your brushes, paper, and ground ink for a practice session and use the following method to charge the brush with three tones.

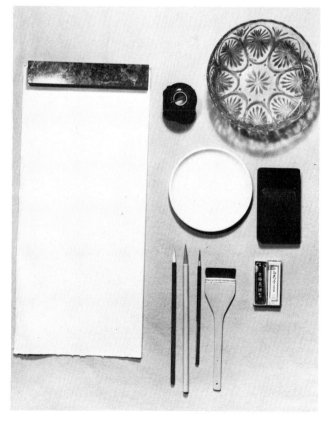

To protect furniture and to provide a better work surface, place a piece of felt cloth under the paper and materials.

Dip a brush in clear water and let the excess drops drain out.

Touch the brush tip to the dark ink on the flat surface of the inkstone.

Begin by dipping your brush (number two) in a bowl of clear water. Hold the brush upright for a moment or two to let the excess droplets of water drain back into the bowl. Then touch the tip of the brush to the flat surface of the inkstone, in the center, where the darkest ground ink should be.

Allow the ink to rise up into the bristles. As the ink rises away from the tip, it becomes increasingly diluted by the water in the brush. To help distribute the ink to the upper bristles, press the bristles gently several times against the nonabsorbent surface of a clean, white porcelain saucer. The area of bristles furthest from the tip will contain the palest tone; the tip and the bristles closest to it will become medium in tone. If you then touch the tip of the brush to the darkest ink on the stone, the brush will finally contain three tones, as you can see by placing the inked brush in a fully oblique position and moving it in a line perpendicular to the direction of the handle, without much pressure.

Note how — as the fully oblique stroke is made — the tip, middle, and heel of the bristles are all in contact with the paper, and all three tones are utilized. If you lift the heel of the brush off the paper, by moving the handle closer toward a perpendicular angle with the paper, only

two of the tones are utilized: the dark tone at the tip, forming one edge of the stroke, and the more diluted ink further up the bristles, forming the other edge. If you further increase the angle the handle makes with the paper, only the bristles at the tip of the brush will be in contact and only one tone will be utilized.

You can easily see that, when the brush is used in the oblique position, the angle of the handle controls both the broadness of the stroke and the tone that is employed. This does not mean that if you use only the tip of the brush, you must use a dark tone. Just as you can vary the position of the brush and the portion of the bristles that are utilized, you can also vary the manner of inking to obtain the desired tonal qualities. For painting the rugged contours of trees, rocks, and mountains in a landscape, for example, the brush is inked in a light tone and only the tip of the obliquely held brush is used. In painting lotus leaves, the brush is inked in a light, medium, or dark tone, but the fully oblique position is used and clear water in the upper bristles can provide an extra tone in each case. We will come to the task of mixing different tones in a moment. First, we must be sure to understand the difference between the obliquely used brush and the upright brush.

Press the bristles against a porcelain saucer to help mix the ink at the tip with the clear water in the upper bristles.

Then touch the brush to the stone again to pick up more ink and redarken the tip.

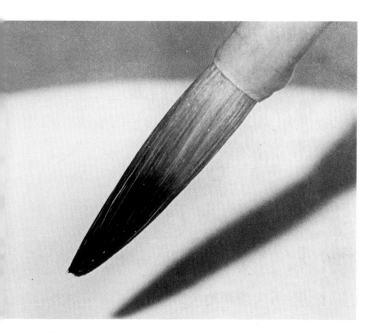

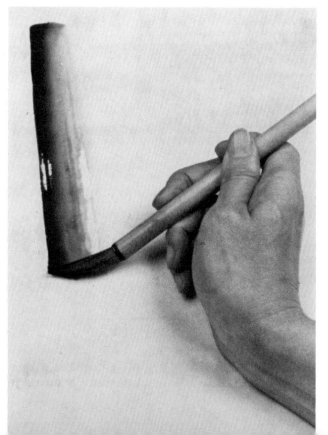

The brush will contain three gradations of tone, ranging from dark at the tip to pale at the heel, where the bristles meet the handle. In the fully oblique stroke, all three tones are utilized. Note that the tip of the brush and the upper bristles move alongside each other; their paths are parallel but separate, and the tones remain distinct.

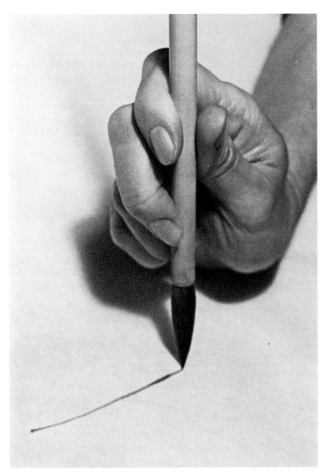

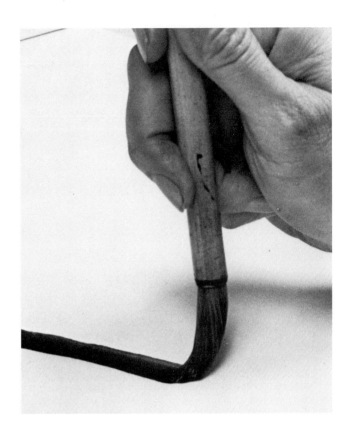

For the upright stroke (*left* and *above*), broadness and tone are regulated by pressure. When pressure is increased, the upper bristles move ahead of the tip, which generally follows in the same path; thus separate tones tend to merge.

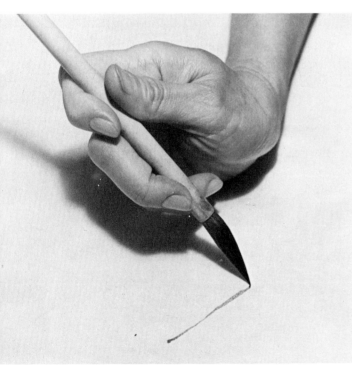

For the oblique stroke, broadness and tone are controlled by the angle of the handle. When this is increased so only the tip is in contact with the paper (*above*), the stroke is narrowed and only one tone may be employed. The tone may be dark, medium, or light. The narrow oblique stroke is used for outlining rocks and trees.

When the brush is in an upright position, it is not the angle of the brush but the regulation of pressure on the brush that controls both the broadness of the stroke and the use of tone. If only the tip of the upright brush is touching the paper, the stroke will be thin and the tone will be that of the bristles at the tip. When pressure is applied, the bristles immediately above the tip are brought into contact with the paper; the stroke is broadened and the second tone is employed, but not in the same way as when the brush is in the oblique position.

In the oblique position, the tip of the brush and the upper bristles move *alongside* each other; their paths are separate and parallel. In the upright position, the upper bristles move *ahead* of the tip along one congruent path. The tip of the brush, therefore, is moving through a path of diluted ink already provided by the upper bristles, and the two tones tend to merge rather than to remain distinct and separate. Depending upon just how the brush is manipulated, the stroke may appear to be a single tone, or it may appear slightly lighter wherever the darker ink of the tip has not fully penetrated. Again, you need not ink your brush with three tones. In painting orchid leaves, for example, you may ink the brush with a medium tone. The clear water in the upper bristles will still provide the second, lighter tone, wherever pressure is applied to broaden the stroke.

The application of pressure is also related to the speed with which the stroke is made. Generally, broad strokes

are executed at a more leisurely or deliberate speed than thin strokes are. Occasionally, you will desire a drier stroke. In such cases, the procedures for charging the brush with water and ink are the same as for moist strokes. The excess water is removed *after* the brush has been inked, by tapping the brush against the edge of a clean, porcelain saucer.

Now that we have seen how water in the brush is used to provide an extra tone, we come to the task of mixing ink and water outside the brush, to obtain the basic light or dark tones. The first step is to pick up dark ink from the stone's well or reservoir with a water-charged brush (drained as before) and to deposit the ink on a white porcelain saucer. Gradually dilute the ink by using the same brush to transfer clear water from a bowl to the saucer, a brushload at a time. Mix the two liquids together with the brush. Learn to judge the ink tone by its look on the saucer. It is very tempting to test the tone on a piece of paper, but that is not the proper method and, once you have become accustomed to mixing tones, you should not need to do that. Initially, of course, you will need to confirm your judgment by making a stroke on paper, but get into the habit of reading the tone on the saucer from the very beginning.

If you judge the tone to be too dark, add more water to the mixture in the saucer; if you judge it to be too light, add more ink from the stone's reservoir. The saucer of diluted ink actually provides another reservoir, and this

Broad strokes with an upright brush are usually done at a slower speed; thinner strokes, at a faster pace.

one may be regulated back and forth in tone by adding ink or water as often as is required by the strokes in your painting. If the saucer nears the stage of overflowing, empty it or use a fresh saucer for mixing more ink. Whenever very black ink is required, return to the flat surface of the inkstone, replenished with ink from your special supply (see page 15), and pick up the ink with a wet but not sopping brush.

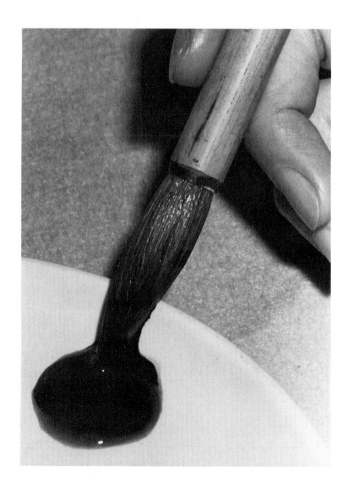

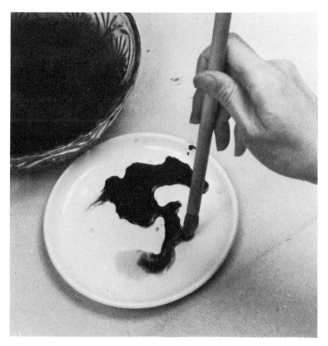

To mix a tone, deposit a brushload of ink from the stone's well onto a porcelain saucer and add water with the same brush to dilute the ink. Learn to judge the tone by its look on the saucer.

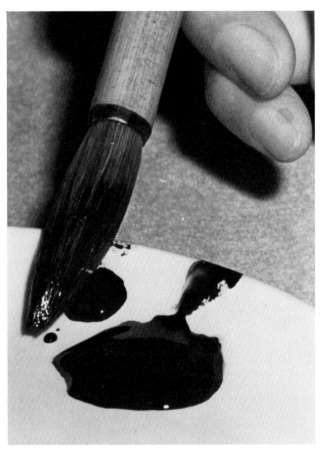

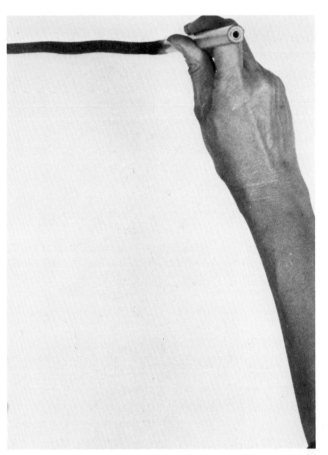

Use a water-charged but drained brush to pick up as much ink as desired from the saucer. Tap the bristles against the saucer's rim to remove excess moisture, and if you are using clear water in the upper bristles as an extra tone, press down to mix the ink well.

For this exercise, charge a number two brush with dark ink almost to the heel and do not tap out excess moisture. Hold the brush upright and with light pressure paint a series of horizontal strokes across a sheet of paper.

Once you have mixed the desired tone, you may charge all the bristles or only a portion of the bristles, depending on the effect you seek. Rinse the brush first in clear water and allow the extra drops to drain back into the bowl. After picking up the desired amount of ink from the saucer, be sure to tap out excess moisture by stroking against the edge of the saucer, and if you are using the clear water in the upper bristles as an extra tone be sure to distribute the ink by pressing down on the bristles. If you are going to paint a fine line, you need only charge the brush to about one-third of the way up to the heel. If you are going to broaden the stroke without varying the tone, you may charge the brush halfway up to the heel or further. If you are going to vary the tone, however, charge only the tip of the brush and allow the clear water in the upper bristles to provide the second, lighter tone. Or charge the brush to halfway up the bristles for the first, lighter tone and charge the tip with darker ink, for the second tone.

Because there are so many variables it is not feasible to list all the combinations of inking and brush positioning that may be encountered. What is essential to the success of any possible combination is the ability to control the amount of water in the brush. You must acquire a feel for the water-bearing capacity of your brush and learn what to

expect in the way of tonal changes and loss of fluidity as moisture is diminished. The following exercise is very useful in helping the inexperienced painter gauge the amount of water and ink required, by first becoming accustomed to the feel of the brush as these commodities are expended.

First charge a brush (number two) with clear water, letting the excess droplets drain back into the bowl. Then charge the brush almost to the heel with dark-toned ink from a saucer. Do not tap out extra moisture. Holding the brush upright, and maintaining a steady but very light pressure, paint a series of straight, horizontal strokes moving from left to right across a sheet of paper. Place each new stroke beneath the previous one, spacing them about one inch apart. Notice that each new stroke is progressively lighter in tone and drier as well, and that it is necessary to re-ink the brush after about four to six strokes, to regain both fluidity and tone. (Always rinse the brush in a bowl of water before re-inking and, when the rinse bowl is no longer clean, change the water.)

Continue with the horizontal strokes until you have filled the paper, and then repeat the procedure with vertical strokes running from the top to the bottom of the paper. Add diagonal strokes moving upward from left to right, and then diagonal strokes moving downward from

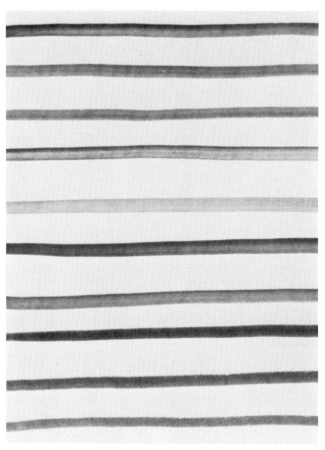

Space the horizontal strokes about one inch apart.

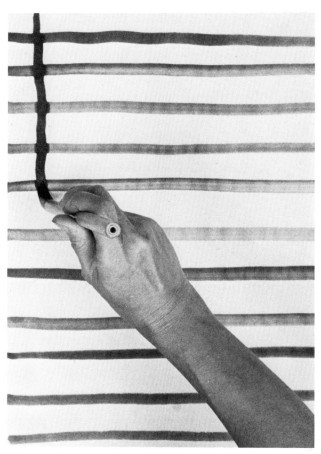

Add vertical strokes moving from the top downward.

Add diagonal strokes moving upward from left to right.

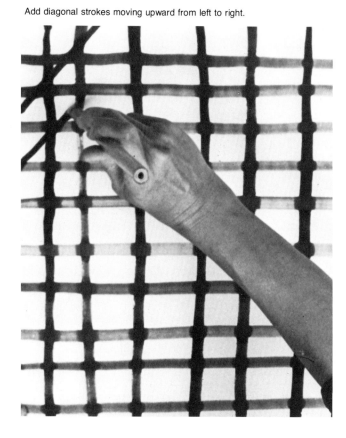

Add diagonal strokes moving downward from left to right.

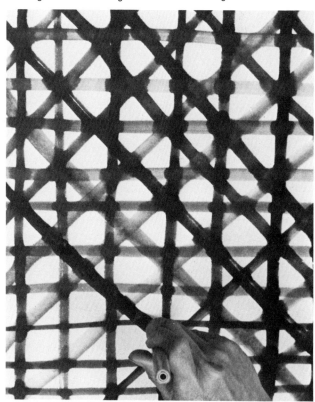

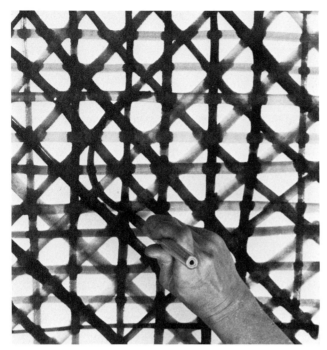

Paint one half of a circle.

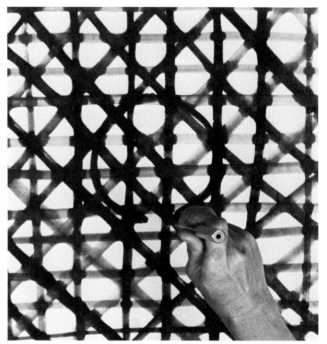

Add the other half.

Surround the first circle with a larger one, using the same two strokes. This exercise will teach how much water and ink the brush can hold, how many strokes can be accomplished with one inking, and how the brush feels as it loses moisture.

left to right. Finally, paint a central circle in two strokes, one counterclockwise from the top, the other clockwise from the top. Repeat the circle exercise with a larger circle enclosing the first one.

Once you are acquainted with the basic capabilities of your brush, you will want to learn more about its manipulation. Instead of applying straightforward pressure to the upright brush, try varying the pressure, using only the tip of the brush at the beginning and end of the stroke; try moving the brush in an arced path instead of a straight one. These are essentially the movements used in painting orchid leaves. Abbreviate the stroke to a three-part sequence — point, press, and lift — and you have the movements for orchid petals.

Don't forget that pressure and movement are combined to shape the upright stroke, and that the angle of the brush controls the oblique stroke. Once you master a stroke, you will be able to use it again and again, for there are many similarities as well as differences among the shapes in nature. Two ovular shapes side by side, for instance, are used to paint a bud; two very similar strokes are used to paint lobed leaves. Practice charging your brush with water and ink and practice the strokes in this chapter.

The secret of Chinese painting is in putting the correct tones in the proper parts of the brush and in being able to call them forth by proper handling of the brush. These are skills that can only come with practice, but you will soon begin to develop an instinct for knowing when to hold the brush upright and when to slant it, when to apply pressure and when to release it, when to charge only the tip of the brush and when to charge the upper bristles. This instinct can blossom into certainty only as you become more deeply involved in painting.

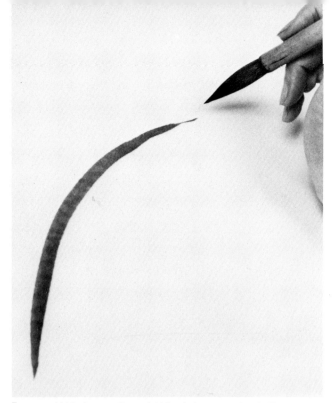

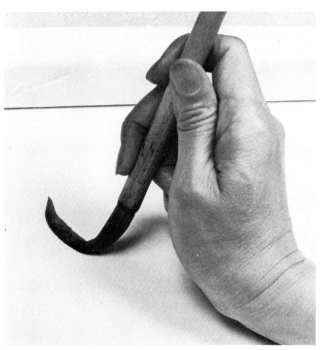

For an orchid leaf, move the upright brush in an arced path. The small or medium-sized leaves at the base of the plant are in a medium-toned ink, rising halfway up the brush.

Abbreviating the arc results in an orchid petal form — see next page.

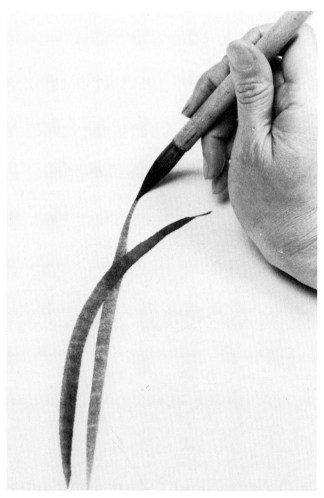

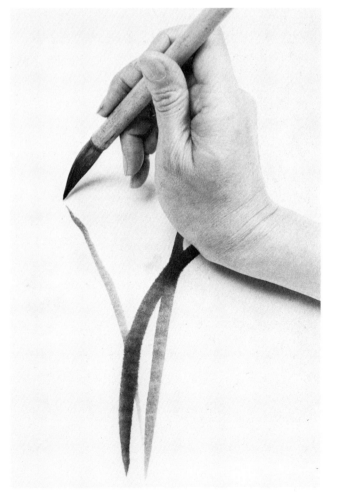

The leaf stroke begins at the bottom of the form with scarcely any pressure. Moving upward, pressure is increased to broaden the leaf and is decreased again at the pointed tip of the stroke.

After tapering the stroke to its fine point, lift the brush from the paper.

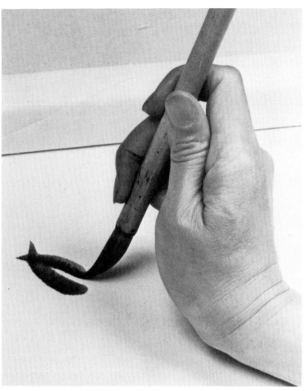

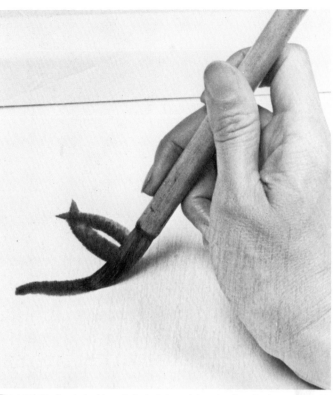

Form the orchid-petal tip with the point of the brush; press down to broaden the stroke, and release pressure at the end of the stroke. Re-ink with a medium or light tone halfway up the brush for each stroke.

The petal may be stroked from its tip to its base (*above*) or from the base outward to the tip (*below*). End the stroke without tapering.

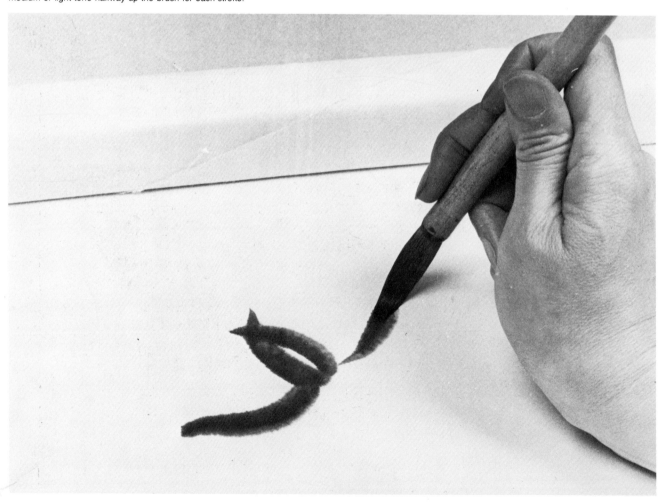

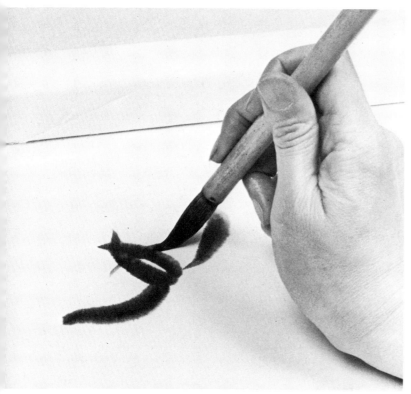

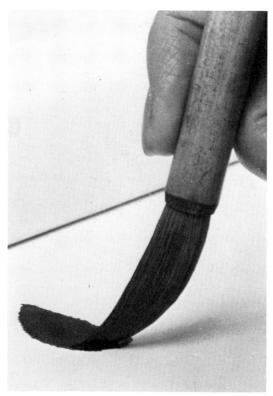

Each of the orchid's five petals reaches in a different direction.

Above, the first stroke of an orchid bud; *below,* the second stroke.

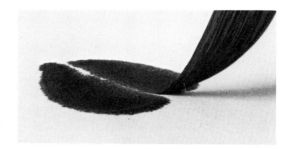

Each orchid bud is painted with two ovular strokes placed side by side. A thread of space is left between the strokes to define the form. Note how each stroke is shaped by applying and releasing pressure and note how the tip of the upright brush glides through the form.

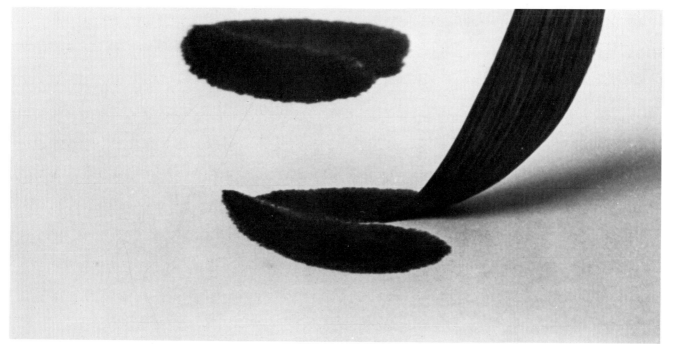

The complicated form of a lobed leaf is accomplished with a series of ovular strokes, each pair placed side by side in the same manner as for orchid buds. It is necessary to experiment with the amount of ink and water in the brush and with the placement of the brush tip to obtain tonal variations.

The first stroke, with an upright brush. The tip is in the center of the stroke.

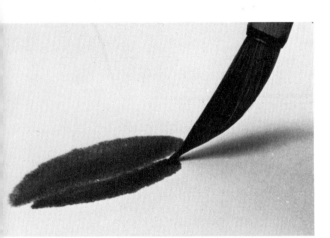

The second stroke, leaving a thread of white space. The brush tip is parallel to this space and is at the inner edge of the stroke.

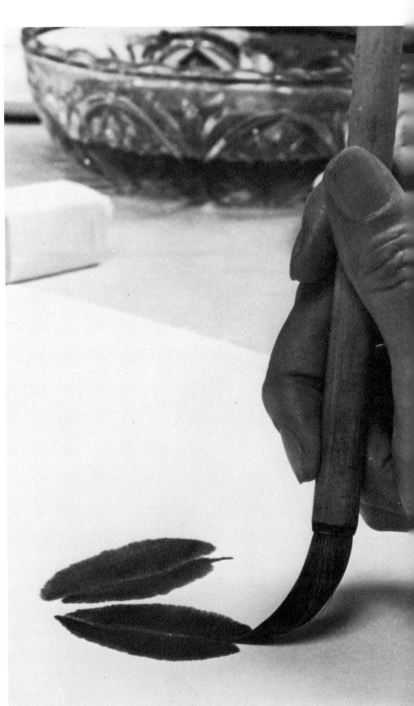

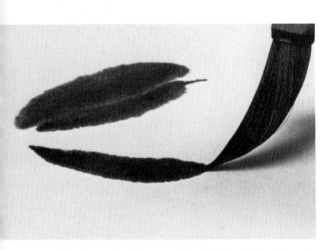

The first stroke of the second lobe. The brush tip is at the outer edge.

The second stroke. Note that when the tip of the upright brush is next to the thread of space, at the inside edge of the stroke, the tone of the outer edge is slightly diffused.

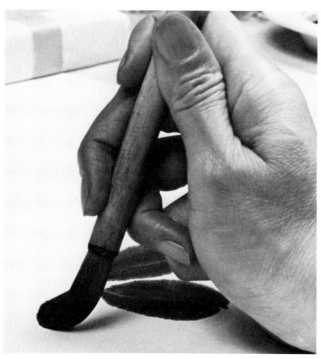

The beginning of the third lobe. The brush is in a partially oblique position with the tip at the outer edge of the stroke.

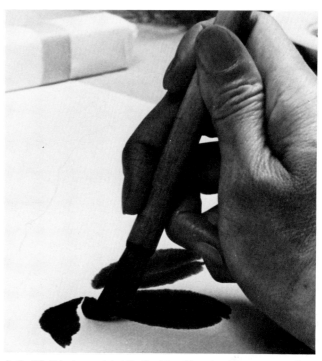

As the third lobe is completed, the tip of the oblique brush moves perpendicularly to the thread of white space with the tip at the inner edge.

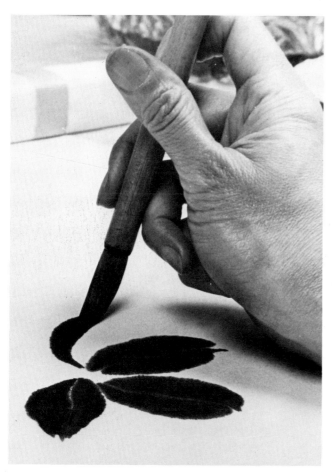

The fourth lobe, with the brush once more in an upright position.

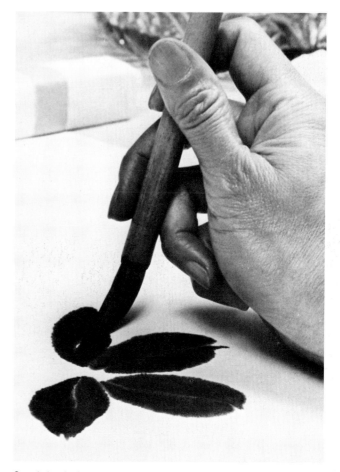

Completing the fourth lobe, the brush tip again moves parallel to the thread of space.

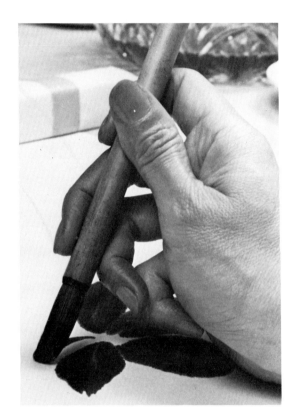

The fifth lobe is added with two strokes of an upright brush. The long central vein, or midrib, which divides four of the lobes into almost symmetrical pairs and extends from the fifth lobe to the stem, is added with one stroke. In a more difficult version, for chrysanthemum leaves, this midrib is formed solely by leaving white space between the lobes.

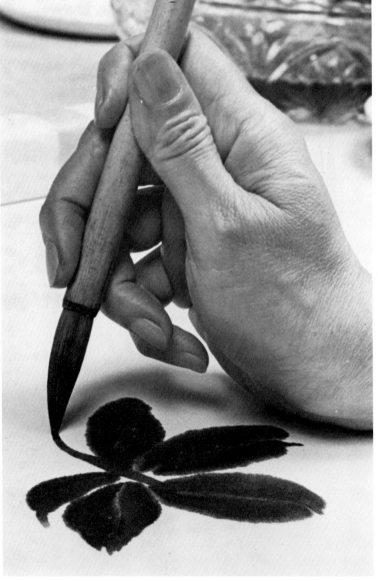

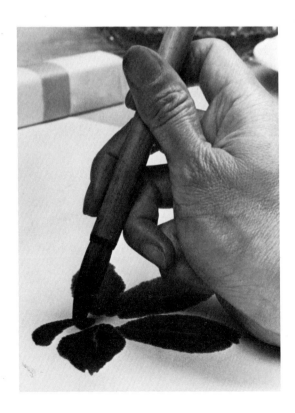

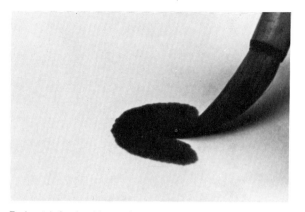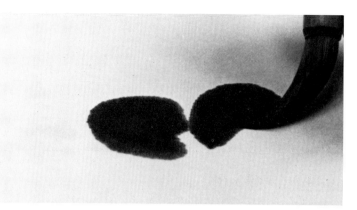

Each petal of a plum blossom in *mo ku* style is formed by one circular stroke. The brush is inked with two tones to provide nuance of tone. Hold the brush upright with the tip pointed in toward the center of the intended circle. Swing the brush around in a circle to the right while slowly rotating the brush handle clockwise between the fingers. The tip will shift to the outside of the circle and then back in to the center.

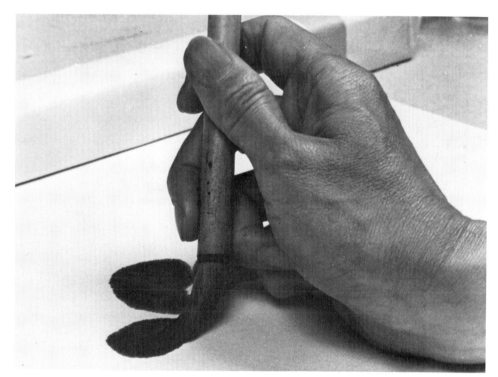

The circle may also be stroked in a counterclockwise direction while rotating the brush handle to the left.

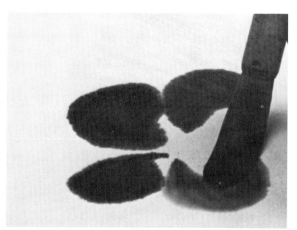

As additional petals are painted, the brush loses ink and moisture, providing further variance in tone. Deciding when to re-ink is a matter of personal preference. There are five petals in a plum blossom, so five circles are stroked. Two values of color may be used instead of ink tones.

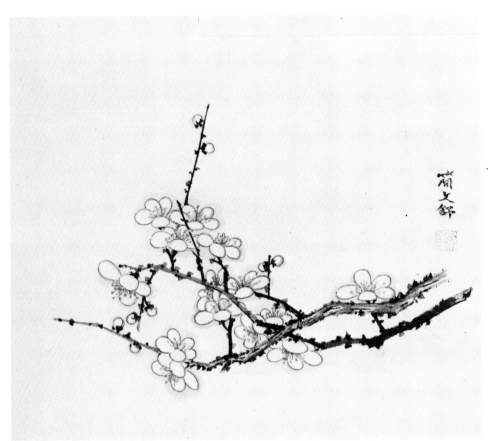

Contour-style petals of the plum blossom in color. The petal forms are outlined in pale ink reinforced by thin, dark lines, and a wash of light blue is added around the contours. The filaments of the stamens are in medium ink and are dotted with cadmium yellow. The contour-style branch is outlined in medium and dark ink and is washed with successively darker shades of burnt sienna. The *mo ku* style branch and shoots are done directly in inky tones of burnt sienna.

The *mo ku* style petals are done in cadmium red and alizarin crimson with an admixture of white. The pigment is necessarily thicker than in the wash of the contour style. The filaments are in cadmium yellow and are dotted in white. The *mo ku* style branch and shoots are in an inky blue (indigo).

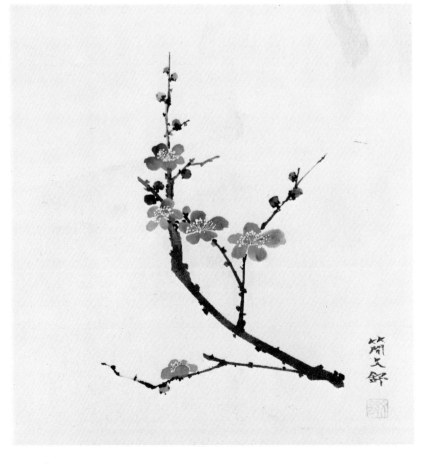

3. Color

The role of color in Chinese painting has historically been limited, perhaps because of the close relationship between writing and drawing and the consequent reliance on ink. Color has, however, always been in evidence, its use on silk having been recorded from the fifth century B.C. In traditional landscapes, muted colors — generally, blues, greens, and browns — are used to enhance the outward appearance of the forms — trees, rocks, and mountains — whose true structure has already been shown by the ink brushstrokes. Thin, transparent washes — color greatly diluted with water — are used in a suggestive way and are applied within the contours in successive layers, beginning with the palest tones and working toward the strongest ones, but maintaining overall subtlety and softness, in harmony with tranquility of spirit.

In painting flowers, depending on the species and on the style, a greater vibrancy of color is often appropriate, and sometimes thicker pigment may be used to enliven and define the individual petal forms, especially when painted on silk, which affords a stronger support. Thus when the fragile plum blossom is outlined in pale ink, its color is indicated only by a pale wash around the contours; but when the flower is painted in *mo ku* style, without an ink outline, the petals are done in a variegated pink or lavender that is of sufficient strength to show the form in a single stroke.

The same necessity for strength of color is true of the orchid painted in *mo ku* style; although the hues — pink, yellow-green, lavender — may be light in tone, they should not be as transparent as a wash, because the color of each form is not built up in separate, thin layers but is applied in a single stroke. On the other hand, the pigment must not be so thick as to impede the flow of the brush and obscure the form. When the orchid is done in contour style, the petal colors may be deeper and the pigments thicker, because they are applied over a base coat of white and are built up in layers within the outlines of light, gray ink.

In applying color, behind each individualistic variation you will encounter, there is actually a simple rationale. When color is used in place of ink, to provide form, the color is strong but moderately thin. When color is used in addition to the ink outlines, it may be indicated by a single wash, as with the plum blossom; it may be built up in thin layers of wash as in landscapes, branches, and leaves; or it may be built up in thicker layers of pigment over a base coat of white, as in orchid, chrysanthemum, and lotus petals.

Cloudy Mountains, Fang Ts'ung-i (active circa 1300–1378); ink and color on paper. (The Metropolitan Museum of Art, Gift of J. Pierpont Morgan, by exchange.) This is the right-hand portion of a scroll which measures 10¾ inches in height and 27⁷/₁₆ inches in length in its entirety. Traditionally, the structures are established first with ink outlines and modeling strokes; color is then built up in thin washes.

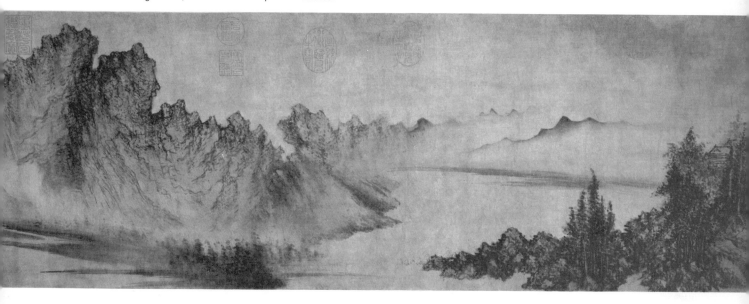

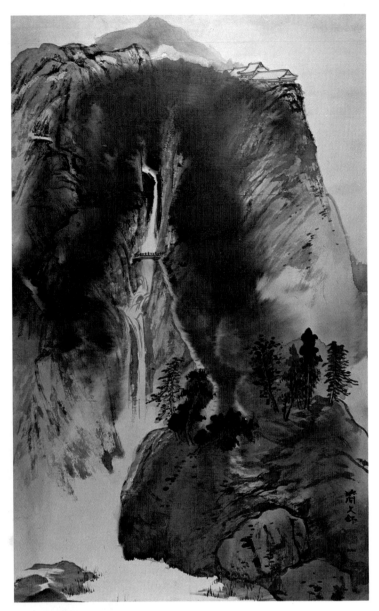

Cascade; rice paper, 23 by 36¾ inches. The structure of the mountains, trees and water is established first with ink outlines and modeling strokes. The color is then built up in pale washes of indigo and burnt sienna. The soaring mountain shows perspective in height.

Mighty Mountain, Tiny Men; silk, 24 by 48 inches. The ink structure is overlaid with indigo and burnt sienna. Most of the foliage is accomplished wth ink used in a dotting technique, but two trees have contour-style foliage outlined in ink and colored with mineral green (emerald) and one is colored with mineral blue (prussian).

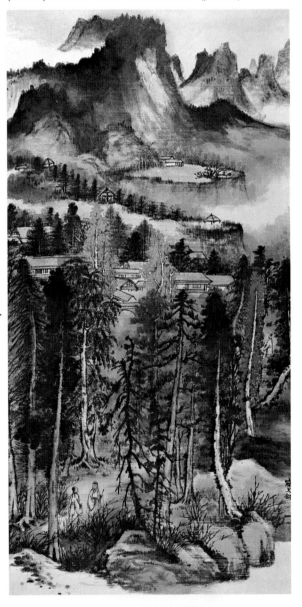

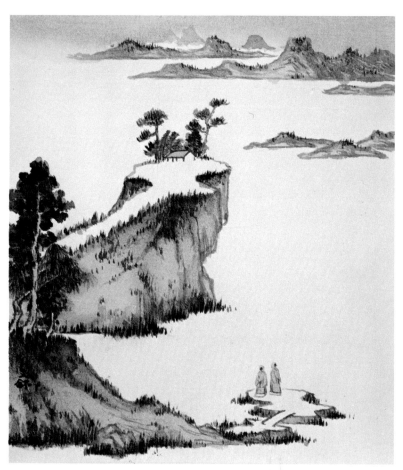

On the River Bank; silk, 9½ by 10½ inches. Traditional landscape technique with color washes of umber, indigo, and green (indigo and yellow). The flat expanse of water, indicated by unpainted areas, combined with the figures in the foreground and the distant mountains, gives the illusion of receding space (perspective on the level).

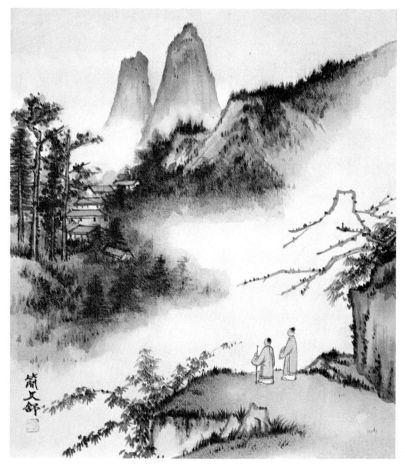

Leisurely Encounter; silk, 9½ by 10½ inches. Another traditional landscape using the same color washes, with burnt sienna added at the left and on the rooftops. The composition here shows perspective in height and the distance does not recede as much as before. Mountains in the distance are painted without any outlines.

Originally, all Chinese colors were derived from natural sources and were classified as either mineral or vegetable. Today many of these colors are synthesized, and we use the term "mineral colors" to refer only to those pigments that are actually prepared from the same natural materials as in the past. The most brilliant of these colors are made from semiprecious gems: mineral green from malachite; mineral blue in various hues from azurite. Two other bright mineral colors are: vermilion, a scarlet red produced from cinnabar (ore of mercury); and mineral yellow, a golden color produced from orpiment (a crystalline form of arsenic and sulfur).

These precious and expensive pigments are exceedingly potent. Even when diluted and used as washes they are exceptionally vibrant. Consequently, they have always been used sparingly, primarily for pictorial accents, although one famous school of landscape painting did employ bright blues and greens. I use these pure mineral colors almost exclusively for broad landscapes in p'o mo style, an advanced technique of splashed color or ink; and I substitute artificially produced colors for other styles of painting. A chart of the original Chinese colors and their synthetic equivalents is given on the opposite page.

Not all modern-day paints are synthetic. The earth colors are still made from iron oxides: umber, a light yellowish-brown; sienna, a dark reddish-brown; and yellow ochre, a dull brownish-yellow. These are also mineral colors, but they are much more commonly used than the bright mineral colors previously described. This is because they are not only much less expensive, but they are also very prevalent in the natural colorations of landscape forms.

The vegetable colors were originally derived from various plant forms and these, too, have been supplanted by artificially produced colors. (See chart opposite.) However, the principles of mixing these colors, with each other and with some of the mineral colors, remain unchanged. The original vegetable colors — rattan yellow, indigo, and rouge or carthamin red — gave the Chinese artist a much greater palette range than might be expected. Rattan yellow, for example, could be mixed with umber to produce yellow ochre. Mixed with vermilion, rattan yellow yielded a deep orange-yellow called cock yellow. (A mineral version of cock yellow was derived from realgar, which is related to orpiment, but is less stable.) Mixed with indigo in varying proportions, rattan yellow yielded two varieties of grass green (ts'ao lu). More yellow indicated young green (nun lu); more blue indicated older green (lao lu). These combinations are still used today, employing the synthetic substitutes.

Today, as in the past, black pine ink is added to any color that requires darkening or graying. The lampblack pigment supplied by paint manufacturers is used only when matte effects rather than glossy ones are desired. Similarly, zinc white (originally made from ground seashells or pearls, and later from lead) is used to lighten petal colors in some floral paintings, but it is never used to lighten the natural browns and greens of the leaves or trunks in these studies or in landscapes. An admixture of white would make these forms appear chalky and unnatural. Instead, pale washes of diluted color are built up in layers to the desired tones. Light brown washes are obtained by diluting umber or sienna with water. Pale shades of green are obtained by diluting various mixtures of blue and yellow, the combination of vegetable colors being more similar to the hues of foliage and vegetation than is pure mineral green. As a rule, do not use white to lighten the tone of any color applied as a wash, including the blue of water and skies.

The Oriental colors of today are supplied in convenient cake form in little round, porcelain dishes. These include the synthetic substitutes for the bright mineral colors (malachite, azurite, cinnabar and orpiment), which — although they are not as potent as the true forms — are still used sparingly. The dishes of color may be obtained from Oriental art-supply stores* and are used in the following way. Each cake must be softened by covering it with a teaspoon or so of water and allowing it to stand for about an hour. (Use cold water for all the colors except indigo and cobalt blue, for which you use warm water.) The necessary amount of softened pigment may then be picked up from the color supply and transferred to a porcelain mixing dish with a brush, where it may be diluted or mixed as desired by adding water (with the same brush) or another color (with a separate brush.) The large, soft number two brush is best for applying thin washes, using the tip of the obliquely held brush for small areas and the side for larger ones; for other applications of color, use the brush you feel most suits your purpose. For thin strokes, for instance, you will use the tip of a smaller brush, held in an upright position. You do not need a separate brush for each color if you remember to wash your brush before picking up a new color from the individual cakes. You may also use the same brushes for ink and for color by cleaning them well.

If you cannot obtain the Oriental cakes of color, the most appropriate substitutes are the American and English watercolors in tube form. Two recommended brands are Grumbacher and Winsor & Newton. You need only squeeze some of the moist color from a tube into your porcelain saucer and proceed as with the Oriental colors.

When you have finished using your cakes of color, be sure to allow them to dry out before replacing them in a covered storage box or the moisture may encourage the growth of molds.

* See list of suppliers on page 176.

CHINESE MINERAL COLORS	WESTERN COLORS	DESCRIPTION AND USES
Azurite (*shih ch'ing*)		
1st shade (*tao ch'ing*)	Manganese Blue	a turquoise blue; for distant mountains and foliage
2nd shade (*erh ch'ing*)	Cobalt Blue	a bright, clear blue; use over a base coat of indigo for a richer color (wait for base coat to dry); for mountains, rocks near water, and distant foliage
3rd shade (*san ch'ing*)	Prussian Blue	a greenish blue; dilute with water for a lighter tone similar to cerulean; for distant mountains and trees
Malachite (*shih lu*)		
1st shade (*tao lu*)	Emerald	a bright green; for mountains or bright leaves; can be used as an extra wash over vegetable green in contour leaves
2nd shade (*erh lu*)	Viridian	an intense green; dilute with water for a lighter shade; for mountain cliffs, water, and landscape foliage
3rd shade (*san lu*)	Hooker's Green, light	a yellow-green; use for washes on rocks and vegetation
Vermilion (*chu sha*)		
light (*chu piao*)	Vermilion, light (Gr)* or Scarlet Vermilion (W&N)	a pale orange-red; can be obtained by diluting the medium shade with water
medium (*chu sha*)	Vermilion, deep (Gr) or Vermilion (W&N)	a scarlet red; for autumn foliage or distant spring flowers
dark (*yin chu*)	Cadmium Red, light (Gr) or Cadmium Red (W&N)	a bright red; for flower petals (mix with white for contour style, with water for *mo ku* style); can be used as a wash for clothing on figures
Mineral Yellow (*shih huang*)	Cadmium Yellow, medium (Gr) or Cadmium Yellow (W&N)	mix the pure yellow with white for a lemon yellow; use for flower petals and stamens, for vegetation in non-traditional landscape

CHINESE VEGETABLE COLORS	WESTERN COLORS	DESCRIPTION AND USES
Rattan Yellow (*t'eng huang*)	Cadmium Yellow, medium (Gr) or Cadmium Yellow (W&N)	a strong yellow; mix with indigo for grass green (use for grass, leaves, and foliage); can be used for orchid or chrysanthemum petals and for clothing
Indigo (*hua ch'ing*)	Indigo	a dark, dull slate-blue, sometimes with a purple tinge; mix with yellow for grass green; use as a wash for mountains, water, and sky; use as an undercoat for mineral colors
Rouge Red (*yen chih*)	Alizarin Crimson	a dark, crimson red; mix with white for pink; mix with indigo for purple; use for flower petals
Umber (*che shih*)	Raw Umber	a yellowish-brown; for tree trunks, rocks, and land
Burnt Sienna (*chai shih*)	Burnt Sienna	a reddish-brown; for tree trunks, rocks, and land
Yellow Ochre (*che huang*)	Yellow Ochre	a brownish-yellow; for tree trunks, rocks, and land

*(Gr) = Grumbacher (WN) = Winsor & Newton

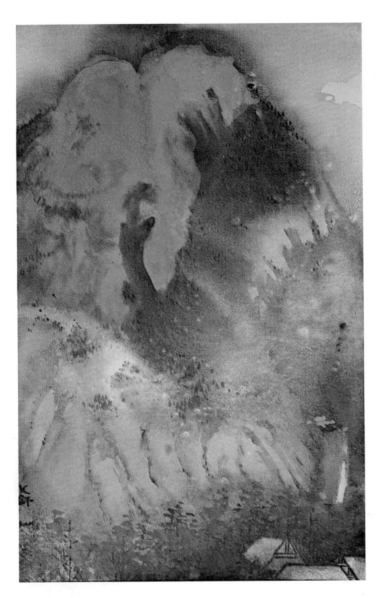

Silvery Cloud on Top of the Mountains (permanent collection, Bruce Museum; Greenwich, Connecticut); silk, 10½ by 16 inches. *P'o mo* technique with mineral blue (manganese) and green (emerald) over a base of indigo, with touches of vermilion.

White Mist, Fall (collection of Dr. Alvin Wolfson); silk, 23⅛ by 11⅜ inches. *P'o mo* technique with ink washes and indigo overlaid with mineral blues and greens. The closest equivalent of the bright blue in the center is cobalt. The trees are of cadmium red and yellow, and the mist is Chinese white.

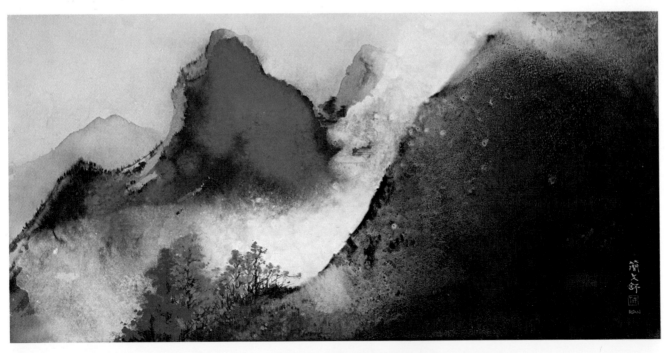

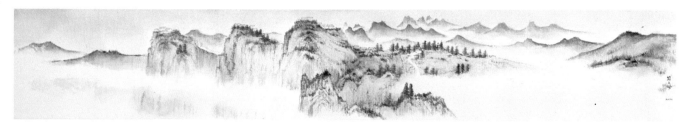

*Looking Down on the Roof of the World (*collection of Mr. and Mrs. Lawrence Ketover); silk, 50½ by 8¼ inches. Traditional landscape with ink foundation and color washes of pale indigo and burnt sienna.

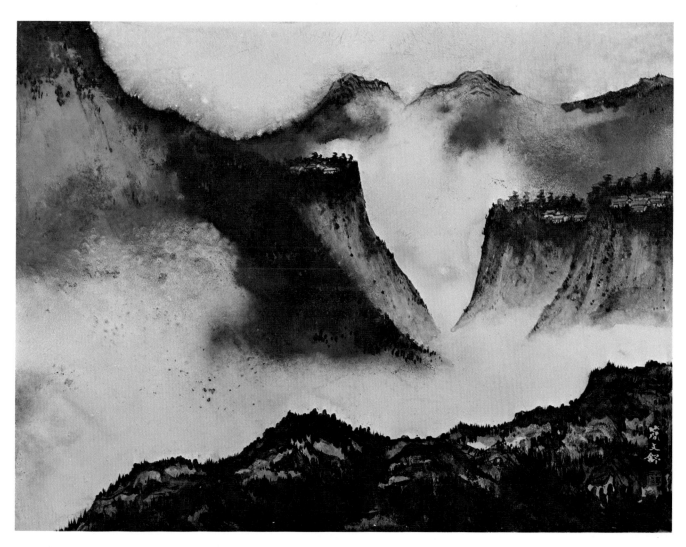

Praise of the Himalayas; silk, 24 by 18 inches. *P'o mo* technique using indigo, mineral colors (yellow, blues and green), and white with pearl powder.

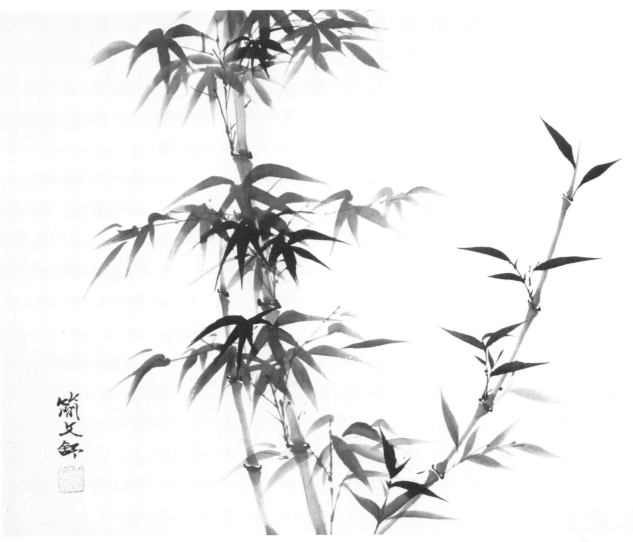

Begin at the top with the first stalk section, using an upright brush. Leave a small space between each successive section.

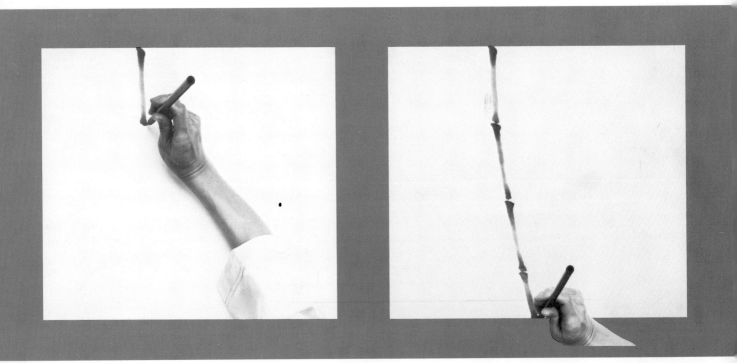

4. Bamboo

If people are playing the word game of association and the suggestion is Chinese painting, the response is invariably bamboo. That is the speedy association for most people because bamboo is a most familiar symbol of Chinese culture and art. To the Chinese, the bamboo expresses the will to survive, the spirit to endure under adverse circumstances. Great trees in their strength resist the winds and are broken; but the pliant, yielding bamboo, twirled and tossed about madly in the storm, bends and bows unresisting, and survives. Great paintings and poems have celebrated the bamboo throughout Chinese art and history. Su Tung-P'o (1030–1101), famous poet-painter, said he would rather live without meat than live without bamboo. Another poet wrote, "The wind in the bamboo is the music of God."

Painting bamboo is an exercise congenial to the soul of those who love beauty of line. It is said that the artist writes a bamboo painting, for bamboo painting is founded on calligraphy and is a progression from writing such as singing is from the speaking voice. Practice of the calligraphic character *yung* (eternity) will be most productive in helping you paint bamboo, because each of the eight strokes moves in a different direction and contributes greatly to your knowledge of the strokes used for the stalks, knots, branches, and leaves.

In painting bamboo, we start with the stalk, a slender, hollow, jointed stem with sections of varying lengths and thicknesses. Although the stalk is constructed in sections, it is always painted with the idea of one continuous brushstroke, and not too much space should be left between each successive section for the connecting knots, to avoid making the stalk seem disjointed. The sections of the bamboo increase in length as the plant grows taller, so those nearer the ground are short while those further away are progressively longer, and those at the very top are again short.

To paint the stalk sections, ink the brush (number one or two) with a medium-light tone, allowing the ink to rise halfway up the moist bristles, and tap out excess moisture. The ink should be fresh, the brushstrokes vigorous and exuberant. Holding the brush upright, start at the top of the paper with the brush tip pointed to the upper left and press down slightly on the paper. Releasing pressure, swing the bristles around so the tip is pointing to the top of the paper and quickly move on downward, as in the vertical stroke of the Chinese character *yung*. Drag the brush a little in pulling it down toward the end of the first stalk section. To finish the stroke swing the brush tip to

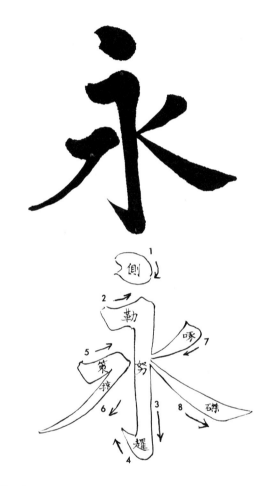

The eight classically named strokes of the character *yung* are: (See page 168 for modern-day strokes.)

1. *Tse*, the dot
2. *Le*, the horizontal stroke
3. *Nu*, the vertical stroke
4. *Yo*, the hook
5. *Ts'é*, the up-tilted stroke
6. *Liao*, the declining stroke
7. *Cho*, the pecking stroke
8. *Chieh*, the trailing stroke

point to the upper left again and press down slightly. Release pressure and draw the brush tip to the slanted end of the stroke before lifting it from the paper.

Without inking the brush again, and leaving a small space for the joint, paint the next section of the stalk directly below the first, using the same pressures and the same vertical stroke as before. Repeat this until all the sections have been completed, but re-ink the brush when it becomes too dry, at about the fourth section. Because you do not re-ink the brush for each section, the strokes become progressively lighter and this lends interest to the stalk.

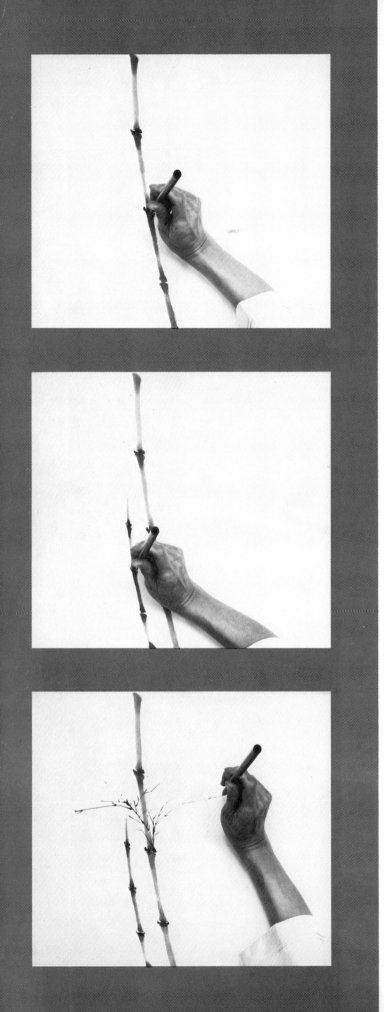

After the stalk, paint the knots which connect the sections, using darker ink applied to the tip of the brush. The knots should be painted in while the stalk is still damp, enabling the darker ink to run into the lighter-toned stalk and producing a more natural appearance. The shape of each knot should be a slightly curved line curling upward at each end and echoing the roundness of the stalk.

Bamboo grows in clusters and forms groves. "Frail is the bamboo that grows in solitude," the poets say. You may therefore show two stalks in your painting, the second executed in the same way as the first. If you wish to show that the second stalk is some distance from the first, you may paint it in a lighter tone. If you wish the stalk to be narrower, decrease the pressure on the brush. The sections of the two stalks should not coincide with each other, so that when you add the dark-inked knots to the second stalk they do not make a horizontal pattern with those of the first stalk. If you add a third stalk, the levels of the sections must again be different, either progressively higher or progressively lower.

When you have finished painting the stalks and knots, you must add the branches. A bamboo branch also grows section by section. It begins at one side of a knotted joint and moves upward from the stalk, thrusting outward as well with each new twig. The next branch begins at the next knotted joint, but on the opposite side of the stalk. All the branches are painted with the tip of the upright brush in brisk, free strokes that follow the natural growths. The ink tone is medium-dark. As a branch grows section by section and twig by twig in nature, it grows stroke by stroke in the painting: one or two supple strokes for young branches with few twigs and smooth joints; a succession of sharp, jutting strokes for older branches with a large accumulation of forked twigs and prominent joints. The joints on thicker branches may be indicated by a small space between sections and a slight pressure of the upright brush at the beginning and end of the stroke. On thinner branches, the junctures may be indicated by pressure alone.

It is easiest to begin with the branches at the center of the stalk, stroking up and then out to the left and to the right, allowing the medium-dark ink at the tip of the brush

The knots are added between the stalk sections in dark ink with the tip of the brush. A neighboring stalk may be added, using the same strokes as before. The branches are then painted twig by twig with brisk strokes of the upright brush.

to diminish in strength as you proceed. Next, re-ink the tip of the brush, move to the knots below, and complete those branches. Finally, with fresh ink, paint the topmost branches. Not only do the branches begin on alternate sides of the stalk at each knot, some may move in front of the stalk and some behind it. The branches and twigs should be at least as dark in tone as the stalk and may be darker if desired.

The order of painting has been: first the stalk and knots, then the branches and twigs. Now we shall paint the glory of the bamboo — the leaves. The leaves grow in clusters, but each leaf must be cleanly drawn and the spaces between must be clearly visible. In shape, the leaves are broad and flat, but they taper to a point at each end. In their various movements, they express their atmospheric conditions, whether tossed by the wind in arabesques, or calm and straight in sunlight; whether heavy with rain or dew and dipping low, or fluttering at the top of the stalk in a light breeze. At all times, the leaves should express vitality and imply an inner spirit of resilience and strength. Although the leaves have their own rhythm, do not forget that they grow out of the branches, which issue from the knots; each part must be clearly related to the other to avoid unnaturalness or rigidity.

Ink the brush halfway up the bristles, and paint each leaf outward from its point of origin with an upright stroke that is decisive and bold. Point the brush, press down on the paper and drag the bristles a little to widen the middle of the leaf. Release pressure and shape the leaf to its tapering point. Quickly lift the brush tip from the paper. The ink should be dark and rich for the foreground leaves, somewhat lighter for the background leaves. Re-ink the brush only as often as necessary to maintain the desired tones. Do not charge the brush with too much water, for the tones should be velvety in effect and the brush should be a little dry when it reaches the tapering end of the leaf. Painting a leaf is not done in a slow movement; brushwork must actually be swift and strong, with the idea of the structure and the enduring strength of the plant well in mind. Again, it is easiest to begin in the center of the composition, painting outward to the left and then to the right. Next, paint the leaves on the bottom branches and finally the leaves on the topmost branches.

The branches issue from the knots, on opposite sides of the stalk. After the central and lower branches have been painted, add the topmost ones. Note that some branches cross in front of the stalk and some cross behind it. Use a medium-dark tone at the brush tip and re-ink after completing each branch. Add the leaves in a dark tone, pressing down in the center of the stroke to broaden it.

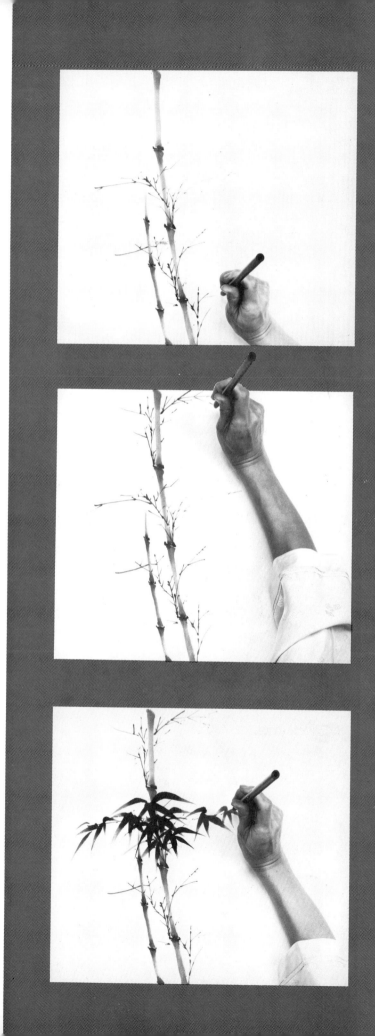

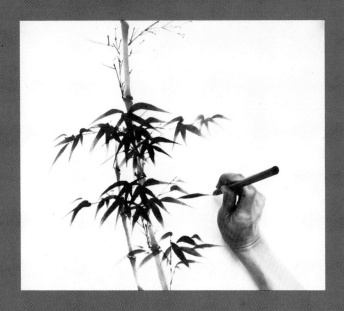

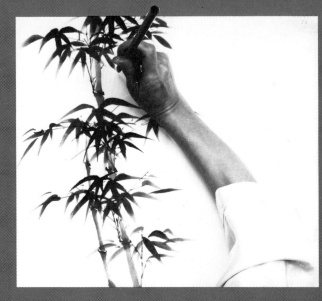

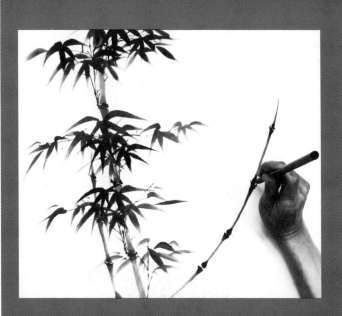

If you wish, you may add another stalk to the composition, completing it with the same sequence of strokes you used previously, and adding the branches and leaves in the same order. Note that, when the stalk is young, the branches are less developed and the leaves are less dense.

Practice, and again practice. Control the brush with mind and heart in accord, and execute this agreement with the hand. The leaves stretch, dip, bend and twist, in rhythm with nature. Like the dance recital that requires practice of techniques, the choreography of the leaves will be worked out by practicing the appropriate brushstrokes until you can perform with freedom and grace.

For painting bamboo in color in *mo ku* style, you can use the same strokes and substitute pigment for the black ink. Usually blue and yellow are combined to make a thin, moderately dark green for the stalks and branches. To this basic green color, more blue is added for the darker-toned knots and foreground leaves, and more yellow is added for the lighter-toned young twigs and some of the background leaves.

You can also paint the bamboo in red if need be. The need be is when a man commissions an artist to paint him a red bamboo in order to frighten away an evil spirit that is hovering over his house and causing him misfortune. He hangs the scroll on the wall, the red bamboo scares the evil spirit, and the man's luck changes for the better.

Study the choreography of the leaves and practice the necessary movements. Point the brush to start, press down to broaden, and shape the stroke to a tapering point. Note that the young stalk at the right of the composition has small, supple branches and few leaves.

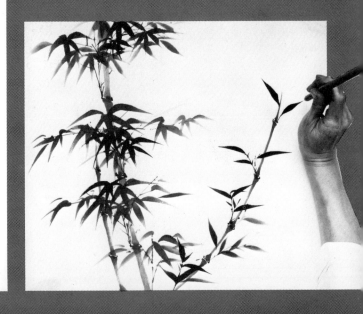

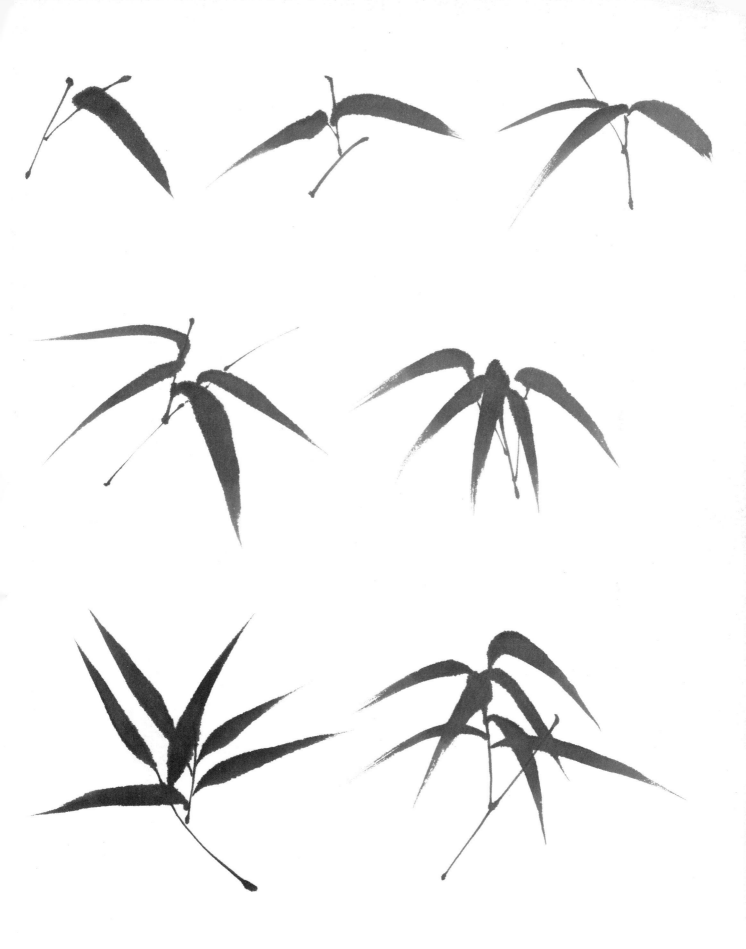

The leaves may dip downward or point upward as long as the movement of each leaf is in unison with the others. They should not be scattered at random. A twig can bear from one to seven leaves.

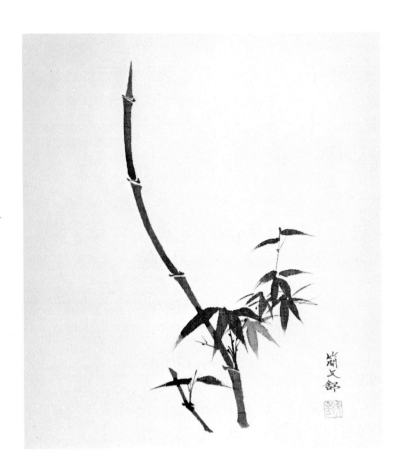

Use the same *mo ku* strokes in color as in ink. Use yellow and indigo to mix a moderately dark green for the stalks and branches. Add blue to darken the color for the foreground leaves and add yellow to lighten it for the background leaves.

In contour style, the forms are outlined first in light ink, then in medium or dark ink. Thin washes of pale green are applied within the contours to build up color and form. Each wash must dry before the next is added. Finally, fine lines of veining are added within each leaf, using the tip of the brush and either ink or color.

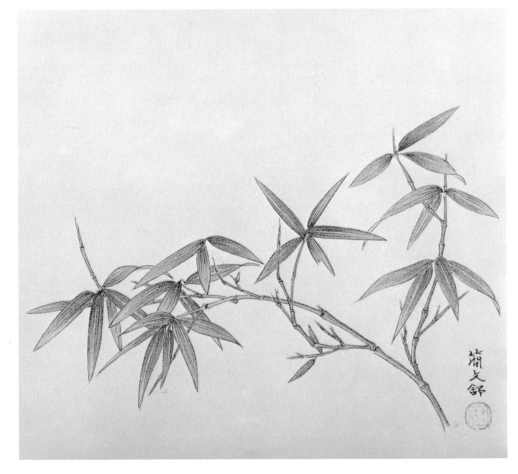

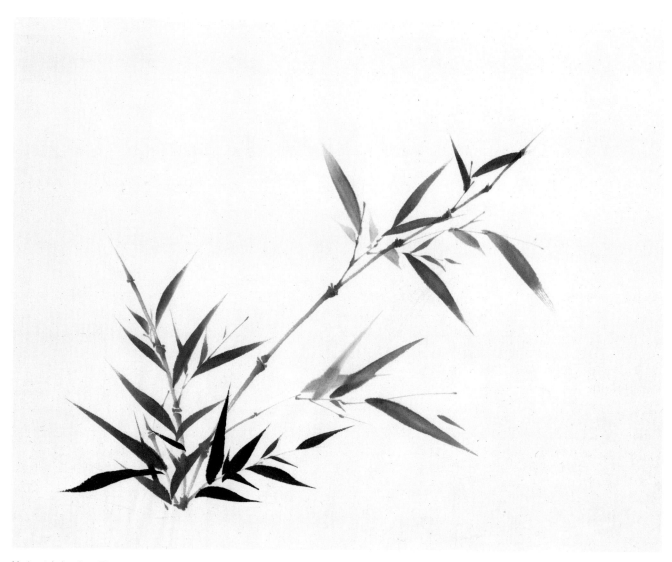

Mo ku style bamboo. The leaves closest to the foreground are a rich velvety black; those furthest away are lightest in tone.

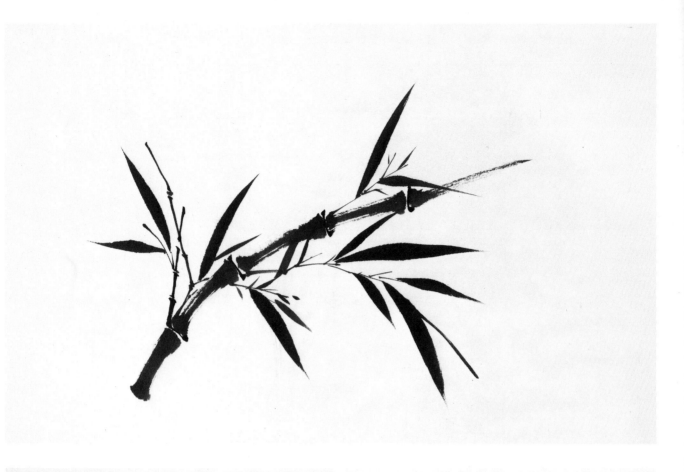

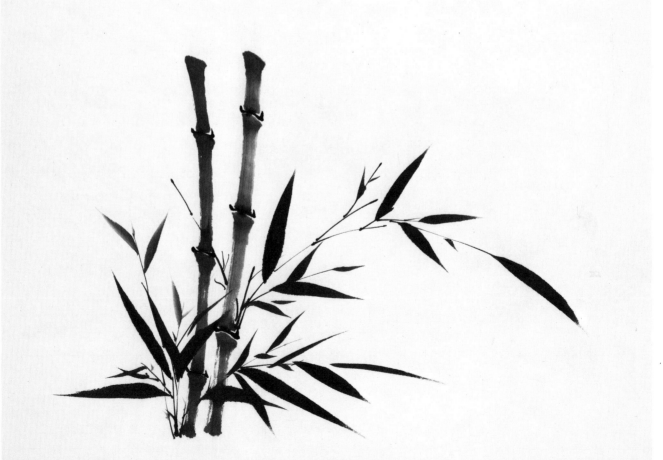

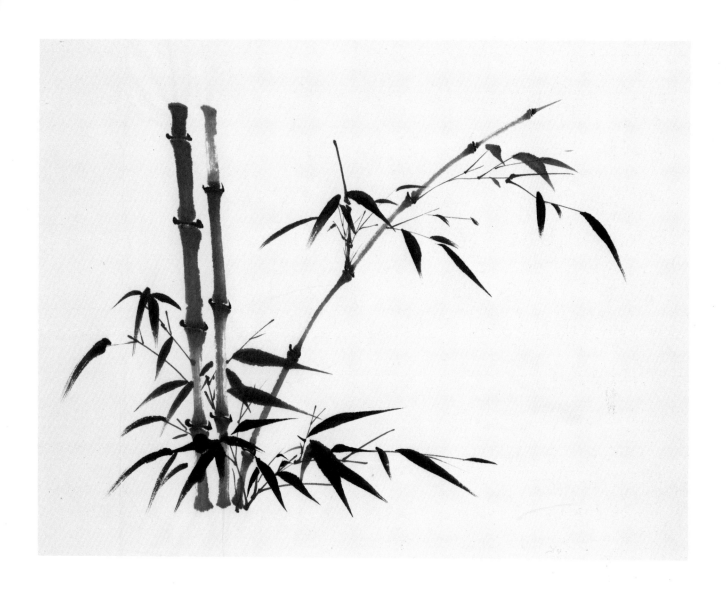

Mo ku style bamboos. Note that the twigs also grow in sections. For thicker twigs, leave a thread of space between sections; for thinner twigs, press down on the brush slightly wherever one section joins the next. Also note in these three paintings how some stalk sections and the tips of some leaves are drier than others.

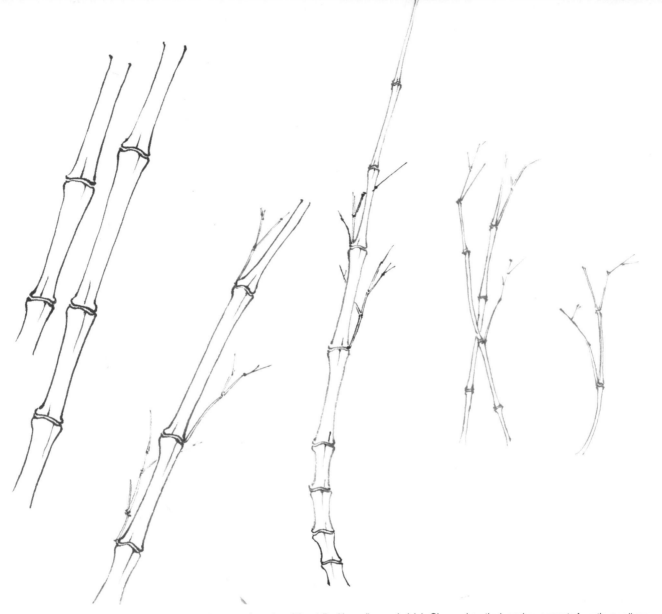

For contour style, use the fine-line drawing brush. Outline each section of the stalk with medium or dark ink. Observe how the branches emanate from the small space between the sections. Instead of an arced line between sections, vertical lines are drawn at the beginning and end of each section.

When painting bamboo in contour style, you use medium or dark-toned ink on the tip of the upright brush to paint the outlines of the stalk sections, branches, and leaves. These lines should have grace and spirit; the brush should not be so tightly controlled that these qualities are forfeited, although the contours should be accurately placed and the forms should be well-proportioned. Note how the lines of the branches emanate from the spaces left between the stalk sections and how the leaves issue from the twigs. In place of the arced line used between stalk sections for the knot in the *mo ku* style, a vertical line is added to each outlined stalk section at top and bottom.

If you paint this bamboo in color, first use light ink for all the outlines, drawing the contours with a line of medium thickness. (Use the number one brush.) Then strengthen these contours by drawing over them in darker ink with a very fine, deliberate line. (Use the number three brush.) This method of reinforcing the contours provides a distinctness of form along with a softness of line. The colors are then built up in layers, with successive washes of various shades of green applied between the contour lines. A wash is a very thin layer of paint obtained by diluting the pigment with a large quantity of water.

First, a very pale tone of green, made by mixing a small amount of blue with yellow and diluting this greatly, is applied to the stalk, branches, and leaves. When this has dried, a slightly darker tone of green, obtained by adding more blue, is washed down the length of the stalk along one edge, and over the beginning and central portions of the leaves, to provide shading. A still darker tone, obtained by adding more blue, is then washed over inner portions of the leaves in selected areas, to darken them and increase the dimensional effect. In shading the leaves, keep in mind that the palest tones should appear at the tip and in a thin vertical line down the center of each leaf. When the leaves are dry, add fine lines of veining paralleling the pale central stripe, with the tip of the brush dipped in dark green, or light blue, or light ink.

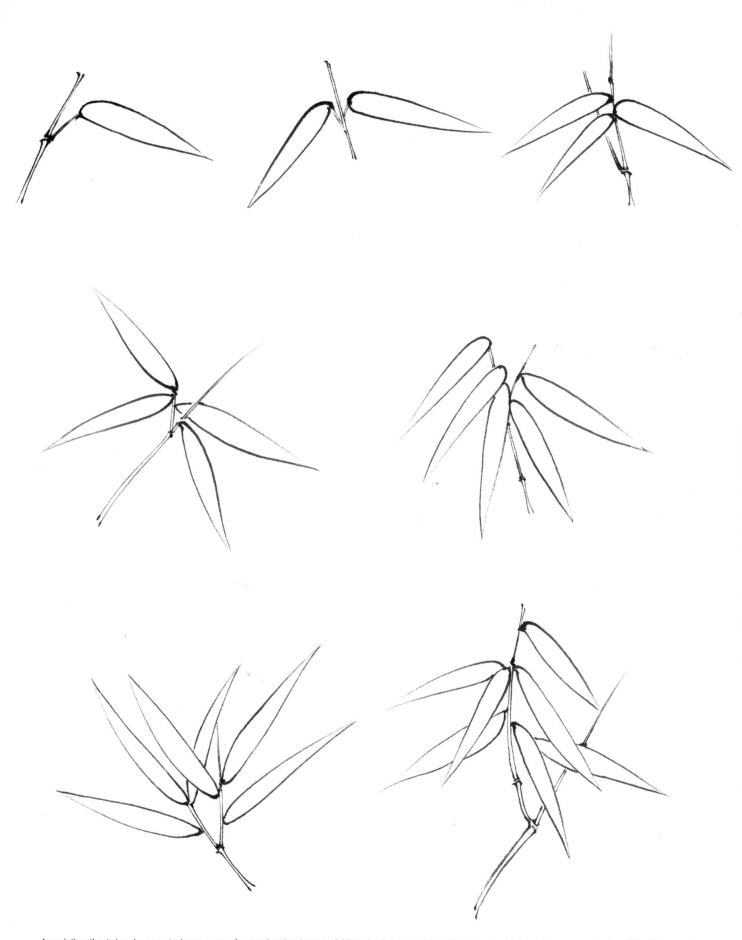

In painting the twigs, be sure to leave space for overlapping leaves. Adding the leaves requires the same precaution wherever one leaf partially hides another. Although the leaves grow in clusters, there should be sufficient space between each form to avoid a crowded, disorderly look.

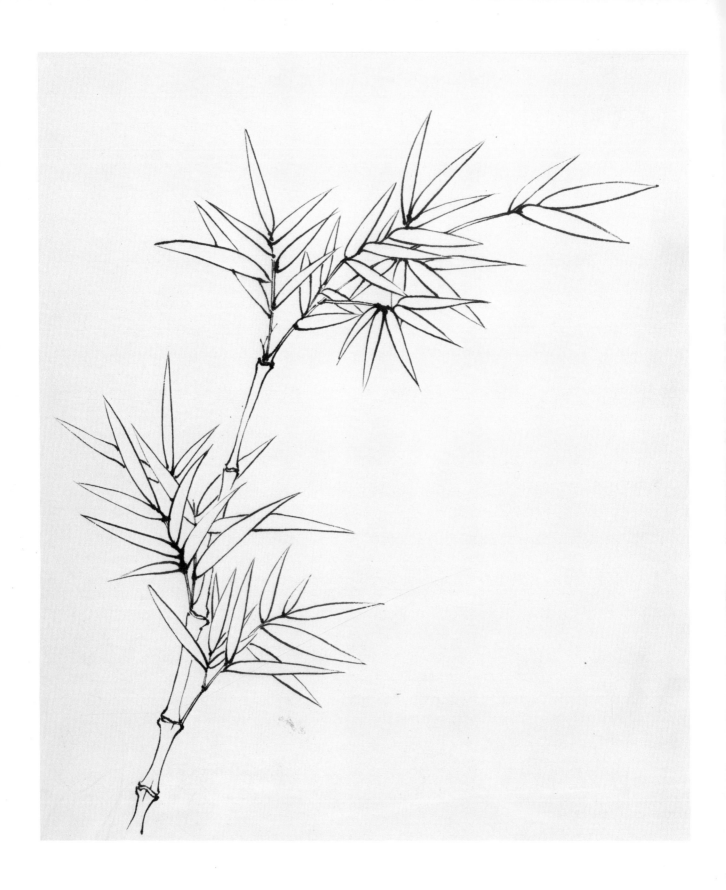

Contour style especially requires careful planning. Each element must be properly placed to leave room for the next element, and even when a stroke is interrupted, the completed outline should look continuous. The outlines may be filled in with ink or color washes.

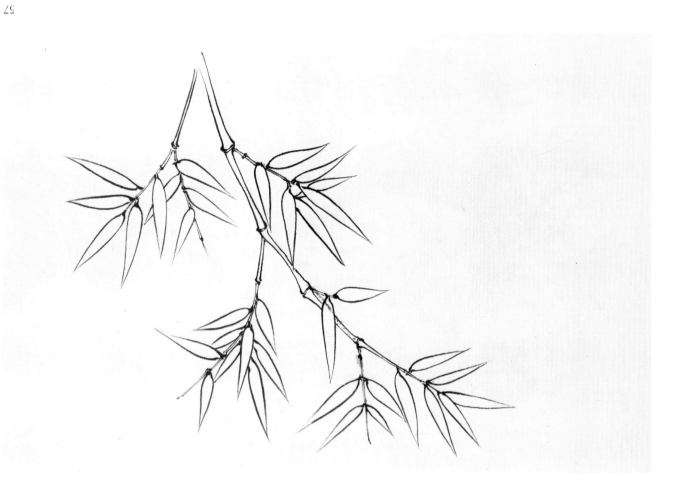

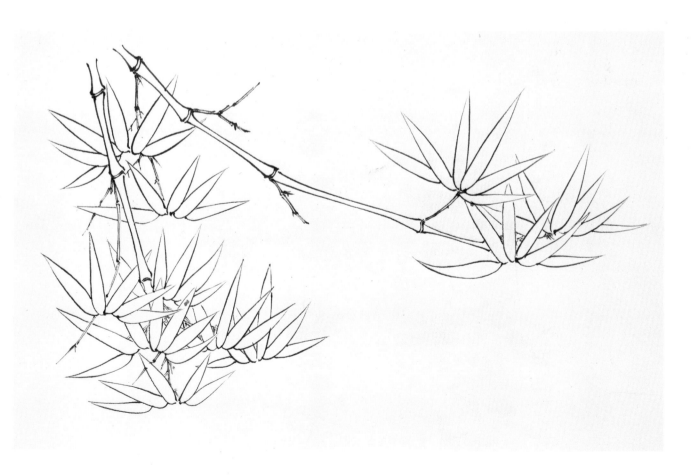

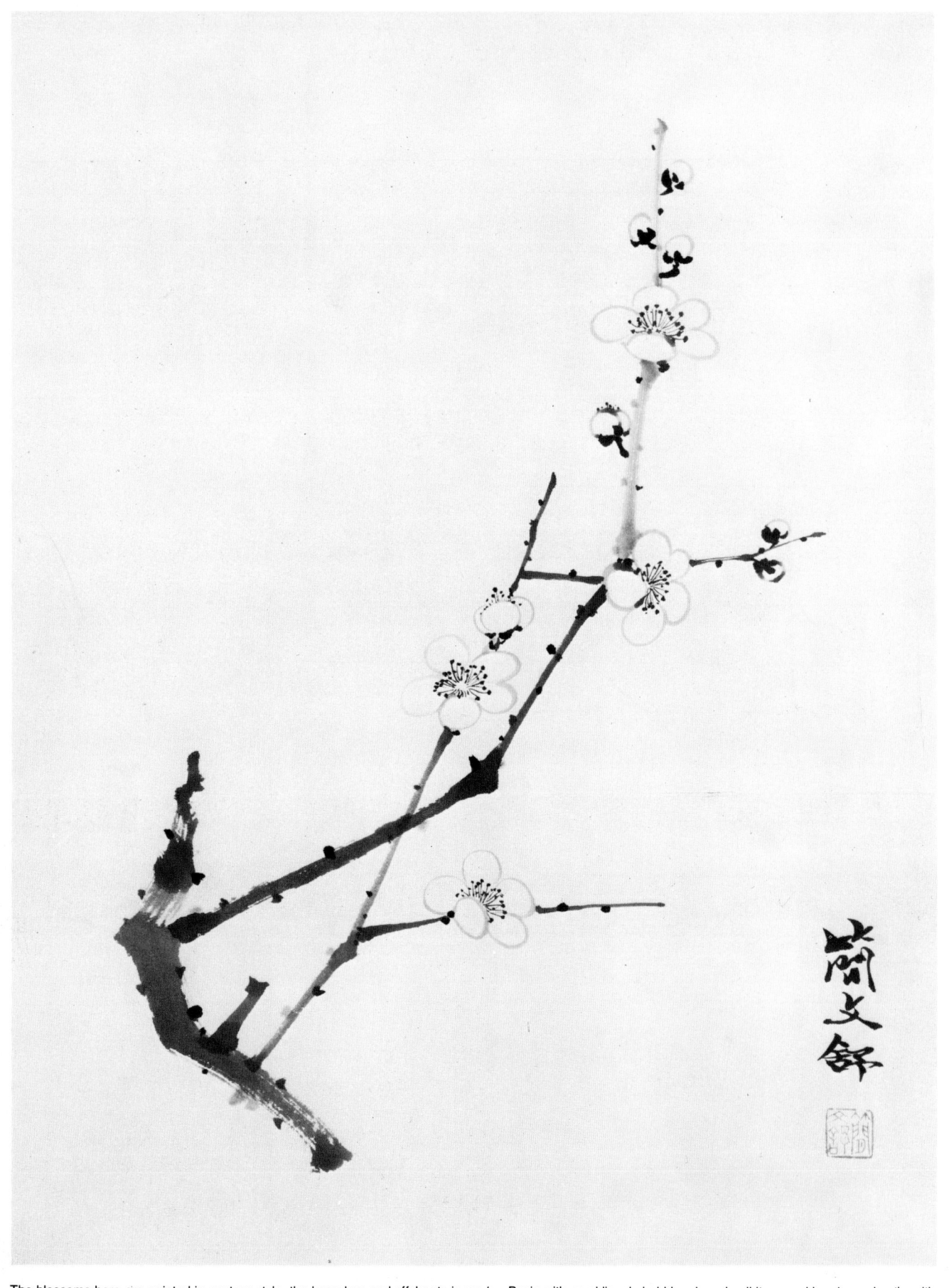

The blossoms here are painted in contour style, the branches and offshoots in *mo ku*. Begin with an obliquely held brush and pull it upward in a jagged path, with varying pressure. Shift the tip to an upright position at the thin part of the branch. Add the jutting offshoot with an upright brush.

5. Plum Blossoms

The plum tree is loved by the Chinese for its cosmic significance, expressing the re-emergence and continuity of life. In the twisted and gnarled shapes and the metallic-like, rough exterior of its trunk and branches, the tree manifests an appearance of hardness, particularly during its barren existence in early winter; yet it nourishes and cradles within itself the mystery and beauty, and the promise of spring. This promise is fulfilled when the delicate and chaste plum blossoms reappear each January, in time to welcome the new year. In China, where the calendar is based on the August — or harvest — moon, this marks the beginning of spring.

The plum, blooming in January frost, is a symbol of hope and endurance, and has long been a national emblem. Views that include the fruit and leaves, however, which develop after the early blossoms have withered and fallen, are not considered interesting subjects.

As the tree grows, slender rodlike extensions are thrust out of the grotesquely angular shapes of the older branches in almost directly horizontal or vertical positions. The boldness of these thrusting offshoots is likened to the daring of the young, while the wrinkled, twisted shapes of the older branches symbolize the accumulated wisdom of the old. In due course, the softly shaped, almost transparent blossoms emerge on these stiff young offshoots, producing a unique combination of images;

and it is this picturesque aspect of the tree that is most often painted.

When painting the tree in bloom, it is common to feature just one or two branches and their offshoots, and to concentrate attention on the beauty of the blossoms. Begin with a number two brush and medium-toned ink. Rinse the brush in clear water and let ink of the correct tone soak halfway up into the bristles of the wet brush, allowing clear water to form a second tone in the upper part. Then stroke the brush against the edge of a saucer to fix the tones and to remove excess water, for the brush should not be too moist. The branch is accomplished by gently pulling or pushing the brush, held obliquely, in a somewhat jagged path, starting at the thickest part of the branch and moving toward the thinnest part. This produces an irregularity of line and creates the various angles of the branch. At the same time, alternate between pressing down and lightly dragging the brush as you move it; this creates wet and dry areas, expressing the characteristic roughness of the branch's surface. Where the branch ends in a narrow point, shift the brush to an upright position.

The jutting offshoots may then be added with a smaller brush, held upright and moved in the same path as the growth itself, which spurts from one juncture to another. Press the brush down at one juncture, release pressure,

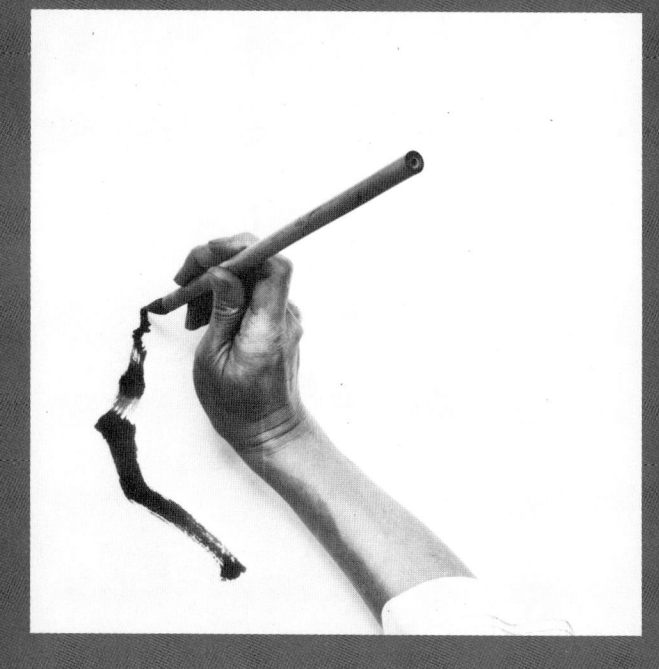

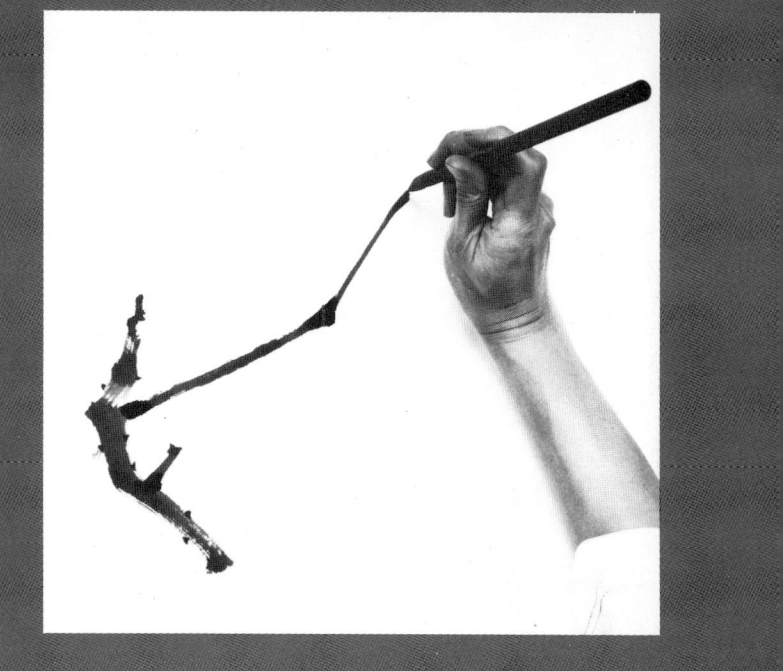

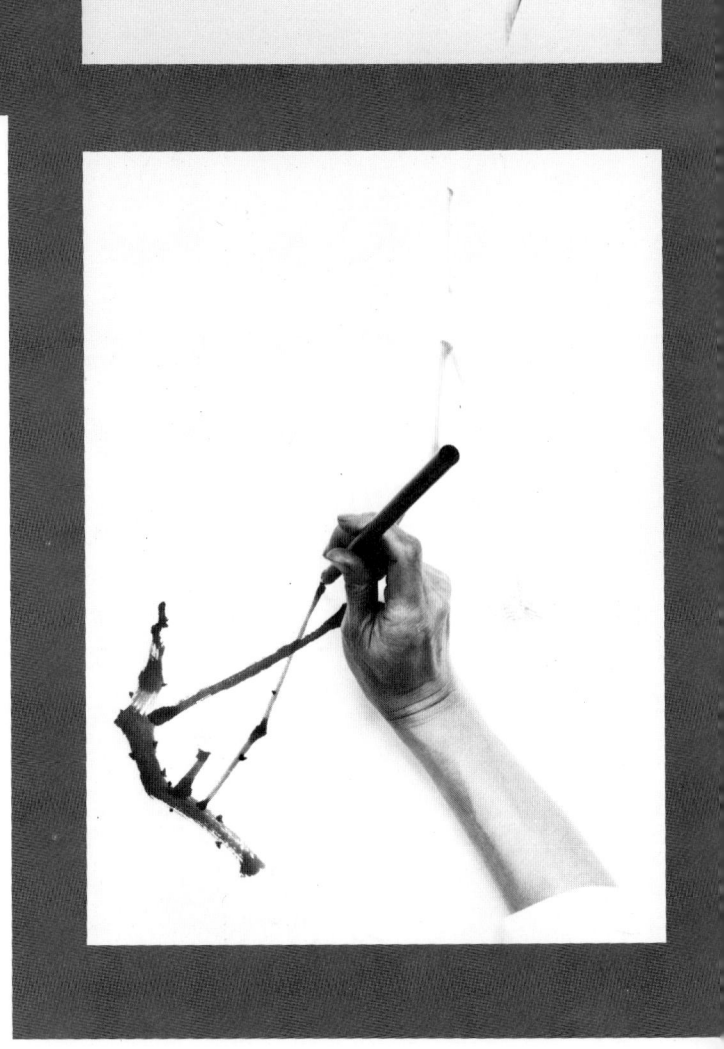

Paint the shoot from its thickest part to its thinnest part; press down on the brush at the beginning and end of each stroke to form the junctures. Vary the tones and the direction of the shoots, and remember to leave room for the blossoms.

and glide the tip smoothly to the next juncture; press down at that juncture and glide off in a slightly different direction. Tones for the shoots may vary from medium to light, with each shoot becoming lighter as it reaches upward or outward. Charge the brush to halfway up the bristles, and re-ink as necessary. For naturalness and interest, vary the length and thickness, as well as the position and tones of the various shoots. The offshoots themselves often have thin, straight spurs issuing from them and darting off in a divergent direction.

To help delineate the branches and shoots, and to give a feeling of the natural incrustations, add some "moss" dots by dabbing here and there along the edges of the forms with the tip of the brush dipped in dark ink.

As the shoots and spurs are added, the position of each blossom must be visualized so that space may be left between some of the strokes, where the flower will overlap and hide the limbs. The shoots may cross one another in interesting ways, but avoid confusion of forms. This is easier to do if you work from the point of origin to the point of termination, thrusting progressively upward or outward with each new stroke and proceeding from thicker forms to thinner ones, from darker ones to lighter

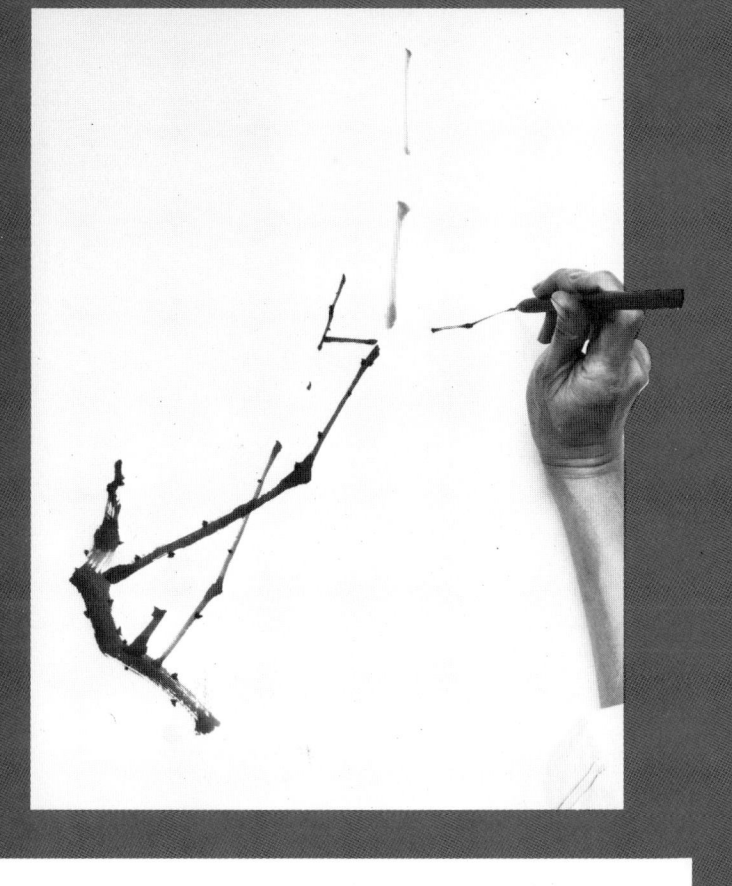

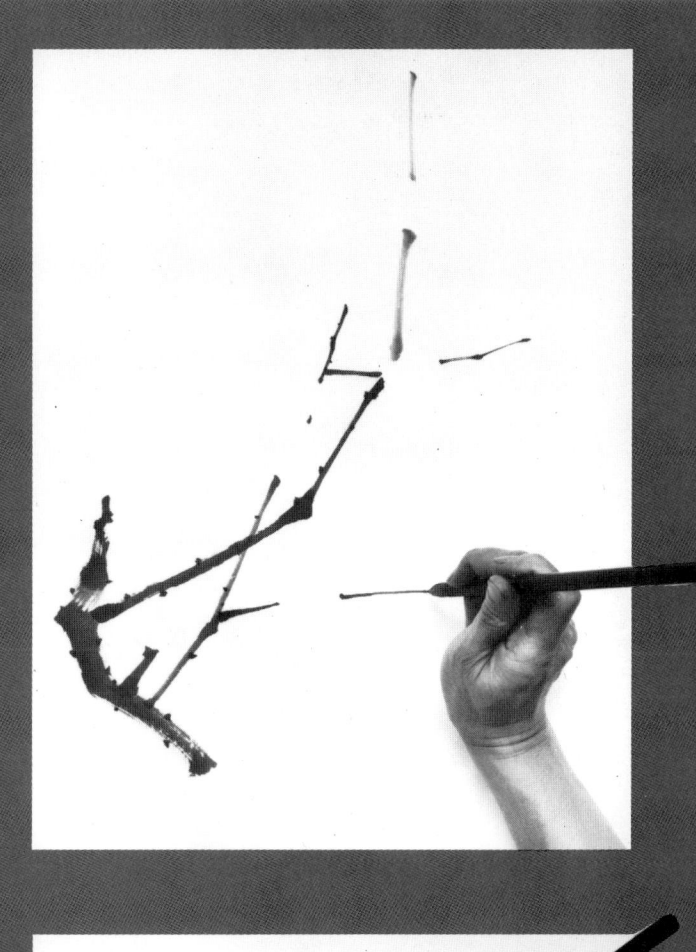

Some shoots have straight spurs darting off in a divergent direction. Add dark moss dots to accent the branch and shoots; then begin to place the buds and petals, outlined with the tip of the upright brush in light ink. Draw the threadlike stamens and dot them with dark ink; add the sepals and small stems in dark ink.

ones. It may be difficult at first to judge the proper amount of space to be left for each blossom, but practice and familiarity with the flowers will overcome this difficulty.

Even when the branches and shoots are painted in *mo ku* style, the blossoms are most often drawn in contour style, with light ink for the petals, to suggest their delicate nature. Each flower has five softly rounded petals, each of which radiates from a central calyx — the outer, cuplike part of the flower that is attached by a small stem to the spurs and shoots. Inside the flower, there is a collection of dotted filaments (the stamens) surrounding a single pistil. These elements are irregular in length and spacing, and, when visible, they are painted in darker tones to contrast with the petals.

When the cuplike portion of the calyx and any of its tiny, petal-like segments are visible, they too are painted in dark ink. The only time all five segments (sepals) are visible at once is when the flower is viewed from the back. However, three sepals and the calyx can usually be seen supporting each round little bud viewed in profile. Painting these parts shows how the flower is attached to the branch, and keeps it from flying away. Buds that are beginning to open may also show the tops of the stamens.

Continue to place the blossoms and buds in the spaces between the shoots and spurs.

In a profile view, the tips of the stamens are visible and the sepals and calyx can be seen supporting the buds and blossoms.

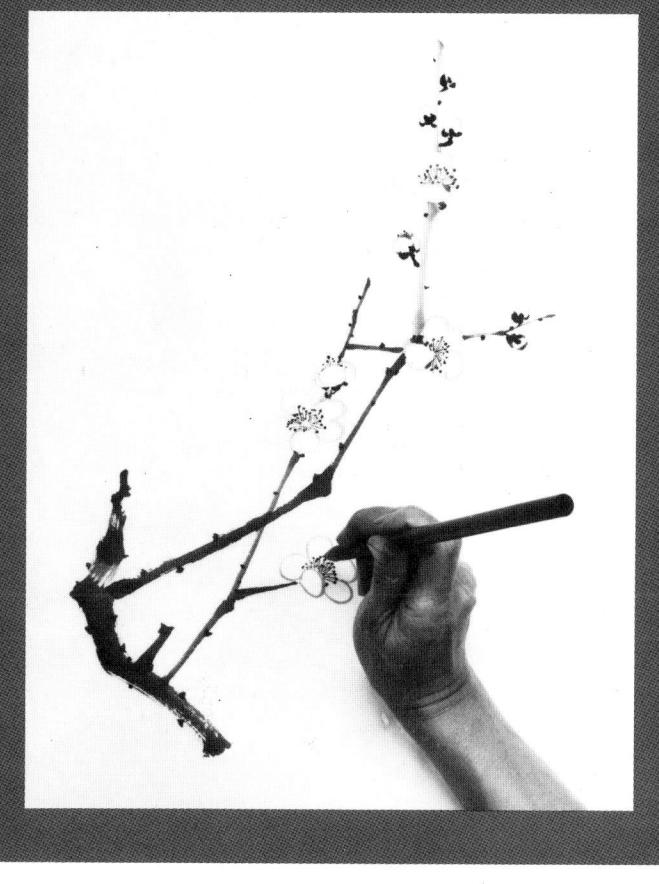

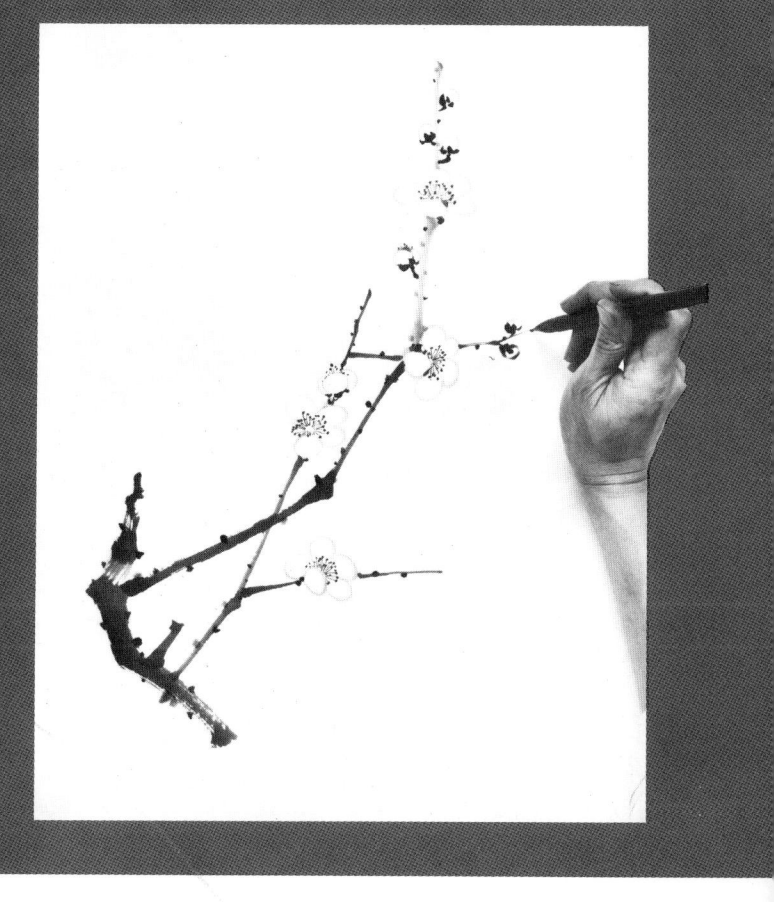

The shape of the petals and the placement of the stamens help to establish the position of the blossom.

More moss dots are added in light and dark tones for accent.

The blossoms should appear in different positions — some facing the viewer, some partially or fully turned away — and in different aspects, ranging from the tightly closed buds to fully opened blossoms. These differences are shown in the shape and position of each petal as well as by the placement of the stamens and sepals. Only the tip of the upright brush is used to make the circular buds and petals, outlining each shape separately with light ink. Very often, these fragile outlines are reinforced by drawing over them with a very fine line of dark ink after they have dried, but that is a matter of personal choice. Use your number one brush for the first outlines, in light ink; use your number three brush for the finer lines.

Where the calyx and sepals are visible at the base of the bud or blossom, they are added in *mo ku* style by pressing down with the tip of the upright brush, using dark ink. Where the inner center of the blossom is visible, the pistil and stamens are added with thin, dark strokes for the style and the filaments; these are dotted in dark ink with the tip

of the brush. The flowers need not all be perfect or whole; some may have lost one or two petals when washed by rain, but they should still maintain vitality and fragrance.

When the plum blossom is painted in color, the *mo ku* branches, shoots, and moss dots are done in a dark, inky color of thin consistency, using either blue, green, or brown mixed with some ink. Sepals and calyxes are in dark blue or dark green, and extra moss dots are added in yellow-green. The petals are outlined in light ink first and then in dark ink, with a finer, more deliberate line, to strengthen the effect. Or they may be outlined instead entirely in pink (cadmium red mixed with white) or entirely in blue (indigo mixed with white). The threadlike filaments are added with lines of medium-toned ink or lines of blue, dark green, or yellow paint. They are then dotted with either cadmium yellow or burnt sienna. (Mix the dotting color with white to give it body.)

Finally, a very pale blue wash is added outside of and following around the contour of each bud and blossom, to make the flowers stand out. If you have outlined the petals in pink or light blue, the color will not bleed into the wash because the white pigment acts as a deterrent. Remember never to use a strong color, such as red, alone if you wish to keep it from bleeding into another color.

Opposite page: The pale outlines of the petals may be reinforced with thin, dark ones if desired. Study the different faces and aspects of the blossoms.

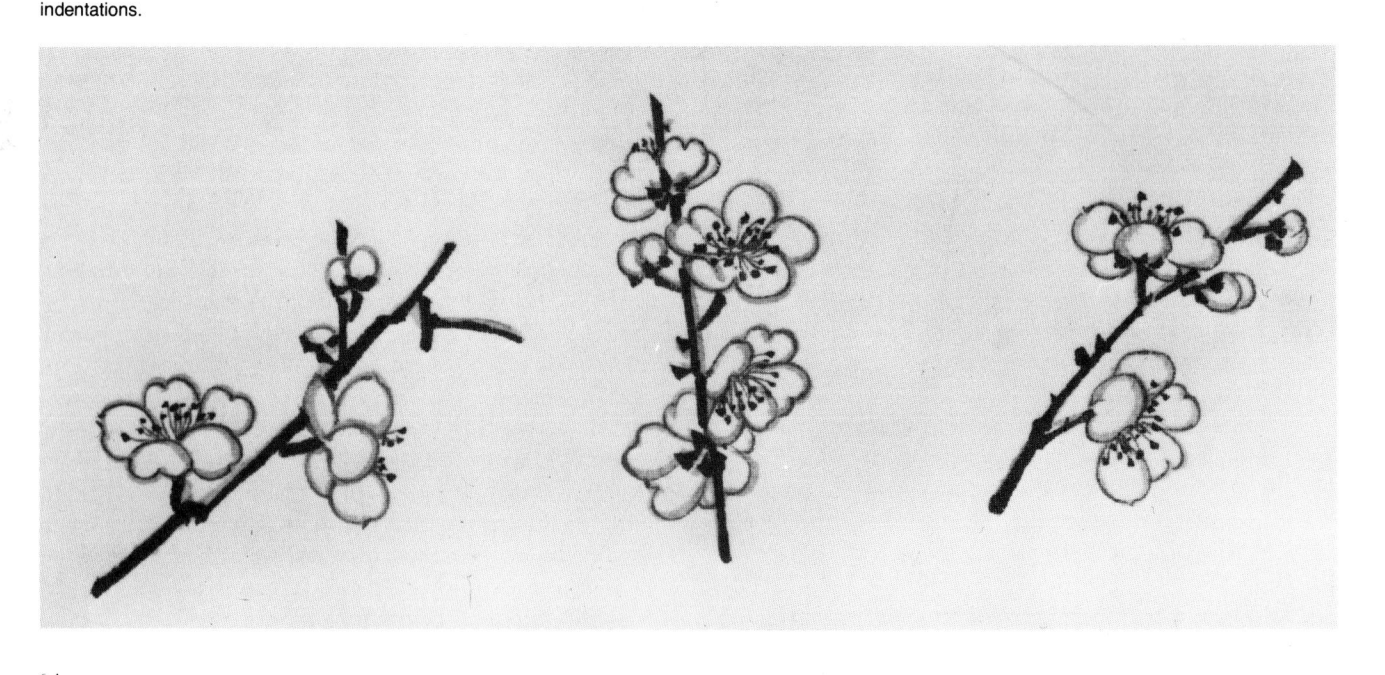

The double outline is usually used when the plum is painted in color. A pale wash is then added around the contours of the petals and buds, and these petals may be used with either *mo ku* or contour style branches (see page 67). Note that in some positions the circular petals become elliptical and that some outlines contain indentations.

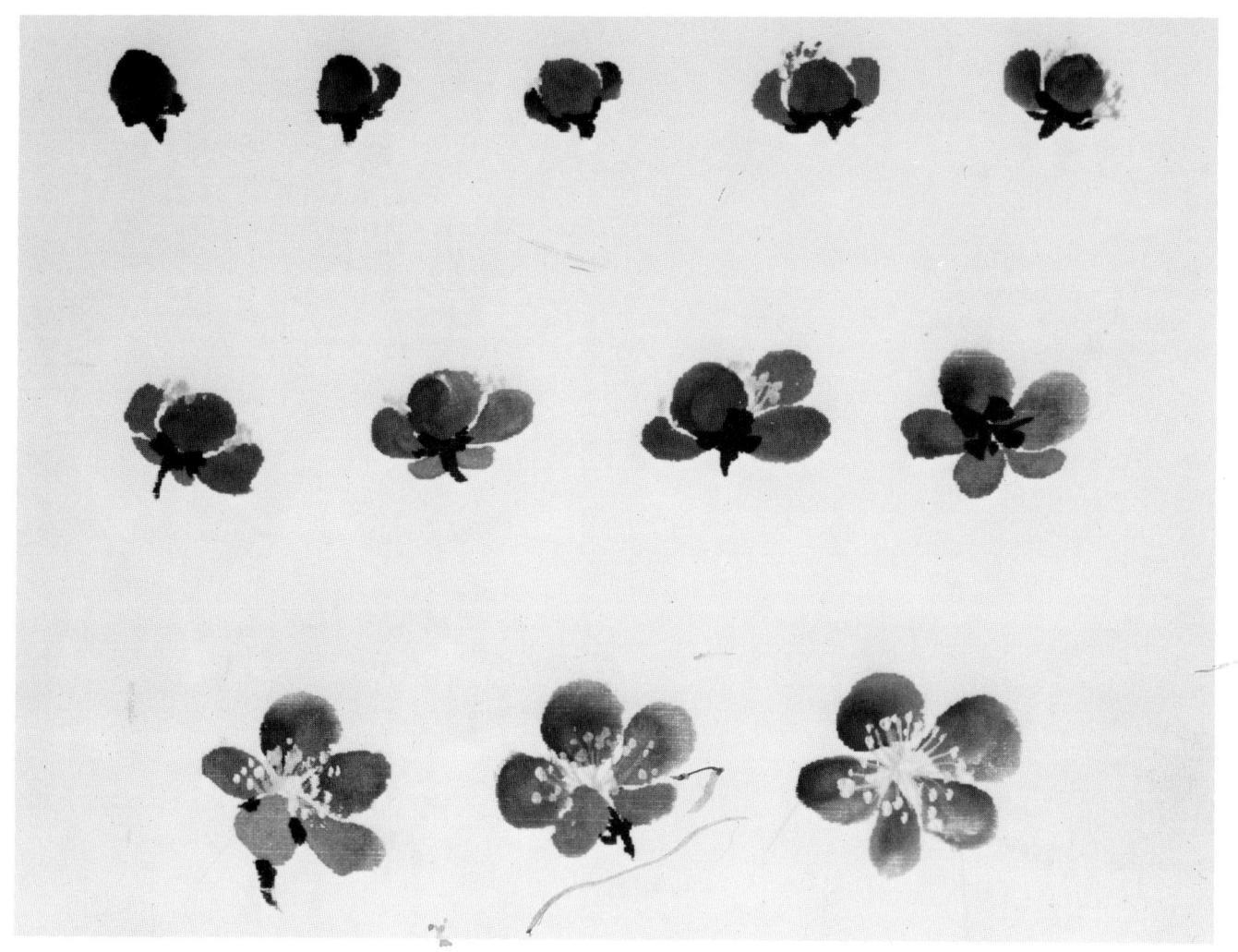

Plum blossoms in *mo ku* style may be painted in ink or in color. These petals may be used only with *mo ku* branches.

The blossoms may be painted in *mo ku* style instead of in contour, in black and white or in color. For this, the water-charged brush is dipped into medium-toned ink, and the ink is allowed to rise about halfway up the bristles, leaving clear water in the upper bristles; or the brush is dipped into two values of color, so that a variety of tones can be created with a single circular stroke. When you are using ink, be sure to create the second tone in the upper bristles by pressing the inked brush against a saucer. When you are using color, dip the brush into the lighter value first and the darker value second. For color, I suggest cadmium red as the first hue and alizarin crimson as the second; each of these may be lightened beforehand with an admixture of white, if desired, and they should be diluted to a medium consistency.

Each petal or bud is formed by pressing down lightly on the upright brush while stroking a circle. Begin with the tip of the brush pointed in toward the center of the intended circle. While slowly rolling the brush handle clockwise between the fingers, move the brush around in a circle to the right. The combined rotations of the handle and the hand will bring the tip of the brush to the outer

edge of the circle at the height of the stroke and swing it back in to face toward the center at the end of the stroke. As a result, the circle will contain soft nuances of tone, being darkest in those areas touched by the tip of the brush and lightest in the areas touched by the bristles that are closer to the handle. The more petals or buds you form, the lighter all the tones or values will become, and you can judge for yourself when you wish to re-ink or recolor the brush. (See page 35.)

The stamens, calyxes, and sepals are added after the petals and buds are dry. For black-and-white compositions, the filaments are drawn and dotted in dark ink; the calyxes and sepals are also done in dark ink. For a color composition using pink petals, the filaments should be cadmium yellow (some of these can be accented with cadmium red) and they should be dotted with white or pale yellow. The sepals and the calyxes are done in the same inky color as the *mo ku* branches and shoots; with pink petals, I prefer to use dark blue branches for elegance. The petals may also be painted in shades of yellow or bluish-white; in that case, use cadmium red for the filaments and pink or red for the dotting.

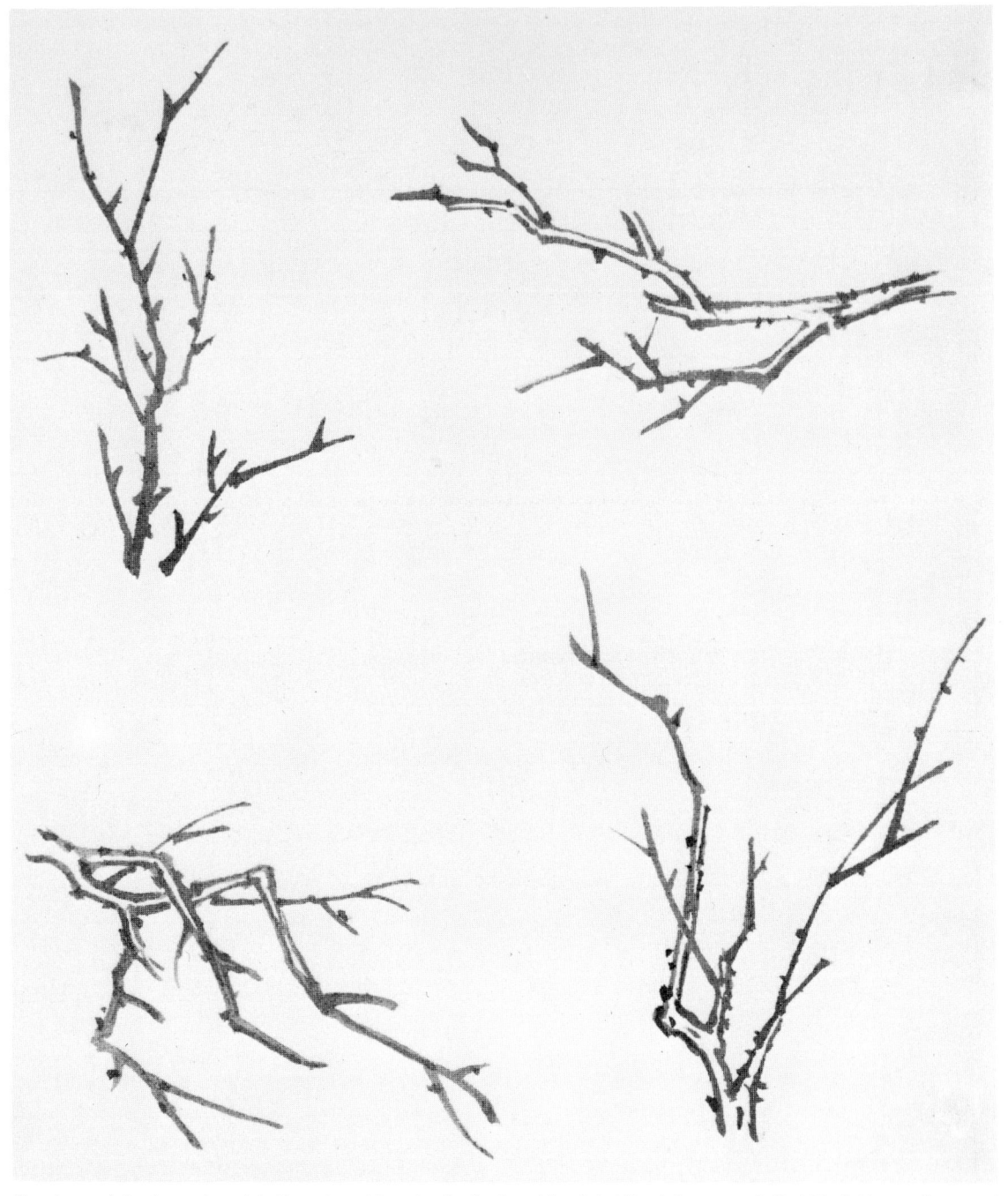

Branches and shoots may be painted in contour style, using the tip of an obliquely held brush for a rugged effect. The light or medium-toned outlines are accented with dark ink, and the lines of the thicker portions should merge into a single *mo ku* line for the thinner shoots and spurs. For color, the outlines are filled in with brown washes.

When the petals are done in *mo ku* style, the branches must be, too. But when the petals are outlined, the branches may be done in either *mo ku* or contour style. The thinnest shoots and spurs, however, are always done in *mo ku* to maintain the strength of a single line. Remembering to leave space for the blossoms, draw the contours of the branches in light or medium ink first and then strengthen selected parts of the contours with darker ink. These outlines, unlike those of the petals, need not be fine and deliberate, because they indicate rugged, uneven surfaces. Add dark moss dots.

For color, outline the branches in ink, with an obliquely held brush, and fill in the light-and-dark ink contours with various washes ranging from light to medium grayish-brown (burnt sienna with dark ink, diluted with different proportions of clear water). Apply the washes in succession, working from lightest to darkest, and waiting until each previous one has dried before proceeding. Place the washes in a way that indicates shading, for roundness of form, and use them to show texture, for naturalness of surface. Add dark ink accents within the contours. Use dark grayish-brown for the offshoots and spurs, done in *mo ku* style, and add some yellowish-green moss dots.

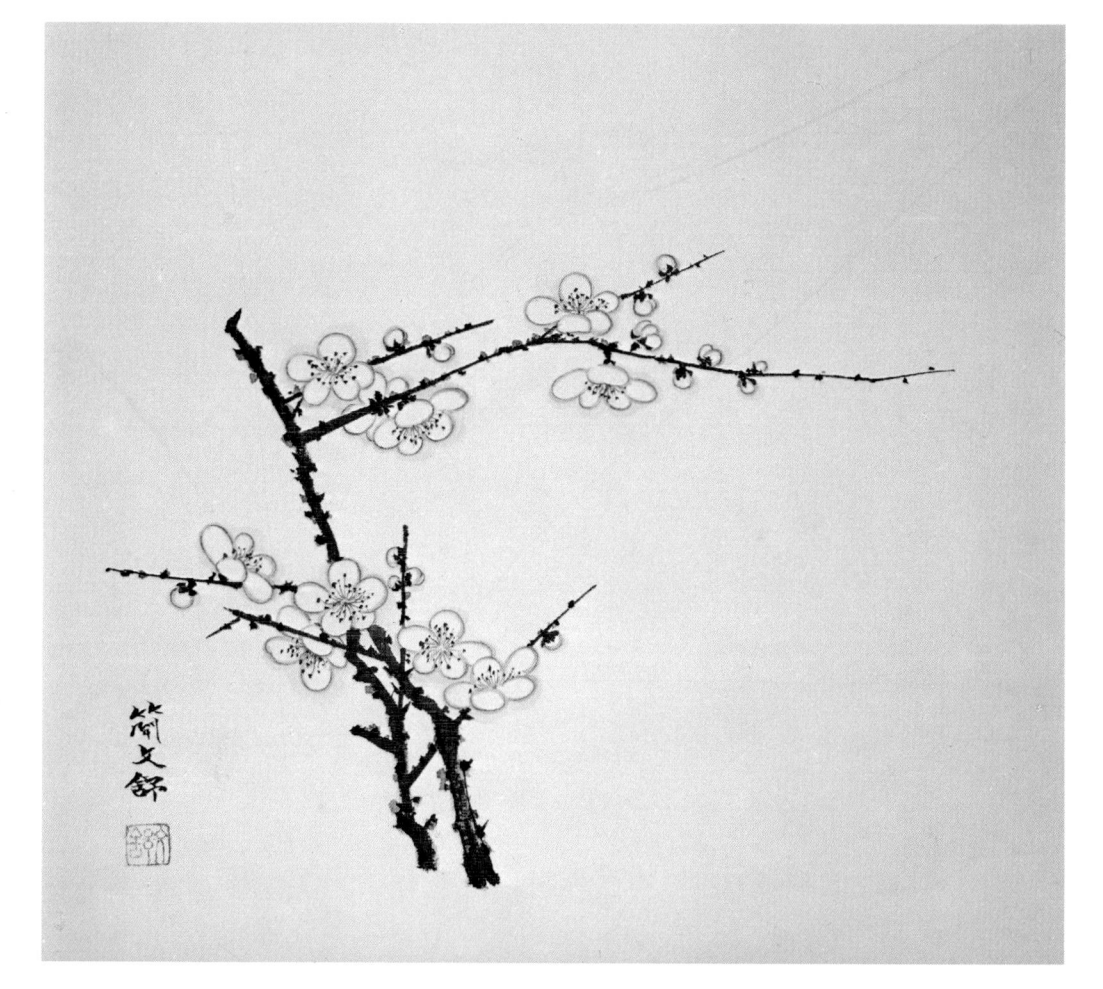

Above: Contour-style petals with a pale blue wash; the filaments are in ink dotted with burnt sienna. The *mo ku* branches are an inky brown. *Below, left:* Pink *mo ku* blossoms with branches and shoots in inky blue; stamens are yellow, dotted with white. *Below, right:* Contour-style petals with blue wash; stamens are in medium ink, dotted with yellow. Contour-style branch and shoots are colored and shaded with brown washes.

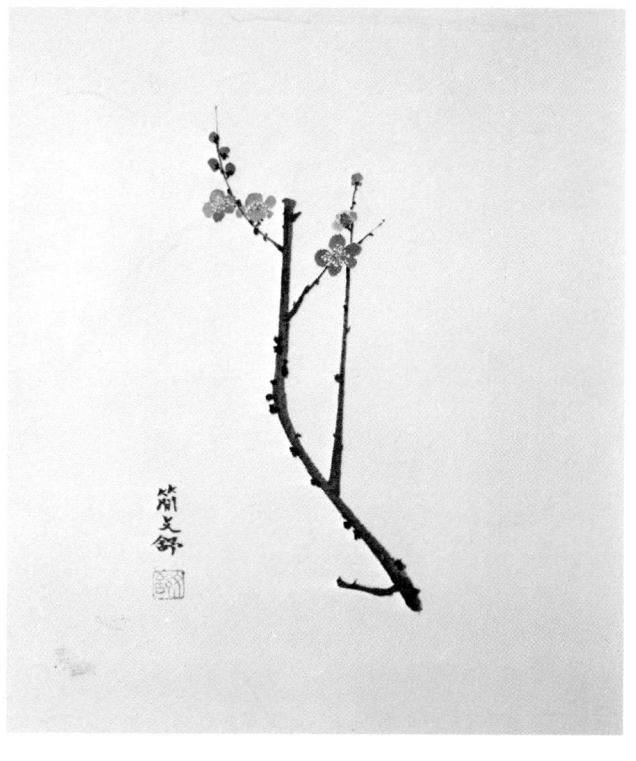

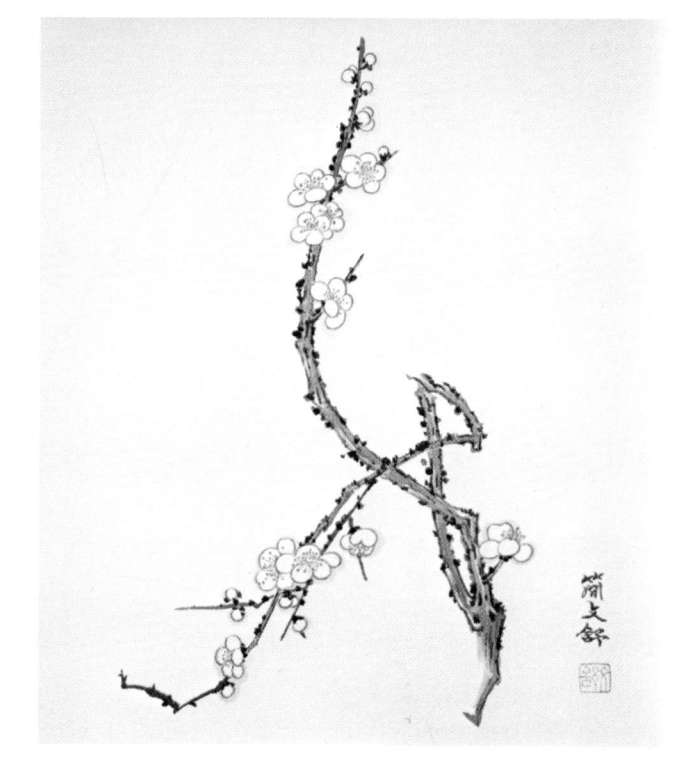

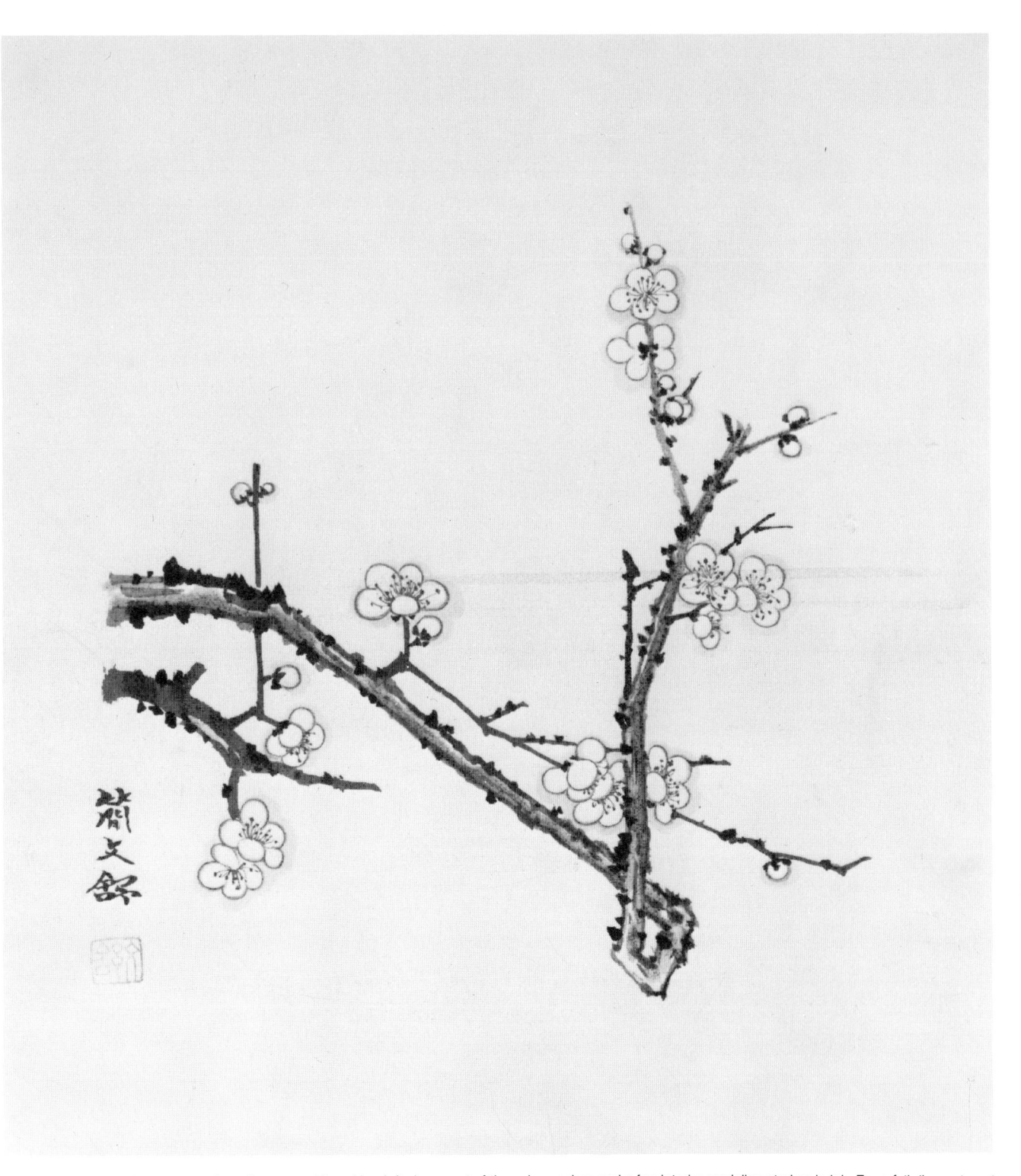

The textural effects of the contour branches are achieved by deft placement of the color washes and a few interior modeling strokes in ink. For a full discussion of modeling strokes see Chapter 8, on landscape.

The forms of the *mo ku* style are less detailed and more direct.

6. The Chinese Orchid

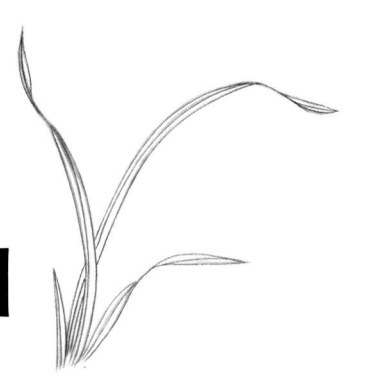

The orchid, growing near wet rocks, or in marshes, or near a stream, represents the desirable qualities of modesty, purity, and inner fragrance. The blossoms are symbolic of femininity in its purest form — fragile, they are protected and dominated by the robust leaves, and yet outshine them.

The Chinese orchid is a small, humble plant and its characteristics are remote from the orchid we know in the West. It is not a complicated structure but a delicate one; it is not ostentatious, opulent, and mysterious, but is forthright, lively and playful. The five petals are like the graceful fingers of a gesturing hand. They are never still and never stiff. Though they are joined together at the stem and have a common heart, each petal is individual and has its own movement, some beckoning inward to the heart of the flower, some reaching outward to catch the air. Usually, the two smaller, narrower petals beckon inward, while the three larger, slightly broader ones reach outward, almost as if they were in flight.

Each petal is accomplished with one stroke, one inking. Only light and medium tones are used; darker ones are reserved for the leaves that soar upward from the roots, protecting and supporting the fragile flowers. The petals must not be too heavy a burden for the foundation beneath.

Many schools suggest painting the leaves of the orchid first. But I follow the method of my teacher, Professor Chang Dai-chien, and begin with the buds and blossoms, spacing them on the paper as they are spaced in nature. The position of the main stem — and of each smaller, connecting stem — must thus be clearly determined in your mind before you paint the first bud. If you add the flowers of young, neighboring plants, these stems too must have their place on the paper.

The fresh buds emerge at the top of the plant; in painting a bud, two small petals are stroked side by side, from each pointed tip downward to the heart, which they envelop softly and completely. A third small petal may be added at the side of the bud to show that the flower is partially opening. In painting the open blossoms, the individual petals may be stroked either from inside the heart outward or from the tip inward to the heart. Again, if you wish to show distance, the forms in the background are lighter in tone than those in the foreground. For each petal stroke, charge the brush to halfway up the bristles with the appropriate light or medium tone. Hold the brush upright. Whenever the stroke requires broadening, press down lightly, and where a tapered point is desired, allow the tip of the brush to glide with no pressure.

Two oval strokes side by side form an orchid bud. A third stroke shows the bud is opening. Each of the five petals of the open flower is done with one stroke of an upright brush, freshly inked with either a light or medium tone.

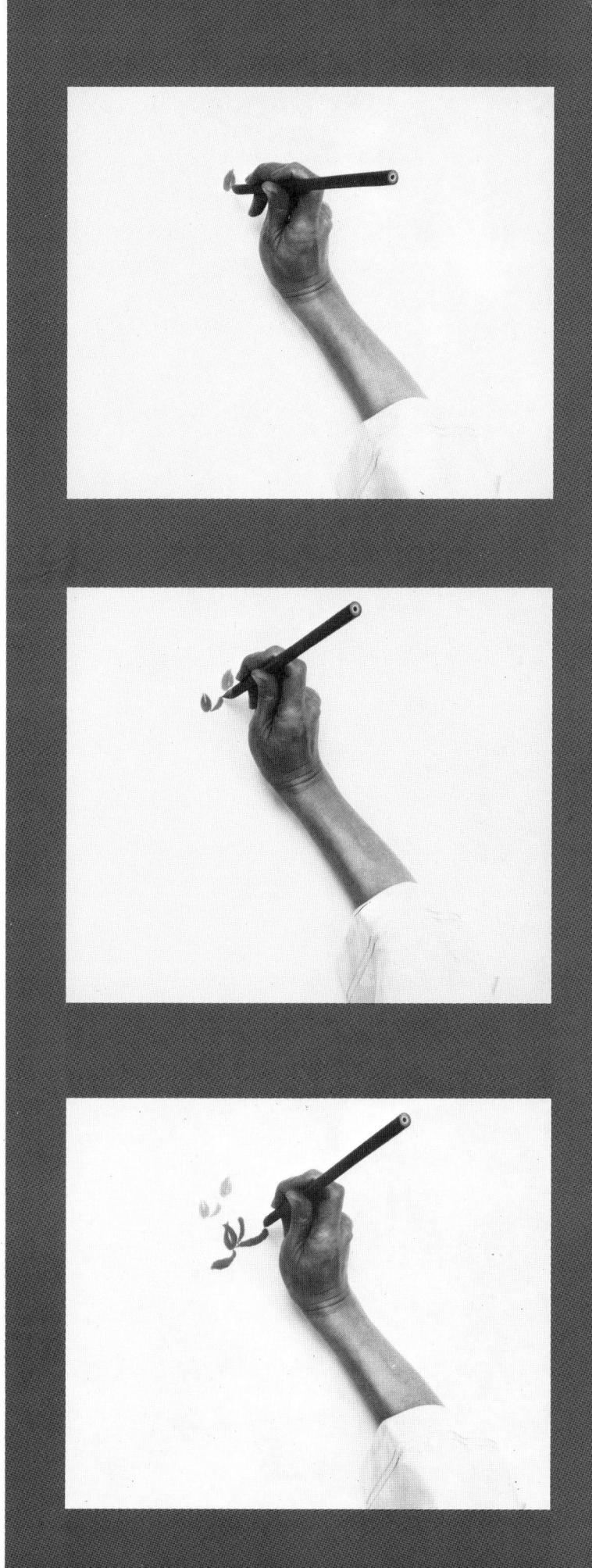

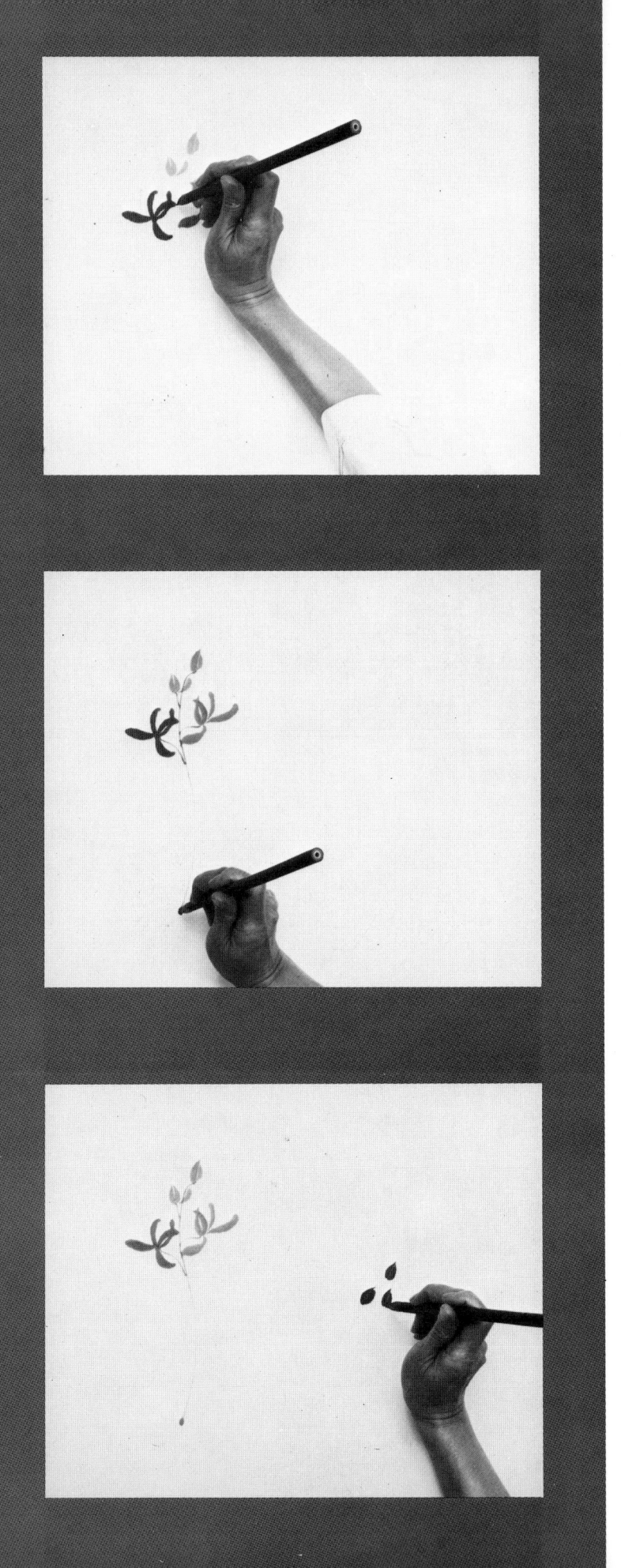

The flowers should assume different positions, some presenting an open face and an exposed heart, some turned partially or fully in profile with half-hidden heart. (The heart of each flower is painted last, with dotted strokes symbolic of the stamens.) The number of flowers in a painting may vary. The *hui* orchid bears from two to seven flowers on a single stalk; the *lan* orchid bears just one. But in both cases the number four — which, when pronounced in Chinese, sounds like the word for death — is usually not chosen, except for commemoration.

After the buds and flowers have been painted, the stems are added one by one. I start with the smaller, individual stems in a medium tone; each begins beneath the heart of the flower it supports and swings downward to join the stalk or main stem. Next, I add the tall, main stem, which is erect but supple and flows freely between the base of the first bud and the ground. This is also painted in a medium tone, with the tip of an upright brush, in a graceful, arcing stroke from the top of the plant to the base. Until you are familiar with the orchid, however, it will probably be easiest to start with the main stem and end with the individual ones.

Often in Chinese painting, two plants or trees or rocks are placed in a composition so that one has a subsidiary but complementary role and the other has a benevolent and protective role, such as the relationship between a host and guest. In the case of the orchid, the guest plant is less erect than the host plant, indicating that it is young and its main stem has not yet attained height and strength.

Place the blossoms in various positions; add the main stem and the thin supporting ones with a slender upright stroke in medium ink. A neighboring "guest" plant can be added to the composition.

Opposite page: Again study the different aspects of the blossoms. The petals are very delicate and graceful. As many as seven flowers may appear on one main stem, which flows between the topmost bud and the base of the plant.

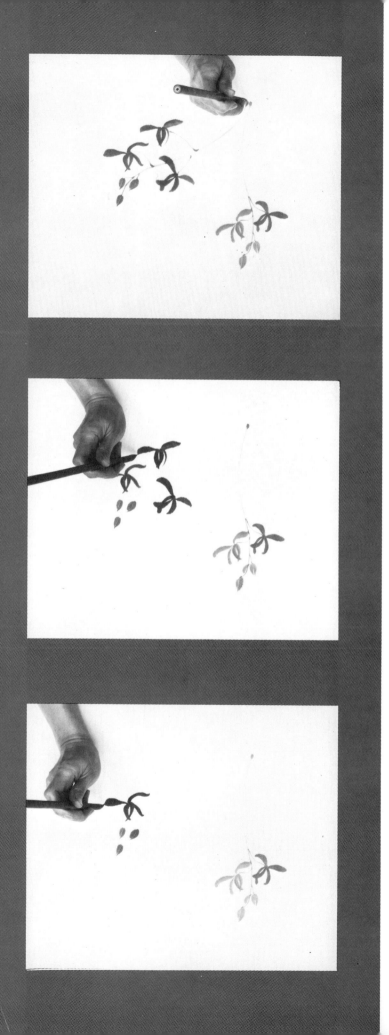
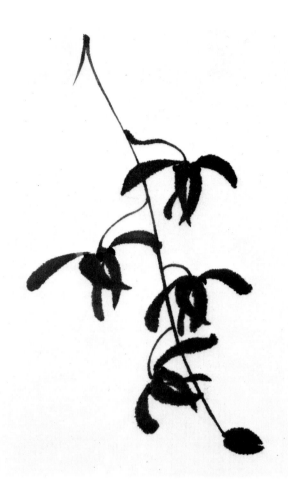

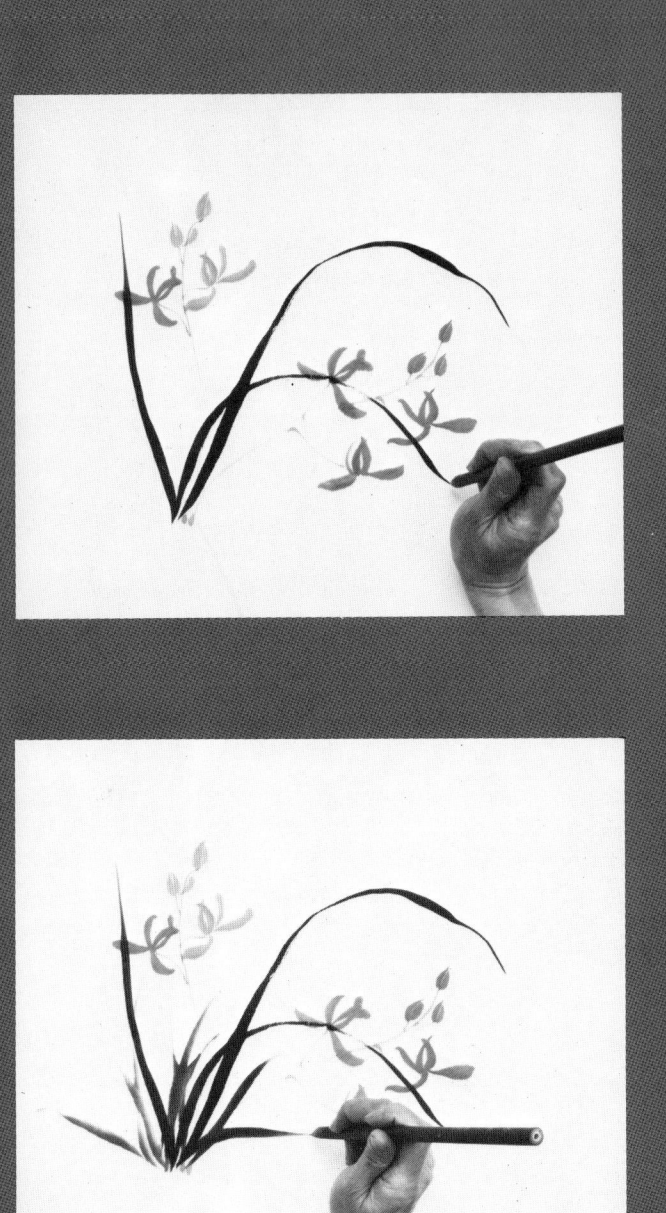

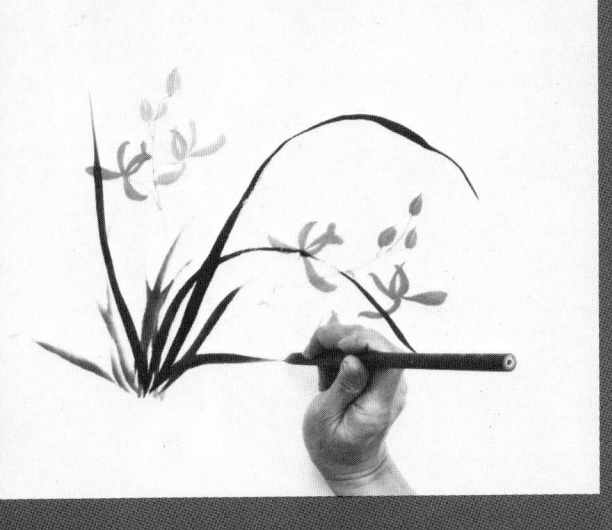

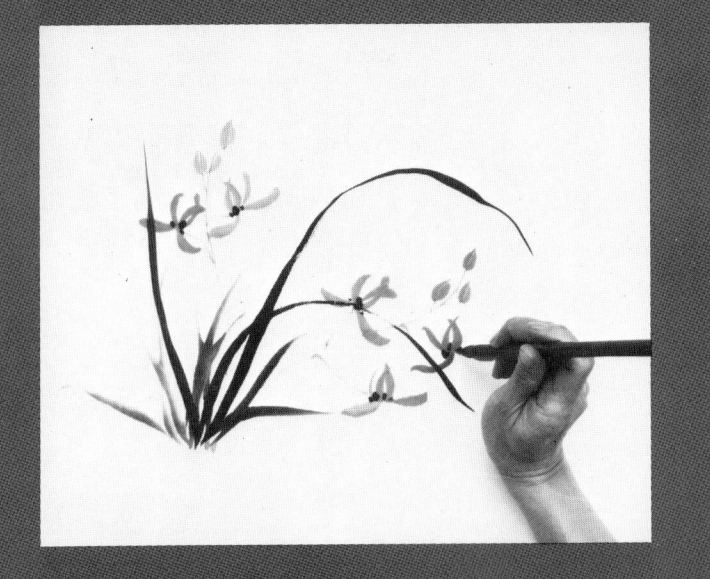

The leaves of the orchid, like the leaves of the bamboo, have their own choreography. The tall, dark leaves springing upward from the roots of the orchid float and bend, some to the right of the stem, some to the left. Even those that are upright sway. Though they grow in clusters, they are not bunched or in confusion; each has its own path. Though they are uneven in length and width, all are fluid in movement. The leaves at the base of the plant are shorter and less animated than the longer ones, but you must avoid stiffness or too thin a line lest they resemble weeds. You must paint them as tossed about and lively, in medium and dark tones.

In painting the long, supple leaves, use a single continuous stroke, rising upward from the base of the plant, for each one. Practice these strokes with free movements of the arm and shoulder. Hold the brush upright and, using dark ink at the tip, paint in large gestures with a flourish. Follow the flow and curve of each leaf, whether it be to the right or left of the stem, and press down slightly on the brush wherever the stroke requires broadening. Release pressure wherever you wish to create thinness of line; the brush may even be allowed to hesitate momentarily and then resume its path, or it may be gently rotated between the fingers as it moves, to indicate a turning of the leaf in a new direction. The line may be interrupted but it maintains continuity. Taper each stroke off cleanly at the top. Practice three leaves at first, then five in various positions, bending, curving, stretching up and out, or crossing.

For leaves nearer the ground, ink the brush halfway up the bristles in a medium or dark tone and stroke upward from the roots. Pressure on the upright brush is greatest at the beginning and middle of the stroke and is lightest at the end. In this way with one stroke, the leaf is billowing in shape below and finely tapered at the top, and it proceeds from darkness at the roots to a paler tone at the tip.

The leaves in the background may be lighter in tone than those in the foreground, to indicate distance, but all leaves should be darker than the flowers themselves. Do not pause to re-ink the brush for each small stroke or you will lose the rhythm of the leaves. You can paint several smaller leaves with one inking. Do not try to paint two longer, darker leaves in succession with a single inking, however. In practicing, you will learn how much ink is left on your brush and what you can accomplish with it.

Dotting the heart of each orchid is the final touch. This is because it is like painting the eyes of a dragon. When

Each long leaf is painted with a single, dark stroke of varying pressure, swooping upward from the base of the plant. The short leaves are done in medium-to-dark tones with a point-press-and-taper motion upward from the base for each. Dotting the heart of the orchid with dark ink is the final step.

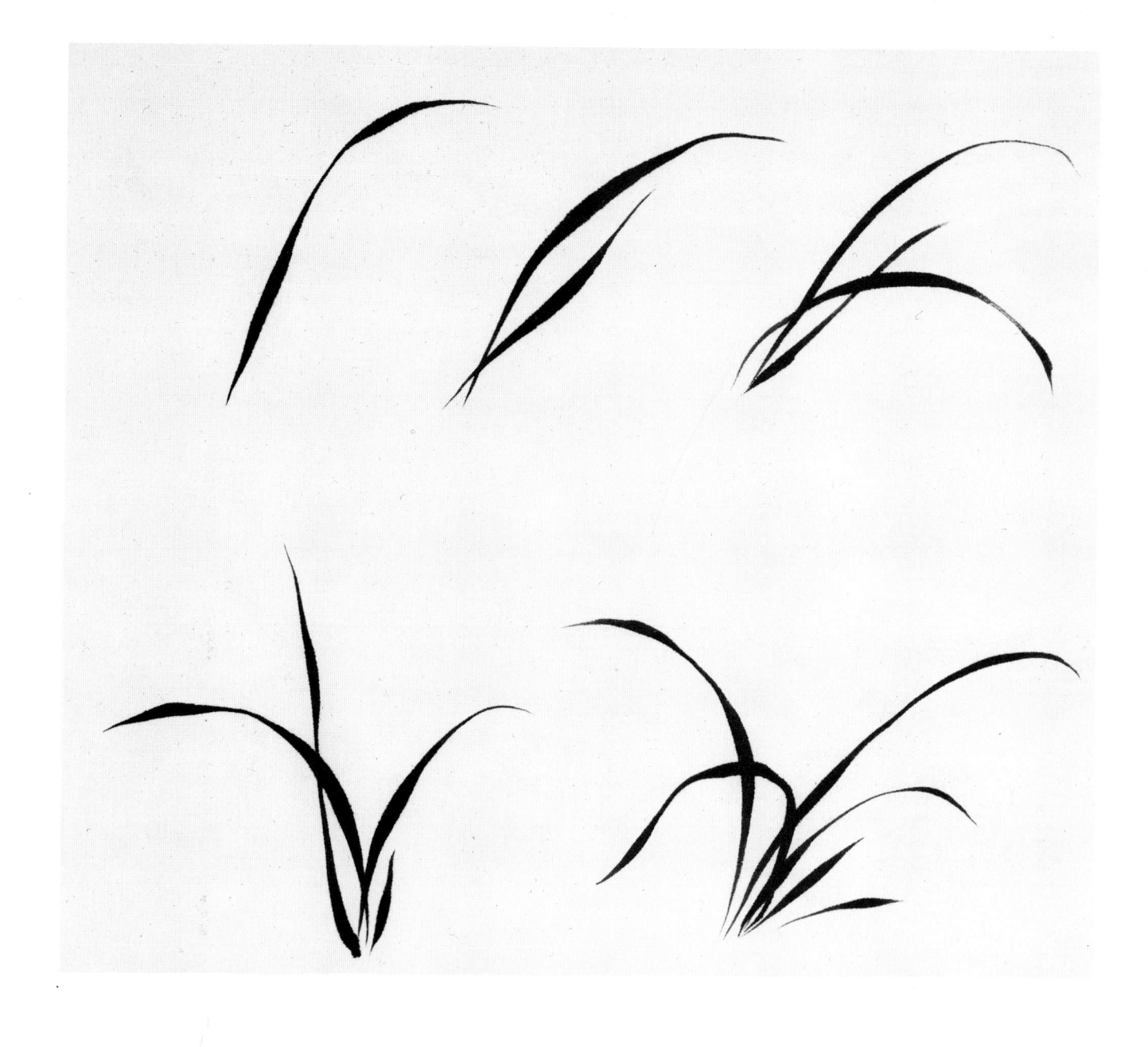

you are finished, the form is so alive that it will fly away. A dark ink tone is used, at the tip of the brush, and three dots are pressed into the heart of the flower. In some cases, a petal may hide a stamen and so you place only two dots at the heart, or a very small dot may peek from behind the petal.

Although the Chinese orchid is difficult to paint, the strokes are basic ones and, with practice, the effort will be lessened. Finally, you will enjoy the exuberance of painting this happy plant, of whom it is said, "The petals sing and the leaves dance." Work with some rapidity of movement; never be sluggish. Strive for a simple composition and natural settings, and show the flowers in their various, changing positions. The tones of the composition should range from dark to light gray. Always use clear water and fresh ink. Do not press hard on the paper; with properly mixed ink, the gently guided brushstrokes will make all the nuances of tone that are required.

Practice the flowing movements of the orchid leaves. Remember to press down wherever the form requires broadening and to release pressure when tapering the stroke. End each stroke cleanly; do not let the brush tip linger on the paper. To create a twist in the form, rotate the brush handle between the fingers as the stroke is made. Strive for continuity of line.

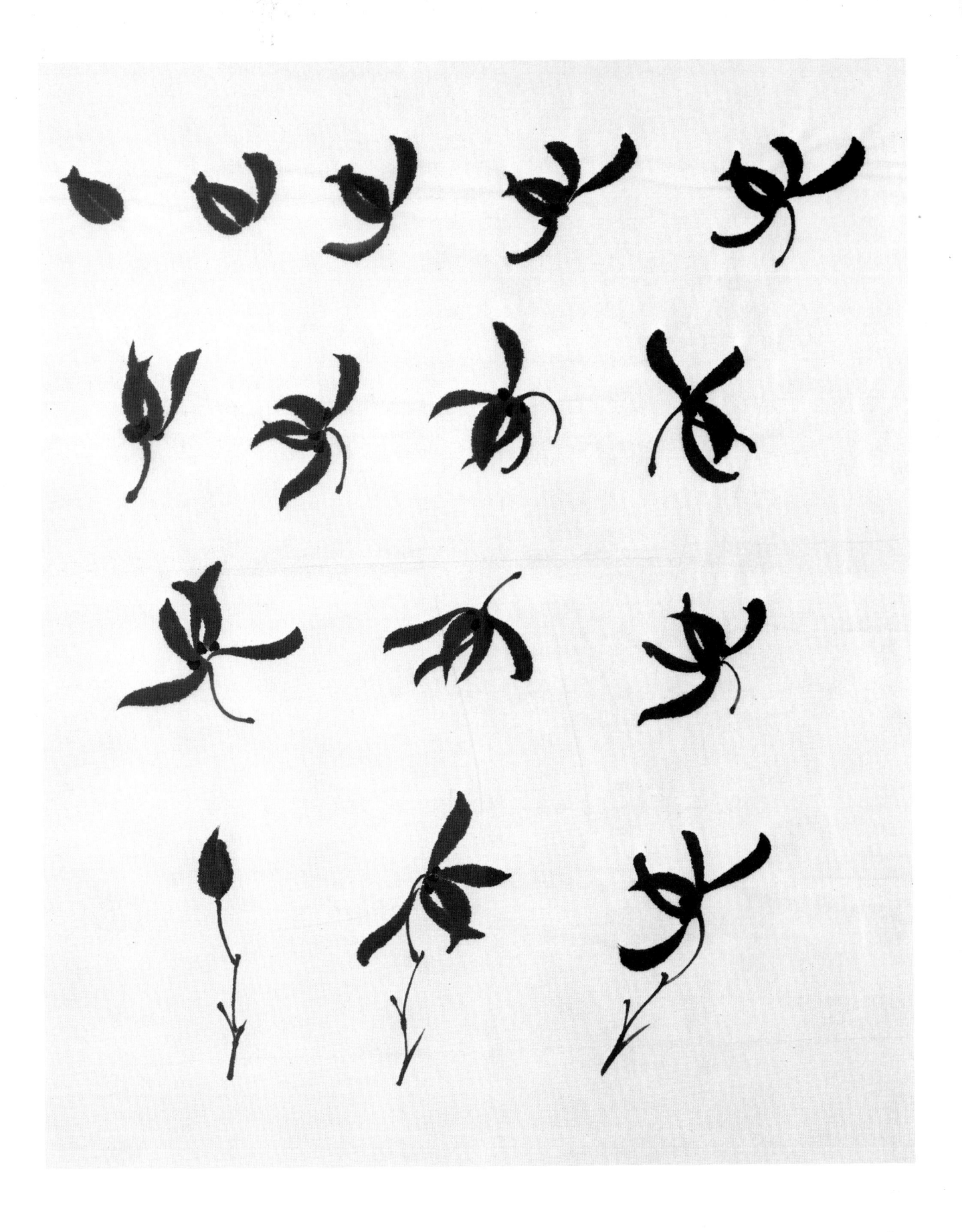

Whether in ink or in color, the strokes for the *mo ku* buds and blossoms are the same. For color, use a medium-thin consistency of light green, pink, yellow or lavender. See page 78 for completed color painting.

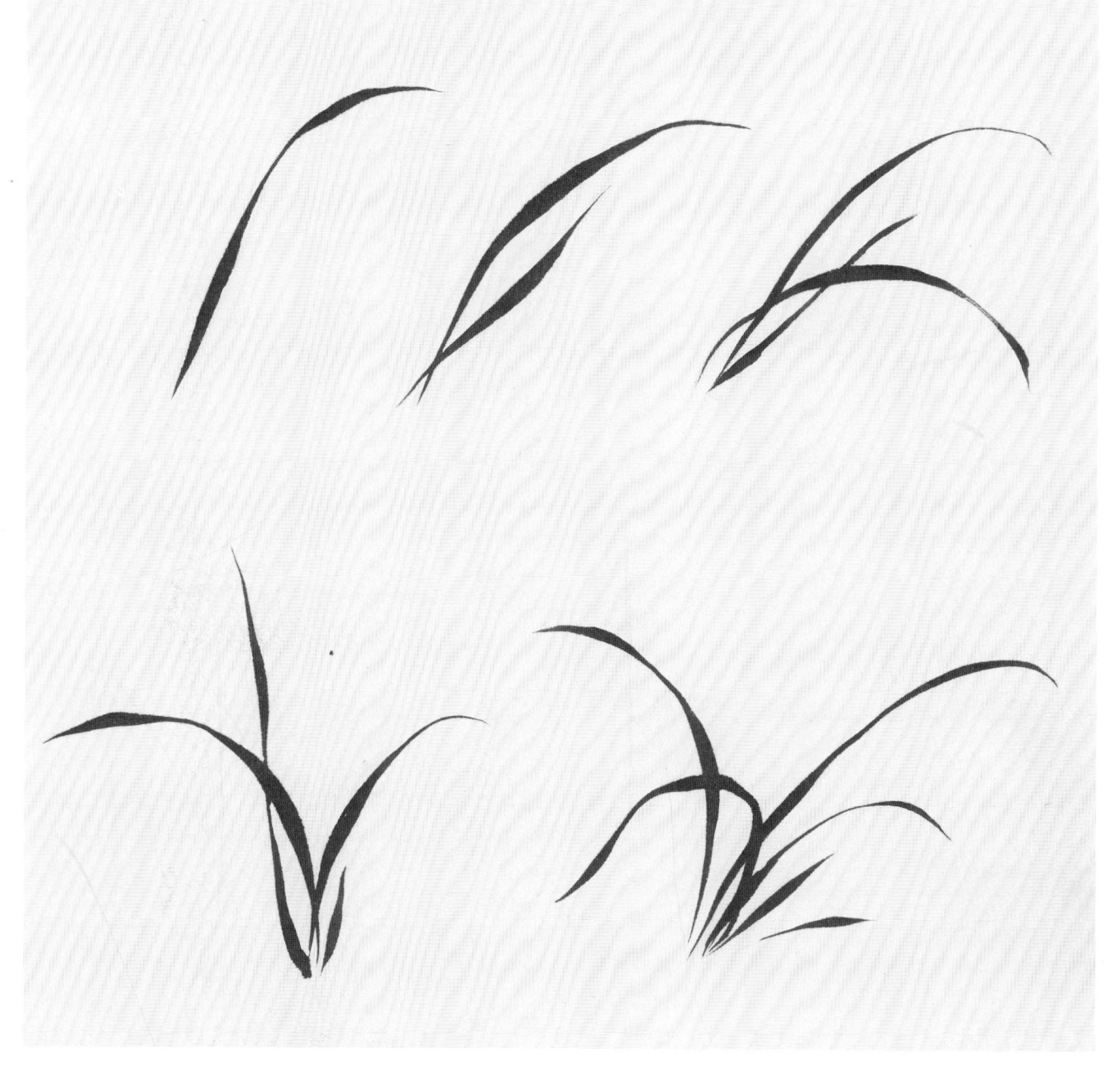

For the *mo ku* leaves in color, use various shades of green, obtained by mixing yellow and blue together in different proportions.

The *mo ku* style orchid may also be painted in color. For the buds and petals use a light shade of green, pink, yellow, or lavender, diluted to a medium-thin consistency. The strokes in color are identical to those done in ink. When these strokes have dried, add fine lines of parallel veining which follow the natural shape of each petal; use a small brush and a darker tone of the color used for the petals (add ink to the original color to darken it about two values).

Paint the stalks, and several of the small leaves at the base of the plant, in a light yellow-green of thin consistency, and use a dark blue-green for the long leaves and the remaining small ones. When these strokes have dried, the forms may be strengthened by thinly outlining them in medium-toned ink and adding a single, central vein to some of the leaves. This is not the same as contour style, however, because the forms are actually shaped by the previous brushstrokes and not by the added outlines. Finally, the hearts may be added by dotting them in yellow or pink.

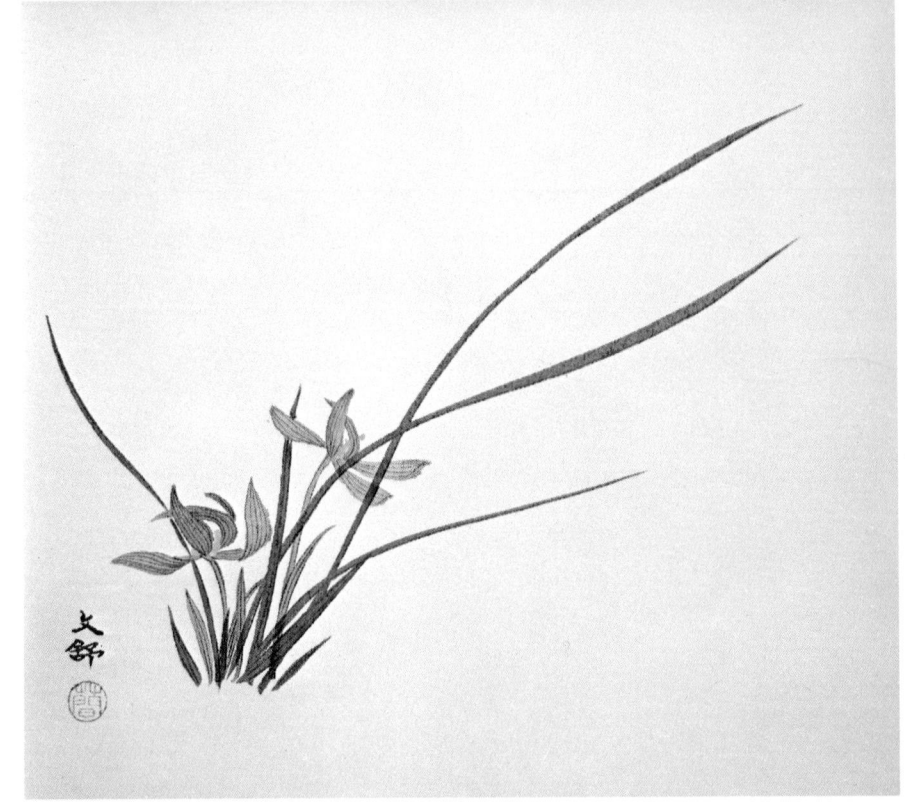

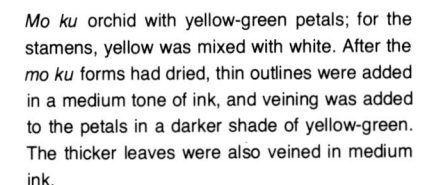

Mo ku orchid with yellow-green petals; for the stamens, yellow was mixed with white. After the *mo ku* forms had dried, thin outlines were added in a medium tone of ink, and veining was added to the petals in a darker shade of yellow-green. The thicker leaves were also veined in medium ink.

For the contour-style orchid, each form is outlined first in light ink. The petals are filled in with a base coat of white and layers of progressively darker color are blended in from each tip downward. The stalks and leaves are filled in with washes of green, and their light-toned outlines are then reinforced with dark ink. Dark-toned lines of veining are added to the leaves. The stamens are dotted with yellow, and a smaller dot of orange is pressed into each yellow dot.

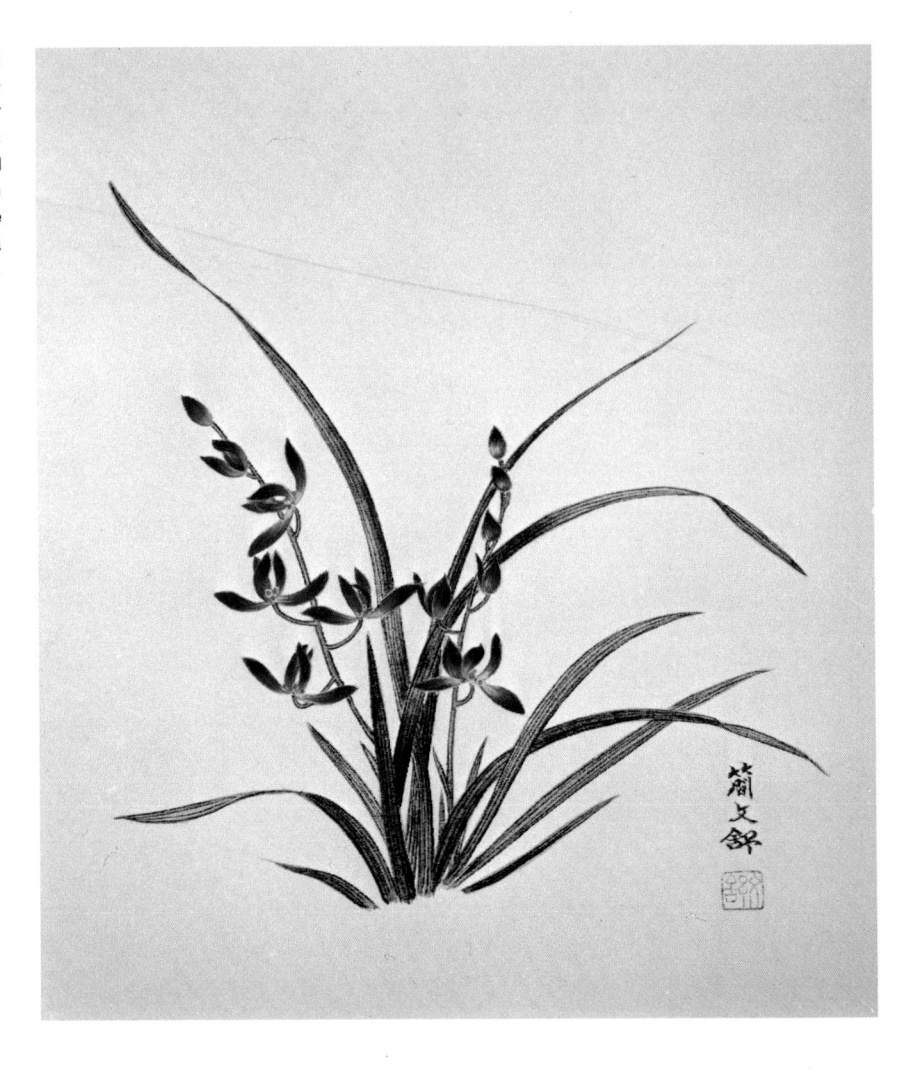

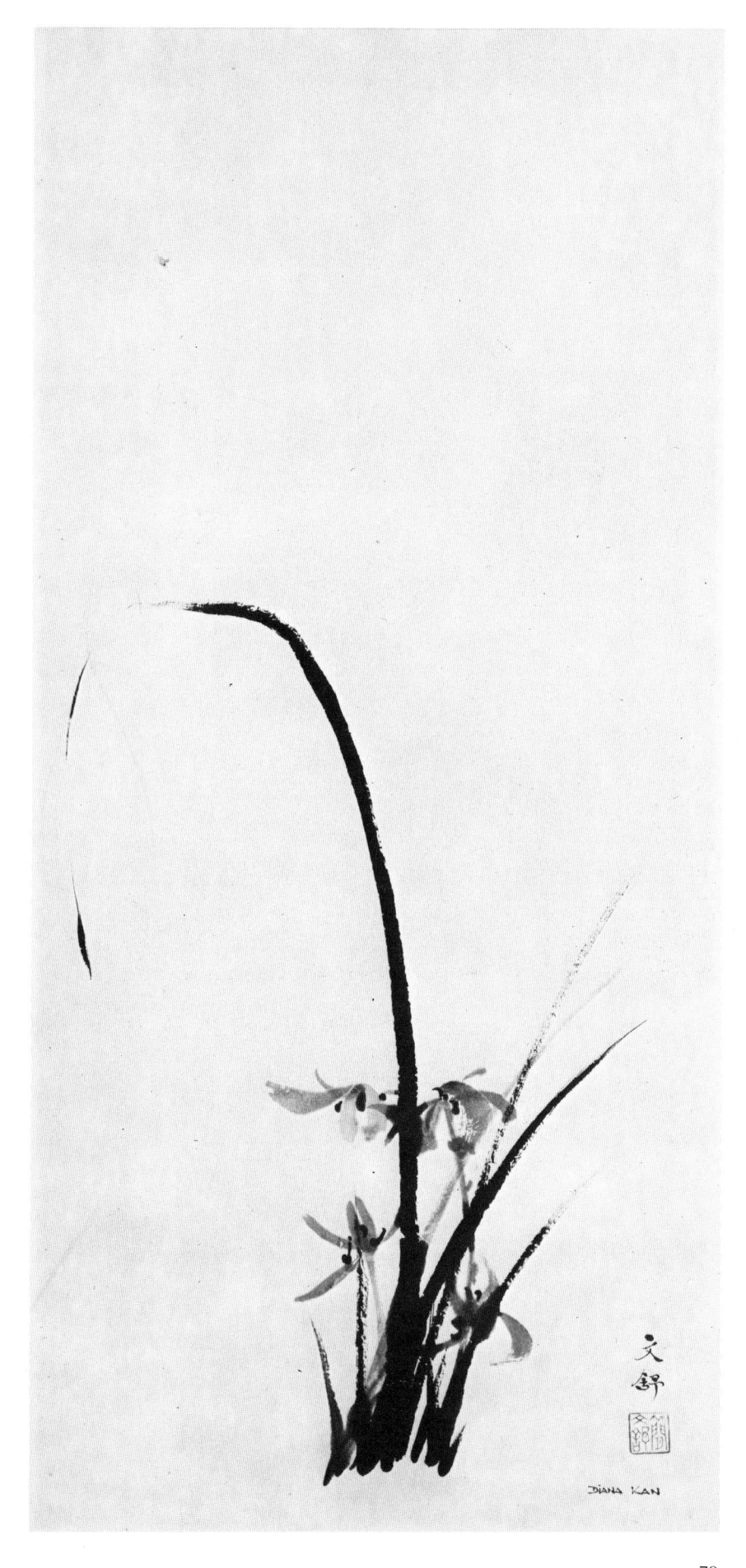

Lan Orchids; rice paper, 11½ by 24 inches. Painted in memoriam on the anniversary of Kan Kam Shek's death. The nine leaves represent his children; one leaf is interrupted but continuous, expressing the idea that, although the father is gone, life is continuous.

The forms of the petals, stalks and leaves done in contour style are precisely the same as those done in *mo ku* style. As in all outlining, the brush is held upright and only the pointed tip of the brush is allowed to touch the paper. For the petals, you will use light ink and form each contour with two lines, each flowing between the flower's heart and the petal's tip. These lines may either join at the tip to close the contour or they may be left separated by a thread of space to open the contour. Where one petal overlaps another, you must interrupt each stroke used for the petal that is behind but do not lose fluidity of line. When these contours are dry, go over each light line with a thinner, dark one to emphasize the shapes.

In painting the stalks and stems, the same sequence of light and then dark outlines is used. Here you must take care to note how the petals overlap the stalk and how the individual stems join it, so that the lines do not intersect unnaturally and cause the forms to appear transparent. The hearts of the flowers are dotted with black ink as in *mo ku* style.

Compare the *mo ku* forms with the contour-style ones.

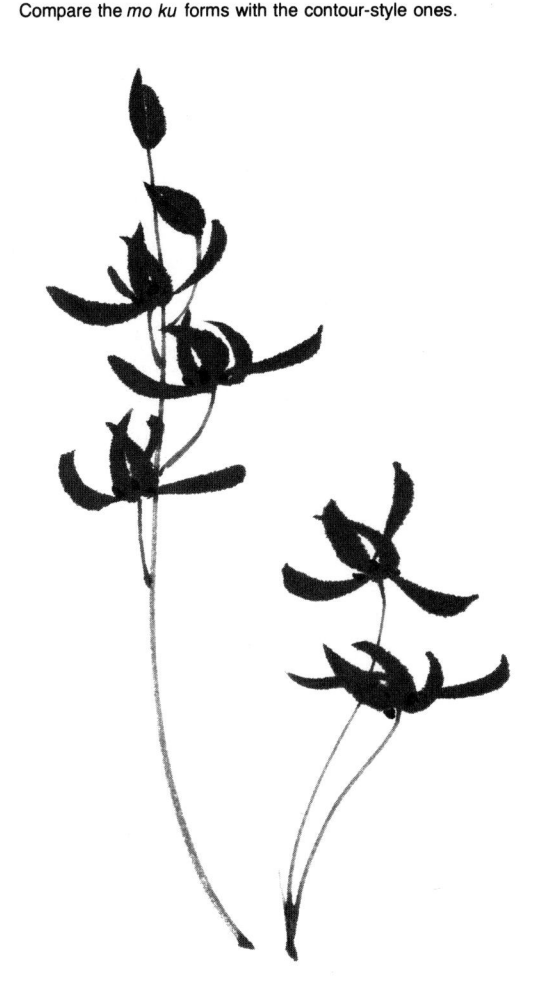

Contour-style petals and stems are done in light ink first, with the tip of an upright brush. The outlines are reinforced with thin, dark ones. Two strokes are used for each petal and the contour may be open or closed. The lines of the overlapping and connecting forms must be interrupted to give the shapes solidity.

Opposite page: Contour-style leaves done in light and dark ink may have a thin, central vein or they may be left unveined.

The form of each petal when the blossoms are in different positions is clearly shown by the outlines.

The folded and gently twisting forms of the leaves are accomplished with curved lines.

The long, central vein of the leaf follows the curving of the contour.

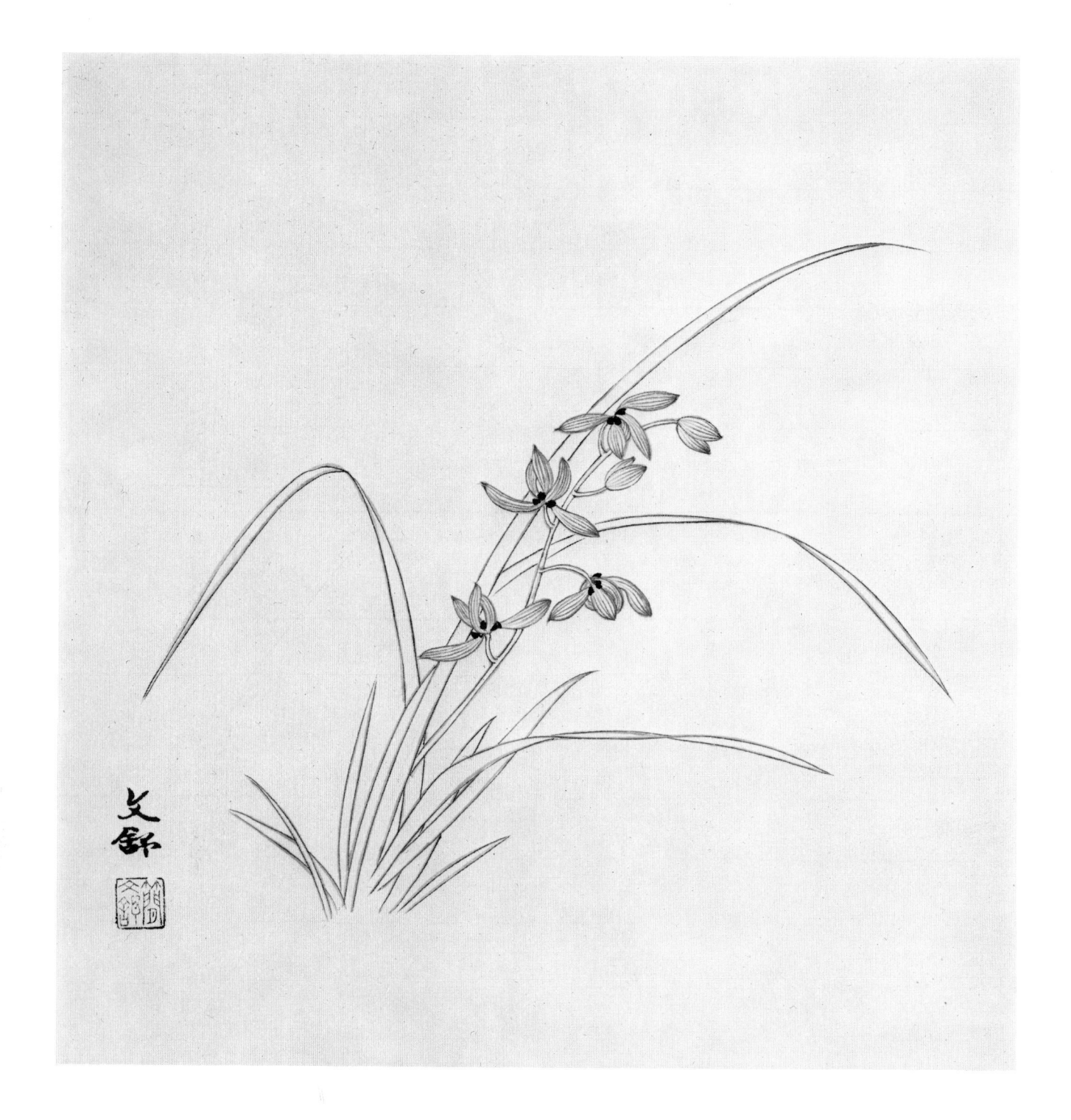

The contour-style leaves offer an excellent exercise in visualizing the choreography of the bending, twisting forms, and their overlapping paths. Again, the light-toned contours are set in place first, laying the groundwork for the fine, dark contours. A simple leaf may be formed with only two uninterrupted lines; the sinuous form of a bent or twisted leaf may be shown with one continuous, arcing line, joined — at the height of its curve — by one line branching out to the left of it and another line branching out to the right of it. Wherever forms overlap, the lines must necessarily be interrupted but — again — without losing continuity.

If the leaves are left unveined, fine lines of veining may be added to the petals in a back-and-white contour-style composition.

Both the leaves and the petals may be shown with fine lines of veining. In a black-and-white contour composition, a leaf may have one, long central vein, and in that case the petals are painted without veining. Or the leaves may be left without veining, and each petal may then be painted with many parallel veins running lengthwise from the heart to the tip.

The composition above has veined leaves; the composition below has veined petals. These contours, done in light ink first, may be filled in with color before the veining and dark outlines are added.

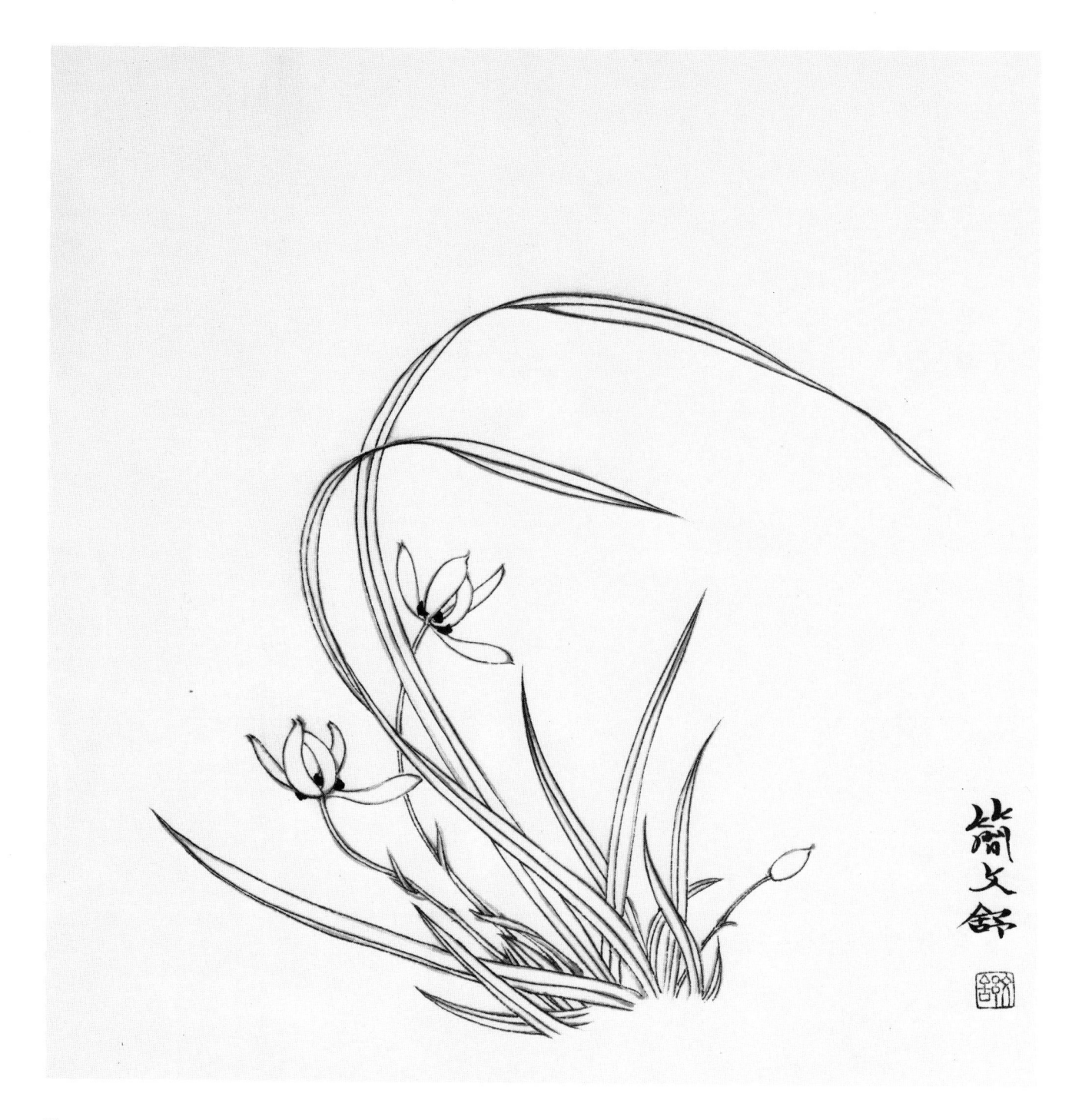

When a central vein is added to the leaves, the petals are left without veining.

When the orchid is painted in color in contour style, the buds, petals, stalks and leaves are first outlined in light-gray ink. The buds and petals are then filled in with white pigment of medium consistency. While these strokes are still moist, add a layer of color over the white, stroking from the tip of the petal toward the heart and allowing the color to blend with the white and get progressively lighter as you proceed. Darken the tips with additional strokes of the same color moving toward the heart. This color can be purple, yellow, green, or pink.

For the stalks, stems and leaves, use a wash of light green within the ink contours and, when this is dry, over-lay it with a wash of darker green on some of the leaves to create interesting shading. When a leaf is folded or twisted, it should be light green on top and dark green below. Never add white to the leaves or their color will be artificial. Instead, mix the green color from yellow and blue and dilute it with water. To darken the green, add a bit of diluted ink or add more blue pigment. When the colors have dried, add fine lines of parallel veining along the length of each leaf with a number three brush and dark ink; the light-toned outlines of the leaves, stalks, and stems may also be strengthened with dark ink. Finally, dot the hearts with yellow and orange.

The petals are outlined in broad strokes for a modified *mo ku* effect. Each successive layer of petals is placed in a concentric ring.

7. Chrysanthemum

"Defiant of frost and triumphant in autumn" is a common saying expressing the sturdiness of the late-blooming chrysanthemum, whose blossoming in the cold autumnal air presages the coming of winter. This is the last of the Four Gentlemen associating fragrant plants with high ideals of moralistic behavior and with the change of seasons.

The structure of the chrysanthemum exemplifies the principle of the whole being the sum of its parts; for the overlapping layers of petals, radiating from the center of the flower and spreading out in circles, build up and create the form of the flower. Each petal is part of the whole and has its own place. Therefore, study the structure of the whole flower and the integration of each petal into the unit before you begin to paint it. Think quietly of how to express, by hand and brush, the invisibles of spirit, fragrance and fortitude. Note that the many varieties of chrysanthemum have different characteristics: some flowers are flat and disclike on top, the petals long, narrow, and ovular; some flowers are dome-shaped, the petals smaller and rounder, and more tightly packed. Observe how the flowers and buds appear in profile and how they appear when the head is fully or partially turned to face you.

Most often, when the flower is done in *mo ku* style, the petal strokes are modified. Instead of using one stroke for each petal, as in the orchid, two strokes are used to produce a broad outline of the form. Unlike the deliberate, finely drawn outlines of the contour style, these strokes should generally be freer and more varied in thickness or weight.

For a blossom directly facing you, start where you imagine the center, or heart, of the flower should be. Using the tip of an upright brush and medium ink halfway up the bristles, outline the smaller, central petals ringing the heart first. Begin each of the paired strokes at the base of a petal and move them up opposite sides to join at the tip. Increase pressure at the end of each stroke. This creates a slight thickness of line at the tip and adds roundness to the petal. For variety, some petal tips may be left with a small space between the two strokes, which are thus unjoined.

Next, add a concentric ring of petals behind the central group, filling them in between the spaces left by the first group of petals. This second group of petals is a bit longer and is partially hidden. Continue adding concentric rings of petals, keeping in mind that the outer rings or layers are progressively longer and are increasingly hidden behind the previous ones. Also keep in mind the curve and shape of the flower to be: whether the flower is to be disclike or domed, whether the heads are to be firm and compact or freely outspread, whether the petals are clustered together or uncrowded. As the petals grow, so grows the flower.

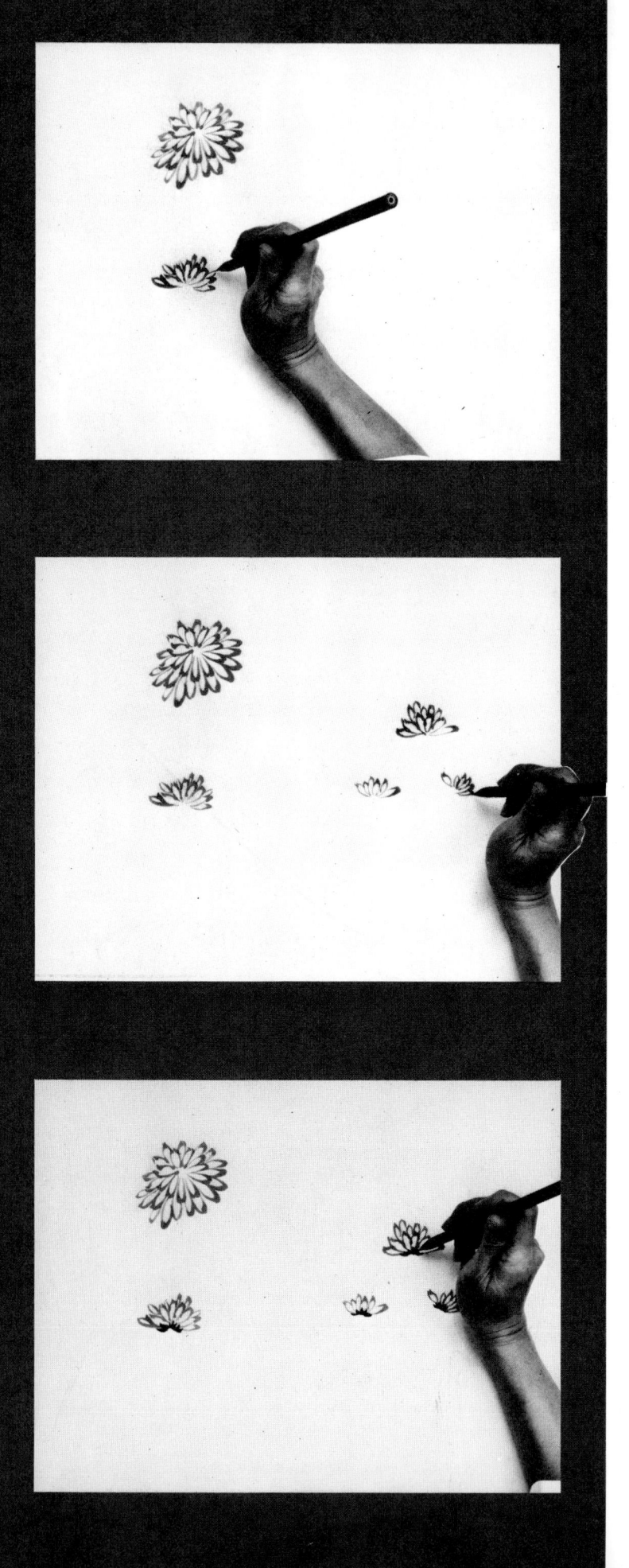

For the flowers in profile, begin with the outermost layer of petals arranged in a semicircle around the center. These petals are the longest and they hide portions of the inner layers. You need only suggest the inner layers by adding the tips of their petals in the space above the first semicircle. As the sepals are visible in this view, add them in dark ink at the base of the flower head.

Paint as many flowers as you wish to have in your composition. If you wish to add buds, first observe them in their natural development so you may record whether the bud is round and tightly contained or half-open and showing burgeoning petals. The old masters believed that, while the beauty and fragrance is in the fully developed flower, it is in the bud that the spirit resides, so you must note these forms faithfully.

In placing the flowers and buds, be sure to leave enough space between them for the long stalks and the large, spreading leaves. The main stalk, the slender connecting stems, and the impressive leaves are painted in unison, working downward from beneath the base of each flower. A slender upright stroke in a medium tone will suffice for each section of the stalk and stems not hidden by the leaves.

The stalk, although delicately thin at its topmost reaches and only slightly thicker at its base, should appear sturdy and strong, dependable and upright in posture, but never rigid. The connecting stems are even more delicate and these may appear slightly weighted by a large flower in bloom. For these portions of the plant, there should be enough water and ink in the brush to impart an impression of moisture (but not wetness) and to avoid a dry, lifeless look. Each stroke should express the vitality of the plant.

The leaves of the chrysanthemum are difficult to paint, but the saying is, if you can paint chrysanthemum leaves you can paint anything. The leaves are large and are undulating in shape with an irregular contour. They are dark in color and have clearly visible veins. Spilling out as they do beneath the flowers, they provide a setting for the hovering blossoms such as a saucer does for an uplifted cup.

There are two methods of painting a leaf in *mo ku* style. The first is to create the form of each individual lobe or section of the leaf entirely through gradations of ink tones and to indicate the veins, which actually define these forms, by an absence of ink between the lobes. The second is to define the individual lobes after they have been formed, by adding the thin veins in black ink. The first method is exceedingly difficult for the beginner to

Petals seen in profile are placed in a semicircle with the tips of the inner layers just peeking above the outer layers. Use the tip of an upright brush with varied pressure and medium-toned ink. Place the dark-toned sepals that are visible in profile.

accomplish, but it shows clearly the brushstrokes that are necessary for both methods. The difference is that, when you intend to add the black veining lines, the strokes need not be so carefully painted or gradated in tone.

For both methods, think of the typical leaf as having five lobes or sections. One lobe is longer than the others and emerges at the end of a long central vein, or midrib, which is an extension of the leaf's stem. The other four lobes are placed in pairs, almost symmetrically, to either side of the midrib, and each of these has a smaller vein that branches out from the midrib.

Each lobe may be accomplished with two brushstrokes, holding the brush in either an upright or an oblique position. These strokes are long and ovular in shape and are placed alongside each other, leaving a faint line of space lengthwise between the two to indicate the lobe's vein. When the upright position is used, the handle and the tip of the brush should move parallel to this line of space or vein. When the oblique position is used, the handle and the tip of the brush should move at a right angle to this line.

The gradations of the leaves depend upon which movement and inking you choose for each stroke. If you ink the number two brush halfway up the bristles with a medium-dark tone and use the oblique position, you will get a different effect than if you use the upright position. In addition, if you place the tip of the oblique brush, where the ink is darkest, at the outside edge of the lobe, you will get a different effect than if you place it alongside the vein. The best means of determining these effects is to practice these strokes beforehand (consult the illustrations on page 32). Do not be concerned if you cannot control the gradations precisely, because you can further define the forms later by adding the veins in black ink if you wish.

After the first lobe has been placed, the neighboring lobes are painted in turn, each with two ovular strokes separated by a fine line of space. Although the neighboring lobes often appear to overlap in part, their separate identities are maintained by the individuality of each brushstroke and by re-inking the brush whenever necessary to darken the tone of a new stroke. If you wish to paint the leaves without adding the black lines of veining, a thin thread of space should be left between the lobe sections as well as between the two strokes of a single lobe. This is especially important in creating the line of the midrib, which separates the four lobes to either side of it into symmetrical pairs and then forms the long vein in the center of the largest lobe.

The leaves and stems are painted in unison, working downward from the topmost flower. A slender upright stroke of medium tone is used for the stem sections. The leaves are difficult to paint and much practice is required. Two ovular strokes are used for each lobe (see pages 32 to 34).

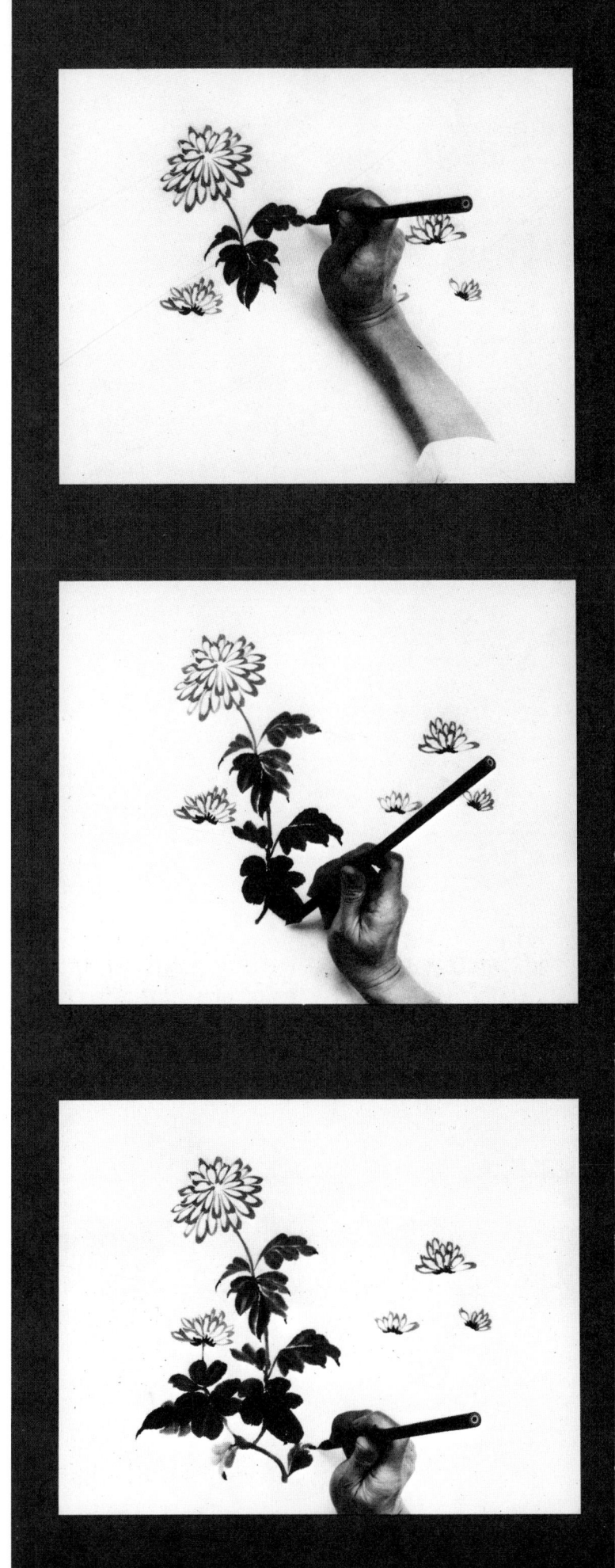

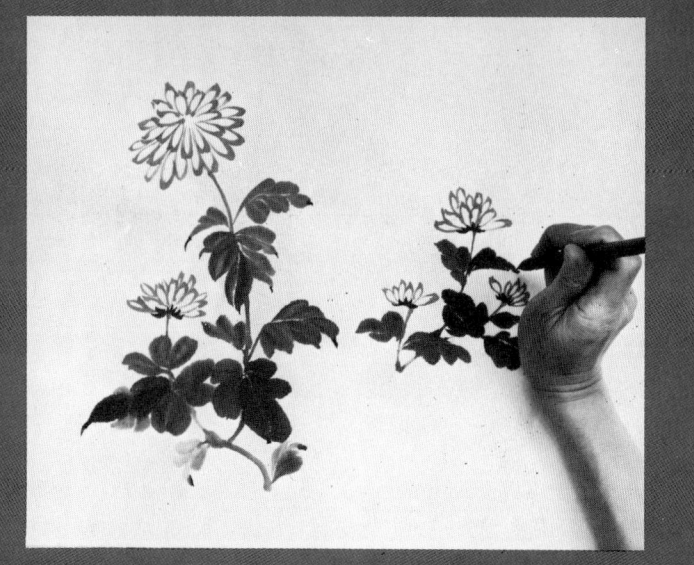

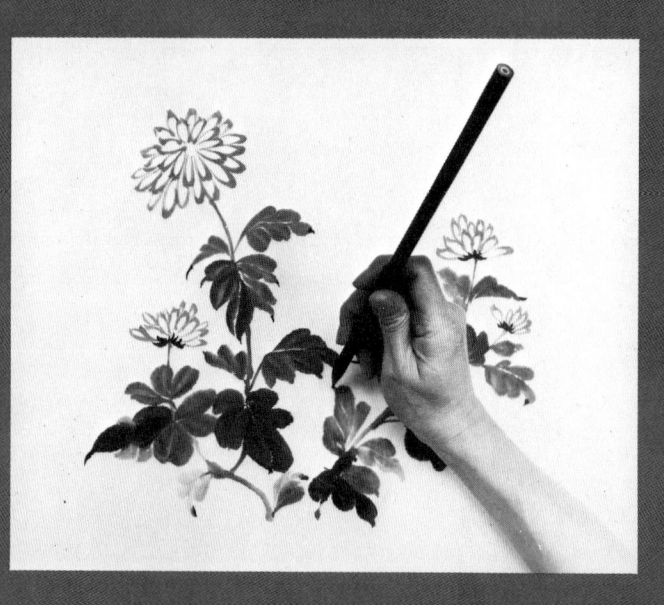

As a final touch, as you finish each grouping of leaves, stems and stalks, the tips of some of the lobes may be pointed and strengthened with a tiny stroke of dark ink. Dark accents may also be added to the junctures between the connecting stems and the main stalk. If any of the flowers in the composition are in a position that displays their stamens, these are added last by dotting in dark ink.

The leaves, like the flowers, assume different positions and present different faces, so that some may be indicated with fewer lobes of various shapes. It is necessary to practice and study these aspects before you commit the leaves in a composition. But when you are familiar with the required strokes, you will find it less difficult to add the stems, stalks and leaves, one by one, to the painting, working downward from beneath the base of each flower.

When the veins are to be added in dark ink, the individual lobes are formed in the same way as before, with two strokes. However, the threads of white space and the gradations of tone need not be so accurate and the strokes may merge with one another to a greater extent. The veins are added in black ink with the tip of an upright brush after the *mo ku* strokes have dried.

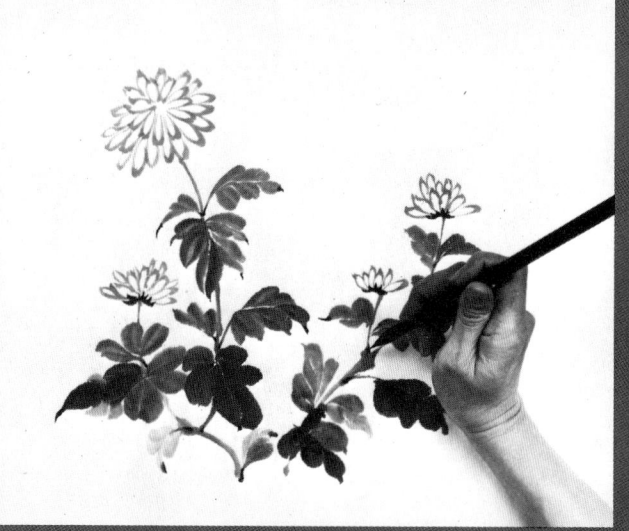

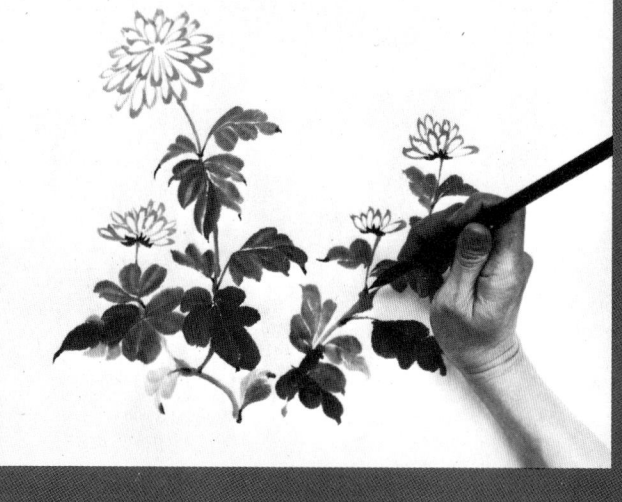

As each grouping of leaves is completed, the tips of the lobes may be accented with dark ink and the junctures between the main stems and connecting ones may be similarly accented. Finally, dark dots may be pressed into the center of the flower if the stamens are visible.

Opposite page: These *mo ku* leaves have been formed with two strokes for each lobe, but instead of having white spaces between strokes to indicate veining, thin black lines were added with an upright brush after the *mo ku* strokes had dried.

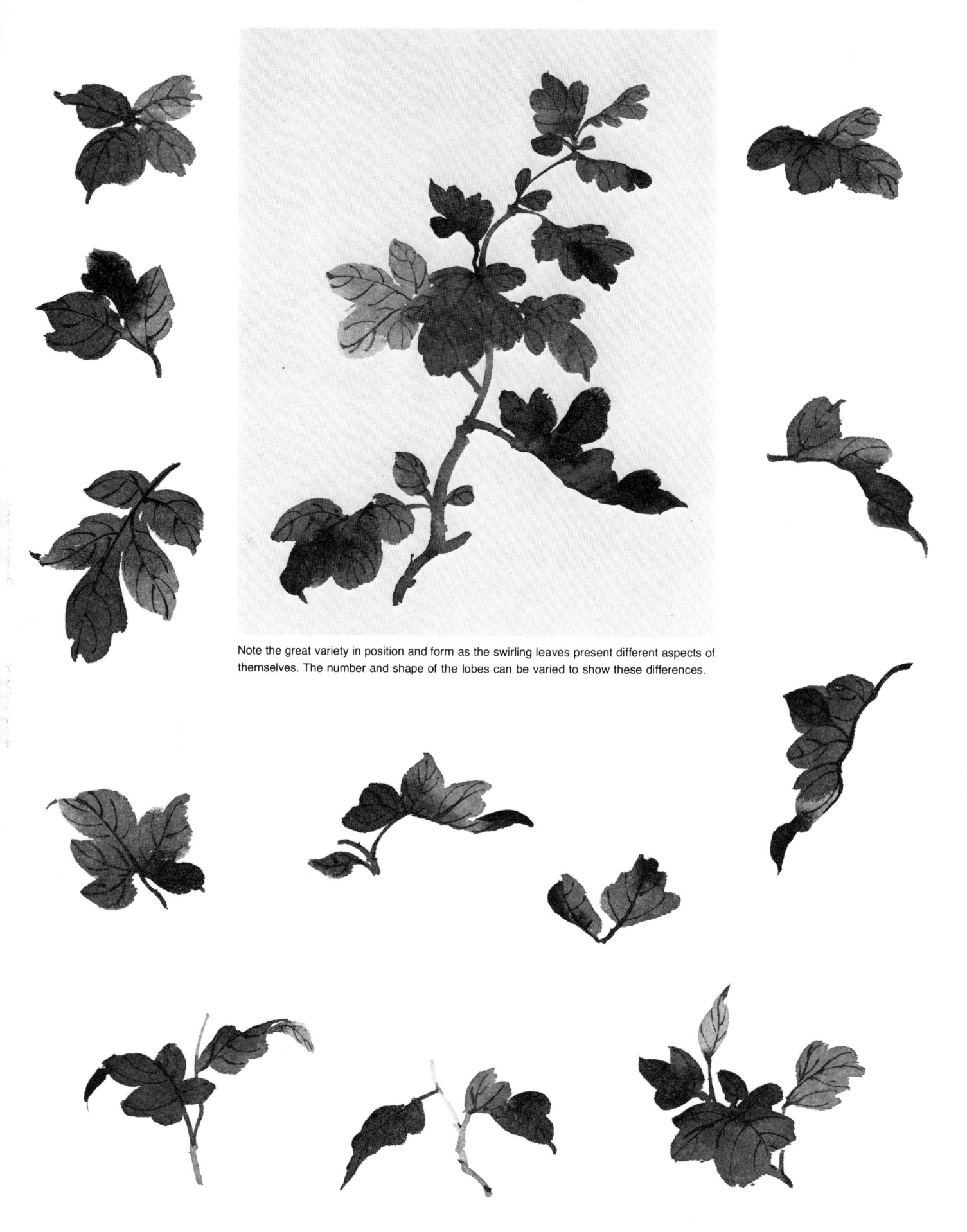

Note the great variety in position and form as the swirling leaves present different aspects of themselves. The number and shape of the lobes can be varied to show these differences.

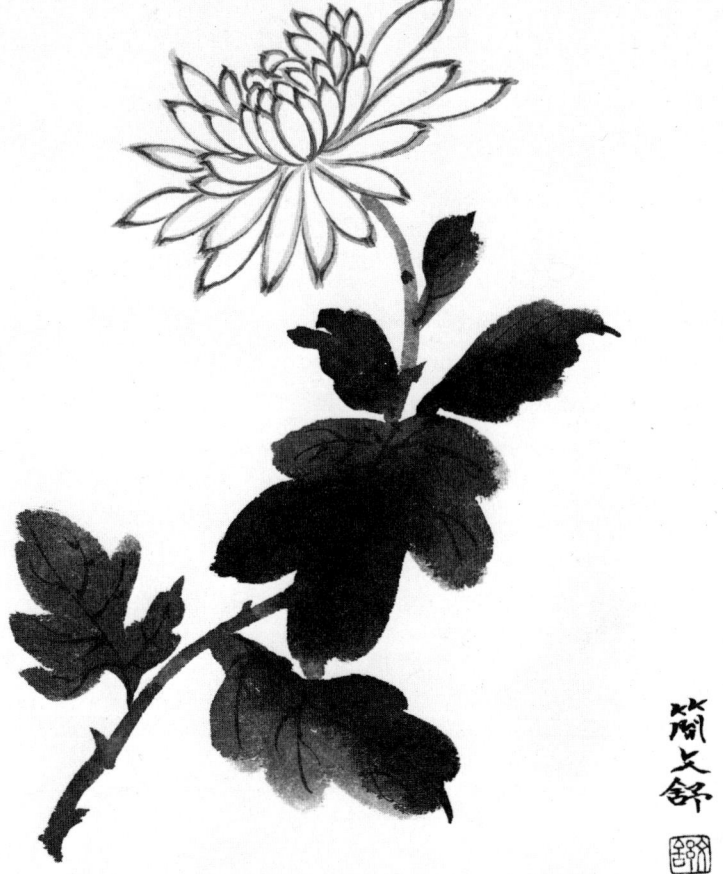

Contour-style buds and petals are outlined first in light ink and then in fine, dark lines. This style can be used with *mo ku* leaves.

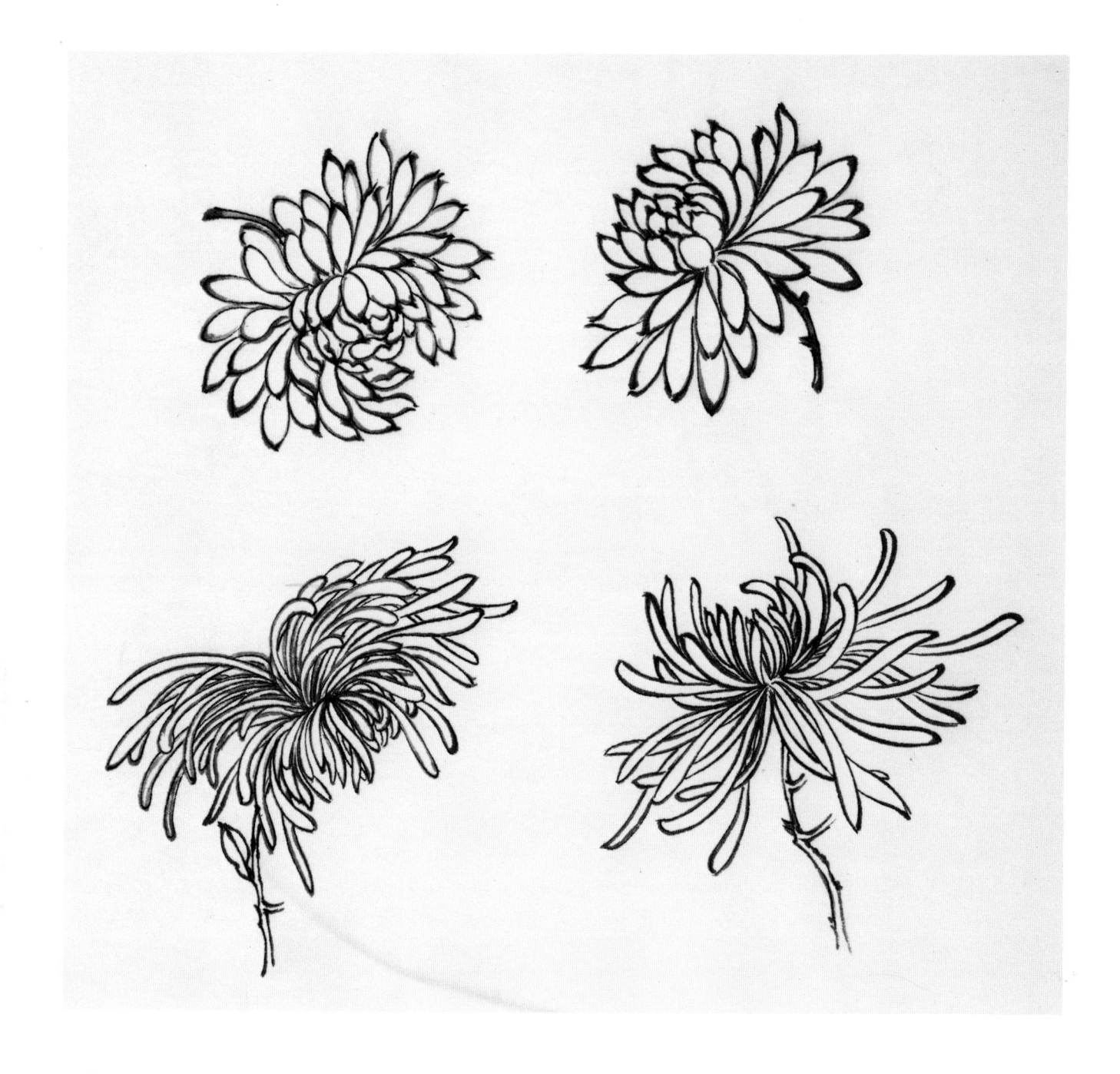

The petals and buds may also be done in the more deliberately drawn, pure contour style. For this, the outlines are first made in a light tone with the tip of the brush, and when those lines have dried, a finer line is drawn over each with dark ink. The petals are again drawn first, each with two strokes curving from the base to the tip. The stalk, leaves, and stems are added in the same way as before.

Do not forget to carefully study the characteristics of each variety of flower. You will note that some oval-shaped petals are very elongated and tend to flutter in different directions as they emerge from the flower's heart. Some petals curve inward, hiding the heart and stamens; some are sharply pointed instead of rounded or oval; and some are slightly furled instead of flat at the edges.

Chrysanthemums come in many different varieties; some petals are short and pointed, while others are long and flowing. Study each species carefully.

93

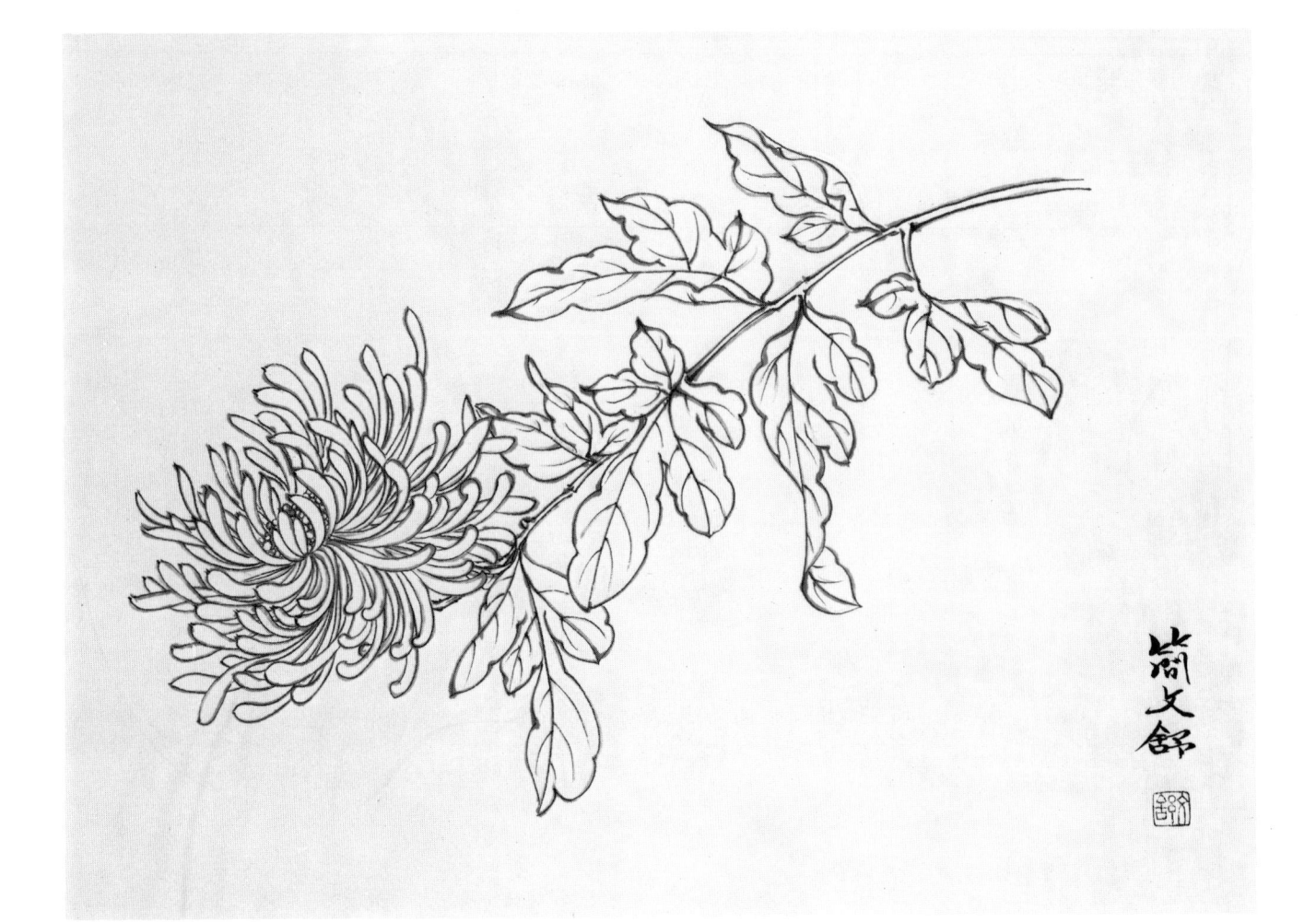

Another method of rendering the chrysanthemum is with the leaves as well as the flowers in contour form. The petals, stalks, stems, sepals, and leaves are all outlined first in a light tone. For a black-and-white composition, these outlines are then all strengthened by going over them with a very fine line in dark ink. The dark veins are then added within the leaves.

For a color composition using contour style, the petals, stems, stalks and leaves are all first outlined in light-gray ink. The veins are also outlined in this color, leaving a thin white space between two lines. The veins, stalks, and stems are filled in with a wash of pale green, although some of the veins may be left white. When the first color wash is dry, a darker yellow-green may be applied to one edge of the stalk, giving it a round dimension.

Various shades of yellow-green and dark green washes are applied to the leaf sections depending on their positions. A folded leaf will have dark green on the areas facing forward and light green on the areas that are curled behind or furled upward. Some dark-green leaves may have light areas at the outer edges. These washes are added in sequence, always working from the lightest shade to the darkest. The veins are always left as the palest color, so where the leaf section is light green the veins will be white.

To fill in the outlined petals with colors, use a technique similar to the one described for the contour-style orchid. First fill each petal with white. While this paint is still moist, use a light color, such as lavender, to make numerous fine strokes from the base of the petal spreading outward toward the tip. These should be uneven in length and each stroke should stop short of the tip, partially blending in with the white. Then, using a darker color, perhaps brownish-red with the lavender, make some shorter strokes from the base of the petal outward, partially blending in with the first color. This technique makes each petal distinct and gives dimension to the flower.

For a color composition using *mo ku* strokes, broadly outline the buds and petals in one of several colors: golden-brown or rust, pink, purple, pale green, or yellow. For the stems and the thinner portions of the main stalk, use a light yellow-green with a touch of ink added; for the sepals and thicker portions of the stalk use a bluer green, very thin in consistency and darkened with some black ink. For the leaves, use both these green colors, applying them separately to individual lobe strokes. Be sure to make use of the extra tone provided by the water in the upper bristles. Add the central vein, and the branching ones belonging to the lobes, after the leaf has dried by using thin, dark-brown strokes. Dark brown may also be used to accent the stems and stalks at their junctures. The stamens may be dotted with inky yellow-green.

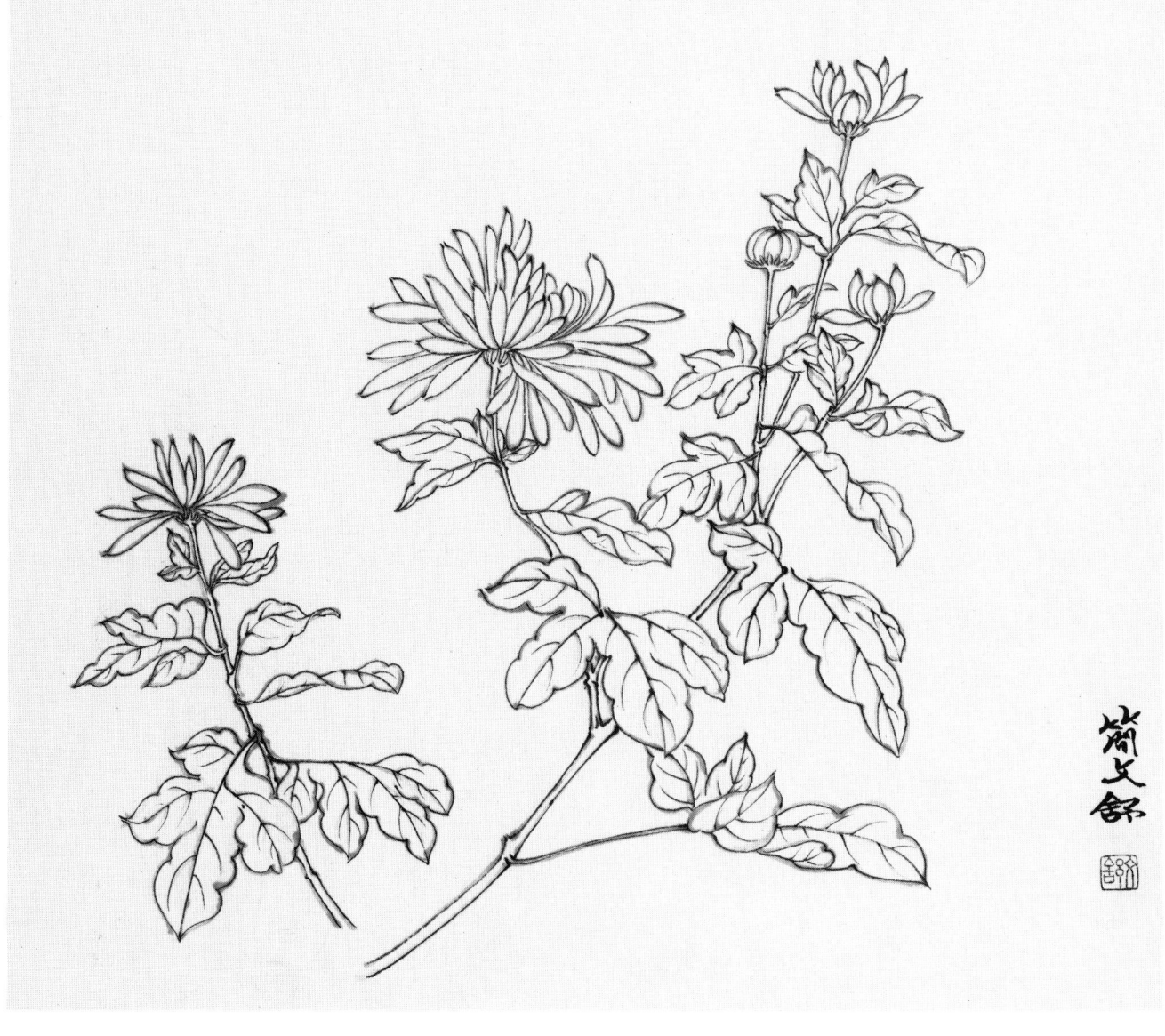

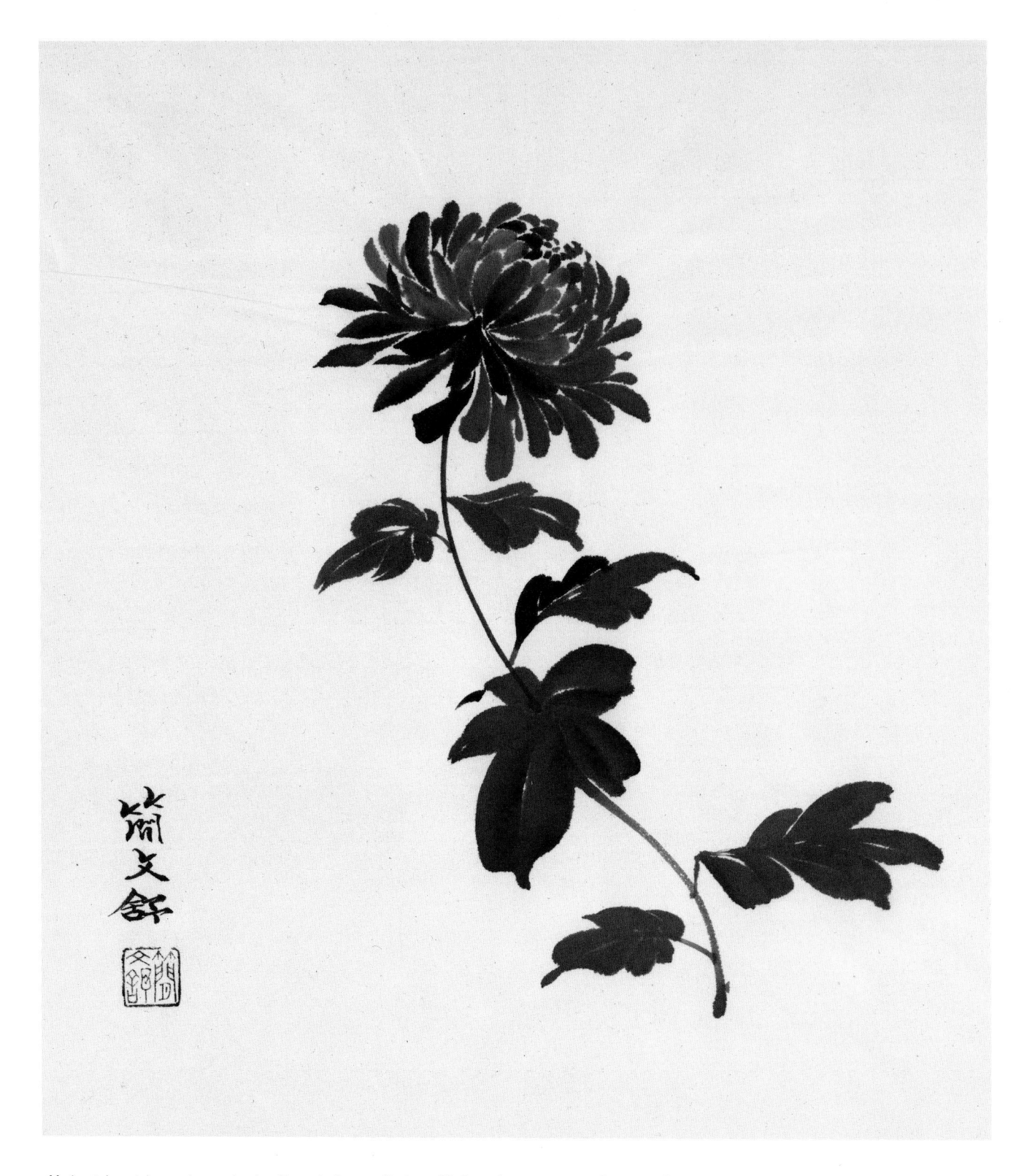

Mo ku style petals may be used only with mo ku leaves. Each petal is formed with a single upright stroke of varied pressure, using a medium to dark tone.

A technique that is used least often is to paint the petals in pure *mo ku* style. Each petal is formed with one stroke, using an upright brush inked halfway up the bristles with a medium-dark tone. Almost all of these strokes are moved from the center of the flower outward, and they are again placed in concentric circles around the center, with the outermost ring done last. To maintain a balance of parts, the stems, stalks, and leaves are also painted in *mo ku* style.

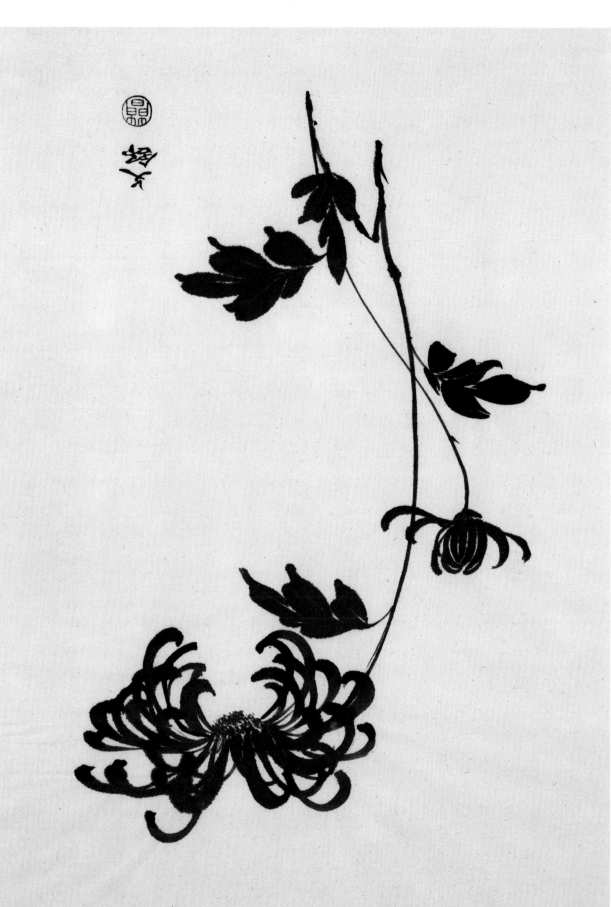

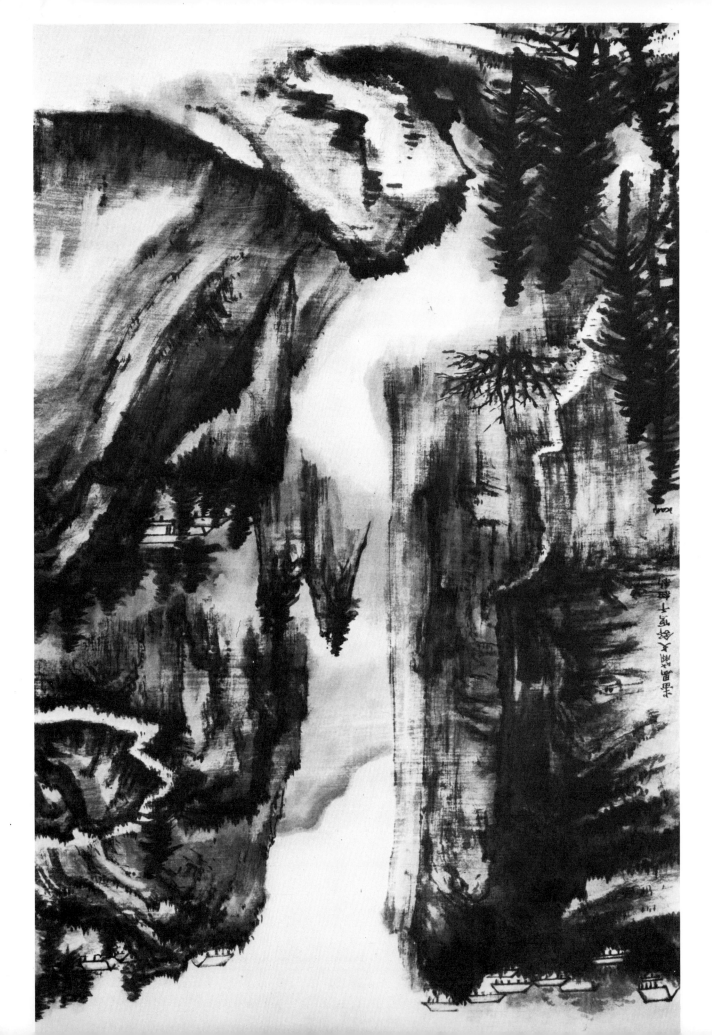

8. Landscape

Since earliest times, landscape has been the loftiest subject for the Chinese artist, demanding the same searching attention which in the West has traditionally been lavished on the human form. In stressing a philosophical preoccupation with the immensity of nature and the overall rhythm of life, rather than with the individual struggles and triumphs of human life, Chinese art focuses on the towering peaks of timeless mountains and the endless, repetitive patterns of flowing waterfalls or rolling streams. The Chinese word for landscape is in fact conveyed by the characters *shan-shui* — literally, mountain-water.

A convention of Western art that often appears to be lacking in traditional Chinese landscape painting is the use of scientific perspective, that is, the principle that as objects recede in space they diminish in size. Instead, the idea of receding space is conveyed by arranging the near and far elements on different levels of the composition, moving from the bottom for the nearest objects to the top for the most distant objects, without necessarily diminishing the proportionate size of the distant objects. Thus a mountain in the background may be rendered in height as though it were being seen from a closer view, as long as its position extends to the top portion of the composition. A lake in the middle ground may reach as high toward the sky at the top of the composition as the artist feels is necessary to convey its expanse, without regard to a conventional horizon line.

In this use of sectioned space on the flat surface of the paper, Chinese painting opens up endless vistas of soaring mountain ranges, plummeting waterfalls, verdant forests and meandering streams, where the observer is invited to wander rather than to note a specific point of view. Consistent with the underlying concepts of landscape painting, man's vulnerable and transitory position in nature's immensity is expressed by depicting human forms, dwellings, bridges, and boats as relatively small

elements of the picture. The minuteness of human activity, in contrast to the grandeur of high mountains and cascading waterfalls, is said to contribute to perspective, as does the shrouding of mountains in vaporous clouds and mist.

There are actually three kinds of perspective applied to landscape. When the height of the mountain is stressed and the form stretches sharply upward from its base at the bottom of the composition to its peak at the top of the composition, it is called perspective in height. When the base of the mountain is hidden and the peaks are seen rising upward but receding gradually into the near distance, it is called perspective in depth. When a broad expanse of mountains is seen in the far distance across a flat plain or body of water, it is called perspective on the level.

The brushwork of landscape painting is necessarily more varied than that of the subjects we have studied so far and cannot be considered strictly in terms of being either outline style *(kou le)* or boneless style *(mo ku)*. Although one school of landscape painting originating in the eighth century (T'ang Dynasty) did employ an ornate, detailed style of fine outlines filled in with rich color, a divergent style — developed at the same time — eventually became the dominant one.

This first style was created by Li Ssu-hsun and his son Li Chao-tao, known as the two Generals, and it was called the blue-and-green school because bright azurite and malachite were the predominant colors. The second style is said to be based on the ink monochrome paintings of Wang Wei; and with the adherents of ink monochrome, the individual brushstrokes took on a more calligraphic quality. Instead of building up mountain forms with thin outlines and ornate color, the followers of Wang Wei used carefully gradated washes and small dabs of ink to model the forms; closely packed dots were used to render the leaves of trees.

Opposite page: Mount Omi, China; ink and color on silk, 26 by 40 inches; traditional landscape showing perspective in height. *Below: The Music of Nature;* ink on silk, 45½ by 17 inches (perspective in height).

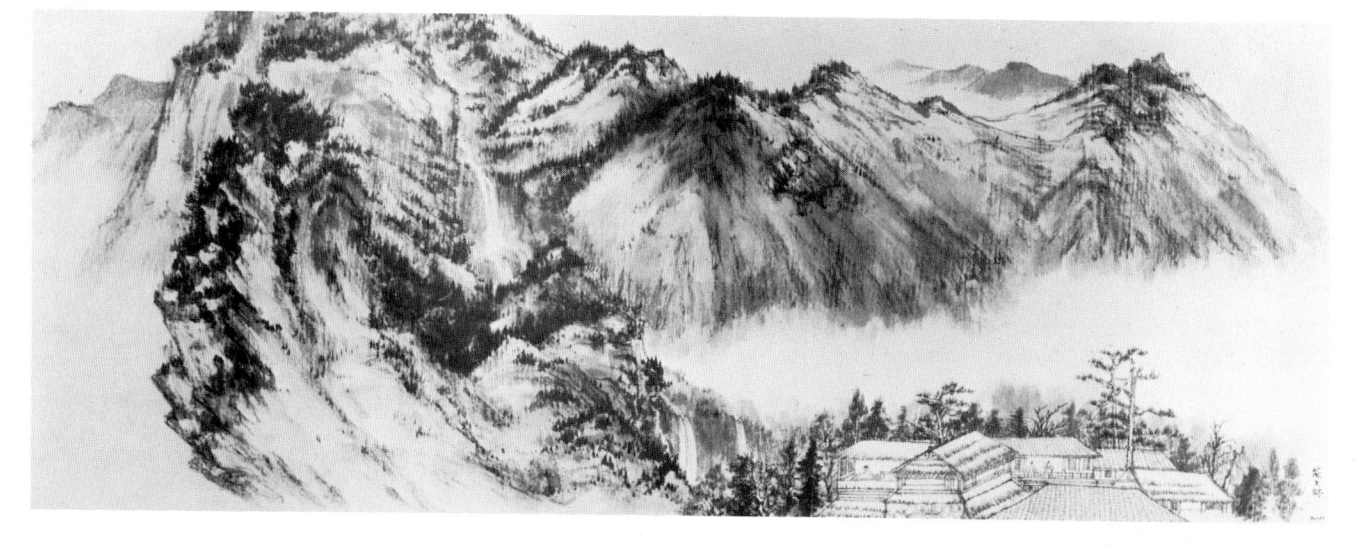

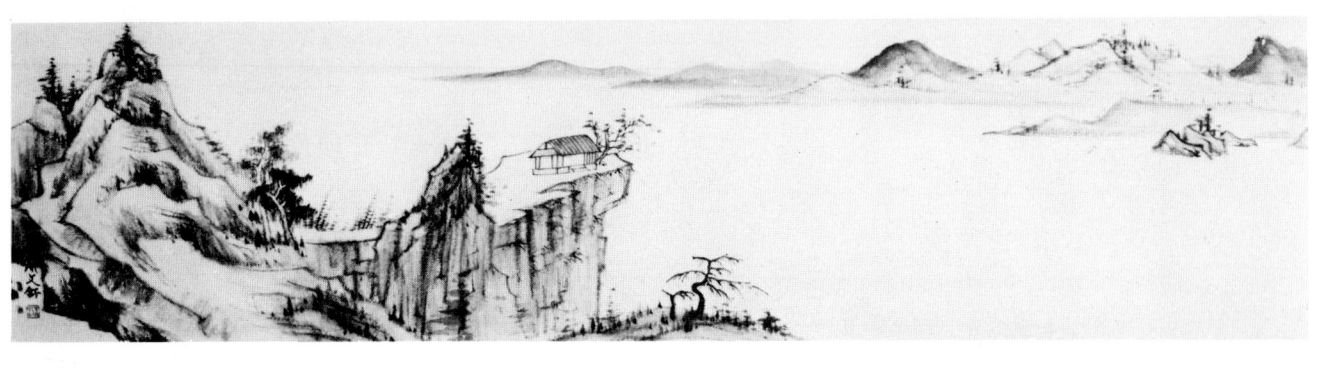

Above: Spring Hills After Rain; ink and color on rice paper, 30¾ by 7⅜ inches; traditional landscape showing perspective on the level. *Opposite page: Creation's Forms;* ink and mineral colors on gold leaf, 24 by 36 inches (collection of Mrs. Robert Kennedy); broad *p'o mo* style showing perspective in depth.

Succeeding generations of painters extended these ink techniques and developed a large vocabulary of modeling strokes called *ts'un*. Two painters of the Northern Sung Dynasty, Tung Yuan and Chu-jan, modeled their carefully constructed rock forms with long, wavy and soft strokes (hemp fiber) and used dots of ink to suggest distant vegetation. Mi Fei relied entirely on short horizontal dabs (Mi dots) to create an impressionistic view of mountains, vegetation, and mist. In the thirteenth century, the hemp-fiber strokes of Tung Yuan and Chu-Jan became the inspiration for the Yuan Dynasty masters, some of whom tended to use ink more sparsely, with a drier brush, and to avoid washes and outlines.

The use of various modeling strokes continued into the Ming Dynasty with Shen Chou and Wen Cheng-ming of the Wu School. In this style, outlining is not abandoned but is used in conjunction with the modeling strokes in a manner that indicates the rugged nature of the mountain and tree forms; often this outlining is done with the side of the brush tip rather than with the upright brush. Color is used only in pale washes and it remains secondary to the structural character of the brushstrokes and ink tones.

Although it is apparent that these opposing trends (ornate color versus ink modeling) represented stylistic differences, during the Ming Dynasty, landscape painting was divided into two schools based on what was thought to be philosophical differences. The term Northern School was applied to those who were thought to paint outward appearance and the term Southern School was applied to those who were thought to paint inner reality. These terms were chosen because they paralleled a comparable philosophical division within a Ch'an Buddhist sect of the seventh century and they do not signify any identification with a geographical location.

All those who followed the tradition of Wang Wei were classified as the Southern School. The Northern School was said to consist of Li Ssu-hsun and Li Chao-tao and the prominent, later followers of the blue-and-green school, Chao Po-Chu and Ch'iu Ying. However, to this list of Northern style painters were added the Southern Sung Dynasty* Academy painters — artists stylistically far removed from the linear style of the blue-and-green school. These artists, beginning with Li T'ang and continuing with Ma Yuan and Hsia Kuei, had increasingly broadened the style of their Northern Sung predecessors* from densely packed small ax strokes to large ax strokes and had dramatically simplified the range of ink tones, replacing carefully gradated washes with broad washes to obtain sharp contrasts of light and dark.

Although some painters of the Ming Dynasty, known as members of the Che School (Tai Chin and Wu Wei), revived the style of these Southern Sung painters, it was the style of the opposing Wu School and the so-called Southern School that prevailed throughout the Ming and subsequent Ch'ing Dynasties; it is this style we will explore.

The connection of the Southern School with the tradition of literary amateurs who painted for the enrichment of their own lives and those of their friends does not mean that the stringent standards of fine brushwork were abandoned in a search for self-expression. The style is actually quite carefully controlled.

The basic method is to establish the main forms of the composition first, with calligraphic outlines in light-toned ink. The characteristic interior markings of each form — the deep fissures and clefts of rocks and mountains, the protruding nodes and dark, empty knotholes of trees — as well as the outer boundaries, are included in this preliminary outlining. These ink strokes are then accented with darker ones. The effects of dimension and surface texture are built up in the same way, working from light to dark tones of ink, with the appropriate modeling strokes.

Only after the ink structure of outlines and modeling strokes has been firmly established is color added in pale washes. (In ink monochrome, light-toned ink washes are used in place of color.) The washes are built up in successive layers wherever shading or intensified color is desired. The previous wash must be allowed to dry before an additional one is applied, and the added washes should be only slightly darker in tone than the initial ones.

The effects of water, clouds, and mist, which are so important to Chinese painting, are most often obtained by leaving vacant areas between painted forms. Foliage, distant trees, and vegetation are formed by various dotting and *mo ku* techniques; distant mountains are formed with unoutlined and unmodeled washes. Any human forms and man-made structures appearing in a landscape are done in fine contour style with the tip of an upright brush.

*The Sung Dynasty was interrupted by invasion and war. The era before this upheaval is known as the Northern Sung (960 to 1126). The era from 1127 to 1280, after the capital had been re-established further south, is known as the Southern Sung.

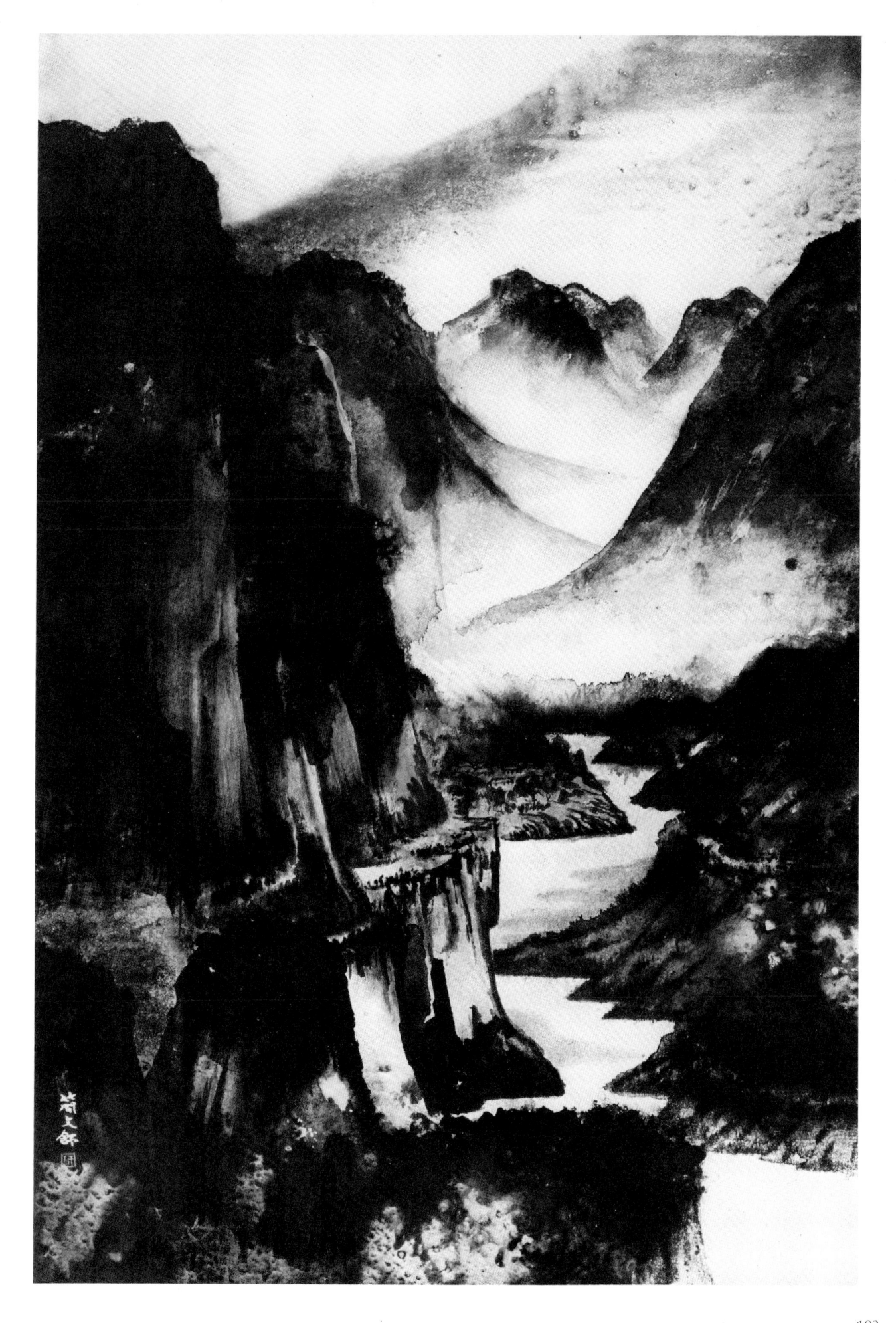

The pine tree, the bamboo, and plum blossoms are favorite subjects for scholars. Painted in one composition, the three plants symbolize friendship.

TREES

Trees perform various functions in landscape. Several small stands of tiny trees on the outcroppings and crags at different levels of a high mountain help show perspective in height. One or two large trees in front of a mountain help to establish the foreground. In front of an expanse of water or flat land, a large tree contributes to the illusion of vastly receding space behind it (perspective on the level). Small trees in the background, painted in dabs alone, create the impression of both distance and atmosphere.

Trees are also used symbolically to indicate admired virtues and attributes associated with individual species, such as the sturdy, reliable pine and the mysterious *wu t'ung*, and to indicate changes of season. The flowering plum and the pliant bamboo, symbolizing winter and summer respectively, became specialized subjects as we have already seen. Other flowering trees — such as peach and apricot — painted in blossom, before the fruits of summer, are symbols of spring. The snow-laden branches of such trees, and the silhouettes of evergreens against snowy hills, are indicative of winter. Many trees have several seasonal aspects. A willow in early spring is fresh and green, its boughs not yet bent by the full and drooping foliage of summer and early autumn; by winter its foliage is dulled in color and sparse. Any of these aspects may be used to show the appropriate season.

Before you people a landscape with trees, study the structure of each basic species and observe the integration of the parts — branches to trunks, twigs to branches. Be aware of the direction in which each of the main branches emerges from the trunk. Some limbs point to the left, some to the right; some limbs appear to thrust forward, some appear to lean backward. The twigs, too, fork off in different ways. Some resemble the acute angles of fish bones, some curve out like deers' horns and some spread out like birds' claws.

Right: The trunk and limbs are outlined in light ink, reinforced with dark ink. *Far right:* As the branches narrow and become small twigs, a single *mo ku* stroke is used in place of the double contour. The pattern of the forking branches and twigs may resemble fish bones, deers' horns, or birds' claws.

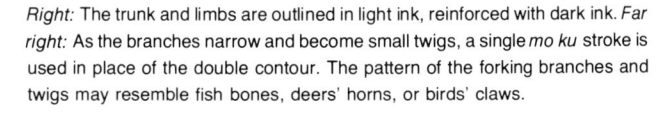

Deer's horn

Fish bone

Bird's claw

Observe various species of trees and study the structure of each. Note how each limb emerges from the trunk.

Fish bone Deer's horn Bird's claw

Above: Fantasy (collection of Mr. and Mrs. Howard Silver); gold leaf, 36 by 24 inches. *P'o mo* technique with mineral colors (blue, green, and vermilion) and white over indigo and yellow.

Right: White Serenity (collection of Dr. Norman J. Levy); silk, 17¼ by 17¼ inches. *P'o mo* technique with mineral blue (cobalt), white, and cadmium red over indigo, burnt sienna, and yellow.

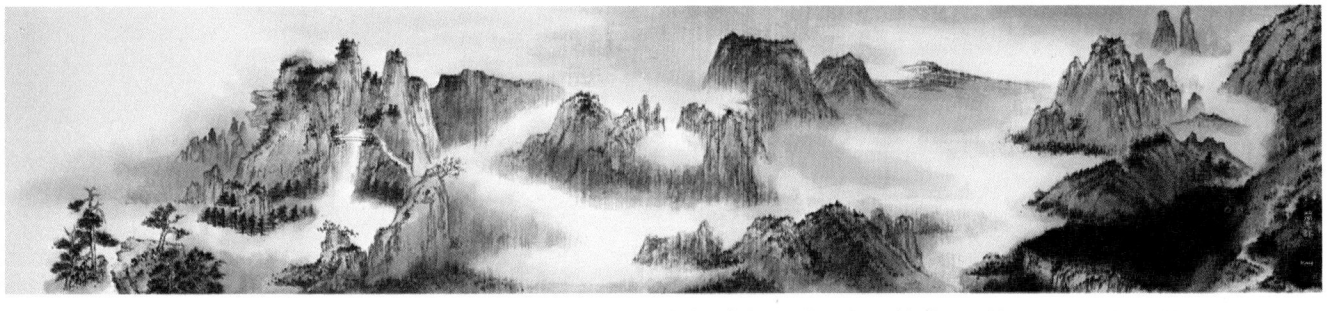

Riding with the White Cloud; silk, 50 by 10½ inches. Traditional landscape with ink foundation and washes of indigo and burnt sienna. The mist and streams are indicated by unpainted areas.

The Valley Awakes (collection of Mr. and Mrs. George Saks); silk, 24 by 18 inches. *P'o mo* technique with mineral yellow over indigo, burnt sienna, and vermilion.

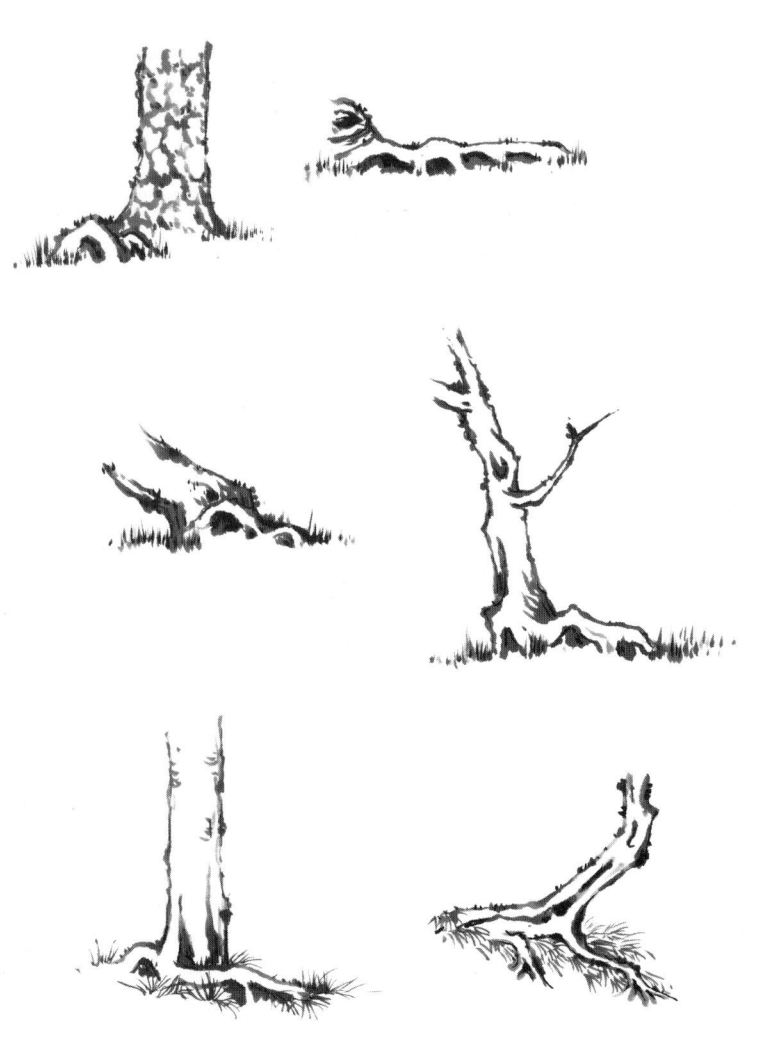

Do not neglect the roots of the tree, for they should reflect the natural surroundings and the character of the species. The roots of an ancient pine or cypress are large and sinuous; the roots of young trees are less apparent. When grappling for a foothold on the edge of a cliff or near rock-strewn and shallow water, the roots of these and other trees are partially or completely exposed. When firmly emplanted in the earth, amid deep underbrush, the roots cannot be observed. These bare structures, all of which are done in outline form, must be learned first.

Next, learn to place one tree next to another. Two neighboring trees have a guest-host relationship, the host large and protective, the guest smaller and more modest in bearing. When the young guest is placed behind the host, it is known as leading the young by the hand; when a young guest is in front of the host, it is known as carrying the old on the back. When a third tree is added it should have its own identity; neither its roots nor its topmost reaches should align exactly with those of its neighbors. When you combine three trees with two, you have properly placed five trees. To place four trees, use two pairs or add one to the grouping of three. Observation from nature and personal preference will play at least as great a role in determining your groupings as will following any ritualized rules.

After you have studied the basic structures of trees and have observed their groupings, you should practice the outlining and dotting techniques to be used for the various foliages. The foliage is always added to the tree after the trunk and limbs have been outlined and modeled. When contour-style foliage is to be used, some areas of the trunk and limbs should be left blank to leave room for the leaf outlines. When dotting strokes are to be used, this is not necessary.

Generally most of the foliage is placed outside of the main outlines of the tree, overlapping the face of the trunk in only a few selected areas, so that the overall effect is of a pale, structural silhouette against dark foliage.

Above: The roots are an integral part of the tree structure and should be included in the composition whenever they are exposed in nature. *Below:* Neighboring trees should be arranged in pleasant groupings.

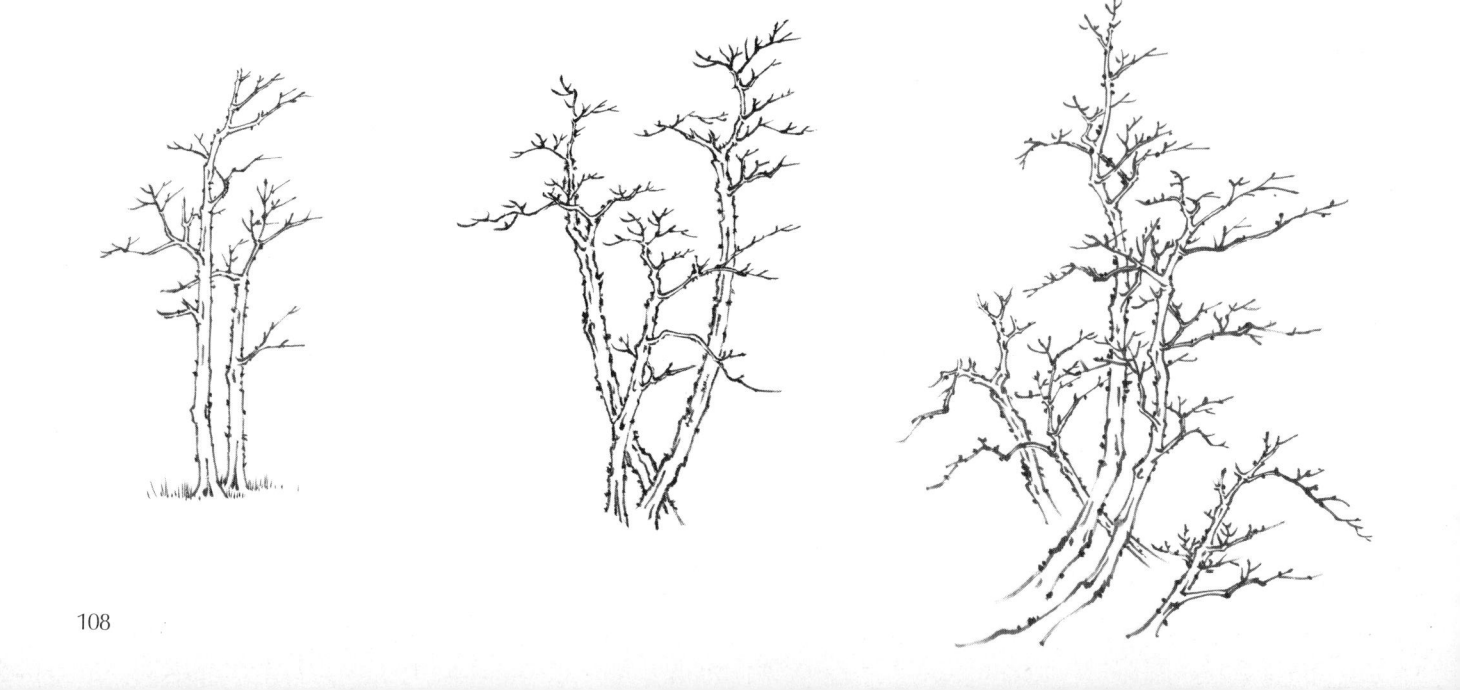

Methods of Outlining Leaves: Contour Foilage

For all types, used the tip of an upright brush. The strokes may be done in light ink first and reinforced with dark ink, or they may be done in a single tone, using a medium tone for some groups of leaves and a lighter or darker tone for neighboring groups. The outlined forms may then be washed with various tones of ink, or with shades of appropriate hues for a color composition. (The outlines may also be done directly in color, if desired.) Groupings should be pleasing to the eye but there are no specific rules. The *wu t'ung* strokes can be used for that species only. The other styles may be used to show general species other than pine, cypress, and willow.

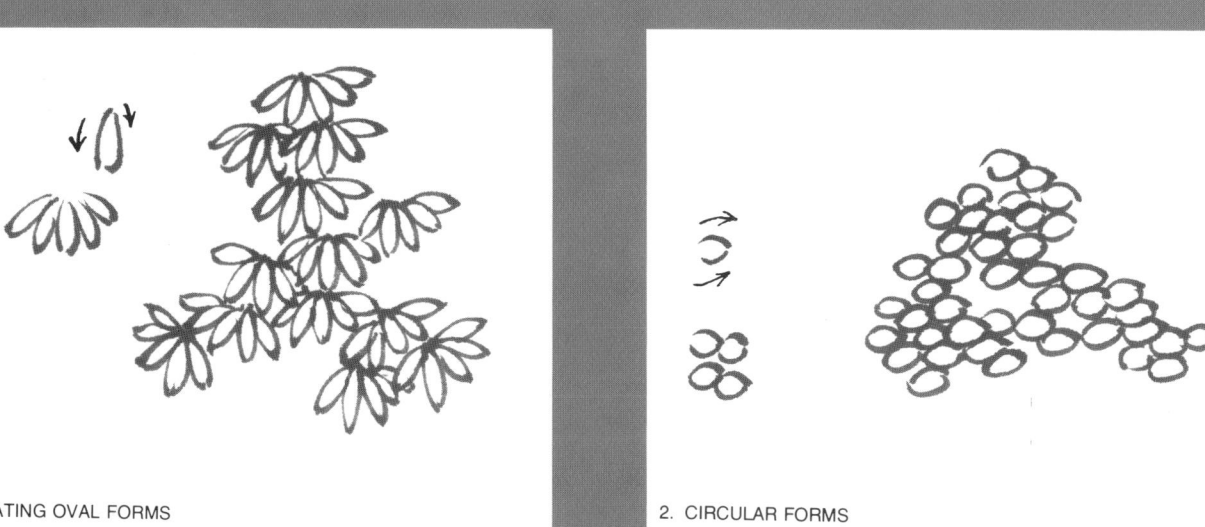

1. RADIATING OVAL FORMS
Use two curved strokes moving downward for each leaf. A series of five ovals should radiate from one point.

2. CIRCULAR FORMS
Use two curved strokes moving from left to right for each leaf.

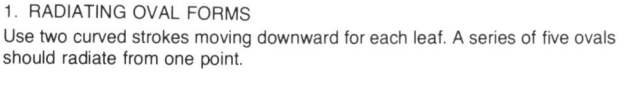

3. TRIANGULAR FORMS
Use one horizontal and two downward strokes for each leaf.

4. LOBED FORMS
Use an arced stroke and place a scalloped stroke beneath for each leaf.

5. RADIATING TRIANGULAR FORMS
Join two downward strokes with a horizontal one to form a flat tip for each leaf. These triangles are narrow and cluster around a central point in groups of five.

6. WU T'UNG LEAF
These are similar to the radiating oval forms, but each oval has a central vein added.

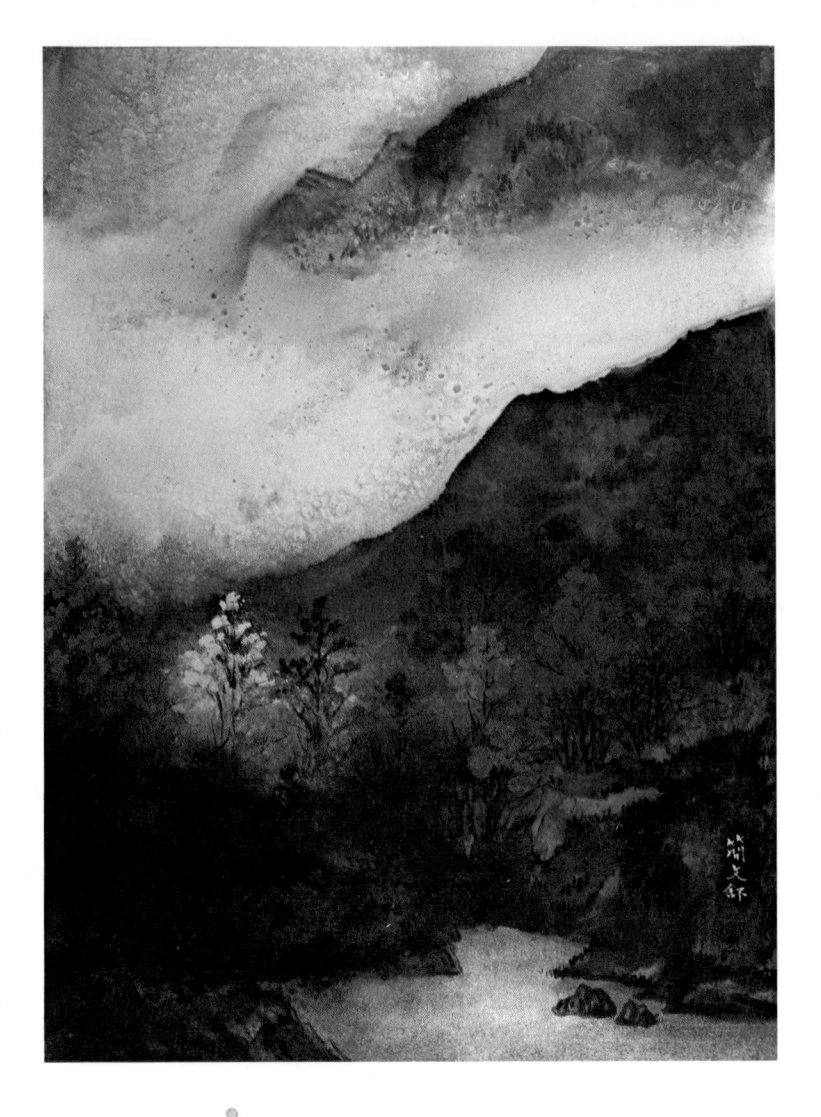

Luster of Autumn (collection of Mr. and Mrs. William Waldron); gold leaf, 18 by 24 inches. *P'o mo* technique with mineral blues, mineral yellow, and cadmium red over indigo; the white is mixed with pearl powder. The yellow in the foreground is the gold leaf background showing through the extremely thin rice paper that is overlaid as the painting surface.

The Rain That Has Just Cleared (collection of Mr. and Mrs. James K. Bruner); silk, 24 by 18 inches. *P'o mo* technique using mineral yellow with washes of brown, red, and green for the land, and indigo for the sky.

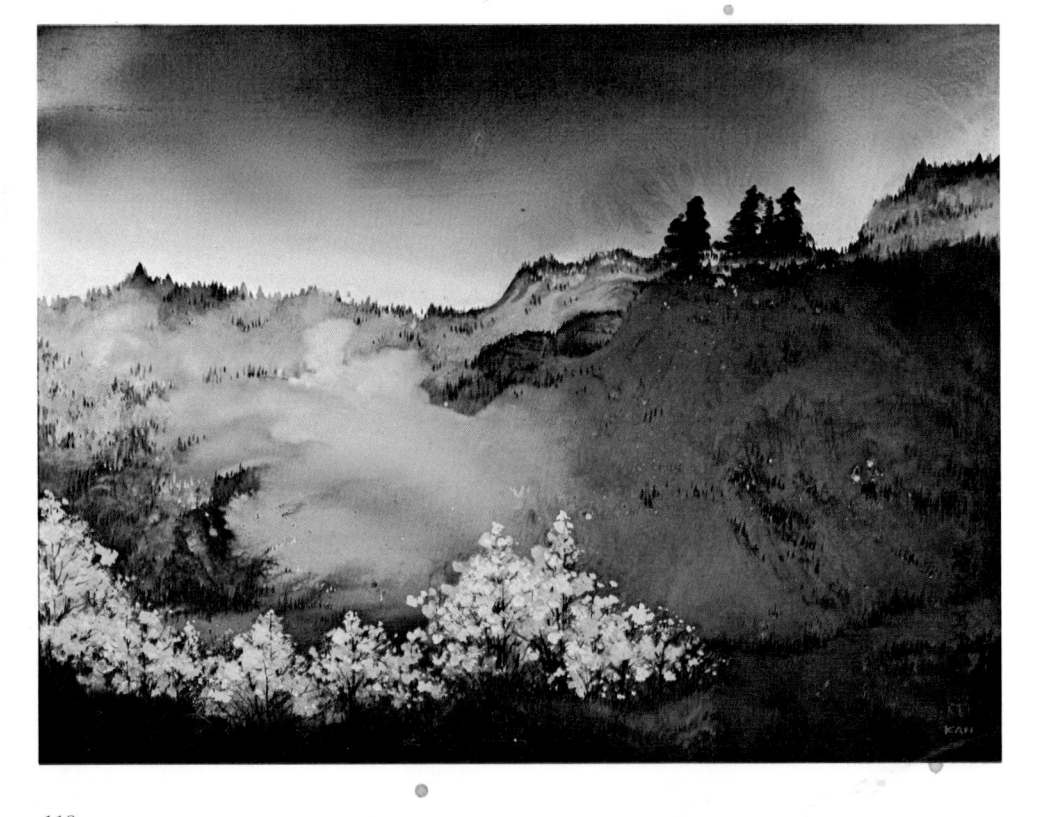

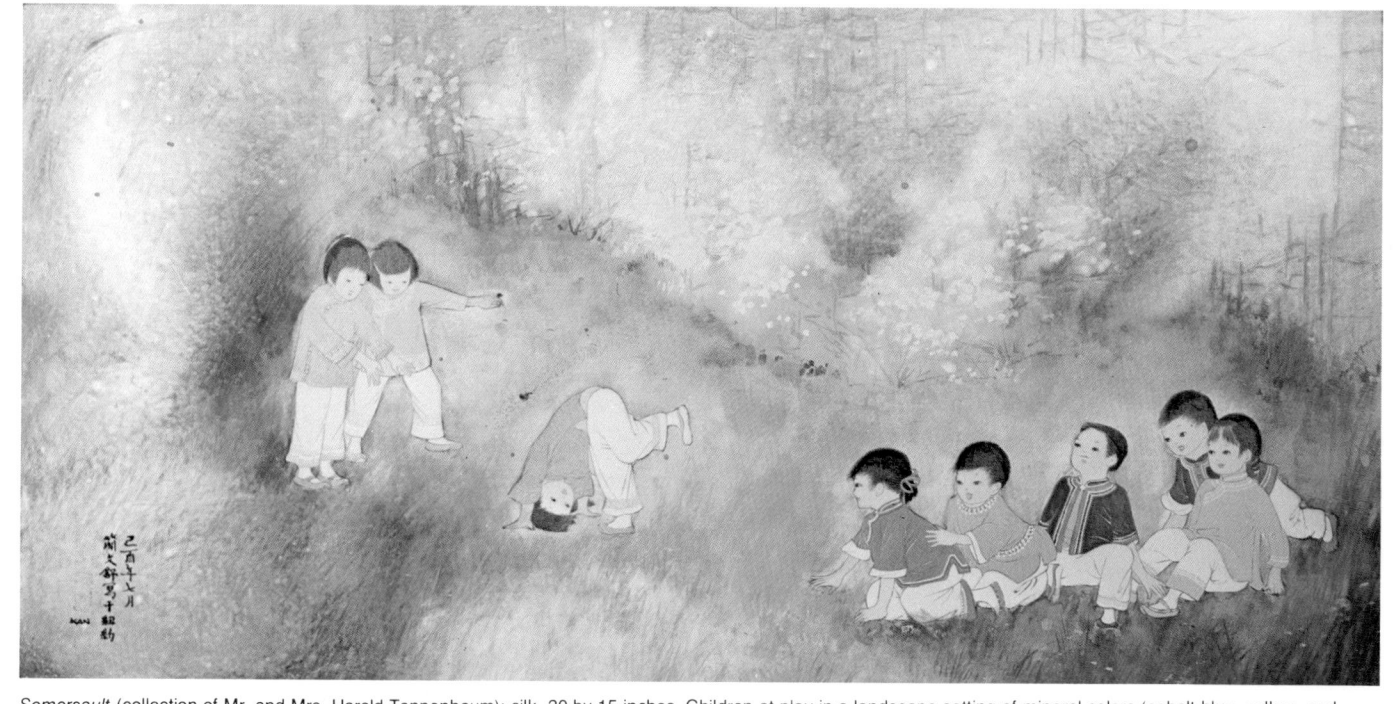

Somersault (collection of Mr. and Mrs. Harold Tannenbaum); silk, 30 by 15 inches. Children at play in a landscape setting of mineral colors (cobalt blue, yellow, and green). The figures are outlined in ink and are filled in with color washes.

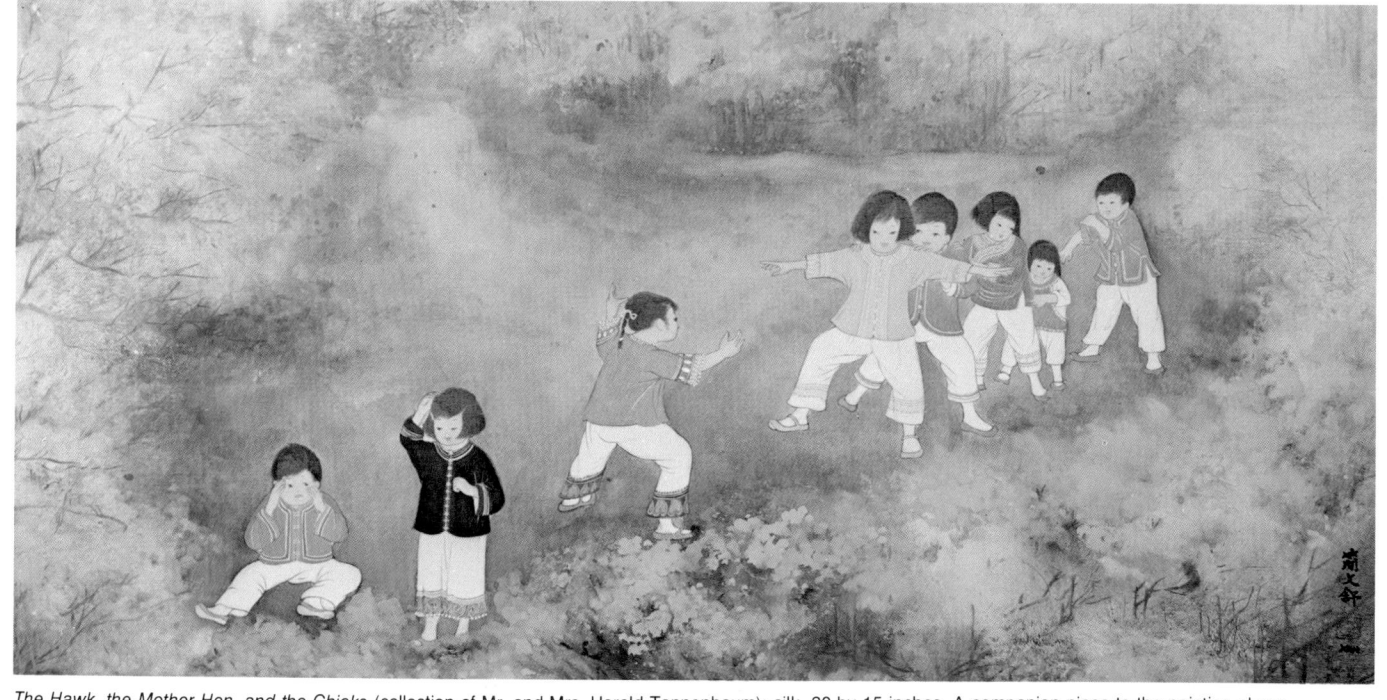

The Hawk, the Mother Hen, and the Chicks (collection of Mr. and Mrs. Harold Tannenbaum); silk, 30 by 15 inches. A companion piece to the painting above.

1. THE FLAT HEAD TECHNIQUE

Hold the brush at an acute angle to the paper with the brush tip pointing to the left. Draw the bristles across the paper moving horizontally from left to right. Although the brush is at an angle to the paper, it is used in an upright manner because the tip follows in the direction of the upper bristles. Use a light touch, applying only slightly more pressure at the end of the stroke than at the beginning of it.

3. THE KAI TECHNIQUE

Hold the brush upright and stroke downward. Press down on the brush tip, to start; release pressure and taper to a point as you end the stroke. Place four strokes together as a unit.

5. PEPPER DOTS

Hold the brush upright and dab at the paper as if the brush tip were jumping up and down. The dot size depends on the size of the brush and how much pressure is applied.

2. SMALL COMBINATION DOTS

Hold the upright brush at a slight angle to the paper with the brush tip pointing to the left. Place the tip in contact with the paper, press down to bring the side of the brush in contact, and lift up without dragging or sliding the bristles. Work horizontally across the paper from left to right, two or three dots at a time.

4. THE DROOPING HEAD TECHNIQUE

These are long, thin strokes similar to those of the flat head technique. Here, however, the strokes are curved as the side of the upright brush is drawn across the paper from left to right, and these strokes overlap each other.

6. THE BROKEN STROKE TECHNIQUE

Hold the brush in an oblique position with just the tip touching the paper. Use quick, short strokes sweeping downward, and release pressure to taper the pointed end of each stroke.

GRASSES, RUSHES AND REEDS

Use an upright brush and stroke down from the top with increasing pressure.

Stroke from the base upward, increasing pressure in the center of the stroke only.

Dotting Techniques: Mo Ku Foliage

The vocabulary of dotting strokes is a versatile one; the strokes may be as definitive as carefully drawn contours in describing the leaves of a foreground tree, or they may be vague and suggestive in describing distant trees. A variety of small dabbing strokes is used in painting grasses, rushes, and reeds. All these *mo ku* strokes may be done in various tones of ink. For a color composition, the strokes may be done in ink (color washes may be overlaid if desired, but are not necessary); or the strokes may be done directly in color.

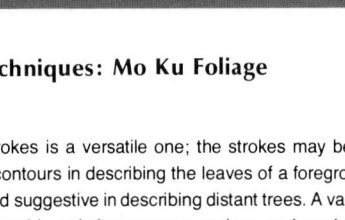

7. THE DROOPING LEAF TECHNIQUE
Use an upright brush to make simple downward strokes with increased pressure in the center.

8. THE PINE LEAF TECHNIQUE
All the strokes are quick, downward movements with the tip of an upright brush. Place the center, vertical stroke first. Then place the strokes fanning to the left, starting to the left of the center stroke and working to the left. Place the strokes fanning to the right, starting at the right of the center stroke and working to the right.

9. THE RAISED HEAD TECHNIQUE
These strokes are similar to the drooping head technique. Instead of being pulled in a downward curve as the brush tip moves from left to right, these are pulled in an upward curve.

10. THE WU T'UNG LEAF
Each unit is made of four strokes. Hold the brush upright with the tip placed at the top of the stroke; press down and allow the upper bristles to form the bottom of the stroke.

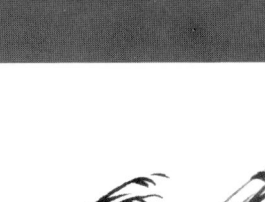

11. THE PLUM BLOSSOM TECHNIQUE
Each unit consists of five round dots. Press down on the tip of an upright brush; then release pressure while directing the end of each stroke toward the center of the grouping.

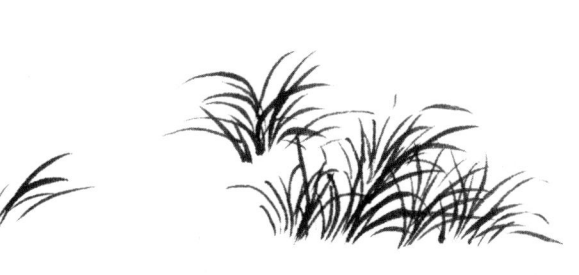

Use longer upward strokes, with some twisting like orchid leaves. Vary the direction of the strokes and group them in patches.

Long upward strokes bending in a single direction form the blades. Short, curved strokes are added to each blade by pressing down slightly on the tip of the upright brush and releasing pressure while moving away from the blade.

Long blades such as these usually appear in the foreground of a painting. They are uneven in height and some stretch upward while others bend downward.

The forms of trees in the distance are simply shown by adding foliage to the trunks with dotting techniques. The trunk may be painted in outline form and appear silhouetted against the dark foliage, or it may be painted with a single *mo ku* stroke.

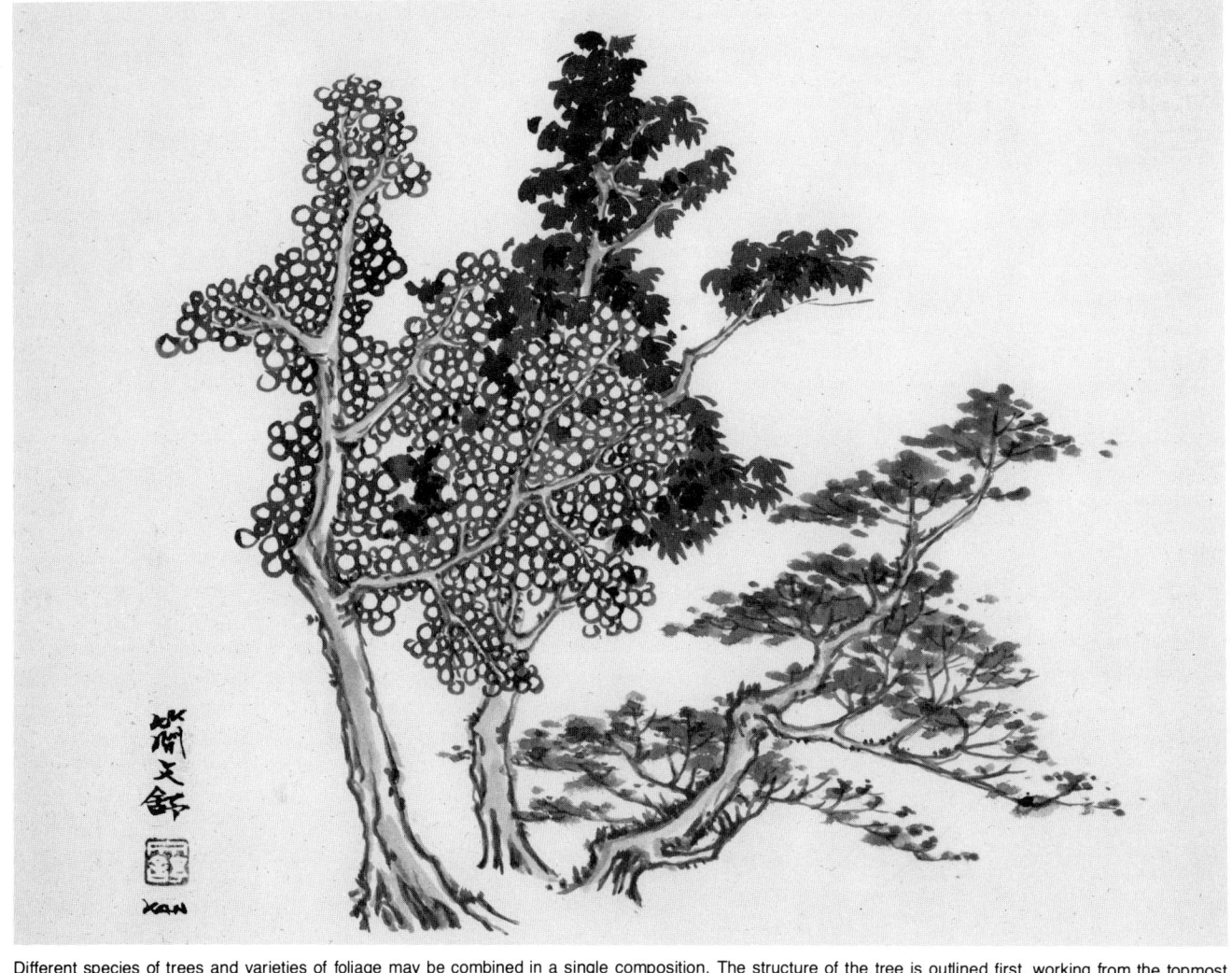

Different species of trees and varieties of foliage may be combined in a single composition. The structure of the tree is outlined first, working from the topmost branches downward.

In painting a tree, then, you begin with the trunk and main branches, drawing the outer boundaries with the tip of the brush, in light-toned ink. Work from the top down, placing the limbs on alternate sides of the trunk at different levels as you proceed section by section to the roots. Make certain you show how each limb emerges from the trunk. Not all limbs are a direct extension of the trunk's outline; some arise from the interior within the contour. The outlines of these branches must reach into the trunk. As the main limbs narrow in size, and smaller branches and twigs appear, the double outline in the form of birds' claws, deers' horns or fish bones may merge into thin *mo ku* strokes of the same form to indicate the forked twigs.

Whether you hold the brush obliquely or upright for the outlining strokes depends on the nature of the tree. For the straight, smooth lines of the *wu t'ung*, the brush will be upright; for the angular, hesitant lines of the pine, the brush will be oblique. This applies, too, to the interior markings of the tree. The small protuberances of the nodes and the uneven hollows of the knotholes are accented as agreeable accidents in the composition. These are added with light-toned, irregular outlining strokes that comply with the natural forms. The texture of the bark is similarly shown with light-toned modeling strokes, using long, jagged lines, smooth arcs, or curved fish scales, de-

pending on the characteristics of the tree. The rougher the texture of the bark, the drier the ink should be.

When the preliminary outlining and modeling have been completed, they are reinforced with strokes in a darker tone of ink — and, if necessary, in a third, still darker tone. Building up the outlines and modeling in layers of increasingly darker ink allows for the correction of the preliminary strokes and adds richness to the form.

The leaves, like the trunk and limbs, may be built up with outlines of pale to dark ink, or they may be expressed directly with *mo ku* strokes, in various ink tones, from the vocabulary of dotting techniques. Leaves in contour style may receive layers of ink wash in pale to medium tones to set off the outlined trunk, while no wash is necessary for *mo ku* foliage.

When color is to be added, the preliminary steps are exactly like those of ink monochrome. In that case, though, instead of an ink wash, leaves in contour style may receive color washes appropriate to the species and season. *Mo ku* strokes may be done in ink tones as before, or in shades of color, primarily inky greens. The trunk and limbs of the tree are then washed in pale brown, which may be slightly darkened for dimension with a second or third wash in selected areas. The areas around the knotholes are left lighter than the rest of the trunk.

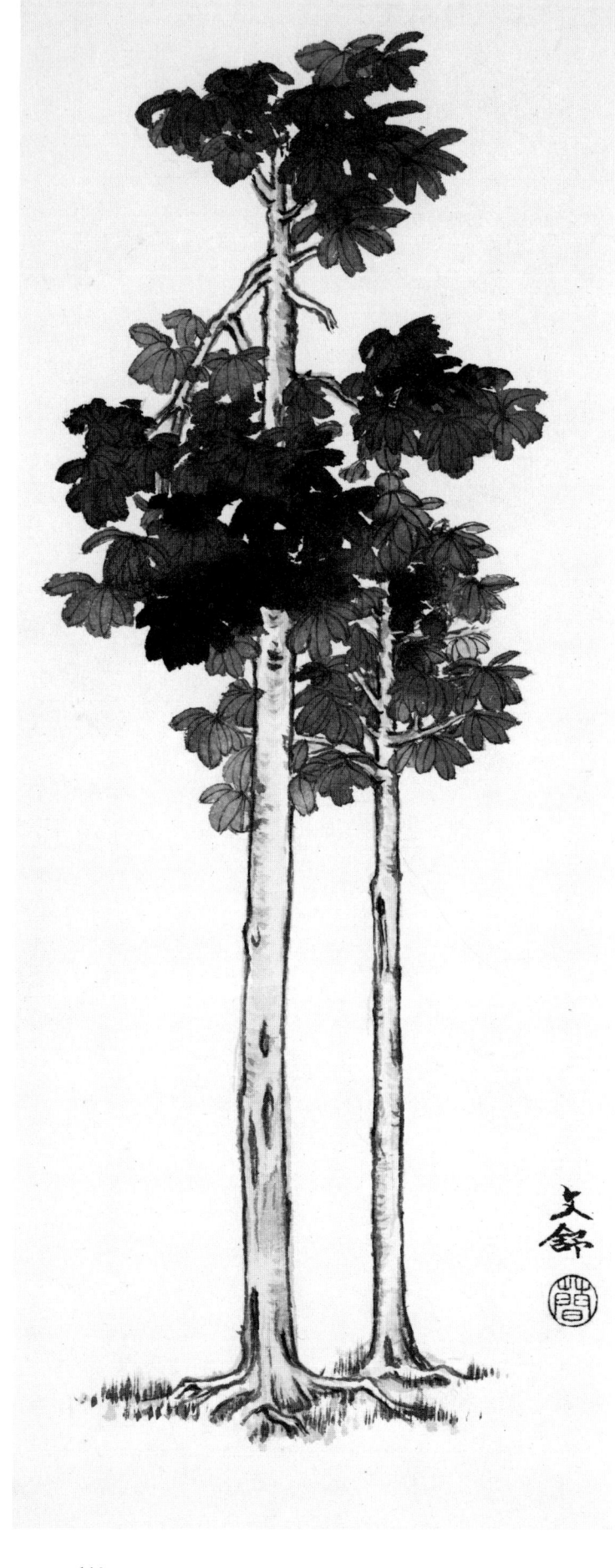

The specific trees most often painted are the plum, pine, cypress and *wu t'ung*. The *wu t'ung* is a plane tree similar to the sycamore. Apart from its uncompromising straightness and verticality, it is important in landscape because its branches are said to be the resting place of the legendary phoenix, the bird of good omen, symbolic of rebirth and regeneration. Its leaves are lobed and they grow near the top of the smooth, tall trunk, where they spread outward like a parasol. To emphasize the tree's smoothness and straightness, outlining is done with an upright brush. Smooth modeling strokes, curving horizontally around the trunk, stress its cylindrical form. The erect bearing of the tree, its uppermost reaches pointing straight to the sky, is said to symbolize the concept of one universal heart.

There are of course many varieties of pine — some tall and majestic, other sinuous and contorted; but all have roughly hewn surfaces. In painting these outlines, hold the brush obliquely, and push and pull the tip in hesitant but continuous strokes, pressing down to broaden some parts and releasing pressure to narrow other parts, for irregularity of form. Use a dry, not moist brush. Be certain there is a logical transition between the outlined branches and the smaller *mo ku* twigs by pressing down at the end of the outlining strokes to broaden them. Add structure and texture to the trunk by showing nodes and knotholes and by dabbing moss dots along the contours, as in the plum tree. Arced, fish-scale modeling strokes may also be added, using light ink with a dry brush held obliquely.

The trunk of the cypress, like that of the pine, may be either great and towering or crooked and entangled, with rough bark. Its foliage is stubbier and more compact than the long needles of the pine and appears in compressed patches, leaving many branches looking relatively bare. Pepper dotting is used to express this foliage.

The willow in summer foliage expresses grace and refinement. Its trunk is rough and angular; its bark dark and wrinkled; but its long, slender branches are beautifully arched and low-hanging when laden with fresh leaves. The leaves are rendered in long, thin curves sweeping downward from the branches. These may be feathered in small, sharp strokes if desired.

Many times, trees of different species are grouped together to offer variety in trunk forms and the foliage techniques.

Left: The straightness of the *wu t'ung* tree is emphasized by outlining it with an upright brush. Knotholes are added as part of the interior structure. The outlined leaves have received ink washes in various tones.

Opposite page: To show the roughness of the pine, use the tip of an oblique brush to obtain irregularity of line. Note how the outlined branches merge into *mo ku* twigs and how most of the foliage silhouettes the limb forms instead of hiding them.

ROCKS AND MOUNTAINS

In painting rocks and mountains, a basic structure of rugged boundaries and deep interior markings serves as the foundation for the modeling strokes, and this structure is established first, usually in light ink and in a manner that coincides with the modeling strokes to be used. These preliminary strokes are then accented with darker ink, and the modeling strokes are built up in layers of various tones to add dimension, texture, and character. Light color washes (or ink washes in monochrome) are added last, using shades of brown, green, or blue for the modeled rocks and mountains. Distant mountains fading into mist are rendered by washes of light ink or blue color alone, without preliminary outlines and modeling. The following series of outlining and modeling strokes can be used to render both rocks and mountains, depending on the proportionate size of the forms in the composition.

Modeling Strokes

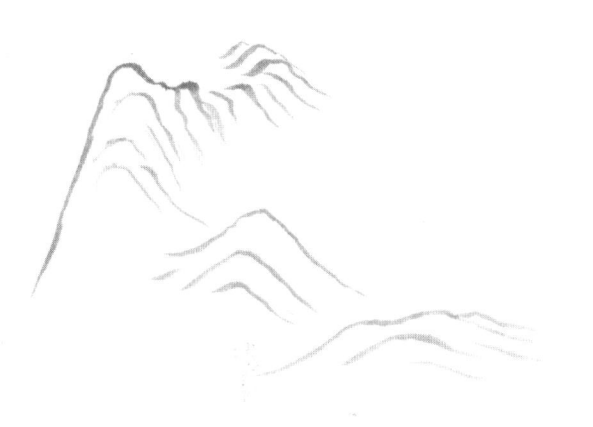
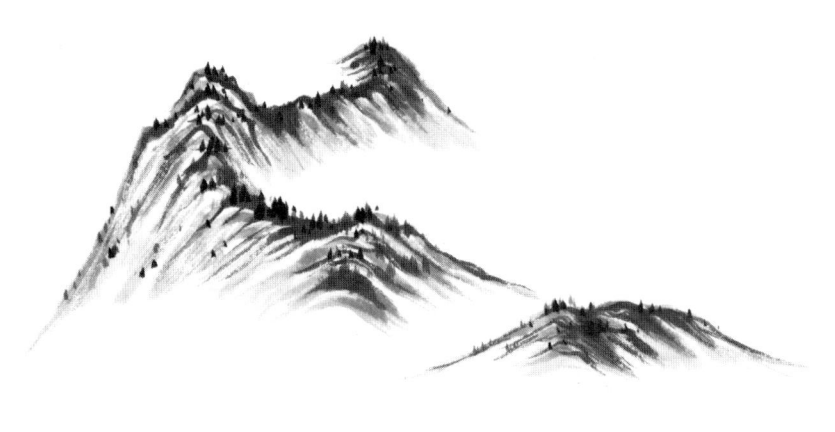

1. HEMP FIBER WRINKLES

Using the tip of an oblique brush and light ink, draw a series of curved peaks, beginning with the lowest, nearest one and ending with the highest, most distant one. Use a continuous stroke of irregular thickness, moving from left to right for each curve.

Add modeling in light ink first, using the tip of an oblique brush. For forms directly facing you, use one continuous stroke of varied thickness, starting at the left of the curve and moving over the peak, then down the right side. For forms showing only the left side, start at the left, move up to the peak and stop there. For forms showing only the right side, start at the peak and move down the right side. Then use the same techniques to apply darker tones of ink, varying the degree of moistness, so that some of the strokes are fairly dry. Add small pepper dots in dark tones on some of the ridges to show vegetation and to strengthen or accent the mountain structure.

2. UNTWISTED ROPE WRINKLES

Use an obliquely held brush to form the outlines and interior structure in a dry, light-toned and hesitant line.

Add the modeling with narrow, sketchy strokes of mainly dry ink, beginning with a light tone and overlaying darker ones as you progress. Use both long, vertical strokes and shorter, horizontal ones. Accent the outlining with dark strokes. Remember that the oblique brush moves perpendicularly to the line of the handle.

3. SMALL AX CUT WRINKLES

The structure and texture of the rocks show sharp edges and planes, as though the marks had been cut with an ax. The outlines and interior marks are in light, fairly dry ink, with an obliquely held brush.

The modeling wrinkles are small, sharp strokes, each shaped like a flat-headed nail, beginning broadly and tapering to a thin end. The brush tip is held obliquely for these strokes. Start with medium ink and then use darker, drier ink. Accent the structural lines with dark, dry strokes.

4. RAINDROP WRINKLES

Outline the forms in light ink with a fairly dry, obliquely held brush.

Add the modeling with dots of varying sizes and in varying tones, using an upright brush. (This is also known as Sesame Wrinkles.)

5. ALUM HEAD WRINKLES

Outline the forms in light ink with a fairly dry, obliquely held brush. The fissures and clefts indicating the jutting shapes should have harmony and rhythm.

Add the modeling in short and long, horizontal strokes of light ink with a fairly dry, obliquely held brush. Add dark modeling strokes over this. These are similar to ax cut strokes but are generally longer. Some wrinkles may be placed vertically for accent.

6. ROLLING CLOUD WRINKLES

Outline the forms in rolling curves of light tone, using an upright brush.

Add the modeling in curved strokes of light and medium ink, some moist and some dry, with some dark dots for accent. Use an oblique brush.

7. OX HAIR WRINKLES

Do the outlines and planes with an upright brush using light ink and slightly curved, rolling strokes. The brush should be dry, with the bristles spreading out from the point.

Add the modeling with both fine and coarse, sweeping strokes of dry ink in various tones, some fairly dark. Use an upright brush.

8. LOTUS LEAF WRINKLES

The outlines and the modeling are both done with the tip of an upright brush, using medium ink. The interior strokes should spread out like the veins of a leaf. Add small triangular dots (pepper dots) for dark accents.

9. HORSE TOOTH WRINKLES

Draw the outlines and interior markings with angular strokes that move first in one direction and then kick out at an angle, like a check mark. For instance, start with a horizontal stroke and then kick down at an angle. Or start with an angled stroke and then kick off horizontally. Hold the brush at an acute angle to the paper but use it in the upright manner, with the tip moving in the same direction as the handle. Use a fairly regular thickness of line in light and medium tones.

Add the modeling with short, vertical strokes in dry ink of light and dark tones. Flick downward with an upright brush for these strokes.

10. MI DOT WRINKLES

Paint the outlines and the interior markings in the same manner as for hemp fiber wrinkles.

Add modeling with dots in light ink. These dots are horizontal, parallel strokes similar to the flat head dots, but they are broader and made with more pressure. Use an upright brush held at an acute angle to the paper. While the light-toned dots are still wet, add dots in dark ink and let the tones mingle.

The careful placement of rocks in a land-scape allows the eye to travel in a circle from the foreground to the middle ground and back to the foreground.

122

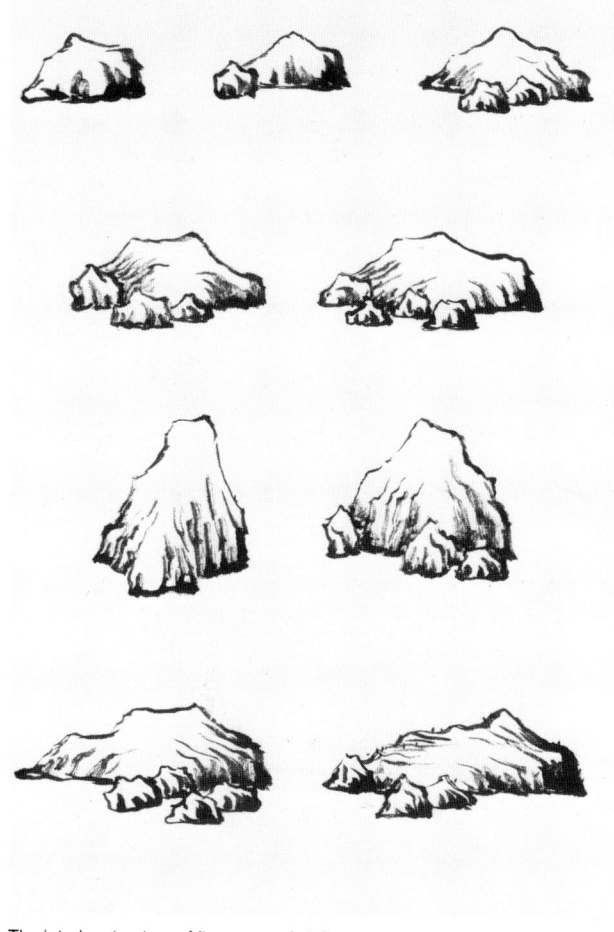

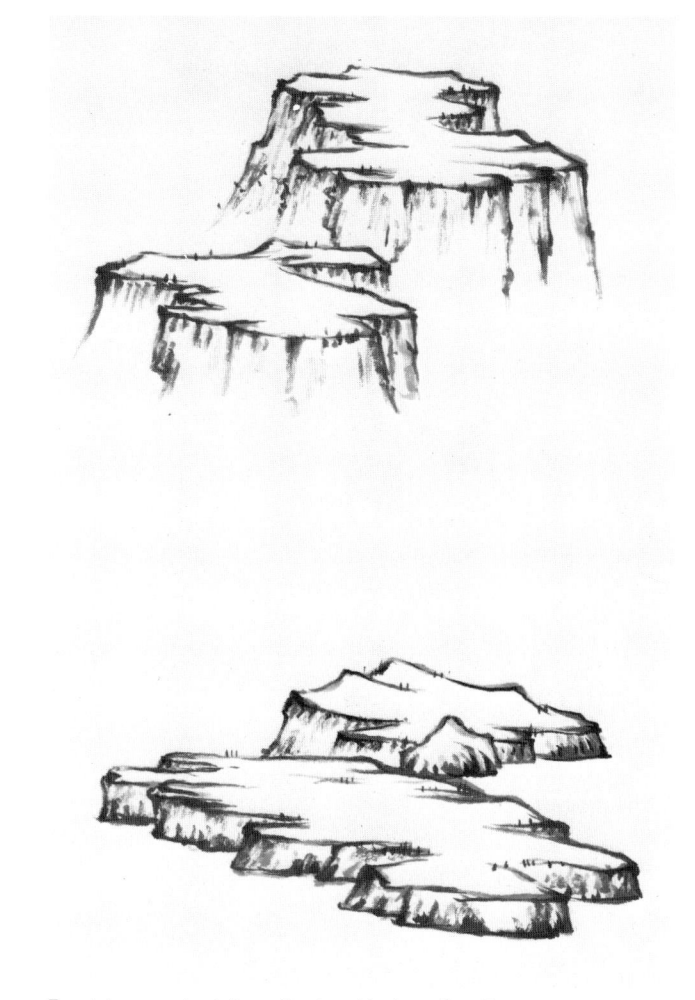

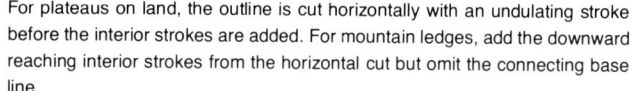

The interior structure of fissures and clefts are essential in showing the solidity of rock forms. Establish the outer boundaries with the tip of an oblique brush, then add the interior strokes, using either an upright or oblique brush.

For plateaus on land, the outline is cut horizontally with an undulating stroke before the interior strokes are added. For mountain ledges, add the downward reaching interior strokes from the horizontal cut but omit the connecting base line.

Rocks should be depicted as being alive with inner spirit, not as inert, lifeless objects. They should seem to be communicating with the viewer, with each other, and with the other elements in the composition. The groupings of various shapes and sizes therefore should take into consideration the host-guest relationship we have already encountered in positioning neighboring trees.

The sculptural aspects, the solidity and fragmentation of these forms, must be studied in order to express the three faces of height, depth, and volume. The following is an example of how to establish and group rock forms, using a variation of the hemp fiber outline. To outline the boundaries, start at the lower left side of the rock and work up toward the top, then over the top and down the right side to the base, which you do not draw yet. Show the irregularity, the grittiness and hardness of the rock by varying the pressure on the tip of the obliquely held brush. Then depict both the roundness and the sharp planes of the form by digging into this outlined shape with strokes that begin as sharp, narrow lines on the upper portion and grow bold and broad as they reach down to the base.

Place these interior strokes at irregular intervals, using more on the right side of the form than on the left side,

and vary them in length. Finally, place the base line with one or more brushstrokes connecting the uneven vertical fissures at the bottom of the form. The base should not appear to be a straight, horizontal line, unless the rock is hidden in a stream or buried on land. In accenting the contours and the structural strokes with dark ink, and in adding modeling strokes, be sure the brush is not too dry. Moisture (but not wetness) is used to express the life and vitality within.

Rocky plateaus on land may be handled in the same manner. Draw the left-to-right outline over the top of the form first. Then sweep horizontally across this shape with undulating strokes to create the flat plane of the top surface. Add the irregular fissures and clefts, moving vertically downward from below these horizontal cuts to the base of the plateau and connect these vertical lines to form the undulating base line.

For flat surfaces on high mountain ledges, draw the fissure strokes reaching downward from the horizontal cuts, but do not add a base line. This gives the impression that the base is hidden in mist. Note that the more distant planes are always drawn higher than the closer ones, to create the illusion of receding space.

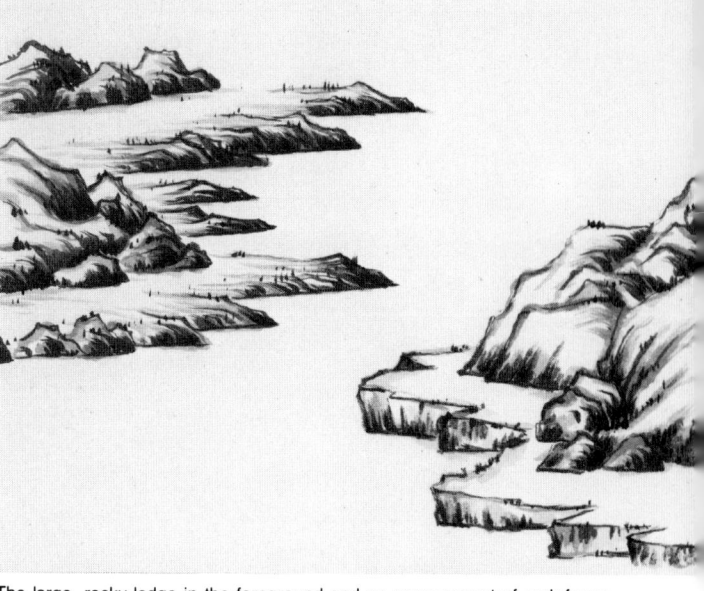

By increasing the scale of the outlining and interior strokes, the rock formations can be transformed into craggy mountain sides. Note that paths among the rocks are never straight but wind around the forms in curves or zigzags.

The large, rocky ledge in the foreground and an arrangement of rock forms beyond are combined to show promontories jutting out into a body of water. Again, the path snakes among the forms and is left open at both ends, to indicate that new vistas are always beyond the bend, the journey is continuous.

The progression from rocks and plateaus to promontories and mountain sides is a natural one. Simply enlarge the scale of the outlining and modeling strokes to combine the flat plateau structures with the large rock structures. By eliminating the base lines, the rock formations can even be transformed into huge mountains. Almost any of the outlines and modeling strokes on pages 119 to 122 can be used. (The separate techniques should not be mixed in one composition, however.)

The piled-up effect of the hemp fiber stroke is favored by many artists for painting mountains, because it is typical of the ranges in China that are composed of evergrowing peaks, each encompassing a previous one, like a long, fluid line of granite waves. This method may also be used for the slopes of hills.

Begin with the outline of the lowest, nearest mound or peak and use a continuous, fluid, arced stroke in light ink. Hold the brush obliquely. Ascend to the space behind this to place the next mound or peak enfolding the first. Continue to place the successive layers of the mountain structure in preliminary outlines, building up height and loftiness. The final peak or mound forms the outermost boundaries of the mountain or slope and the previous outlines form the inner structure, which serves as the foundation for the hemp fiber modeling strokes.

The outlines may ascend in a straight path, or in a wavering one; they may be sharply curved to show precipitous peaks, or softly flowing to show rolling hills or low-lying mountain ranges in the distance. Very often the mountain forms are shown emerging from soft mist, which nestles below the different peaks at high altitudes. To achieve this effect, the form and tone of each peak should be purposefully vague at its lower levels and seem to dissolve into the unpainted areas of the composition. When ink or color washes are applied in the final stages of the painting, they should be placed at the top of each peak and be allowed to fade into clearness at the lower levels. Use a brush with only clear water to blend the lower edges of the wet wash into the vacant, unpainted areas. This method is also used for distant mountains formed with washes alone.

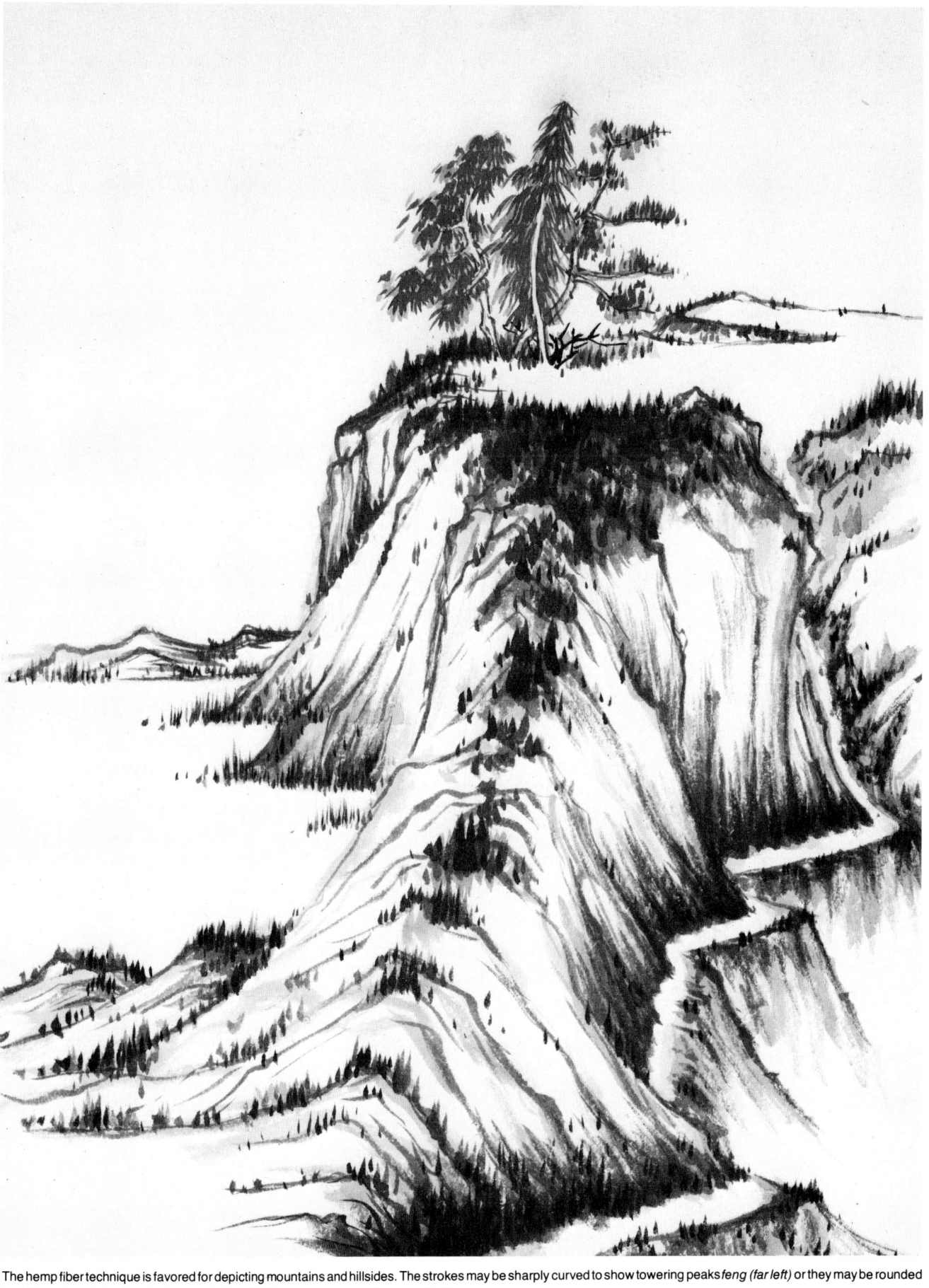

The hemp fiber technique is favored for depicting mountains and hillsides. The strokes may be sharply curved to show towering peaks *feng (far left)* or they may be rounded for hills and low-lying peaks *(left* and *above)*. The rounded summits are called *luan*.

In the grouping above, the large, host peak is surrounded by the lesser peaks. In the composition below, the dominant peak is at the right and the others are arranged like ministers ceremoniously bowing to their emperor.

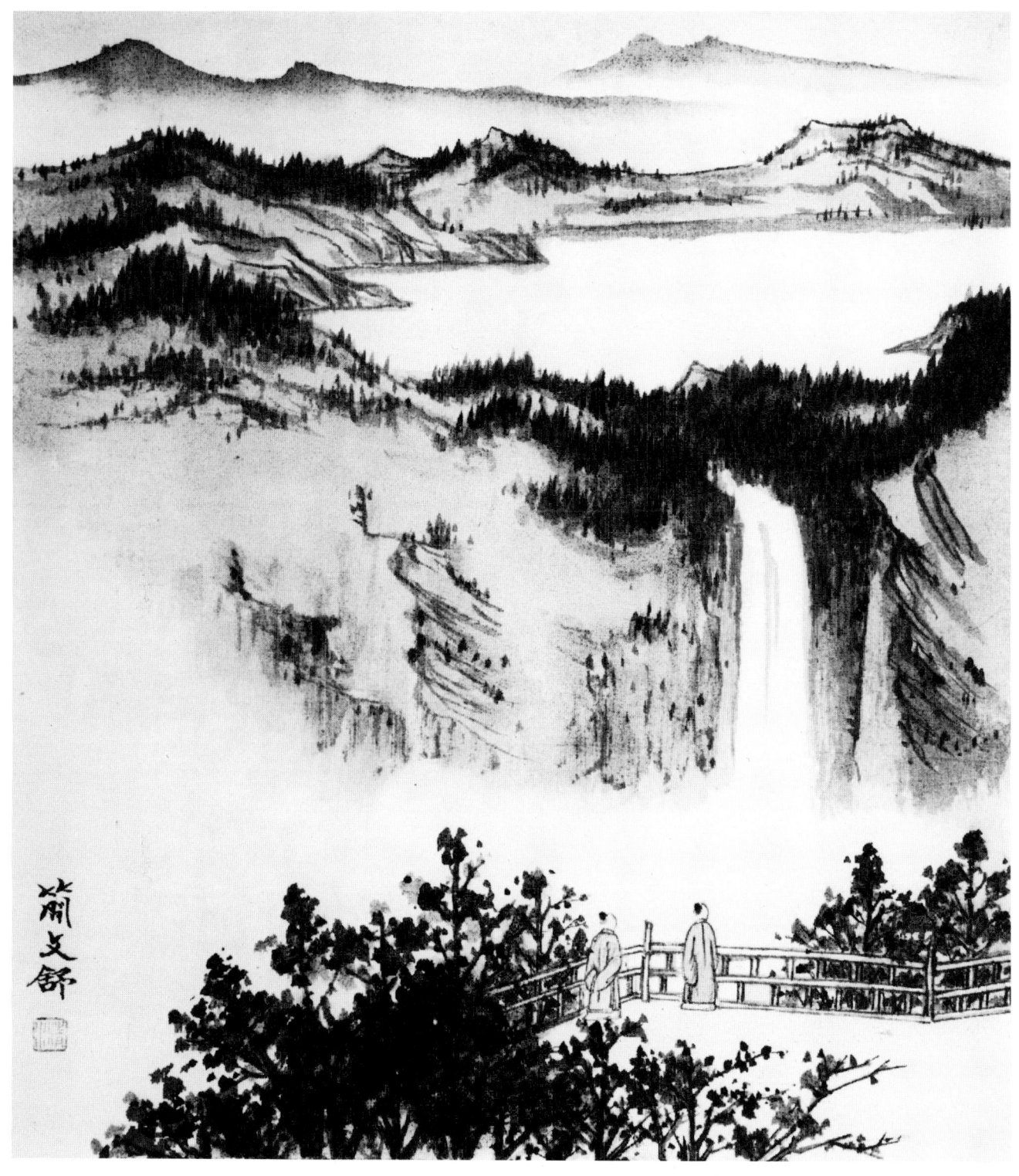

A traditional landscape in ink and color on silk. Mountains in the background are painted with washes alone. The tones are strongest at the peaks and fade into blank areas representing mist.

In combining separate groupings of hemp fiber (or other) mountain forms, it is possible to show the ceremonial aspect of the peaks, in which one large form dominates several small ones, which is likened to an emperor surrounded by his ministers. The dominant form does not have to be in the center of the grouping.

The mountains of a landscape should express the strength and spirit of the forms, their kinship with each other and to man. The mountains are greater than man, but man feels their friendship and understands his relationship to them. It is said, "I look at the mountain, and the mountain looks at me."

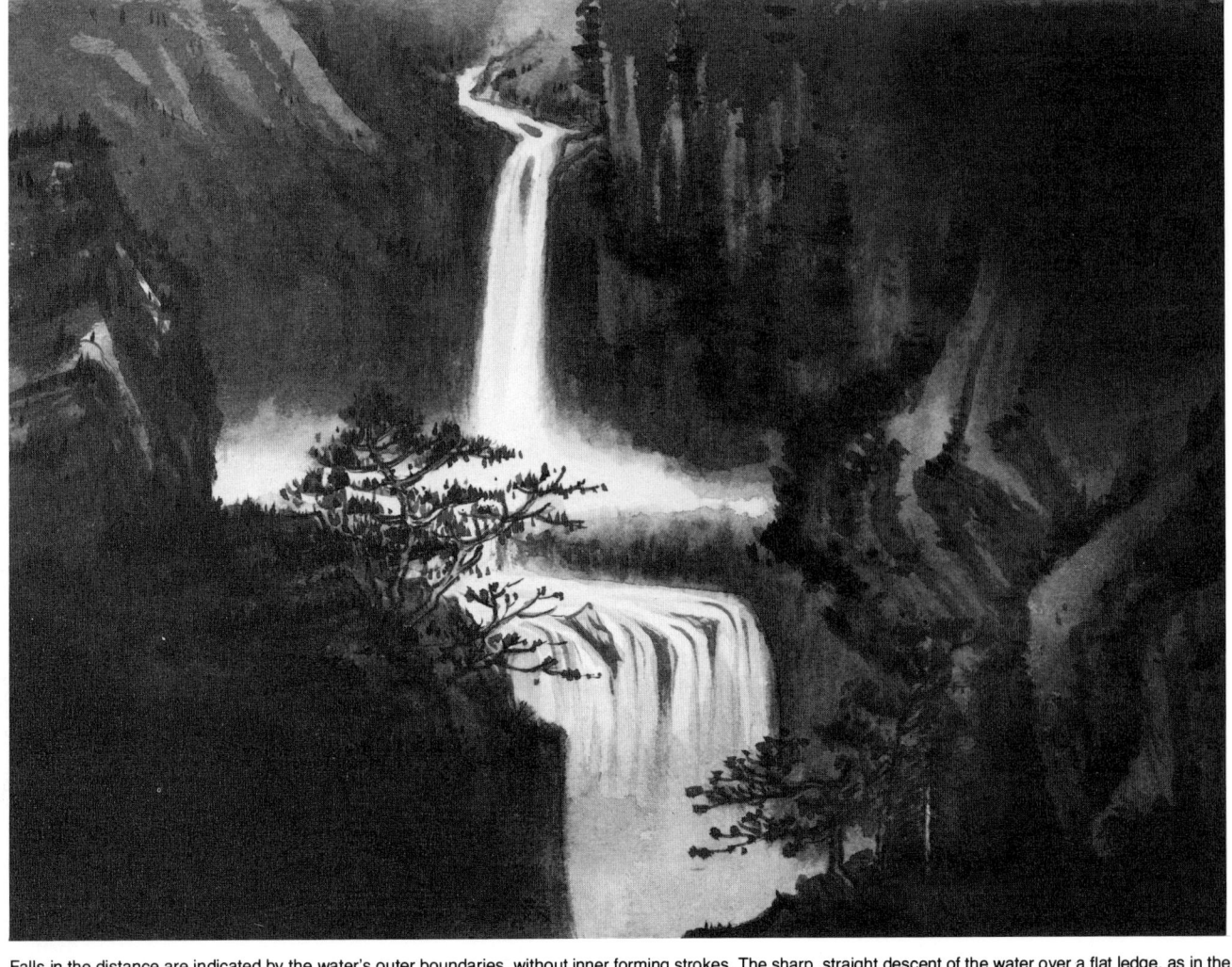

Falls in the distance are indicated by the water's outer boundaries, without inner forming strokes. The sharp, straight descent of the water over a flat ledge, as in the foreground here, is heightened by placing angular rocks in the water's path. This accents the flow by interrupting but not stopping it.

WATER AND WATERFALLS

Water in all of its many forms is the feminine element of a landscape, soft and yielding amidst the massive masculinity of the rocks and mountains. The strength of the water is in its ability to flow steadily on its course, overcoming all obstacles in its path, and wearing down all resistance to its fluid movement, until eventually the water itself shapes its surroundings. Therefore, whether you are painting the flow of shallow rapids arching in short curves over small rocks, the winding course of small cascades meandering down mountain slopes, or the furious descent of steep waterfalls bolting down from immense, almost invisible heights, the path of the water is established first.

This is done with thin outlining and modeling strokes expressive of the water's path and movement — the strokes may be a series of small, parallel curves or a series of longer, swooping ones, only slightly arced at the top. Always work in light ink first, with the tip of the upright brush, and move from the left side of the body of water to the right side. Where movement is slight, or is too distant to be seen clearly, outline only the outer boundaries of the water's path.

The areas between the strokes of interior movement, or between the outlined boundaries if no interior strokes have been used, are left as unpainted spaces. The surrounding elements of the landscape — the slopes of hills, the precipitous mountain cliffs, or the rock-strewn shores of fast-flowing rivers — are then placed in light ink. Trees may be shown looming in the foreground; boulders may be shown jutting from the water; clouds, mist, or land may be shown rising behind the water.

When the preliminary outlining and forming have been completed, you proceed to develop the mountain and tree forms with modeling strokes and dotting techniques as already described. The light, thinly drawn lines of the water may then be accented with medium ink, and dimension may be added with sparingly placed strokes or washes of very pale ink (or blue, in color).

The movement of water seen from a closer viewpoint is expressed with interior modeling strokes. Begin at the top of the fall and work downward. Show how the water alters its course as it meanders down the slope by changing the direction of each series of curved strokes. Pull each stroke down and outward as it descends and vary the length of these strokes.

Express the shallow rapids with short, parallel curves. The rocks and mossy embankments are placed after the water has been established with these strokes. Water eddying around rocks at the base of the falling water should be shown as coming from behind the rocks in curved lines.

Echo the rapid flow of water between two narrow embankments with short, swift strokes. In this case, outline the water's boundaries, the surrounding land, and the protruding rocks first.

The expanse of a body of still water — a quiet lake or pond — is formed almost entirely by its outer boundaries, which provide the foundation for the surrounding elements of jutting land and tall trees.

Rippling water and cresting waves hitting the rocks *(below, left)* are painted with the tip of the brush, first in light ink, then in dark ink. Long, fluid strokes state the rhythm, the rise and fall of the flow. The dynamic crests climax and break the ribbon-like flow but they still show rhythm and continuity in their forms. Stormy water *(below, right)* is more violent, with crests crashing in different directions.

Rocks protruding from the water have a flat base or no base at all. They should appear wet and may be darker in tone than those on land. In color, they may be washed with blue or green.

Above: Water cascading down a mountain is surrounded by steep slopes. The source of the falling water should be shown at the top of the mountain.

Right: The waterfall appears to be very steep but its real height is left open to question because its base is hidden by the rock in the foreground.

CLOUDS AND MIST

Clouds and mist are important elements, dividing or separating heavy masses of mountain structures, giving an upward thrust to the peaks, creating distance between the forms, and extending the vista in all directions. As in expressing the fluidity of water, the vaporous nature of clouds and mist is expressed by primarily unpainted areas. Leave empty space in the composition for these elements as you outline and build up the other forms.

The tops of low-lying clouds rolling through the scene may be outlined with thin, light, multicurved strokes moving in a overall, deliberate rhythm. Avoid uniformity of shape and rigidity of movement in the outlining, which is done with the tip of an upright brush. The preliminary outlines may be accented in narrower strokes of darker tone. Outlined clouds are never placed in an open sky; they appear more natural among the foothills or in the upper reaches of the mountain ledges and peaks.

The sky itself is usually left as a completely blank area of the paper or silk at the top of the composition. Sometimes, however, the sky may be rendered in a pale, even wash of light ink or blue pigment. In that case, washed areas of the sky may be faded into toneless areas, signifying high, distant clouds.

Mist in the mountains is handled like clouds in the open sky. The tones of the peaks are faded into empty space, where no outlining or modeling strokes are used. The crests of the peaks are darkened to accentuate the mist behind them. In order to indicate the continuity and solidity of the mountainous areas hidden behind the mist or clouds, the modeling strokes and tones of the visible peaks must diminish gradually in clarity and strength.

Above: Clouds entering a low-lying valley are stopped at the foothills of a rising peak, and the motion of these clouds, close to the earth, resembles the motion of waves.

Below: Clouds on a higher level travel in a circle around the mountain peak.

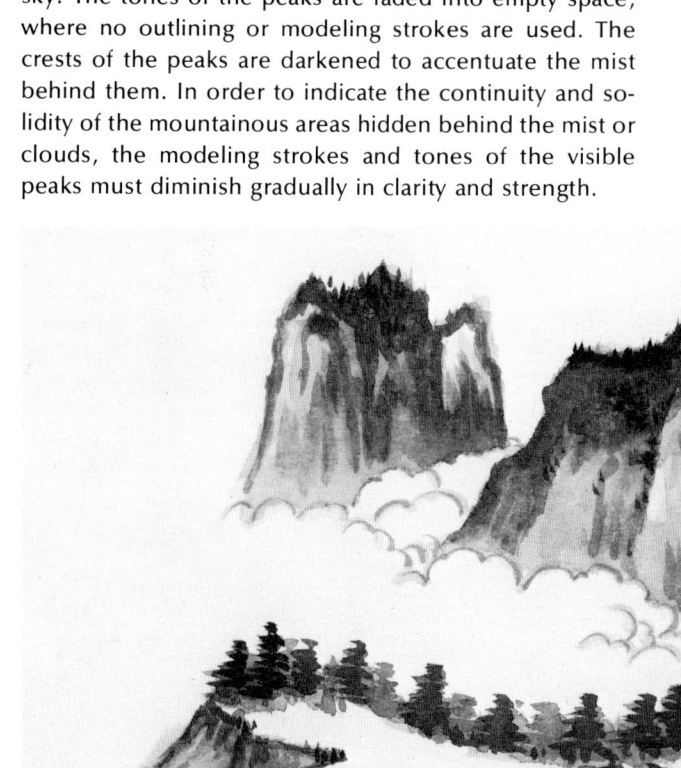

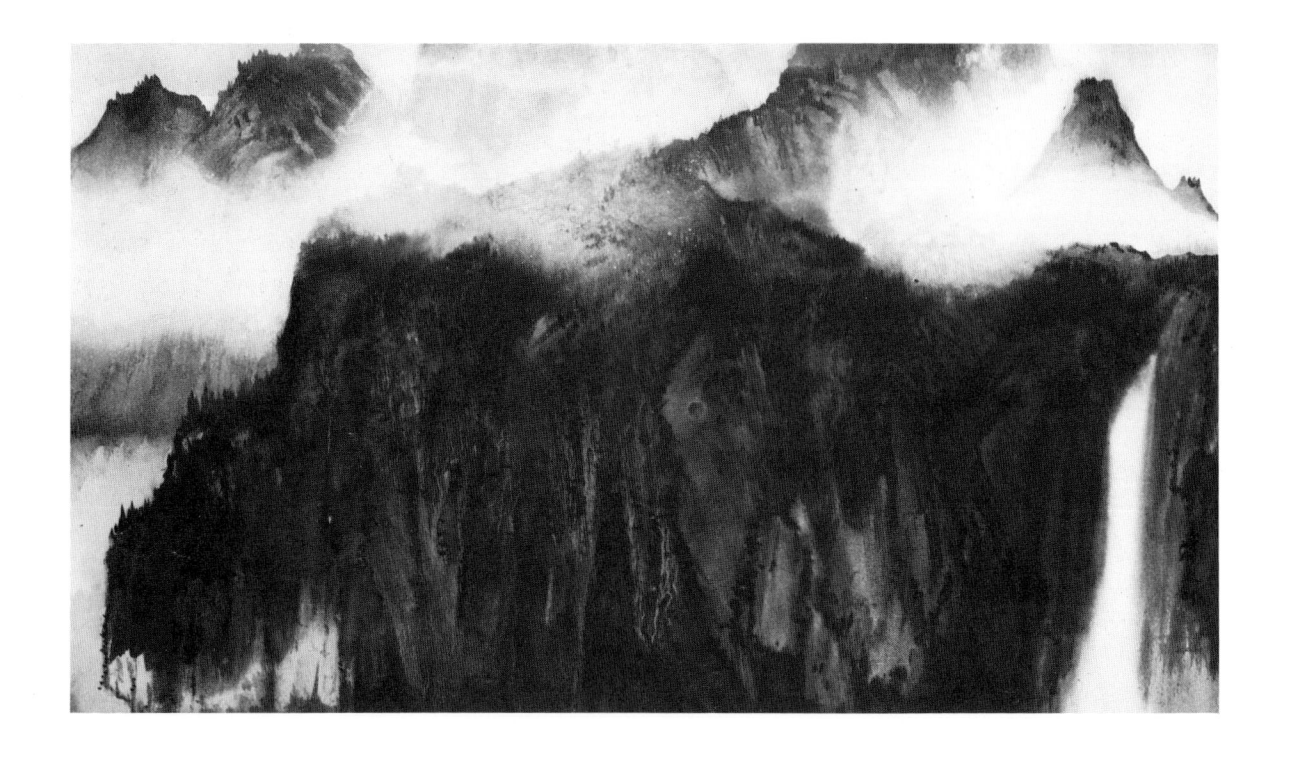

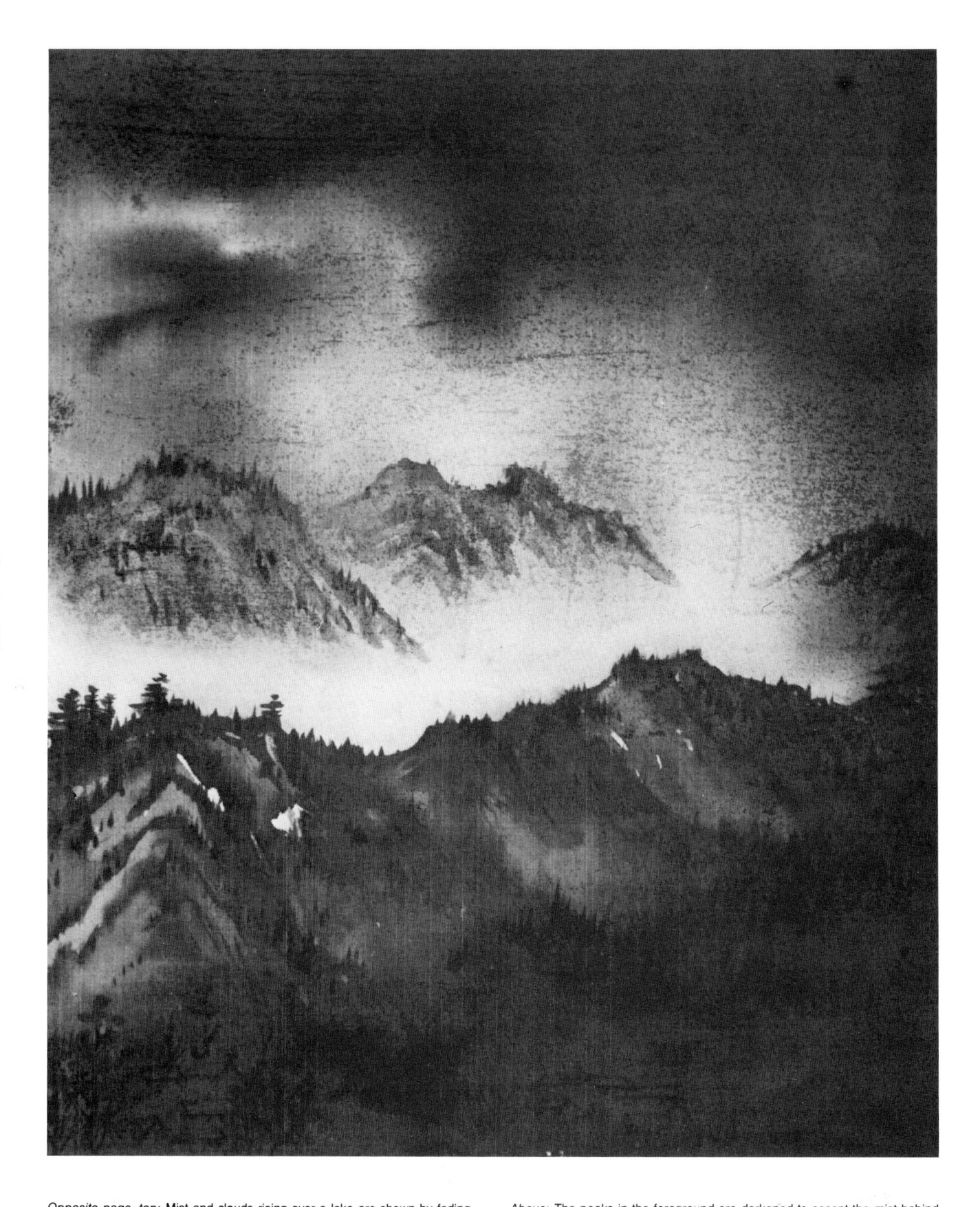

Opposite page, top: Mist and clouds rising over a lake are shown by fading parts of the lightly washed sky into vacant areas. *Opposite page, below:*

Pre-dawn, Himalaya Mountains (collection of Mr. Thomas Smetana); color on silk, 25½ by 14¾ inches. When mist nestles in the mountains, the modeling and tones of the peaks gradually diminish in strength until the forms disappear in the vaporous mist.

Above: The peaks in the foreground are darkened to accent the mist behind them.

Figures are suggested by attitude and clothing, without extreme detail. Outline with the tip of the brush in light ink first, then in dark ink. *Below:* A simple line drawing of children at play is a concert of gestures. The original is 8 by 2 feet, in ink on rice paper, and is called *Symphony*. A landscape background can be added to any such composition.

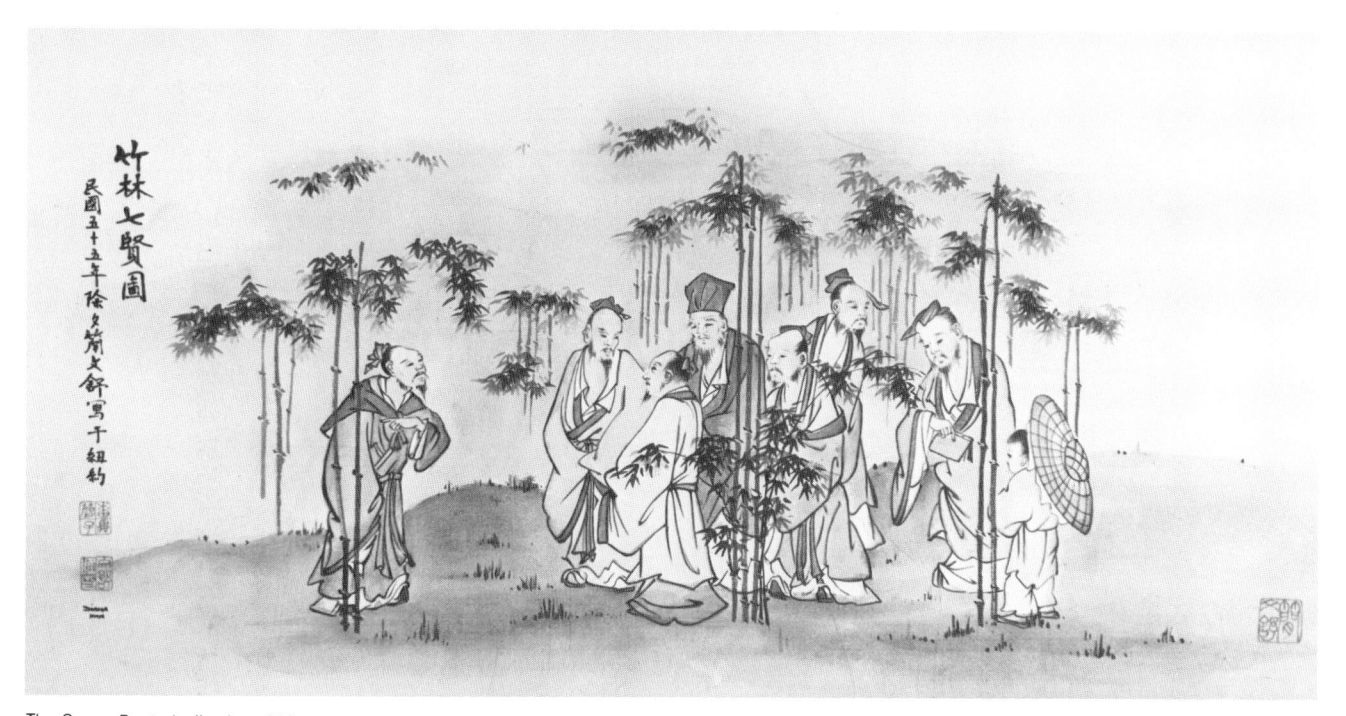

The Seven Poets (collection of Mrs. Janet Hutchinson); silk, 30 by 15 inches. This is a traditional subject reflecting literary gatherings in natural settings.

PLACES, PEOPLE AND THINGS

All evidence of human activity — the dwellings, temples, bridges, boats, and forms of man himself — generally takes place on different levels of the composition and contributes to the grandeur and perspective of the scene by its diminutive and fragile character. All of these forms are added as you construct the outlines of the trees, rocks, and mountains; and they are rendered in fine outlines and structural strokes, using the tip of an upright brush. They are not modeled for dimension, although flat, overall tone may be added with pale ink or color washes.

In the painting of figures, emphasis is on the position and gestures of the form as a whole, not on the details of anatomy or facial expression. The figures of scholars, philosophers, and officials are generally cloaked and the lines of the drapery are most significant in describing the forms. Figures painted apart from landscapes are done in more detail and form a separate catagory of Chinese painting, which we will not examine in this book.

The roofs of simple country huts, to which may be added the simple rectangular forms of the walls, doors, and windows, are sufficient indication of these dwellings. More elaborate multi-leveled homes with tiled roofs and columned porches may also occasionally appear in mountainous landscapes (see page 101), but as they generally belong to wealthier people, they are more common in town settings.

Detailed figures may be used in the extreme foreground of a landscape, but are generally in a separate category of painting.

137

White Cloud (collection of Mr. and Mrs. Lawrence Ketover); silk, 13½ by 16½ inches. *P'o mo* technique with mineral blues and green, white, and some indigo and burnt sienna.

Sunset; silk, 44½ by 18 inches. *P'o mo* technique with mineral colors (cobalt blue, emerald, and viridian) over washes of indigo and cadmium red. The foreground trees are in mineral yellow, cadmium red, and sienna.

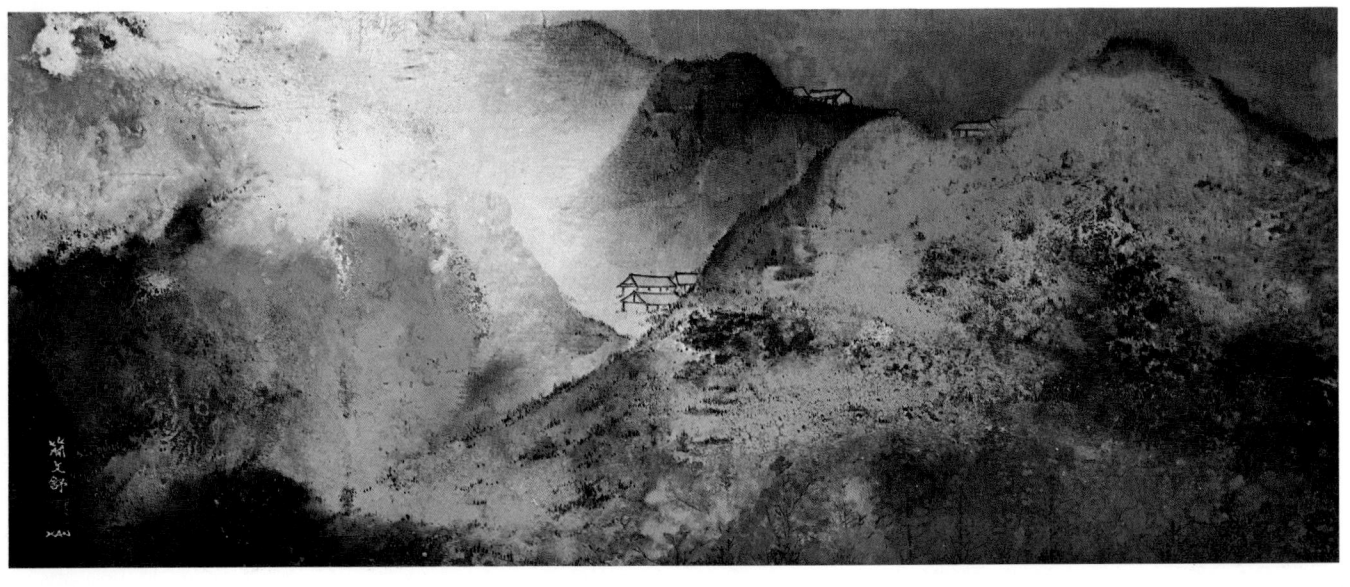

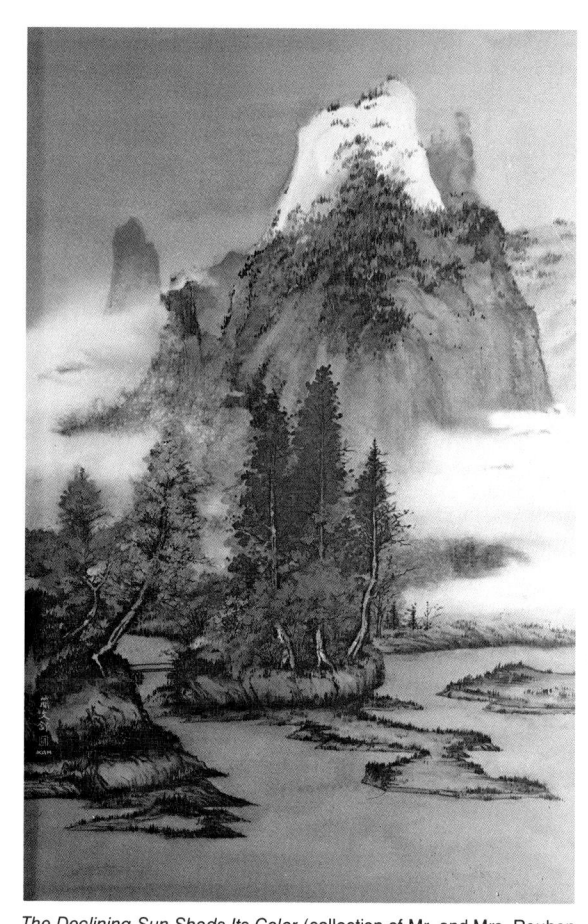

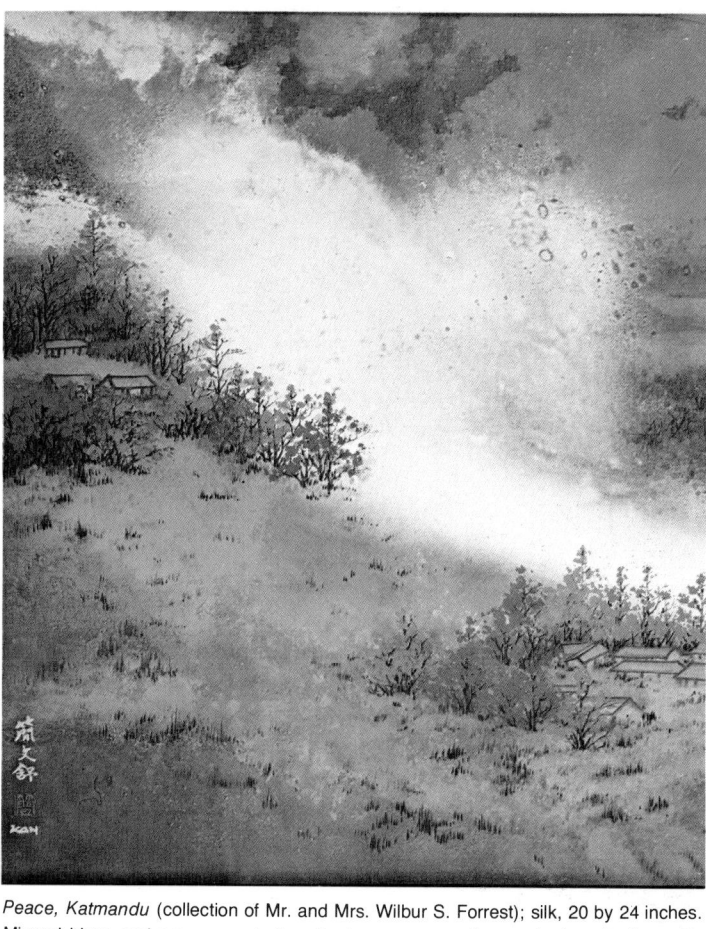

The Declining Sun Sheds Its Color (collection of Mr. and Mrs. Reuben Plevinsky); gold leaf, 24 by 36 inches. Mineral blue and green over a cadmium red wash. Three trees in the center are in indigo; the others are in vermilion and mineral yellow with umber.

Peace, Katmandu (collection of Mr. and Mrs. Wilbur S. Forrest); silk, 20 by 24 inches. Mineral blues and green over indigo; the trees are vermilion and mineral yellow with umber. There is pearl powder in the white.

Autumn (collection of Mr. and Mrs. John W. Payson); gold leaf, 48 by 24 inches. Mineral blues with a touch of indigo and some burnt sienna in selected areas. The trees are primarily vermilion and alizarin crimson, and the white is mixed with pearl powder.

Houses should not be scattered carelessly throughout a landscape. Rhythmic groupings should lead the eye from one house to another.

Above: Pavilions offer a place of rest and quiet enjoyment and they are often placed on the plateaus of a mountain. The roof may be thatched or tiled, and the pavilion may be elevated by a platform. *Below:* Pagodas with balconies or observer's decks may also serve as a platform for viewing the scenery high in the mountains. Protective walls topped by a gate house may surround country estates.

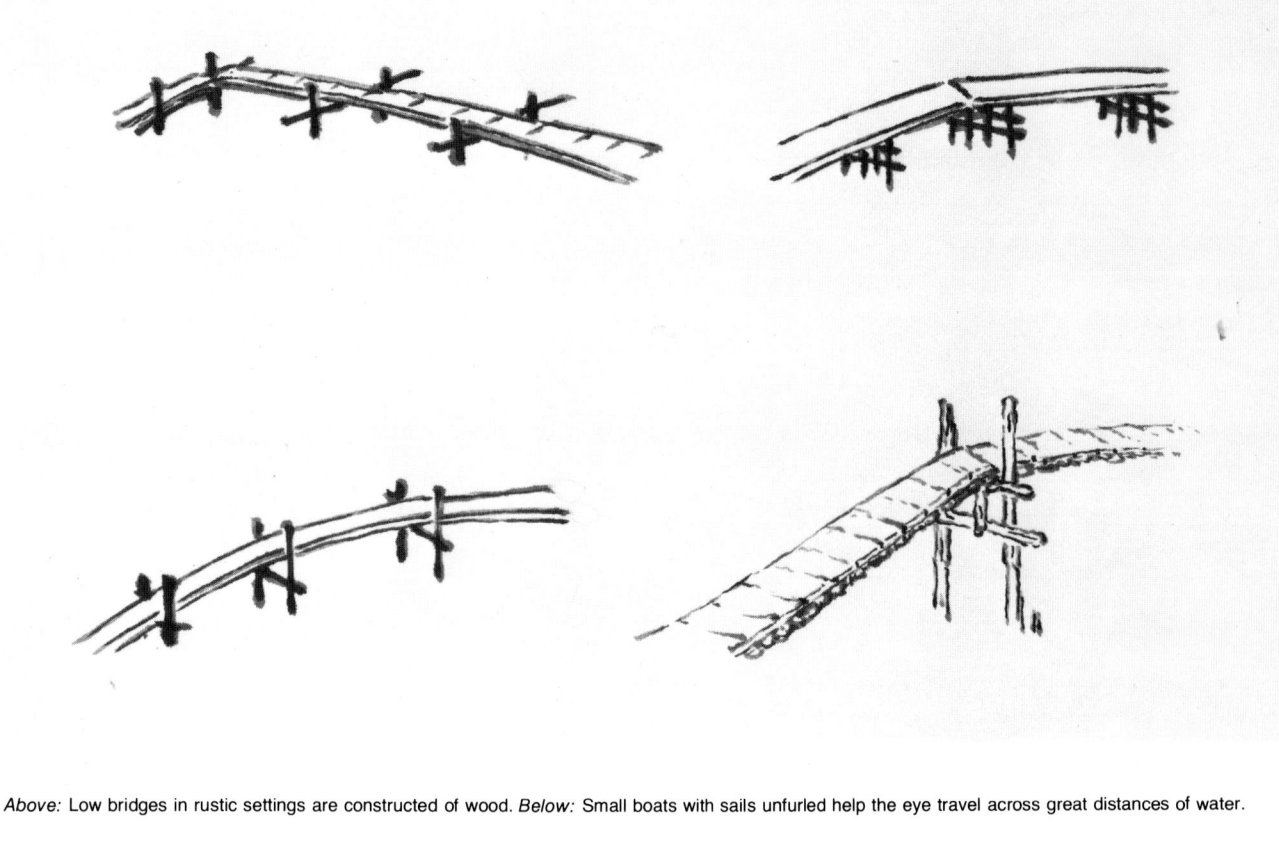

Above: Low bridges in rustic settings are constructed of wood. *Below:* Small boats with sails unfurled help the eye travel across great distances of water.

Above: Stone bridges are higher than wooden ones and vary in construction. They may have smooth, flat stones, or rough, round ones. They may have steps on the top surface and they may have rails at the sides. *Below:* Boats at rest in the foreground may have added details such as wooden cabins or rounded sheds of woven bamboo. The sails are usually not in use.

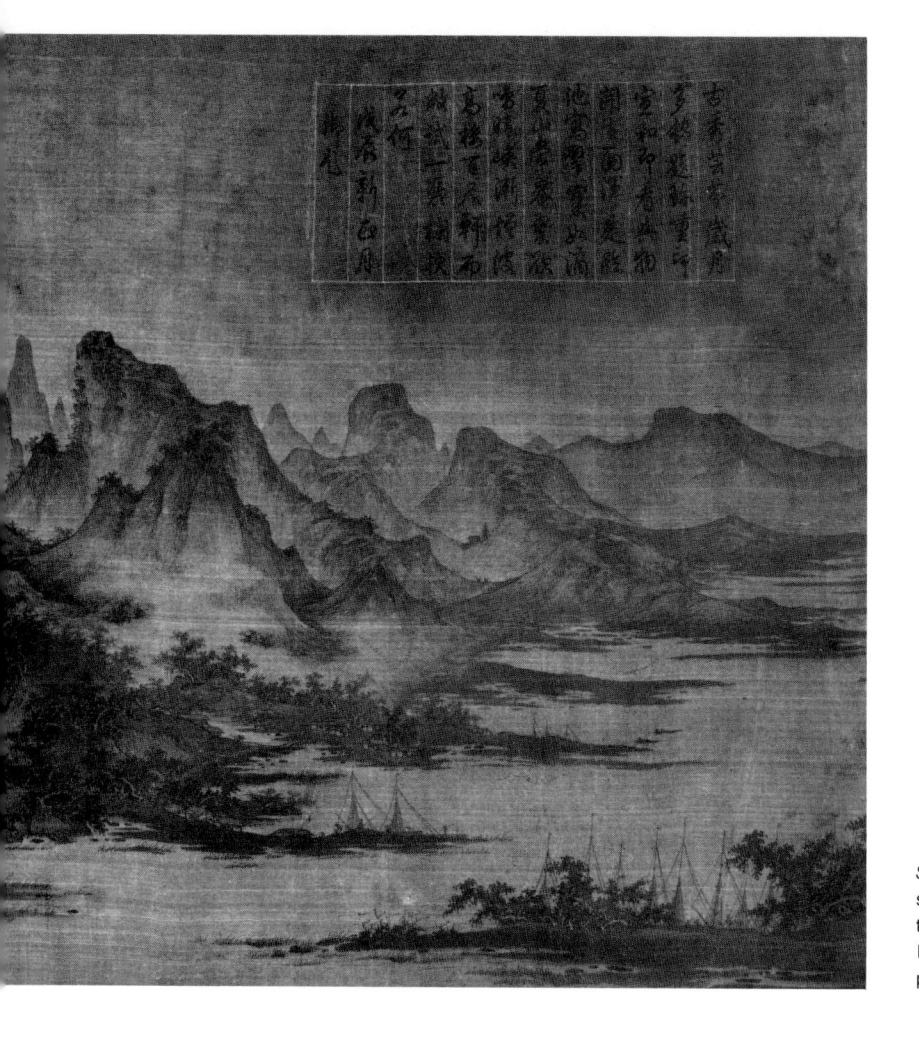

Summer Mountains, Ch'ü Ting (active ca. 1023–1056); hand scroll, ink and light color on silk, 45¼ by 17¾ inches. (Courtesy of the Metropolitan Museum of Art. Gift of the Dillon Fund, 1973.) All the landscape elements are combined in a panorama meant to be viewed slowly from right to left.

Opposite page: Detail of *Summer Mountains*. Note the multi-storied dwellings, the bridge, and the strollers near the water. The diminutive size of these human elements increases the grandeur of the mountains.

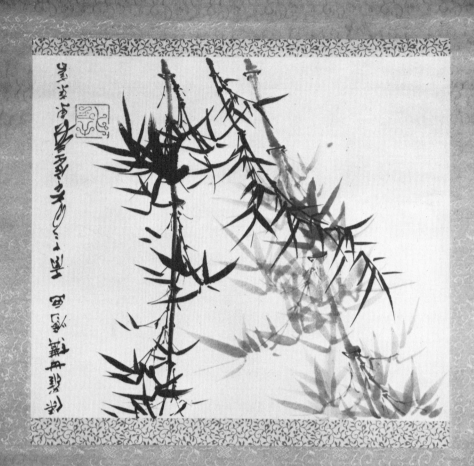

9. Scrolls and Seals

SCROLLS AND ALBUM LEAVES

In the museums of the world, we see Chinese paintings encased in glass and firmly mounted on high walls. In Chinese homes, however, paintings are not meant to be permanent fixtures; they are highly prized possessions and, as such, they have always been in a form that is easily transportable. There are actually three basic forms for these paintings: the vertical hanging scroll, which is hung on the wall for short periods of time and which is then rolled up and stored while a different scroll is hung in its place; the horizontal hand scroll, which is ceremoniously unrolled, a small section at a time, as it is placed on the table for viewing; and the small album leaf which, together with other album leaves, forms a collection of illustrations that may be brought out and looked at page by page like a book.

Bamboo, Professor Chang Dai-chien; rice paper, 17½ by 20¼ inches. (Collection of Mr. Paul Schwartz.) The painting is mounted and matted as a hanging scroll, with borders of silk brocade. According to tradition, the side margins are narrow, and the top margin is taller than the bottom one. Two additional, smaller strips of brocade are added at the top and bottom edges of the painting.

The form of the vertical hanging scroll was probably derived from the ancient Buddhist temple paintings on long banners of silk which, because of their convenience, replaced religious wall frescoes. The vertical scroll is mounted on silk or paper and is matted with strips of silk brocade, with the borders specifically proportioned to place more space at the top, indicating heaven, and less at the bottom, indicating earth. Both sides of the matting are narrow. A flat or half-round piece of wood is added to the top, and a ribbon for hanging is attached. A round dowel is added to the bottom to weight the scroll and to help it hang flat against the wall. In addition, handles may be placed on the ends of the dowel to help roll the scroll up when it is to be stored. These vertical scrolls are displayed according to the occasion; they may be changed to indicate the appropriate season, or to honor the visit of a friend, for example. If the scroll is especially old and valuable, it may be brought out for only a brief viewing.

The horizontal hand scroll is matted with narrow borders at the top and bottom and larger ones to either side. It is a form unique to Far Eastern painting. Although it is usually no more than 19 inches in height, its length may run to 30 feet or more. It is never intended to be unrolled

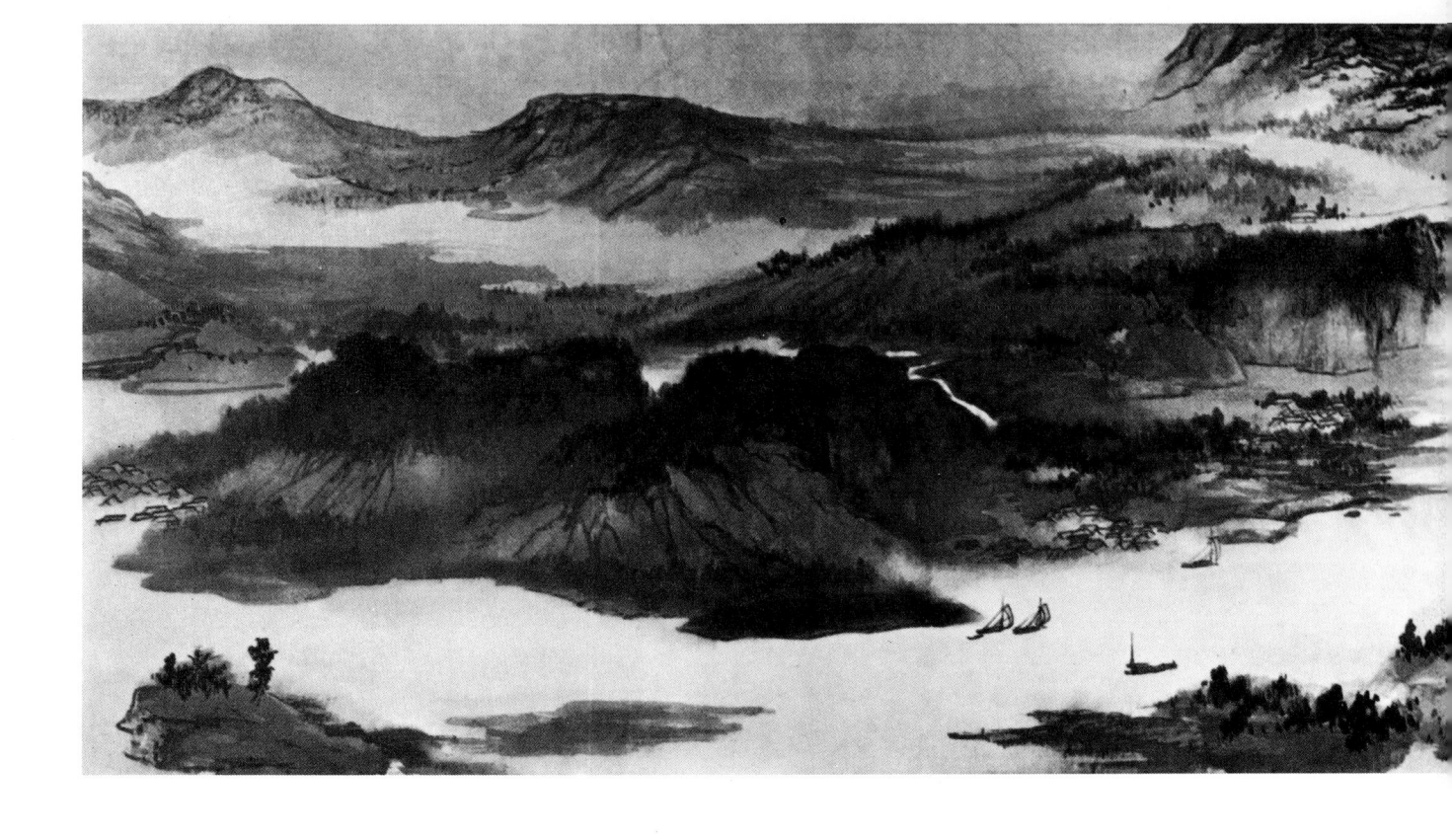

along its entire length, however; instead, the closed scroll is held in the left hand and is opened by the right hand to reveal only the right side of the painting, which is read first. The viewing slowly progresses a foot or so at a time toward the left side of the painting, with the right hand drawing out each new section as it rerolls those sections already seen. After all the sections have been viewed, the painting is rolled back into its original position, by feeding the scroll back to the left hand, which does the rerolling around the dowel at the left side of the mounting.

As the scroll is unfurled and viewed, each section of the painting presents a pictorial whole, but each also leads inexorably to the next, and, as the painting unfolds, the observer becomes a participant in a long journey through the valleys and streams, the forests and rocks of the progressive scenes. Not only do the scenes move the viewer from one place to another, and from one vantage point to another, but they move him through time as well. In the art of painting, this dimension is uniquely Far Eastern, and it enables the artist to compose and orchestrate his painting in a manner akin to that of music or narrative literature, establishing themes, then developing and reiterating them.

Museum exhibition methods make it necessary to show as much of the landscape scroll as possible at one time. It is suggested, however, that the visitor view these horizontal paintings by moving slowly from the right side to the left, examining only a foot or so at a time, because the compositions are most carefully constructed to be viewed in this way and no other.

Album leaves are of much smaller dimensions than either hanging or hand scrolls. There are in general two kinds of these paintings. The first kind is made by mounting small paintings that have been obtained from such sources as the faces of fans or the fragments of a larger, damaged painting. The custom of making these leaves and gathering them into an album collection probably began during the Sung Dynasty (960–1280), and it has been very popular ever since. The second type of album leaf developed at a somewhat later date, probably during the Yuan Dynasty (1280–1367). These leaves are pictures that have been specifically painted in album form. Frequently, they are painted in sets of six, eight, ten, or more. Both types of albums are taken out and perused at leisure as if reading an enjoyable book.

SEALS AND COLOPHONS

Upon completing a painting, the artist often writes a poem or reflection of his own that is appropriate to the subject of the painting, and he studiously places it where it will enhance the composition. Under this calligraphy, the artist places the imprint of one or more seals identifying himself. The seal may bear his given name, his family name, his artistic nom de plume, the name of his home or household, the date of his birth, a poetic phrase, or a pictorial symbol.

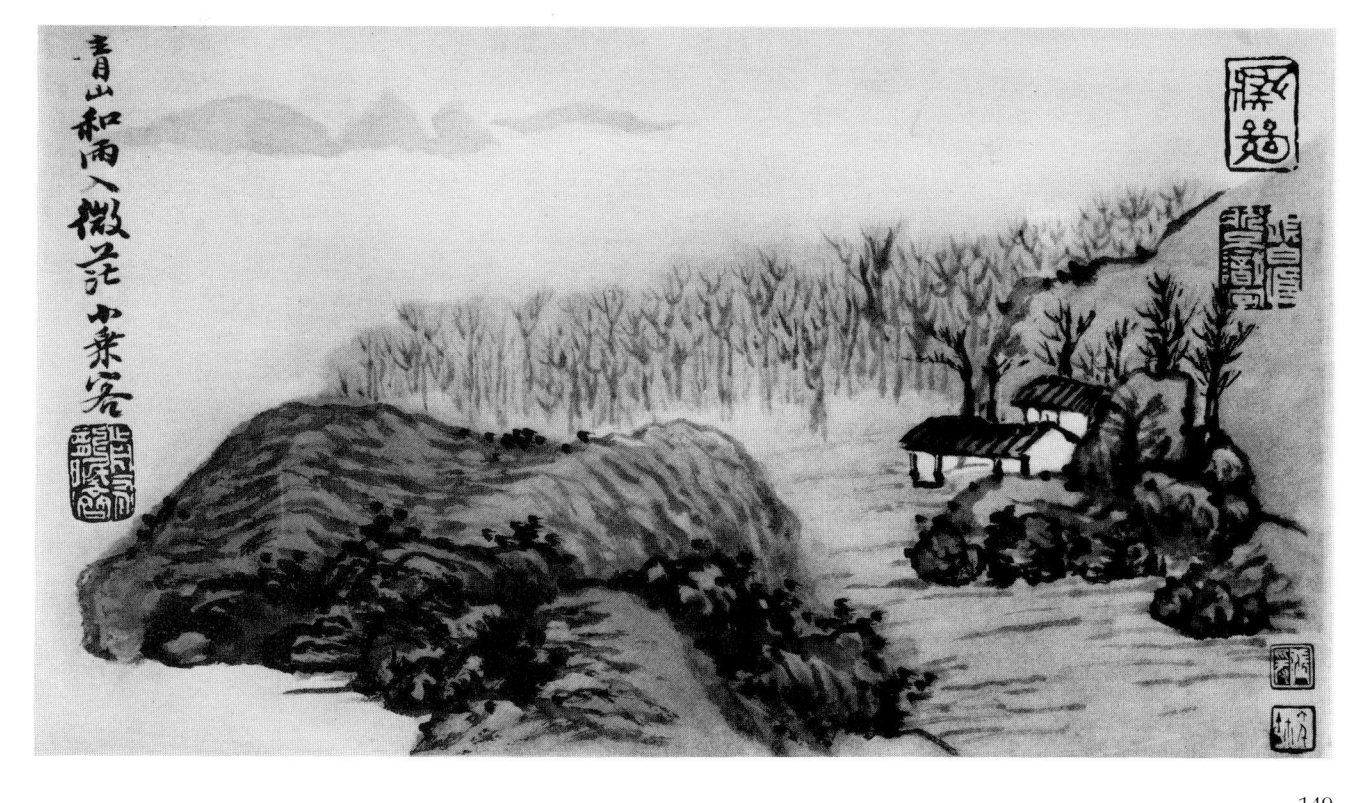

Above: The Great Yangtze River, Professor Chang Dai-chien. (Collection of Chang Chun.) The complete hand scroll, painted on silk, measures 21 inches in height and 786 inches in length. These two sections are from the center of the scroll. Reading from right to left, the section directly above is number ten and should be viewed first. Section eleven, on the opposite page, is viewed next.

Below: Album leaf from a set of eight, by Shih-t'ao (also called Tao-chi; lived 1641 to 1707). (Collection of John M. Crawford, Jr.) The original painting, in ink with light color on paper, is 9½ inches high and 17 inches wide. The poem at the left says, "Green mountain, soft rain blend gently with the small traveler," and it is followed by the artist's seal. The two seals at the upper right are also the artist's; the two at the lower right are the collector's seals.

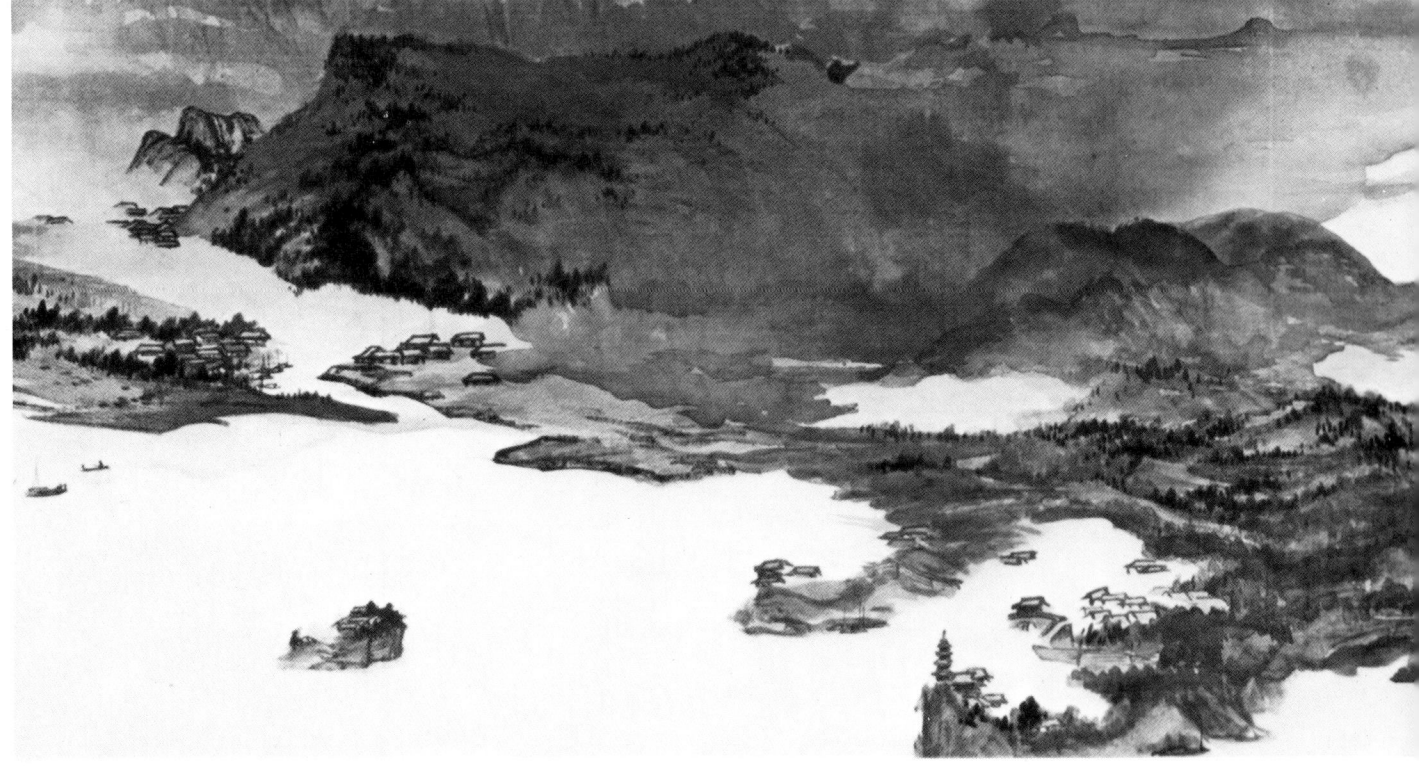

Sections fifteen (on the opposite page) and sixteen (above) of *The Great Yangtze River* scroll, to be viewed from right to left.

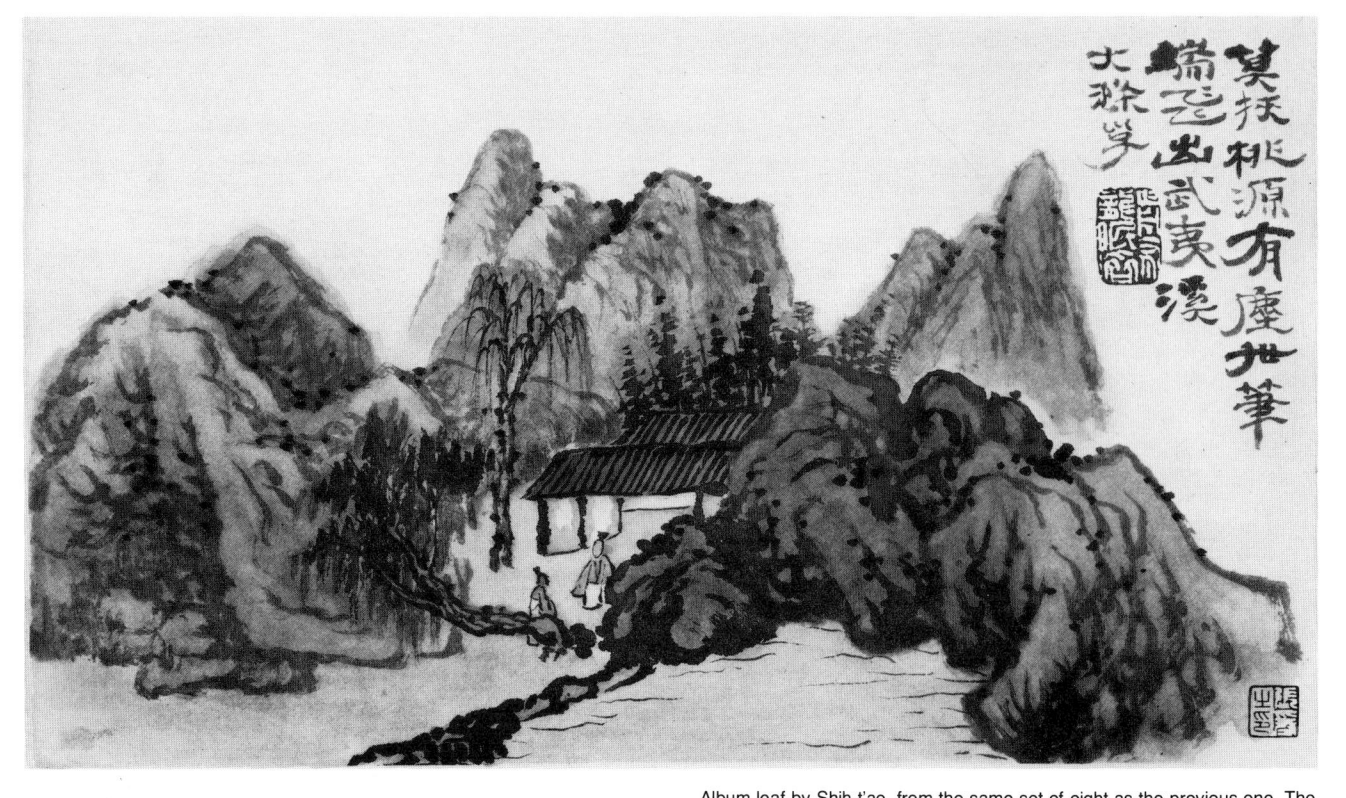

Album leaf by Shih-t'ao, from the same set of eight as the previous one. The calligraphy here says, "The Shangri-la in this dusty world is that from the artist's brush comes a brook with gentle water." Note that the artist's seal under the poem has white (negative) characters and the collector's seal at the bottom-right corner has red (positive) characters.

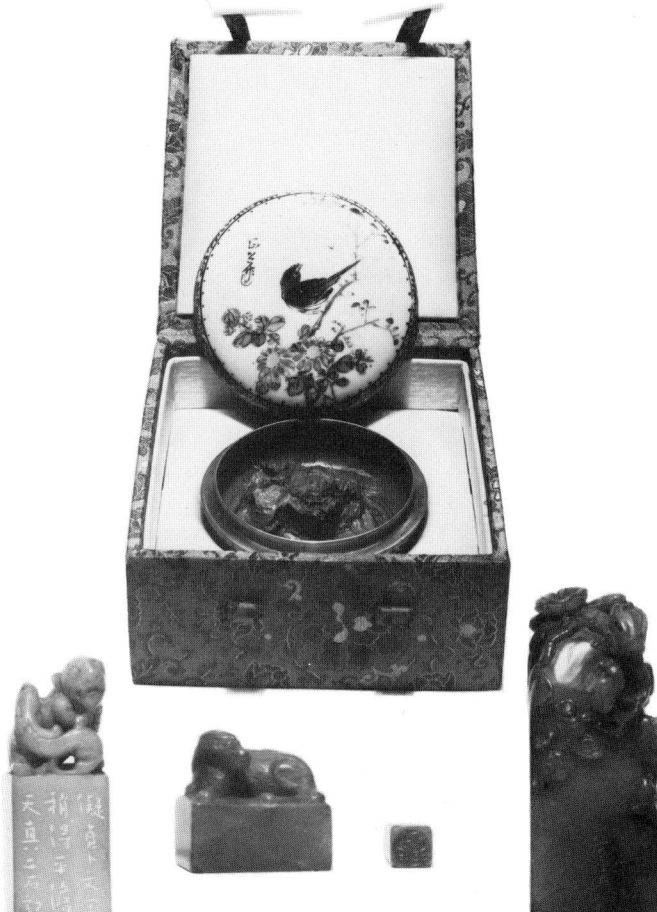

Each seal is inked by pressing it into a red, gummy paste, made of cinnabar, mineral oil, and raw silk. If the characters of the seal have been carved in relief, they will appear red against a white ground *(yang)*. If they have been engraved in intaglio form *(yin)*, they will appear white against a red ground. Intaglio and relief seals are usually used together, to balance one another. After the imprint has been made, the ink must be wiped off the seal to avoid clogging the characters. Many seals of jade or ivory have become works of art in their own right, with beautifully carved lions, dragons, monkeys, or landscapes decorating the handle and with perfectly composed calligraphic characters on the forming face.

Collectors of art also have seals and their use on Chinese paintings is very important in verifying the artist's identity, and in providing a pedigree of possession. Each successive owner may affix his seal at an outer edge of the composition and, according to the prestige of the collectors, these seals may enhance the status and material value of a painting.

In addition, a collector might also add an inscription giving information about the artist, the painting, or himself. Such an inscription is called a colophon, and it is usually placed outside the painting, on a separate panel attached to the hand scroll or on the bordering mat of a hanging scroll. The collector, or the artist himself, might ask an art critic to authenticate the work with a colophon. When necessary, the painting may be remounted to make room for the colophons and seals. Occasionally, however, seals and colophons may spill over from their marginal positions, and these sometimes tend to mar the composition.

The color and quality of the seal paste used for the artist's imprint can help determine the painting's authenticity.

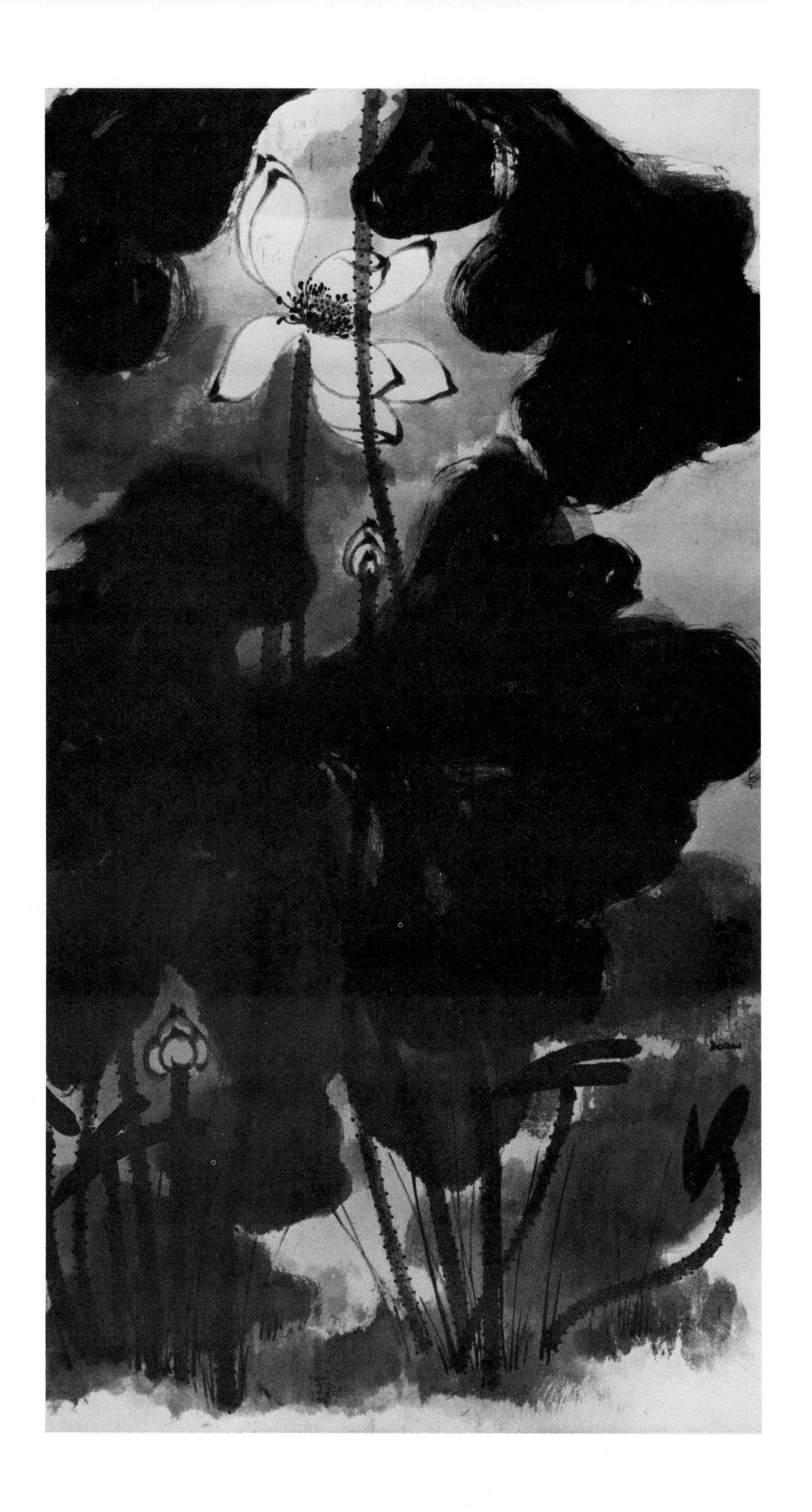

10. The Lotus

The Chinese say that, once having seen the growing lotus, one never forgets it. The rosy pink, pale yellow, or creamy white lotus rises from the water in stately beauty to a height of six or seven feet. A separate, long, tubular stalk supports each flower and each large, round leaf. At times, the diameter of a lotus leaf stretches to two or three feet across the water's surface. The stalk is centered beneath the leaf, whose veins radiate out to the circumference.

Seeded in muddy waters, the immaculate rise and the brief life span of the lotus in bloom demonstrate anew the rhythmic continuity of nature. The flowers are open and animated for just three days. Then each petal falls silently into the water, one by one, at short intervals. The large, green seed head is thus left exposed at the top of the stalk, surrounded only by innumerable, shimmering, thread-like stamens, which are soon blown away.

The seed head, or pod, is a unique receptacle for the lotus seeds embedded in the flat surface at the top of the cone shape. Once the petals have fallen, the pod reverts to the water, where it floats face down, allowing the seeds to take hold in the mud below, where they will germinate and give rise to new lotus plants.

The lotus has been celebrated in literature, fables, and song since the days of ancient Egypt, Greece and Cathay. Homer's mythical land of the lotus-eaters has its origins in truth, for the seeds are still gathered by the young and old to induce a feeling of calm and repose, to ease pain and bring forgetfulness. All the parts of the lotus are in fact edible, whether eaten cooked or raw, and food wrapped in lotus leaves is said to absorb its fragrance. In the daily lives of the Chinese people today, the lotus plays a significant role, whether it is encountered by boatsmen pushing through the thickets of man-made lakes and canals, or whether it is carefully cultivated in huge jars embellishing the courtyards and gardens of city and country homes.

Opposite page: Lotus; ink on silk, 28 by 50 inches. Collection of the National Historical Museum, Taiwan. *Below:* The lotus originates in muddy water; each long, tubular stalk rises separately to support a large, round leaf or a single blossom.

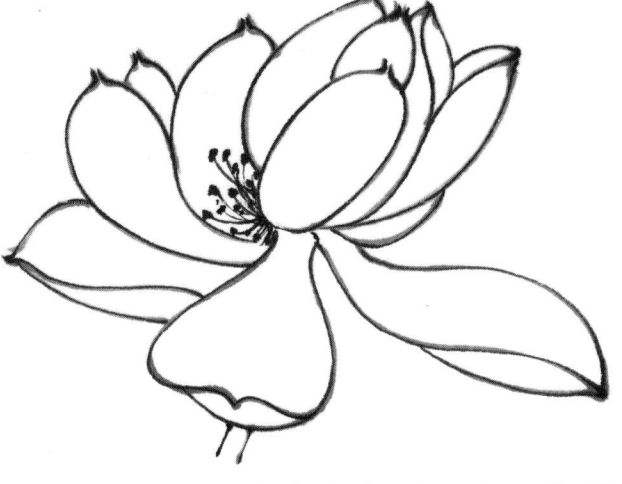

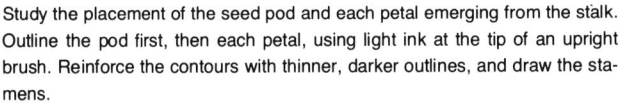

Study the placement of the seed pod and each petal emerging from the stalk. Outline the pod first, then each petal, using light ink at the tip of an upright brush. Reinforce the contours with thinner, darker outlines, and draw the stamens.

Before you take brush in hand to paint, ponder and plan the composition. Every component part of the flower must be in relation to the others. It is very important to unify the disparate elements. If the seed pod, for example, is not properly placed, the whole composition will be wrong. The order of painting, in contour style, is first place and outline the seed pod and the small circular seeds; then outline the petals. Note that the petals emerge from the base of the pod and that, where they overlap and hide the pod, you must leave space in the initial outlining.

Where no petals are present, leave the base of the pod open so that, when the stalk is added later, the joining will be smooth. All of these outlining strokes are done with an upright brush, in light ink first, and are then reinforced with fine, thin strokes. Use the tip of your number one brush for the preliminary outlines and the tip of your smaller number three brush for the dark outlines. The stamens, which are added next, are drawn and dotted with the number three brush in dark ink only.

Place and outline a bud, if you wish, omitting the hidden pod and stamens. Outline the various forms of the leaves next, first in light ink and then in dark ink. Show the leaves in different stages as they unfold from tightly closed positions and grow into large, circular forms. Draw the veins radiating from the center of each leaf, and note that alternate ones are forked at the edge of the leaf instead of meeting it in a straight line.

Again, you must leave space in the outlines for overlapping forms, this time for the stalks, which are added last, with long, smooth lines. Observe that each flower, bud, and leaf is an individual structure and each is supported by a separate stalk.

Opposite page: After placing the blossoms and buds, outline the leaves in two tones of ink and add the veins radiating from the center. Alternate veins are forked at the circumference. Finally, place the stalks.

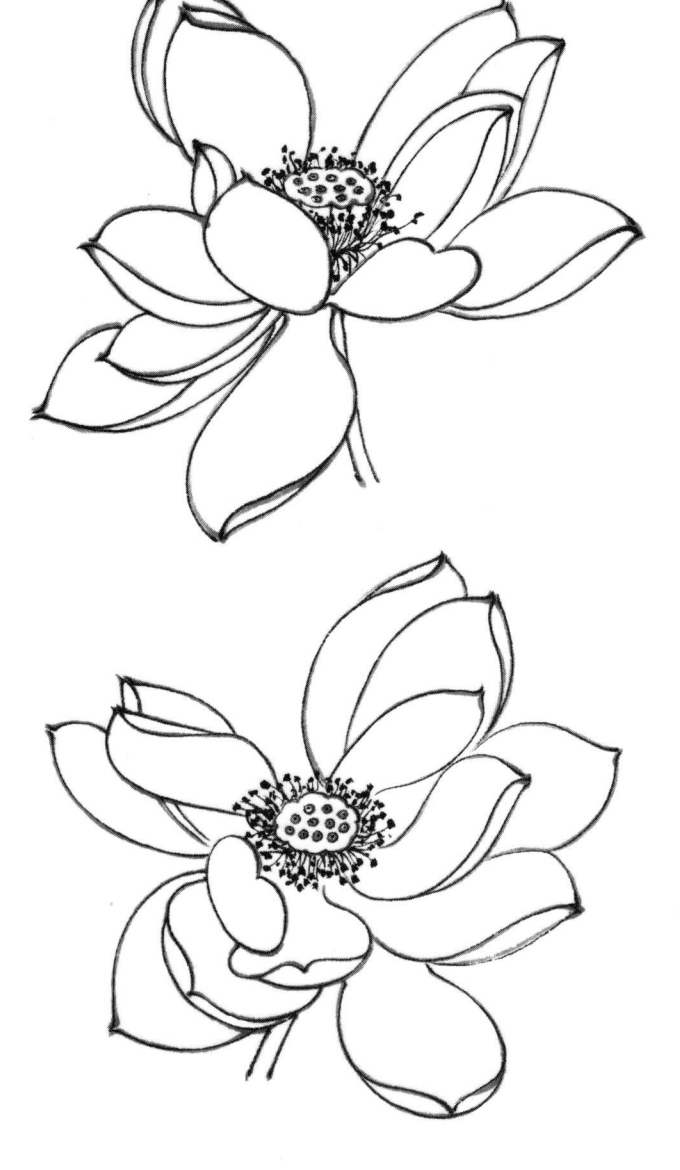

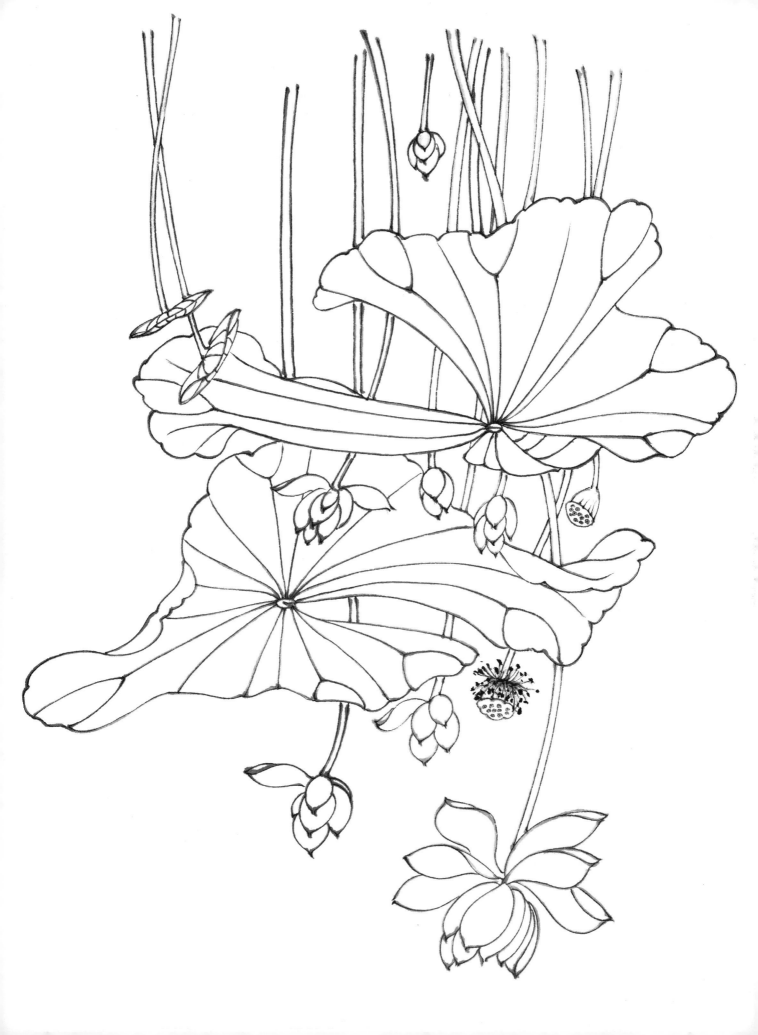

The petals are actually very finely veined. It is not necessary to include this feature; if desired, however, the veining may be shown with light-toned ink, alternating wavy and straight, thin lines.

As further elements in the composition, veining may be added to the outer surface of the petals, alternating wavy vein lines with straight ones; and the wheat stalks that grow in the pond with the lotus may be included in the outlining.

When the contour style is done in color, all the forms are outlined first in light ink. Each vein of the leaf is drawn with two lines, and the space between these lines remains unpainted. The remainder of the leaf is filled in with layers of moderately thin, green paint in various tones, working from the lightest to the darkest. The seed pods are painted in layers of light green building up to a medium green. The seeds themselves are dark green and are accented with an outline of yellow. The petals receive a pale color wash at the edge of their outer surface, and are veined in the same color, usually rosy pink. The stamens are yellow lines dotted with white. The stalk is striped in light and dark green and is stippled with black accent dots.

Composition with veined petals. For color, only light gray outlines are used and the contours are filled in with washes (see next page).

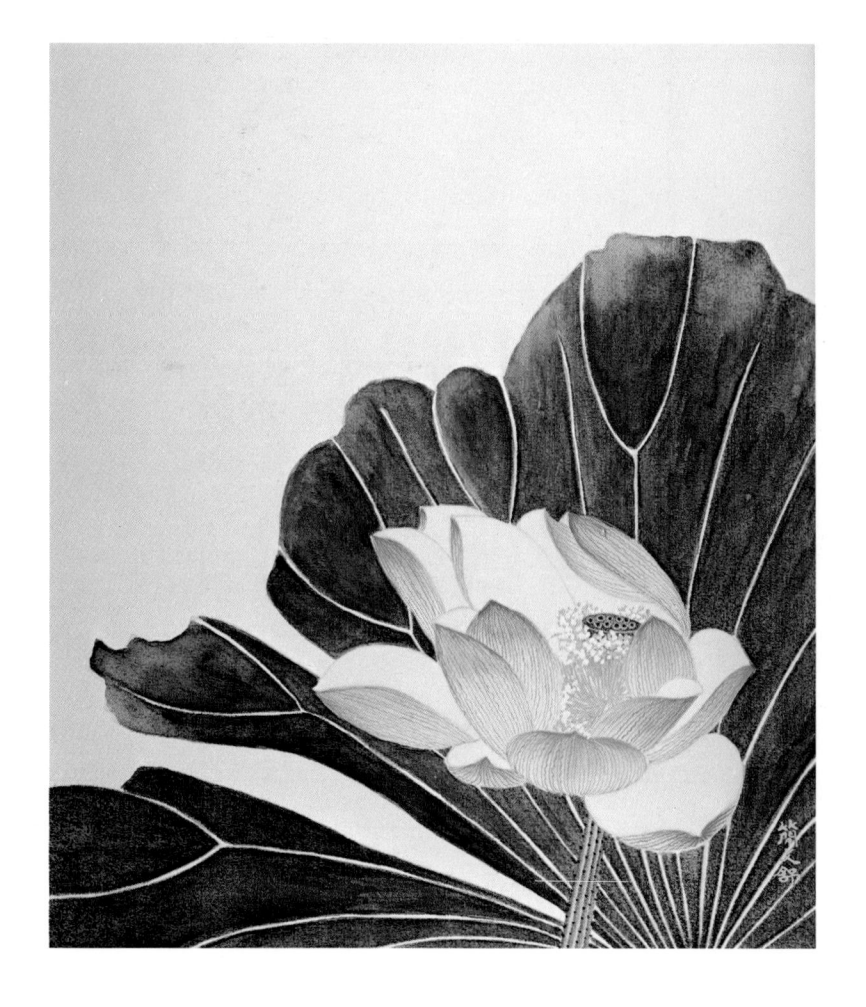

Right: The contour-style leaves are filled in with green washes, except for the veins, which are outlined and left unpainted. The petals, outlined in light gray, receive a faint wash at the edge of each outer surface, and veins are added in thin lines of color. The stalk is striped in light and dark green and has black accent dots. Stamens are in yellow dotted with white.

Below: When the leaves are painted in *mo ku* style, the outlined petals may be filled in with an appropriate color (rosy pink or pale yellow) over a base coat of white, using the same technique as for chrysanthemum or orchid. The leaves are done with broad ink strokes overlaid with color. The large leaf in the background here was washed with yellow-green and the one in the foreground was overlaid with emerald green.

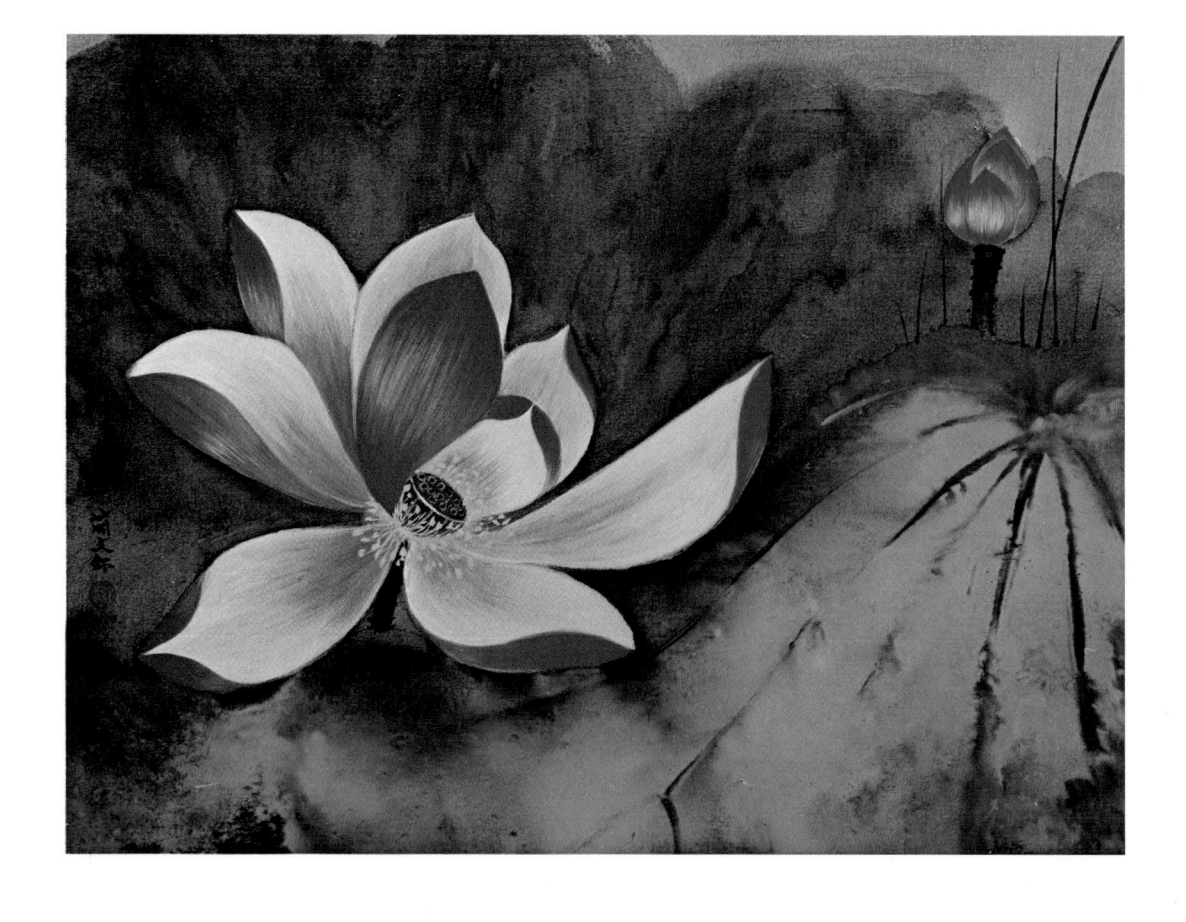

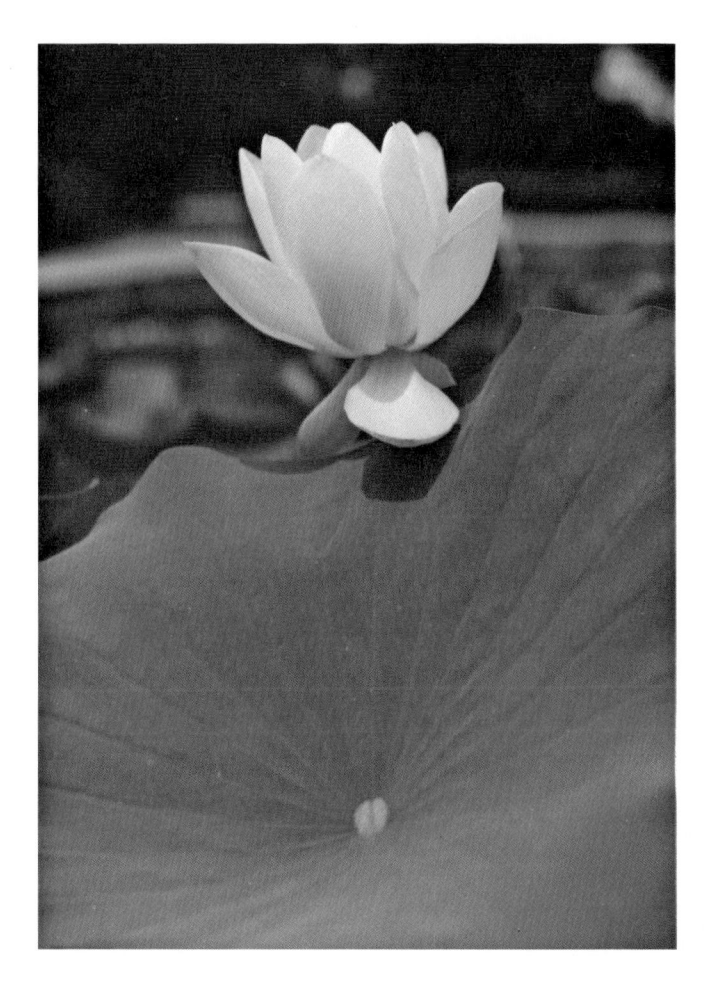

Before painting the lotus, study all of its aspects. Note that the veins of the leaf radiate from the center, where the top of the stalk ends. The pod, embedded with circular seeds and ringed by stamens, is another essential feature.

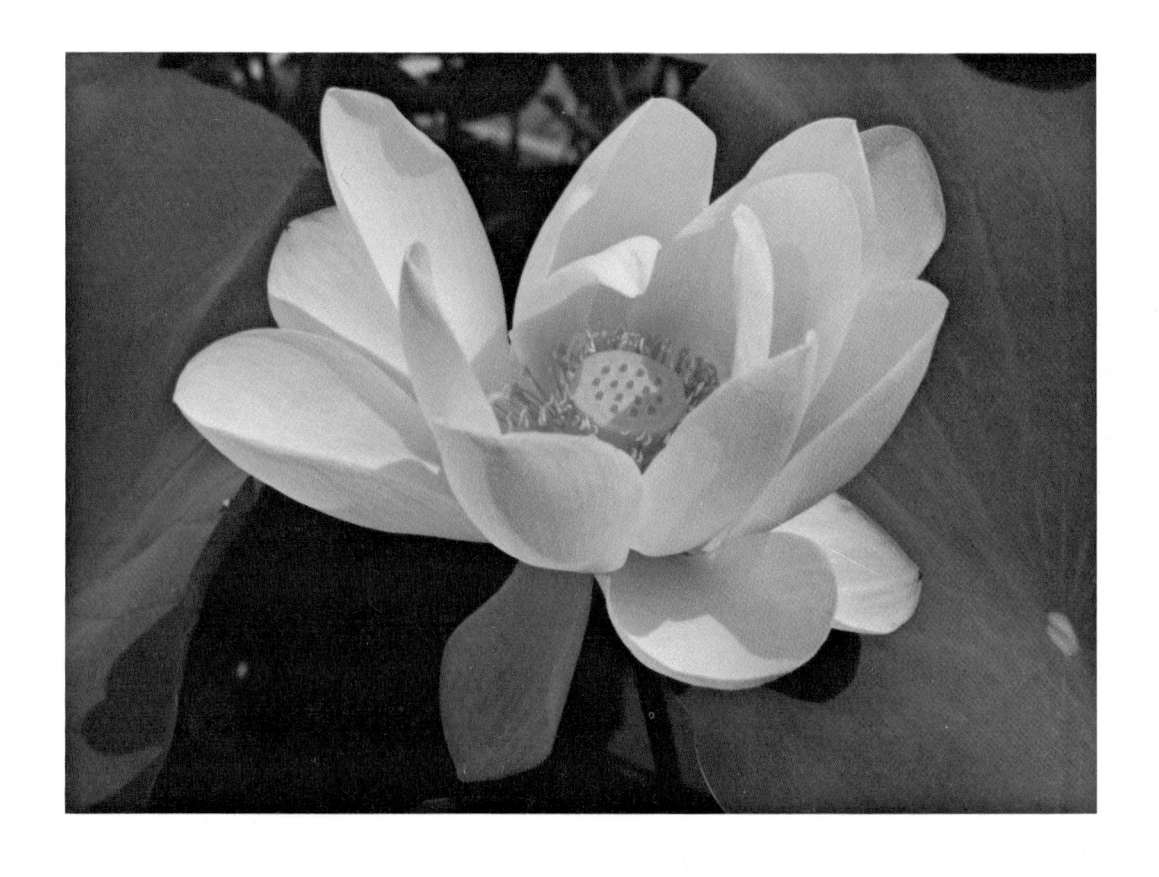

For *mo ku* style, broadly outline the pods in light ink with medium and dark accents; use a thick, upright stroke of medium tone for the stalks, to which black, prickly dots are added for a more sculptural form.

There are two methods. The first is to form all the sections of the leaves with initial strokes in light ink and to overlay these with a darker tone, once the first has dried. Sometimes many more layers of ink are added and it is necessary to wait patiently for each to dry before the next is applied. In each case, clear water in the upper bristles may be used to provide an extra tone. The dark veins are drawn in with the tip of the brush when the final coat of ink on the leaf has dried.

The second method is to add touches of medium and dark ink in successive stages to the initial, light-toned strokes while the tones are still wet, allowing the different tones to mingle. The veins may then be shown by picking up thin lines of the moist ink tones with a brush dipped in clear water only. The leaf tones should be partially dry, however, before veining is attempted. When touched, the ink should feel sticky but not thoroughly wet.

When large *mo ku* leaves are used in a composition, they are painted first. The pods, buds, and petals are painted next, using broader outlines than in contour style. Stamens are added, and finally the stalks are painted from the base of each leaf, bud, and flower, with the stalks of the leaves being slightly darker in tone, than those of the flowers. Accents of dark, prickly dots are added to the stalks, and the tips of the petals are also accented in dark ink.

For *mo ku* style in color, the leaves are built up in ink layers and they may then be washed with shades of pale and dark green. However, they may also be done directly in color, using mineral or emerald green with touches of black ink. The other elements, except the stamens, are outlined first in light ink. The seed pod may be colored with washes of brownish green, with the dark green seeds left rimmed in a lighter tone of that color. The filaments and anthers of the stamens are dark yellow. The outer surface of each contour-style petal is built up in color in much the same way as chrysanthemum and orchid petals, using graded shades of red or yellow over a white base coat. The inner surfaces are built up to a much lesser degree, remaining primarily white with touches of color.

When my teacher, Professor Chang Dai-chien, was accepted as a pupil by Mr. Tseng-hsi, he was asked what subject of painting he liked best. His answer was the lotus. When I, in turn, was accepted by my teacher, I was asked the same question, and I gave Professor Chang the same answer, "The lotus." It has been said many times by the poets of the world, "In the end is the beginning." It is hoped that the end of this book may inaugurate an auspicious beginning in the pursuit of further understanding of the elusive qualities of Chinese brushwork and painting.

The petals of the lotus are always outlined, but the other elements lend themselves to the bolder, freer style of *mo ku*. Begin by practicing a simple composition of seed pods, stalks and a small leaf. Outline the pods with broad, freely flowing strokes in light ink, accented with medium and dark ink. Paint the small, divided leaf with dark ink in an upright stroke; this stroke is pulled down at an angle to the left and then up to the right like a big check mark. While this ink is still moist, add a stalk beneath the leaf with a thick, upright stroke of medium tone; begin the stroke just far enough inside the leaf to pull some of the darker ink down into the medium tone for a short distance. Add a stalk beneath the base of each pod, again using a thick, upright stroke of medium tone for each. Finally, paint in the stamens with thin, dark lines and small dots; and add prickly dots to each stalk in dark ink. Thin strokes painted from the bottom of the composition upward may be added for the wheat stalks.

To paint large, graceful leaves of the lotus in *mo ku* style use a large (Western #15), obliquely held brush, with very broad strokes and with a free movement of the entire arm.

Opposite page: Large *mo ku* leaves are painted with an obliquely held brush and successive strokes of different ink tones. For fragile rice paper, it is necessary to wait for each stroke to dry before the next tone is overlaid; for silk, the stroke need not be absolutely dry. Dark veins are added last. Note, too, that the leaf stalks should be slightly darker than the flower stalks.

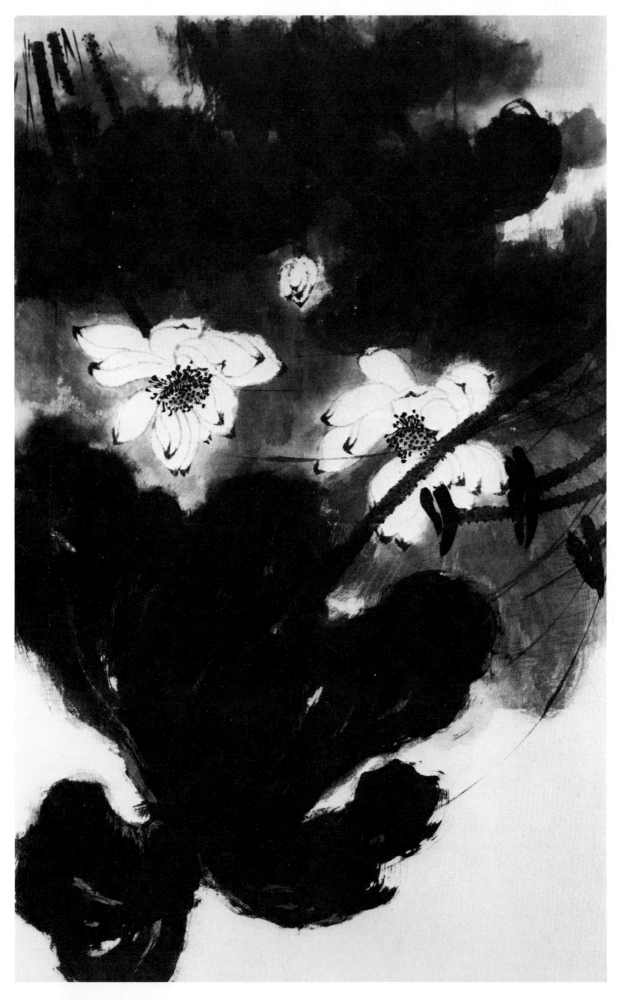

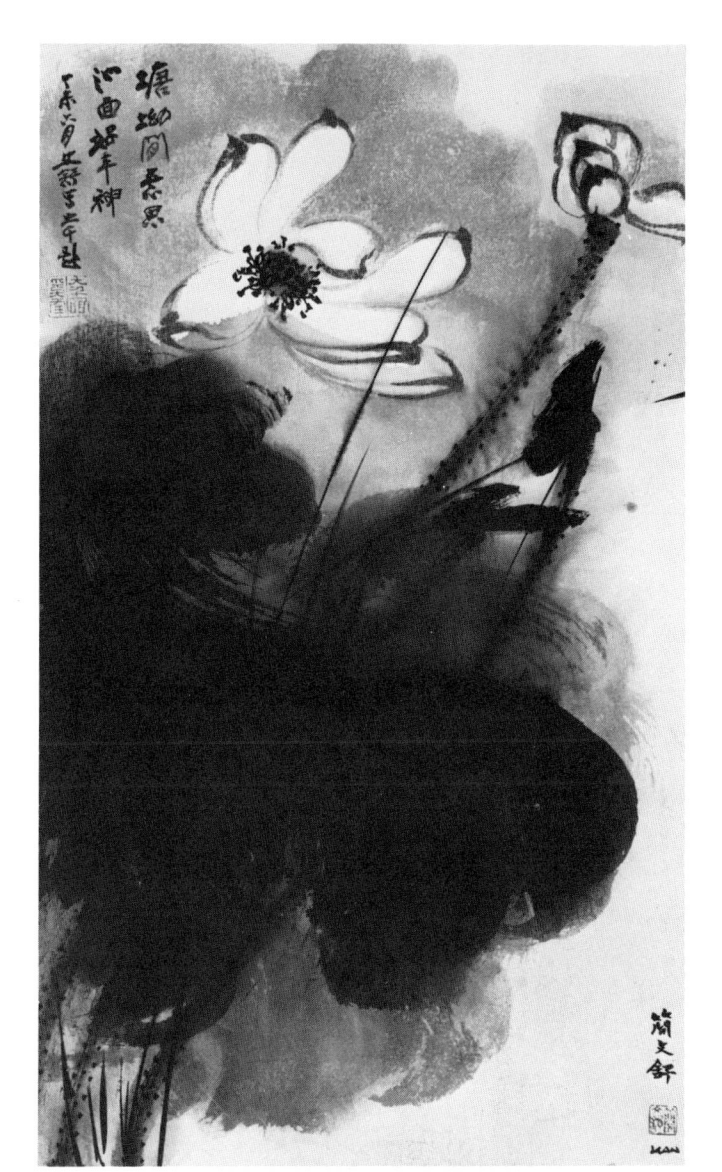

The lotus is a fascinating subject and has been pursued by many artists. No one has achieved more acclaim for this genre than Professor Chang Dai-chien, and to receive praise from such a master is a great honor. Professor Chang has written: "I am very content that my pupil Diana Kan (Man Shu), who studied with me for almost thirty years, has the spirit and feeling and talent to carry through my way of painting lotus."

Opposite page: Lotus, Diana Kan; ink on silk, 28 by 44¾ inches. (Collection of John M. Crawford, Jr.) *Below: Lotus,* Professor Chang Dai-chien; ink on paper, 53½ by 26½ inches. *Above, right: Lotus,* Diana Kan; ink on silk with color wash, 15¼ by 26½ inches. Colophon at upper left describes the elegant grace of this lotus.

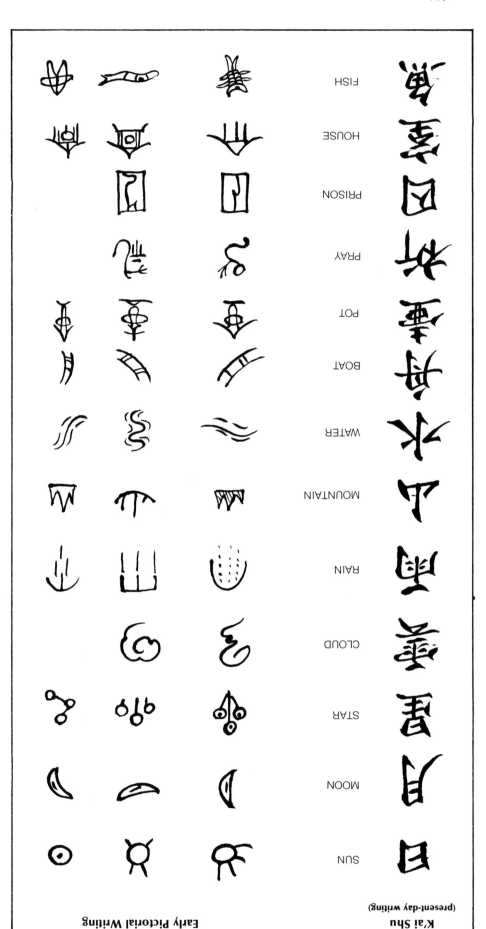

Early Pictorial Writing

K'ai Shu
(present-day writing)

FISH

HOUSE

PRISON

PRAY

POT

BOAT

WATER

MOUNTAIN

RAIN

CLOUD

STAR

MOON

SUN

Calligraphy Appendix

The connection between the art of writing Chinese characters and the art of painting is perhaps easier to understand when you consider that these characters were actually pictures at one time. The earliest mode of written communication was in the form of pictographs akin to the Egyptian hieroglyphics. Eventually, a more complex system of combining pictures evolved and it was necessary to condense the pictorial forms into graphic symbols, or characters, each one standing for a particular word.

Some of these symbols, like the character for *mountain*, represented objects. Other characters, either individually or in combination, came to indicate an idea associated with one or more objects. Thus two bones written as two horizontal lines came to mean *two* (forming a simple ideograph); the combination of the characters for *sun* and *moon* came to mean *bright* (a compound ideograph). Some words were borrowed from other objects and assigned new meanings; the word for *dustpan* came to also mean *its*, *theirs*, *hers*, and *his* (a phonetic loan); the word for *flesh* and the word for *small table* were combined to mean *muscle* (phonetic compound). So, while there are many combinations of characters, there are really relatively few basic root words *(tzŭ)*, which are repeated in forming the complex words.* And, since these root characters are based on pictures, they are not as difficult to understand as they may appear to be at first glance.

The historical evolution of the written language explains the variety of styles found during the different dynasties. The earliest pictographs were found carved on bones and shells from the Shang Dynasty (1766 to 1122 B.C.). By the end of the Chou Dynasty (1122 to 256 B.C.), the more formalized large seal script was evident, inscribed in bronze and stone. During the Ch'in Dynasty (221 to 207 B.C.), the small seal style, which is still used in seals today, was introduced by the calligrapher Li Ssu. This was followed by the more standardized clerical or official style in use from the Han Dynasty (207 B.C. to A.D. 220) to the beginning of the Sui Dynasty (A.D. 588).

Opposite page: At the far left is a comparison of early pictographs and the standard characters of today. At the left is a calligraphy scroll in *k'ai shu* written by the artist at the age of nine; it is 10½ by 55½ inches and contains a poem called *Ch'ing Chi Kao (Song of the Pure Spirit)*.

*The Chung Hua dictionary, compiled in the early years of the Republic, contains 50,000 characters, but the root characters number 214, and the average working vocabulary is between 3,000 and 7,000 characters. The first Chinese dictionary (the Shuo Wen of the Han Dynasty) contained only 9,353 characters in all.

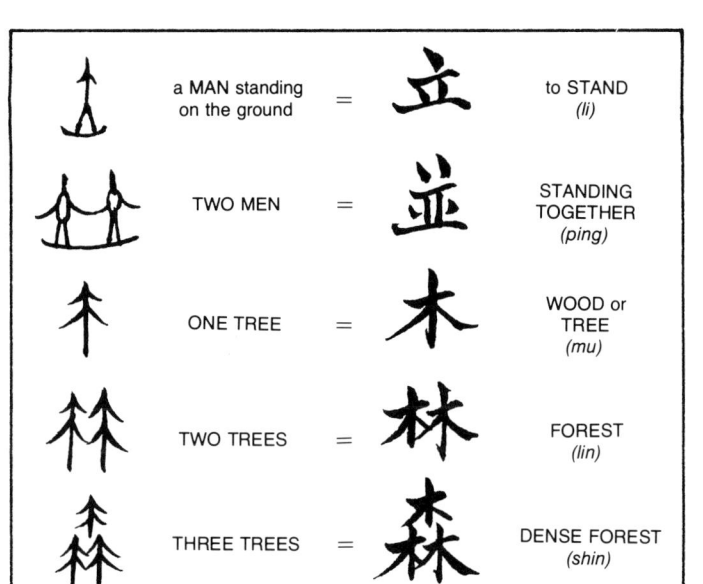

Above: Simple ideographs. *Below:* Compound ideographs.

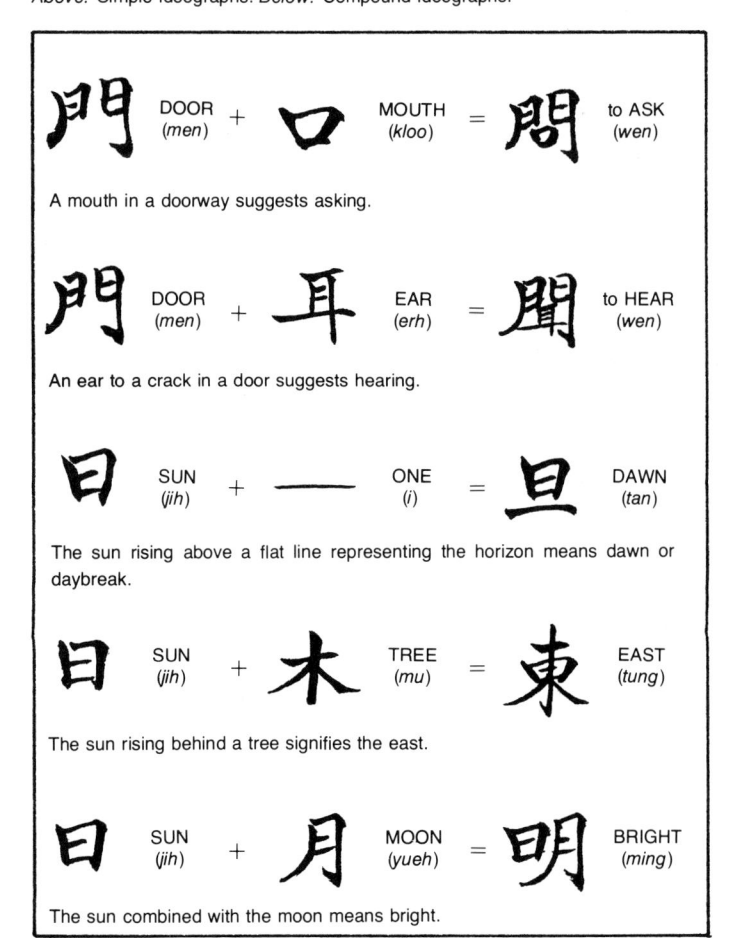

A mouth in a doorway suggests asking.

An ear to a crack in a door suggests hearing.

The sun rising above a flat line representing the horizon means dawn or daybreak.

The sun rising behind a tree signifies the east.

The sun combined with the moon means bright.

	Large Seal *Ta Chuan* (1122–256 B.C.)	Small Seal *Hsia Chuan* (221–207 B.C.)	Clerical Style *Li Shu* (207 B.C. – A.D. 588)	Running *Hsing Shu*	Standard *K'ai Shu*	Grass *Ts'ao Shu*
					(A.D. 588 to present day)	
SUN			日	日	日	日
MOON			月	月	月	月
FIRE	火	火	火	火	火	火
VEHICLE		軒	車	丰	車	車
THUNDER		雷	雷	雷	雷	雷
DOOR	門	門	門	一	門	山
HEART			心	心	心	心
EYE		目	目	目	目	目
MOUTH		口	口	心	口	口
WATER			水	水	水	水
FIELD		田	田	田	田	田
RAIN			雨	雨	雨	雨
FLY			飛	飛	飛	飛

From the clerical style was derived the *k'ai shu* style, which has been the regular form of writing ever since. This style is fundamental and must be learned before the more ebullient and speedier cursive scripts (the running and grass styles), which developed along with the *k'ai shu*. These last three styles are the ones most commonly used in calligraphy.

The term calligraphy (from the Greek *kalligraphia*) means beautiful writing (the Chinese equivalent is *shu fa* — method of writing), and the same high standards of brushwork that apply to painting apply to this art as well. The basic structure of each character in the *k'ai shu* script is balanced and logical and each stroke follows the other in a precise order so that the rhythm prevails. The general rule is to work from the top down and from the left to the right within each character. The successive characters are placed in vertical rows, starting at the top of the paper and at the right-hand side. Each new row begins at the top and is placed to the left of the previous one. To assure straight rows, the calligrapher should be standing or sitting in an erect position.

In the examples on the following pages, the strokes of each character are numbered to show the proper sequence. When attempting to copy these or other characters, remember that very often a complex character can be broken down into its component parts and the strokes can be worked in units.

Practice the individual strokes first. Use the purely upright position for the brush and allow for free movement of the entire arm, keeping your wrist off the surface of the paper or silk. Use only rich, black ink. Remember to increase pressure to broaden the stroke and release it to obtain a narrower line. Strive for graceful hooking strokes, carefree but strongly formed sweeping strokes, well-groomed and self-contained long strokes, and boldly formed, resolute dots or short strokes.

The quality of brushwork is judged not only by the length and thickness of the individual strokes but also by how the strokes meet each other as they are written in sequence to form the character. Observe the joining of the strokes carefully in practicing each character.

The importance of calligraphy in Chinese life cannot be underestimated. A student of painting is required to become proficient in calligraphy first, and skill in either of these arts is considered among the highest achievements possible. Scrolls of calligraphy are traditionally offered as gifts and they are used as wall hangings, hand scrolls, and album leaves in the same manner as paintings. The two arts share a common origin and each evolved as a means of making an aesthetic statement, expressing the underlying principles of nature through the harmony and rhythmic vitality of their united elements.

Opposite page: The chart illustrates the historical evolution of the Chinese language.

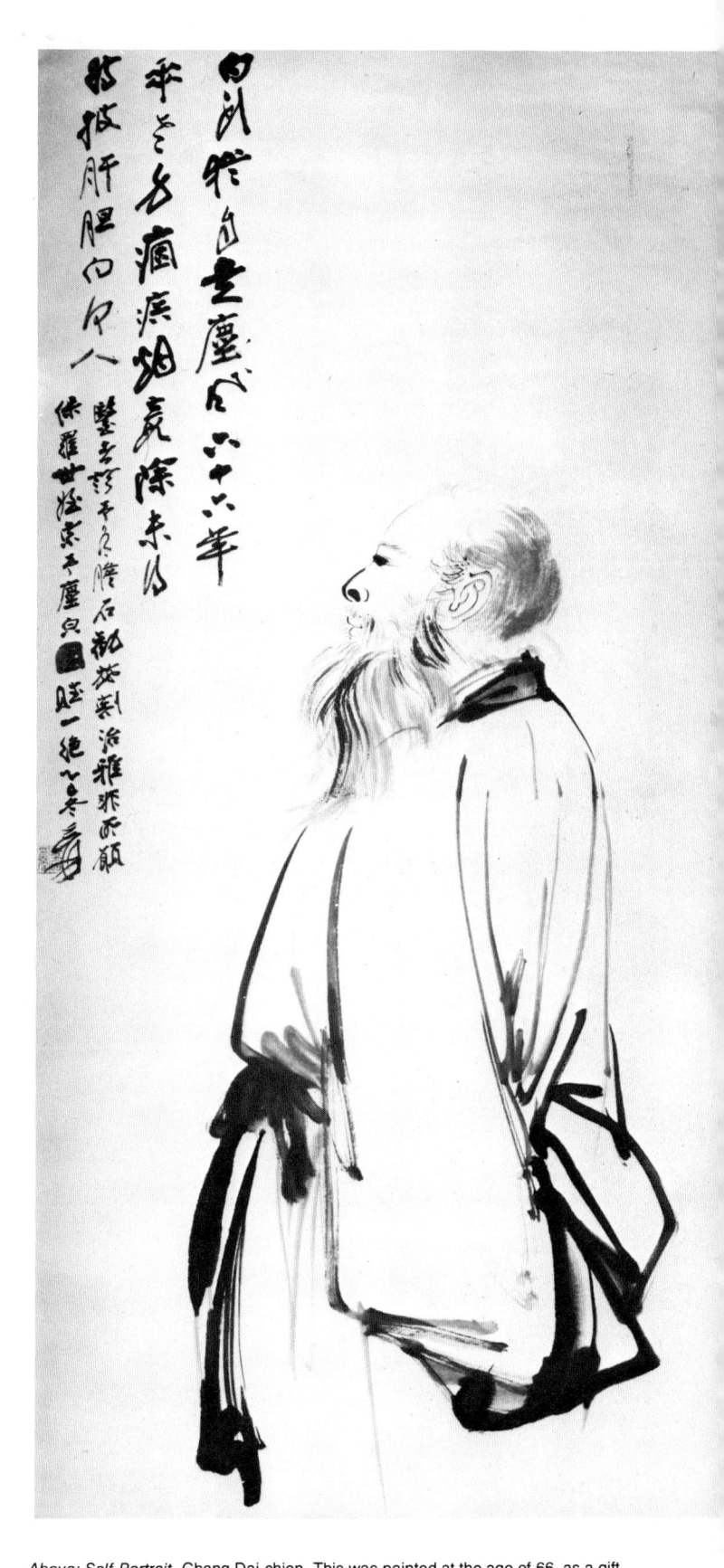

Above: Self-Portrait, Chang Dai-chien. This was painted at the age of 66, as a gift to Mr. Paul Schwartz. The calligraphy, in grass style, is an integral part of the painting and describes the artist's feelings at the time.

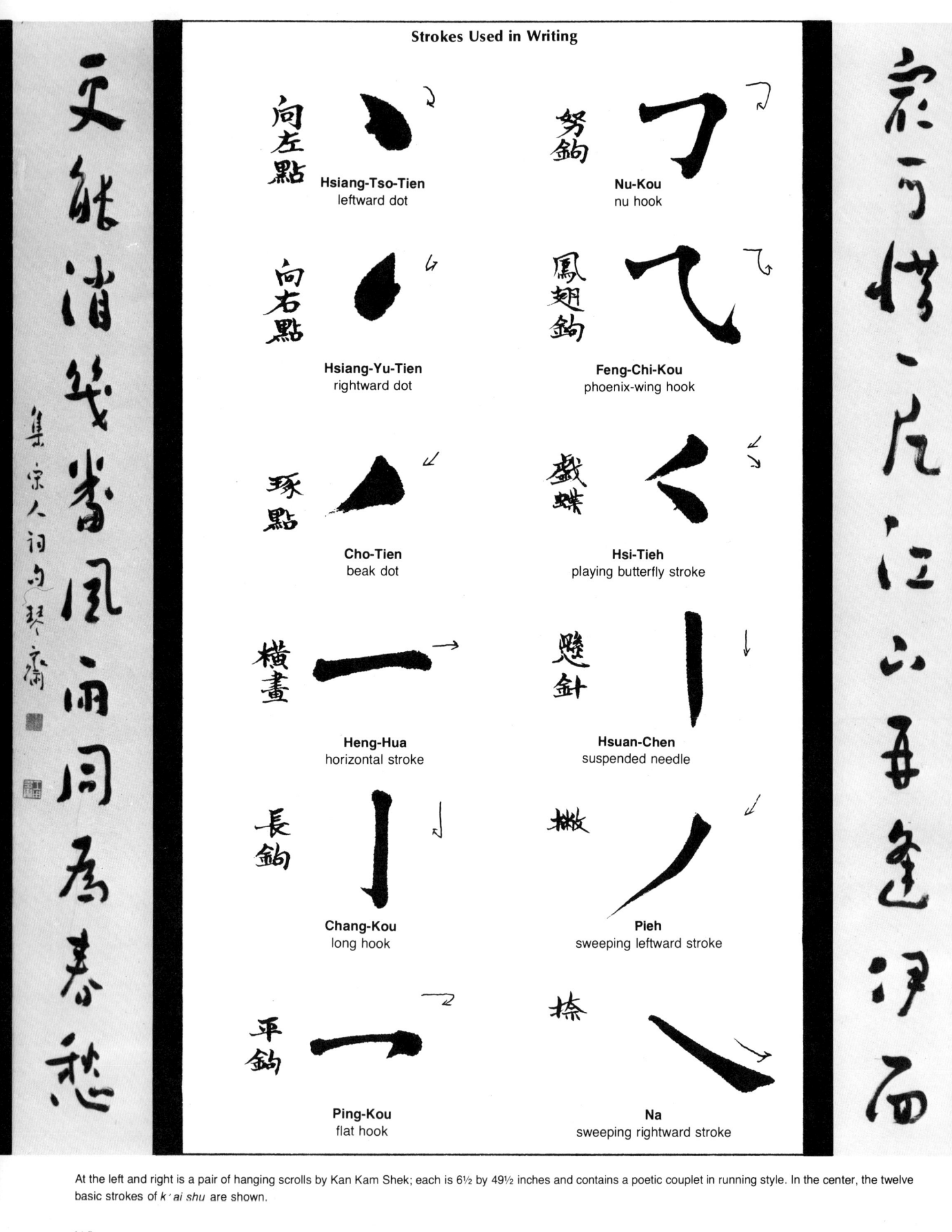

Strokes Used in Writing

向左點
Hsiang-Tso-Tien
leftward dot

努鈎
Nu-Kou
nu hook

向右點
Hsiang-Yu-Tien
rightward dot

鳳翅鈎
Feng-Chi-Kou
phoenix-wing hook

琢點
Cho-Tien
beak dot

戲蝶
Hsi-Tieh
playing butterfly stroke

橫畫
Heng-Hua
horizontal stroke

懸針
Hsuan-Chen
suspended needle

長鈎
Chang-Kou
long hook

撇
Pieh
sweeping leftward stroke

平鈎
Ping-Kou
flat hook

捺
Na
sweeping rightward stroke

At the left and right is a pair of hanging scrolls by Kan Kam Shek; each is 6½ by 49½ inches and contains a poetic couplet in running style. In the center, the twelve basic strokes of k'ai shu are shown.

NINE	九		ONE	一
chia			i	
TEN	十		TWO	二
shih			erh	
HUNDRED	百		THREE	三
pai			san	
THOUSAND	千		FOUR	四
chien			su	
TEN THOUSAND	萬		FIVE	五
wan			wu	
YEAR	年		SIX	六
nien			lui	
MOON, MONTH	月		SEVEN	七
yueh			ch'i	
SUN, DAY	日		EIGHT	八
yer			pa	

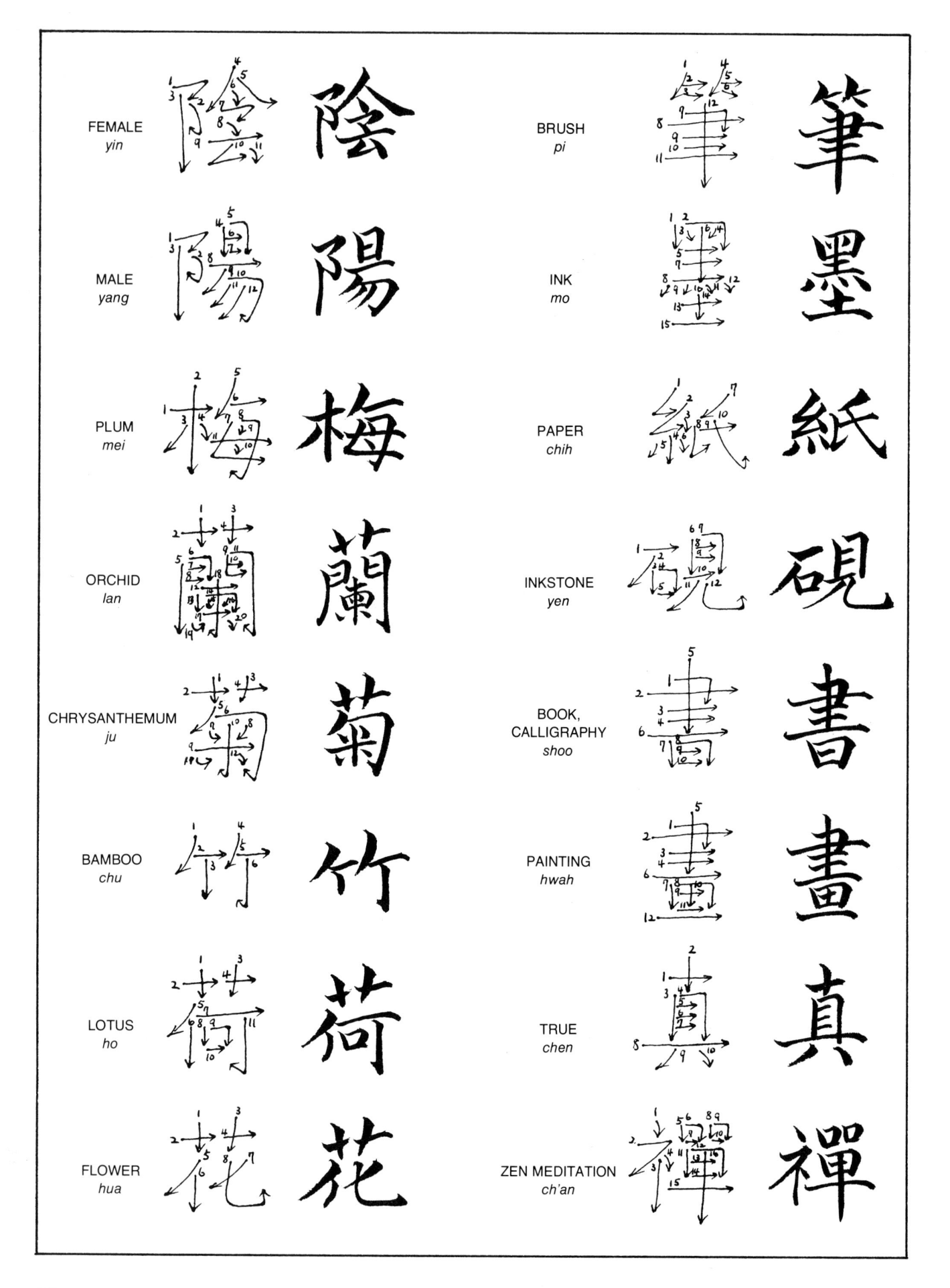

FEMALE *yin*	陰	筆
MALE *yang*	陽	墨
PLUM *mei*	梅	紙
ORCHID *lan*	蘭	硯
CHRYSANTHEMUM *ju*	菊	書
BAMBOO *chu*	竹	畫
LOTUS *ho*	荷	真
FLOWER *hua*	花	禪

BRUSH *pi*

INK *mo*

PAPER *chih*

INKSTONE *yen*

BOOK, CALLIGRAPHY *shoo*

PAINTING *hwah*

TRUE *chen*

ZEN MEDITATION *ch'an*

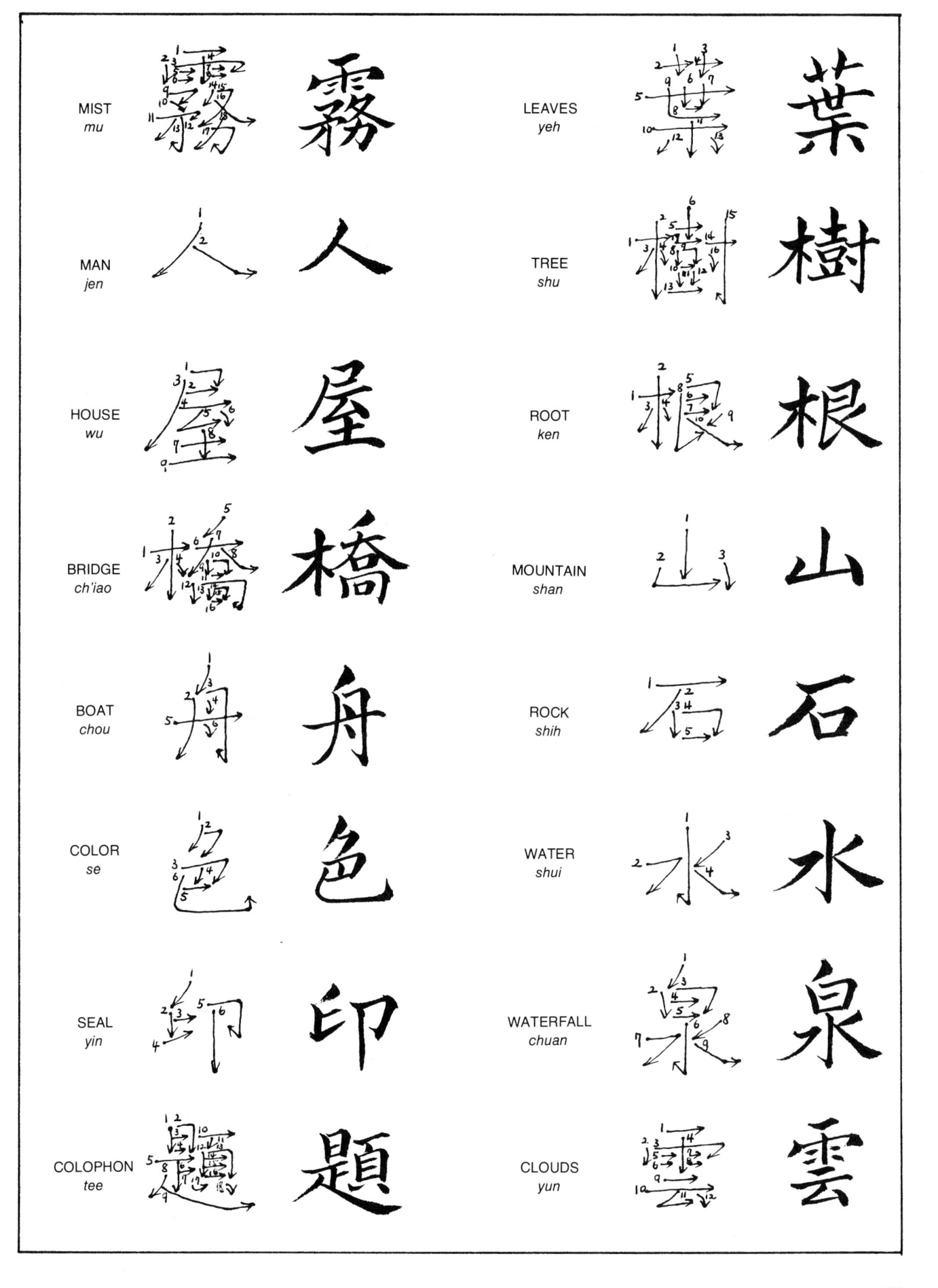

MIST
mu

MAN
jen

HOUSE
wu

BRIDGE
ch'iao

BOAT
chou

COLOR
se

SEAL
yin

COLOPHON
tee

LEAVES
yeh

TREE
shu

ROOT
ken

MOUNTAIN
shan

ROCK
shih

WATER
shui

WATERFALL
chuan

CLOUDS
yun

HAPPINESS *fu*		福
PROSPERITY *lu*		祿
LONGEVITY *ch'ou*		壽
COMPLETE *ch'uan*		全
LIFE, BIRTH *sheng*		生
TIME, DAY *ch'en*		辰
BIG, GREAT *dai*		大
LUCKY, FAVORABLE *chi*		吉
WILLOW *liu*		柳
WU-TUNG TREE *tung*		桐
PINE *sung*		松
CYPRESS *pai*		柏
SPRING *ch'un*		春
SUMMER *hsia*		夏
AUTUMN *chiu*		秋
WINTER *tung*		冬

FILIAL *hsiao*	孝
BROTHERLY AFFECTION *ti*	悌
SINCERE *chung*	忠
FAITH, TRUST *hsien*	信
HONOR, RESPECT *tsun*	尊
TEACHER, MASTER *shih*	師
IMPORTANT, WEIGHTY *chung*	重
WAY, MORAL PRINCIPLES *tao*	道

FATHER *fu*	父
MOTHER *mu*	母
UNCLE (Father's older brother) *pai*	伯
UNCLE (Father's younger brother) *shu*	叔
OLDER BROTHER *huang*	兄
YOUNGER BROTHER *dee*	弟
OLDER SISTER *chieh*	姊
YOUNGER SISTER *mei*	妹

173

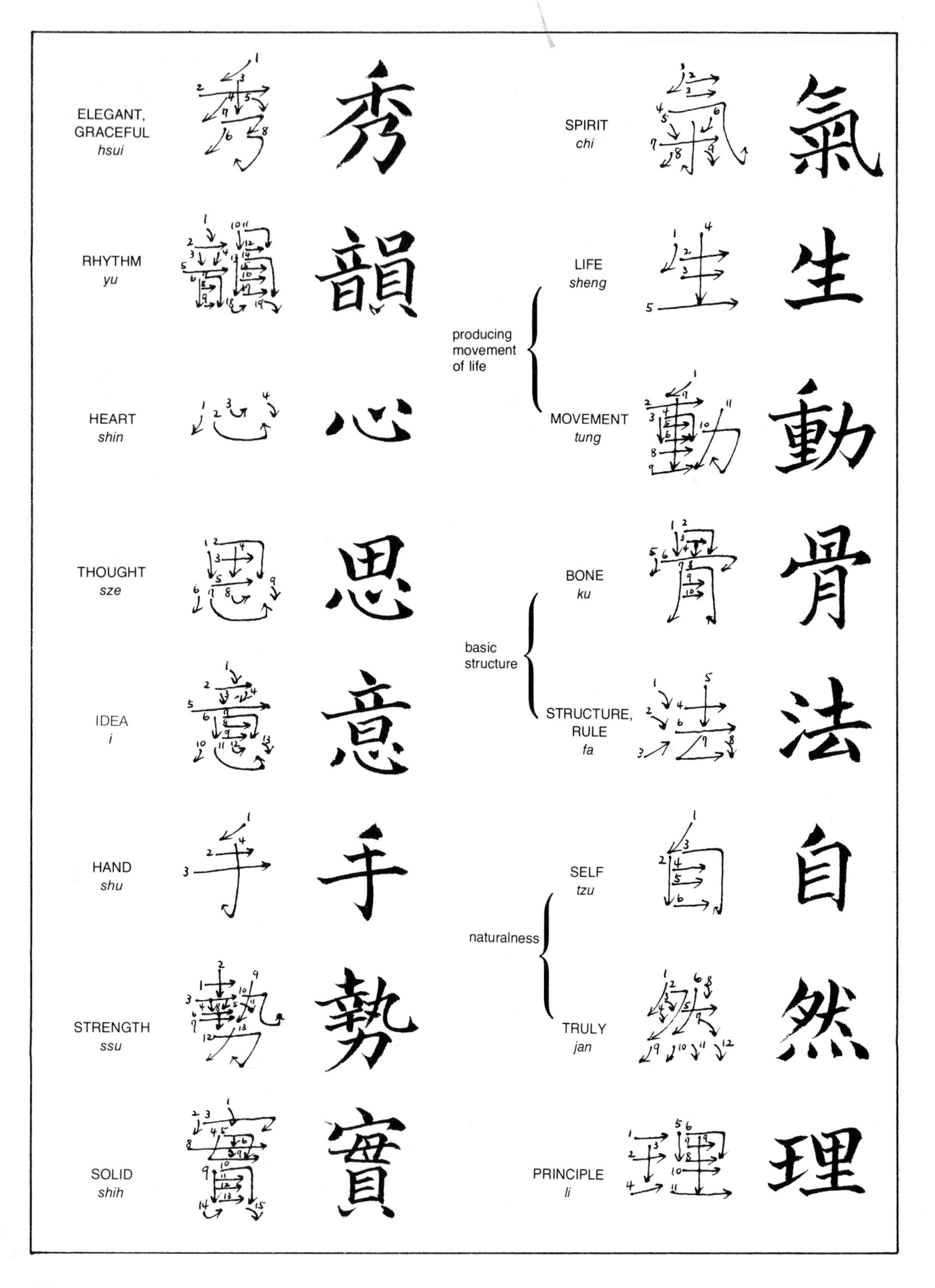

ELEGANT, GRACEFUL *hsui*		秀
RHYTHM *yu*		韻
HEART *shin*		心
THOUGHT *sze*		思
IDEA *i*		意
HAND *shu*		手
STRENGTH *ssu*		勢
SOLID *shih*		實

SPIRIT *chi*		氣
LIFE *sheng*	producing movement of life	生
MOVEMENT *tung*		動
BONE *ku*	basic structure	骨
STRUCTURE, RULE *fa*		法
SELF *tzu*	naturalness	自
TRULY *jan*		然
PRINCIPLE *li*		理

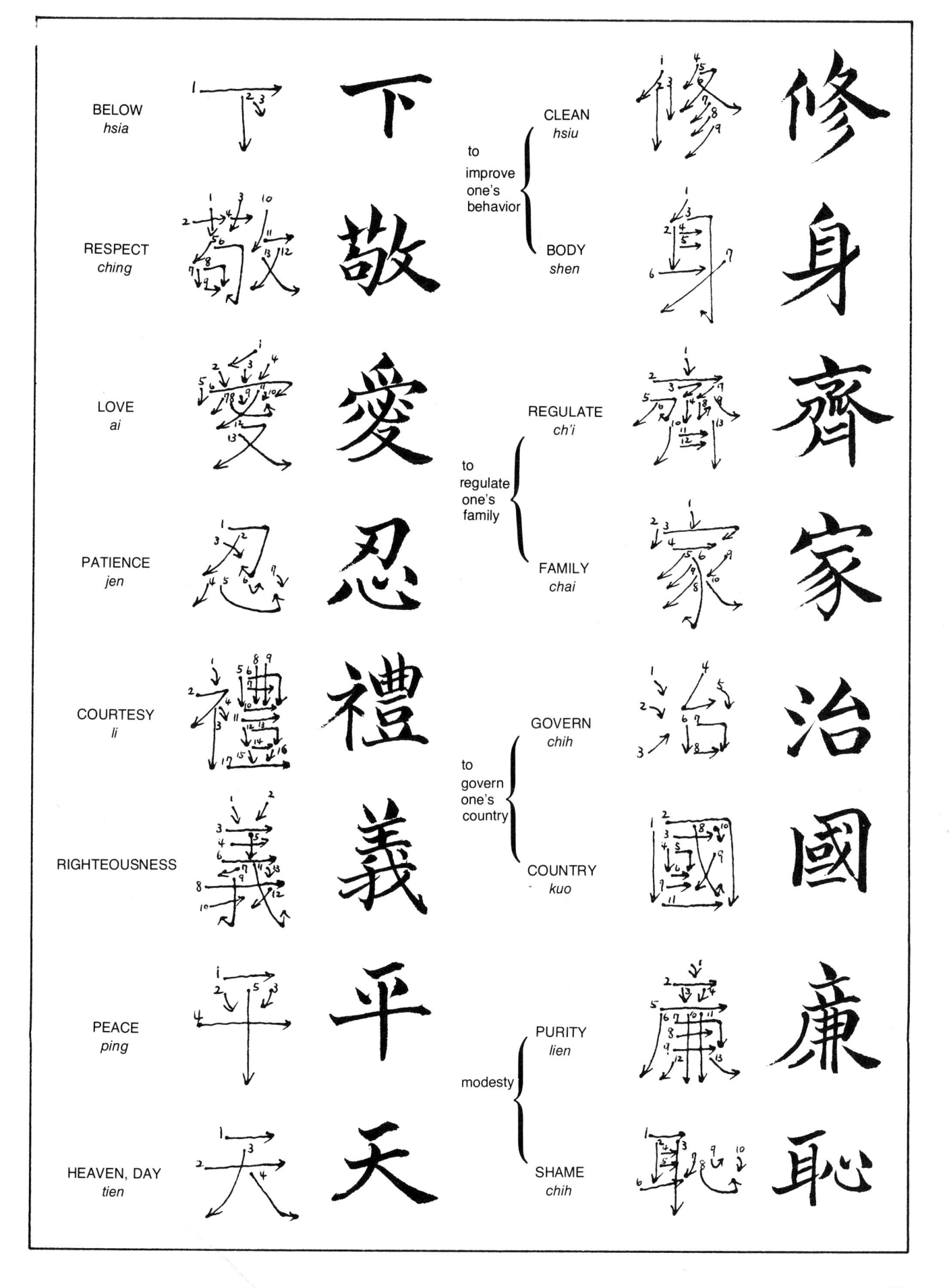

BELOW
hsia
下

RESPECT
ching
敬

LOVE
ai
愛

PATIENCE
jen
忍

COURTESY
li
禮

RIGHTEOUSNESS
義

PEACE
ping
平

HEAVEN, DAY
tien
天

to improve one's behavior
CLEAN *hsiu* 修
BODY *shen* 身

to regulate one's family
REGULATE *ch'i* 齊
FAMILY *chai* 家

to govern one's country
GOVERN *chih* 治
COUNTRY *kuo* 國

modesty
PURITY *lien* 廉
SHAME *chih* 恥

175

SUPPLIERS

Rice Papers and Brushes

The following list is a sampling of characteristic papers; these have been rated for ease of painting and ability to show ink tones. New papers are constantly becoming available, however, and it is necessary for the artist to experiment with different kinds to determine individual preferences. Because bristle composition varies with the manufacturer, brush sizes are not standard. The imported brushes listed here are considered equivalent to the basic Chinese ones. The student may wish to experiment with other brushes as proficiency increases.

Aiko's Art Materials Import*
714 N. Wabash Avenue
Chicago, Illinois 60611

Name and Description	Size	Price	Cat. No.
√*Hosho* **(a)**	17 × 23	.30/ sht	101
√√*Takenaga* **(s)** (ow) (hy)	21 × 31	.40/sht	104
√√*Torinoko* **(s)** (hy)	21 × 31	.50/ sht	105
√√*Hodomura* **(s)** (ow) (hy)	21 × 31	1.15/ sht	108
√√*Kozo* **(s)**	24 × 36	.95/ sht	109
√√*Tamatsubaki* **(a)**	24 × 36	.35/ sht	204
√√√*Sunome* **(s)**	21 × 31	.30/ sht	205
√√*Hakuhosen* **(a)**	27 × 53	1.15/ sht	206
√√*Shoji* **(a)**	11 × 36	.30/ sht	207
	23 × 36	.75/ sht	208
√√*Seicho* **(a)** (ow)	13 × 19	.35/ sht	209
√√√*Minokichi* **(a)** (ow)	24 × 36	.55/ sht	211
√√*Kurotani* **(s)** (ow) (th)	27 × 39	.65/ sht	219
√*Usumino* **(s)** (ow) (th)	23 × 35	.50/ sht	221
√√*Gimpai* **(a)**	9½ × 13	2.50/100 shts	223
√*Hosho* **(a)** (hy) (pad)	9 × 12	4.25/ 48 shts	55 SPH
√*Shoji* **(a)** (pad)	9½ × 13	2.50/ 100 shts	56 GMP
	12 × 18	1.75/ 48 shts	63 SPB-M
No. 1 all-purpose	¼ × 1¼	2.00	CL 1
No. 2 sheep's hair	5/16 × 1⅜	6.15	S 9
No. 3 fine line	⅛ × ¾	2.00	L 3
No. 4 broad wash	1¾ wide	3.50	WP 3
	1¼ wide	2.75	WP 4

Sam Flax**
25 East 28th Street
New York, New York 10016

Name and Description	Size	Price
√√√*Hosho* **(a)** (hy)	19 × 24	.89/ sht
√√*Mulberry* **(s)**	24 × 33½	.77/ sht
√√√*Okawara* (st gr), **(s)** (ow)	18 × 25	.43/ sht
√√√*Suzuki* **(s)** (hy)	36 × 72	3.73/ sht

*Aiko's will fill mail orders. It is suggested that you write for a catalog and order form giving the latest prices and postal fees (enclose $.50 handling for the catalog). A sample book of rice papers is available for $4.00.

**Minimum mail order is $15.00.

Key

√√√ excellent √√ very good √ good

(a) absorbent **(s)** sized (st gr) student grade (ow) off-white

(th) thin (hy) heavy (lo) line only (cal) calligraphy

Yasutomo & Co.***
24 California Street
San Francisco, California 94111

Name and Description	Size	Price	Cat. No.
√√√*Toshi* **(a)** (th)	17 × 27	4.00/ 10 shts	229 S
√√√*Hosho* **(a)**	15 × 20	3.00/ 10 shts	590 X
√√*Hosho* **(a)**	24 × 36	15.00/ 10 shts	590 SP
√√*Hosho* **(s)** (ow) (hy)	24 × 36	15.00/ 10 shts	591 SP
√√√*Hanshi* **(a)** (th) (pkg)	9 × 13	12.00/ 500 shts	6 B
√√√*Gasen* **(a)**	26 × 54	14.00/ 10 shts	589 L
√√*Gasen* **(a)** (th)	26 × 54	7.00/ 10 shts	589 X
	13 × 54	4.00/ 10 shts	
√*Mochizuki* **(a)**	24 × 36	8.00/ 10 shts	M 101
√√*Hosokawa* **(a)** (ow) (th)	20 × 29	8.50/ 10 shts	001
√√√*Hodomura* **(a)** (hy)	20 × 26	8.50/ 10 shts	0V 530
√√*Hosho* **(a)** (pad)	9 × 12	4.50/ 48 shts	6 H
√√*Sumi-e* **(a)** (pad)	12 × 18	2.50/ 50 shts	6 JM
√√√*Shoji* (Unryu) **(a)**	11 × 60'	5.50/ roll	6 SU
√√*Makigami* **(a)**	8 × 20'	2.00/ roll	6 M
√*Gasen* **(a)** (pad) (cal)	13 × 19	4.00/ 20 shts	6 D
√√*Kozo* **(s)** (ow) (th) (lo)	24 × 36	12.75/ 10 shts	547
No. 1 all-purpose	5/16 × 1⁵/16	2.50	6040 S
No. 2 sheep's hair	5/16 × 1⁵/16	3.50	6030 L
	5/16 × 1⅜	6.50	5608 M
No. 3 fine line	⅛ × 1	2.25	3046 L
	3/32 × ⅞	2.00	3046 M
No. 4 broad wash	1½ wide	5.00	BF 217
	2½ wide	8.00	BF 216

***Yasutomo will refer you to the local dealer handling their products. If no dealer is in your area, they will fill prepaid orders as a courtesy. Catalog available, $1.50; sample book of rice papers, $1.00; selection charts of papers and brushes, free on request.

Ink Sticks

These come in different qualities and range in price from $1.50 to $5.00. While it is not necessary to buy the most expensive grade, do not get the cheapest one.

Inkstones

Inkstones range in price from $2.00 to $3.25, depending on size.

Oriental Colors

Porcelain dishes of color are sold by the set ($17.00) or singly ($1.00).

It is recommended that you visit your local dealer or obtain a catalog in order to select the above materials and other accessories, such as bamboo mats, porcelain mixing dishes, seal ink, and so forth. Please note that all prices listed here are subject to change.

Below: A poem by Kan Kam Shek, 25½ by 11⅝ inches, written for his wife on the first month's anniversary of their daughter's birth.